Erotic Art

an annotated bibliography
with essays

Reference Publications in
ART HISTORY

Richard Price, Editor
Non-Western Art

Erotic Art

an annotated bibliography with essays

EUGENE C. BURT

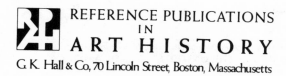

REFERENCE PUBLICATIONS
IN
ART HISTORY
G. K. Hall & Co, 70 Lincoln Street, Boston, Massachusetts

N
8217
.E6
B87
1989

WITHDRAWN

Library of Congress Cataloging-in-Publication Data

Burt, Eugene C., 1948-
 Erotic Art: an annotated bibliography with essays/
Eugene C. Burt.
 p. cm. -- (Reference publications in art history)
 Includes index.
 ISBN 0-8161-8957-9
 1. Erotic art--bibliography. I. Title. II. Series: Reference
publication in art history.
Z5956.E7B87
[N8217.E6]
016.7049'428--dc 19 88-30709
 CIP

This publication is printed on permanent\durable acid-free paper
MANUFACTURED IN THE UNITED STATES OF AMERICA

Contents

Contents

Contents

Contents

Contents

Contents

Acknowledgments

The task of compiling this bibliography on erotic art has seemed herculean at times. While it has mostly been a solitary effort, there are institutions and individuals who need to be thanked for their assistance in this research effort:

Institutions

Boston Public Library
Boston University libraries
Harvard University libraries
Indiana University, Institute for Sex Research Library
Indiana University libraries
Philadelphia Public Library
Seattle Public Library
Temple University libraries
Tufts University Library
University of Massachusetts - Boston library
University of Pennsylvania libraries
University of Texas at Austin Libraries
University of Texas, Fine Arts Library
University of Washington, Art Library
University of Washington Libraries

Individuals

Darlene S. Burt
Dr. Daniel Crowley
Staff of the interlibrary loan office of the Perry-Castaneda
 Library at the University of Texas
Dr. Donald Statner
Dr. Elizabeth Swinton
Dr. Glenn Webb

Introduction

 The art establishment has largely ignored the subject of erotic art. With few exceptions, neither museums nor galleries display erotic art and educators rarely include it in their courses.　There are a number of reasons for this situation, but perhaps foremost is that critics, museum administrators, educators, and scholars are no less uncomfortable dealing with sexuality, especially in the pubic arena, than is our society in general. That someone can earn a Ph.D. in art history and yet know almost nothing about the erotic art of the era or region of his or her specialty indicates the extent to which the subject has been not simply overlooked, but purposefully ignored, if not actively suppressed.　Yet artists throughout history have produced erotic art, during some periods in significant quantity and quality, as they seek to understand and interpret the human experience, of which sexuality is an undeniably universal aspect.　One oft-repeated reason given by art scholars for why there has been so little research and teaching of erotic art is that there is a paucity of literature on the subject.　This bibliography is intended to dispel that notion and to encourage scholarly research into this aspect of the world's art history.

 The late 1960s and early 1970s were an especially productive period in the history of erotic art.　At that time, as part of the so-called 'sexual revolution' and the burgeoning feminist movement, many artists were experimenting with sexual imagery and many galleries were displaying their work.　It is not surprising that a curious graduate student should have become interested in that aspect of art history.　When initially investigating this topic, it was immediately evident that erotic art had not received the same kind of scholarly attention as most other aspects of art.　While developing materials for teaching courses, giving special lectures, and writing articles, a bibliography was begun.　Over the years bibliographic entries grew in number, until it became clear that enough material had been compiled to justify the publication of a major bibliography on erotic art.　The creation of this bibliography is a logical stage in the ultimate goal of authoring a comprehensive history of erotic art.

 In the process of compiling a bibliography, establishing the criteria for inclusion is an essential, but problematic step.　Since there is so little agreement on the definitions of such terms as erotica, erotic art, and pornography, considerable judgment had to be exercised when using the organization and indexing of other bibliographic sources.　For the purposes of this bibliography a broadly inclusive definition of erotic art has been used--that erotic art is art that primarily addresses some aspect(s) of the human

Introduction

sexual experience. While many publications unquestionably are on the subject of erotic art, often proclaiming so in their titles, many potential entries, upon inspection, turn out to be of little value or irrelevant. This was especially true in dealing with what is herein described as 'background' materials. At all times in the compilation of this bibliography the overriding criterion for inclusion was whether an item significantly contributed to an understanding of the history of erotic art.

This bibliography was compiled during a period of over fifteen years by scouring a wide range of information sources including published bibliographies (for instance, Books in Print and various national bibliographies), periodical indexes (for instance, Art Index and ArtBibliographies Modern), antiquarian book dealer sales catalogs (especially valuable are C.J. Scheiner's "Erotica-curiosa-sexology" catalog and Ivan Stormgart's erotica catalog), and library card catalogs. Entries include books, chapters from anthologies, periodical articles, dissertations, conference papers, and unpublished manuscripts. When evidence of the existence of a potentially relevant item was first encountered, the bibliographic information was not always complete and/or correct, so a concerted effort to verify the citation was undertaken. Whenever possible--by purchase, library research, or use of interlibrary loans--the items were inspected to ensure accuracy. When more than one edition of an item exists, preference is given to the first American edition of any book, to English language versions, and to illustrated editions. Information on other editions is frequently provided, but no claim is made that every edition of a work has been documented.

The entries listed in this bibliography range in quality from serious academic research to items that would not normally be found in a scholarly bibliography (such as articles in publications like Penthouse, Hustler, and Playgirl). While some may criticize this approach, it has been adopted for several reasons--a major goal of this bibliography has been to provide comprehensive coverage of the subject, many aspects of the history of erotic art have not been investigated by scholars, and sources with frivolous or little text may have illustrations potentially useful to researchers. Although there are a few excellent scholarly studies, such as Catherine John's survey of Greek and Roman erotic art or Lisa Tichner's analysis of sexual expression in the women's art movement of the 1960s and 1970s, which can serve as models for future research projects, most items found in this bibliography must be viewed critically because they are characterized by one of several deficiencies--many are simply collections of illustrations with little text or documentation clearly intended to titillate rather than educate; text is frequently so politically or religiously biased that the reliability of the information provided is highly questionable; and so much effort is put into justifying the art of a certain period or artist as 'erotic' and not 'pornographic' (a generally fruitless endeavor) that there is little objective information or substantive analysis offered.

The bibliography has been organized into sections and chapters that reflect the major regions and periods of erotic art history, proceeding from entries that offer general or survey coverage to more specific topics. Within chapters entries may be further organized under subheadings, many of which are unique to the chapter (for example, the "Medieval" chapter

includes subheadings on Misericords and Sheela-na-gigs). Users are advised to use carefully the table of contents in order to locate those areas of the bibliography most likely to contain entries of interest to them. The bibliographic essays beginning each chapter frequently suggest other chapters that may have related materials. An author index is provided.

The bibliography is designed to have a consistent format. Each chapter begins with a short essay that defines the subject of the chapter, summarizes the historiography of that subject, and describes the major categories and focus of the items listed. Especially valuable works are noted and other evaluative comments sometimes made. The essays directly reflect the organization of the chapter's bibliography. Each bibliographic entry has been assigned an unique identification number, which consists of a prefix chapter number, a hyphen, and a sequentially assigned number (for instance, entry 5-32 is the thirty-second item in chapter 5). An asterisk (*) following the identification number indicates that the item was not inspected by the compiler. The citation provided is as complete as possible, uninspected items, however, may have incomplete or inaccurate information. Every effort was made to verify entries, but some proved to be elusive.

A brief reader's annotation, included with most entries, is intended to provide a general description of the nature of the works, making evaluative comments only for especially valuable sources and those that are poorly written, badly illustrated, or questionably reliable. Mention is also made when a prevalent point of view is discernable, such as the entries written by feminist critics and scholars. It is assumed that by reading the bibliographic essays, the annotations, and the location of entries within the overall organization of the bibliography, the user will have a reasonable understanding of the potential value of any item for his or her purposes.

Section 1
General Background

Chapter 1
Sex Customs and History

To understand fully the history of erotic art it is necessary to recognize the social and cultural environments in which it has been produced. All peoples have beliefs and sanctioned practices in regard to sexual activity. In many instances these sex customs give rise to the production of objects that depict sexual matters. The entries in this chapter have been included because they offer insights into the milieu in which erotic art has been produced, appreciated, and used; the most useful at least mention erotic art and the best offer insights into its role in history.

Interest in the study of sexual customs arose in the nineteenth century as a consequence of the development of anthropology and psychology. One of the earliest publications is J.E.M Cenac-Moncault's study of love and sex in the Western world, published in 1863. Probably the most famous nineteenth century student of sex customs was Sir Richard Burton, who amassed a remarkable amount of information from Asia, Africa, and Europe. Historical and anthropological studies of the sexual customs of Europe and Asia were undertaken by a number of scholars at the turn of the century, especially in Germany, classic examples being Muller's Das sexuelle Leben der alten Kulturvolker and Saltus's Historia Amoris. Roger Goodland's A bibliography of sex rites and customs is an important bibliography of materials published up to about 1930. By the 1930s there was a proliferation of books based on the writings of those earlier authors together with an increasing accumulation of data on so-called "primitive" peoples; for example, there are works by Bloch, Brusendorff, Cabanes, Calverton, Englisch, and Mantegazza.

General audience books on sex customs seem to have reached a zenith in the 1940s, 1950s, and early 1960s (many of these publications were unscholarly works intended to titillate rather than to educate). Interesting works from this period include Bolen's Geschichte der Erotik, Ellis's Folklore of sex, Hunt's Natural history of love, Lewisohn's History of sexual customs, Partridge's History of orgies, Simons's History of sex, and Taylor's Sex in history. A groundbreaking book, which has become a classic in the study of sex customs, is Wayland Young's Eros denied: sex in Western society first published in the early 1960s. This period of research and publication is overviewed in an historiographic study by Bullough in an article appearing in the Journal of Sex Research.

In recent years several books have been published that summarize our knowledge of sex customs and the role of sex in history—Tannahill's eminently readable Sex in history, Gregerson's anthropological survey Sexual practices, and Davies's extended essay on the subject The rampant god.

Besides comprehensive surveys, publications on the subject of sex customs can take one or more of several approaches. Some focus on a cross-cultural survey of a specific subject, such as the history of prostitution (see entries by Bassermann, Bullough, Evans, Henriques, Wake, and others) or sexual mutilation (see entries by Bergmann, Bryk, Hosken, Khayat, and others). In a similar vein, some entries take a thematic approach, as in the first half of Gregerson's Sexual practices, Bloch's works, and various encyclopedias/dictionaries. Works following a historical chronology have been especially popular since World War II, some of which have been mentioned above.

While many of the entries listed below offer worldwide coverage, most focus primarily on a specific geographic region as in Epton's series of books on the love history of various European countries. Sex in American culture has been reported by Banes, D'Emilio & Freedman, Frumkin, and Smith. Works on the customs of the geographic regions or time periods covered later in this bibliography are included in the appropriate chapters.

1-1 ABLEMAN, PAUL. Anatomy of nakedness. London: Orbis, 1982. 112 pp., index, bib., illus.
 Survey of social attitudes to nudity throughout history.

1-2 AMEZUA, EFIGENIO. La Erotica Espanola en sus Comienzos: Apuntes para una Hermeneutica de la Sexualidad Espanola. Barcelona: Editorial Fontanella, 1974. 216 pp., intro.
 Exploration of the role of Spain in the development of Western sexual mores and practices.

1-3 ARIES, PHILLIPE, and BEJIN, ANDRE. Western sexuality: practice and precept in past and present times. New York: Basil Blackwell, 1985. 232 pp.

1-4 BANES, SALLY; FRANK, SHELDON; and HORWITZ, TEM. Our national passion: 200 years of sex in America. Chicago: Follett, 1976. 230 pp., index, illus.
 Study of the history of American sex mores.

1-5 BASSERMANN, LUJO. The oldest profession: a history of prostitution. Translated from German by James Cleugh. New York: Stein and Day, 1967. 300 pp., bib., illus., index. (Translation of Das asteste Gewerbe, eine Kultur-Geschichte [Vienna: Econ, 1965].)
 History of prostitution in the Western world.

1-6 BATAILLE, GEORGES. Death and sensuality: a study of eroticism and the taboo. New York: Ballantine Books, 1962. 276 pp., bib., index, illus.

Philosophical essay on the relationship between suffering/death and eroticism.

1-7* Bauer, Max. Titanen der Erotik; Lebensbilder aus der Sittengeschichte aller Zeiten und Volker. Zurich: Eigenbrodler, 1929. 330 pp., ill., bib.

1-8 BERGMANN, FR. "Origine, signification et histoire de la castration, de l'eunuchisme et de la circoncision." Archivio per lo studio delle tradizione populari 2 (1883): 271-93.
　　　One of the earliest studies of male genital mutilation customs in history.

1-9* Bildatlas der Sexualitat. 112 pp., illus. (col.).

1-10 BLOCH, IWAN. Anthropological and ethnological studies in the strangest sex acts in modes of love of all races illustrated: Oriental, Occidental, savage, civilized. Introduction by Albert Eulenburg. New York: Falstaff Press, 1935. 197 pp. (text), illus.
　　　Psychological and anthropological study of various sex customs and beliefs around the world, written with a moralistic negative appraisal of non-Christian peoples.

1-11 _____. Anthropological studies in the strange sexual practices of all races in all ages, Ancient and modern. New York: Anthropological Press, 1933. 246 pp., illus. (Reprinted as Strange Sexual Practices [North Hollywood: Brandon House, 1967].)
　　　Survey of sex practices around the world marred by a moralizing, patronizing tone. Includes a chapter on art.

1-12* _____. Ethnological and cultural studies of the sex life in England illustrated as revealed in its erotic and obscene literature and art. New York: Falstaff, 1934.

1-13* _____. Strangest sex acts in modes of love of all races illustrated. New York: Falstaff, 1935.

1-14 BOLEN, CARL VON. Geschichte der Erotik. St. Gall: Allgemeiner, 1951. 260 pp., illus. (col.).
　　　Period by period survey of sex in Western and Asian cultural history.

1-15* BOUSFIELD, PAUL. Sex and civilization. New York: Kegan Paul, Trench, Trubner, 1925. 294 pp., bib.

1-16 BREWER, JOAN SCHERER, and WRIGHT, ROD W. Sex research: bibliographies from the Institute of Sex Research. Phoenix: Oryx, 1979.
　　　List of bibliographies compiled by the Institute.

1-17 BRUSENDORFF, OVE. Erotikens Historie: fra Graekenlands Oldtid til Vole Dage. Edited by Christian Rimestad. 3 vols. Copenhagen: Universal, 1936-38. Illus, index.
Survey of sex customs and beliefs with many illustrations of erotic art.

1-18 BRYK, FELIX. Sex and circumcision: a study of phallic worship and mutilation in men and women. North Hollywood: Brandon House, 1967. 342 pp., bib., illus., figs.
Provides examples of mutilation practices around the world.

1-19 BULLOUGH, VERN L. Sex, society & history. New York: Science History Pubs., 1976. 185 pp., intro.
Study of the history of sex practices.

1-20 _____ . "Sex in history: a virgin field." Journal of Sex Research 8, no. 2 (May 1972): 101-16.
Historiography of sex studies.

1-21 _____ . Sexual variance in society and history. New York: Wiley, 1976. 715 pp., index, bib.
Survey of European sex beliefs and practices.

1-22 BULLOUGH, VERN L., and BULLOUGH, BONNIE. An illustrated social history of prostitution. New York: Crown, 1978. 336 pp., illus., bib.
Study of the role of prostitution through the ages.

1-23 _____ . Sin, sickness and sanity: a history of sexual attitudes. New York: Garland, 1977. 276 pp., index, bib. ref.
Variety of topics in the area of sex belief and practices discussed.

1-24 BURTON, RICHARD. The erotic traveler. Edited by Edward Leigh. New York: Putnam, 1968. 189 pp.
Study of sex customs in the Orient, Africa, and the Americas.

1-25 CABANNES, AUGUSTIN. The erotikon: being an illustrated treasury of scientific marvels of human sexuality. Translated from French by Robert Meadows. New York: Falstaff Press, 1933. 251 pp., illus. (col.).
Illustrated collection of strange sex practices from all ages and cultures.

1-26 CALVERTON, V.F., and SCHMALHAUSEN, S.D., eds.. Sex in civilization. Introduction by Havelock Ellis. Garden City, N.Y.: Garden City Publications, 1929. 709 pp., bib., index.
Collection of essays on aspects of sexual behavior, including some on customs and religion.

1-27 CELA, CAMILO JOSE. Enciclopedia del Erotismo. 5 vols. Madrid: Sedmay, 1977. Illus. (col.).

Alphabetically arranged encyclopedia of sexual matters. Well researched and lavishly illustrated.

1-28 CENAC-MONCAULT, JUSTIN EDOUARD MATTHIEU. Histoire de l'amour dans les temps modernes: chez les Gaulois, les Chretiens, les barbares et du Moyen Age au dix-huitieme siecle. Paris: Amyot, 1863. 448 pp.
Love and sex in the Western world explored.

1-29 CLEUGH, JAMES. A history of Oriental orgies: an account of erotic practices among the peoples of the East and the Near East. New York: Crown, 1968. 220 pp., bib.
In spite of titillating title, an interesting survey of erotic practices of peoples of Africa and Asia.

1-30 _____. Ladies of the harem. London: F. Muller, 1955. 255 pp., illus., bib.
Study of polygamy in human history with emphasis on European and Asian traditions.

1-31 DAVENPORT, JOHN. Aphrodisiacs and anti-aphrodisiacs: three essays on the powers of reproduction: with some account of the judicial "Congress" as practiced in France in the seventeenth century. London: Privately Printed, 1869. 154 pp. (text), fig. Reprint. Introduction by Dr. Paul J. Gillette. New York: Award Books, 1970. 191 pp., illus.)
Study of aphrodisiacs, phallicism, and sex customs around the world.

1-32 DAVIES, NIGEL. The rampant god: eros throughout the world. New York: Morrow, 1984. 300 pp., bib., index.
Anthropologist's survey study of sexual beliefs and practices throughout history in societies from around the world.

1-33* D'EMILIO, JOHN, and FREEDMAN, ESTELLE. Intimate matters: a history of sexuality in America. New York: Harper and Row, 1988. 404 pp., bib., index.

1-34 DENIS, ARMAND. Taboo. London: W.H. Allen, 1966. 203 pp., illus.
Aspects of sex customs in Oceania, Africa, Europe, and Asia.

1-35* DIAMOND, MILTON. The world of sexual behavior: sexwatching. Gallery.

1-36 DRAMA REVIEW. "Sex and performance [Issue]." Drama Review 25, no. 1 (March 1981): 100 pp., illus.
Series of articles on aspects of sex in the performing arts, particularly of the nineteenth and twentieth centuries.

1-37 EDWARDS, ALLEN. Erotica Judaica: a sexual history of the Jews. New York: Julian Press, 1967. 238 pp., index.
Sex beliefs and practices of Jews are surveyed.

1-38 ELLIS, ALBERT. The folklore of sex. New York: Grove, 1960. 225 pp., intro. (Later published as Sex beliefs and customs.) Study of American sex beliefs.

1-39 EMDE BOAS, CONRAD VAN. "Europe, sex life in." In The encyclopedia of sexual behavior, edited by Albert Ellis and Albert Abarbanel, 373-83. New York: Hawthorn, 1961. Concise survey of European sex beliefs and customs.

1-40 _____. Geschiedenis van de Seksuele Normen: Oudheid, Middeleeuwen, 17de eeuw. Antwerp: Nederlandsche Boekhandel, 1985. 208 pp., illus. (some col.), bib. Survey of sexual customs in the ancient world, medieval Europe, and seventeenth century northern Europe. Well illustrated with works of art.

1-41* The encyclopedia of sex practice. London: Encyclopedic Press, 1972. 836 pp., illus. (some col.).

1-42* ENGLISCH, PAUL. Sittengeschichte Europas. Berlin: Kiepenheuer, 1931. 442 pp., illus., figs. Detailed study of sex history in Europe with emphasis on the arts.

1-43 EPTON, NINA CONSUELO. Love and the English. London: Cassell, 1960. 390 pp., illus. Study of love and sex throughout English history.

1-44 _____. Love and the French. Cleveland: World Pub., 1960. 368 pp., illus. Study of love and sex throughout French history.

1-45 _____. Love and the Spanish. London: Cassell, 1961. 216 pp., illus., index. Study of love and sex throughout Spanish history.

1-46 EVANS, HILARY. Harlots, whores & hookers: a history of prostitution. New York: Dorset Press, 1979. 255 pp., bib., index, illus. Survey history of prostitution.

1-47 _____. The oldest profession: an illustrated history of prostitution. London: David and Charles, 1979. 255 pp., illus., bib., index. History of prostitution with most of the text discussing the late nineteenth century and early twentieth century.

1-48 EVOLA, JULIUS. The metaphysics of sex. New York: Inner Traditions, 1983. 329 pp., notes, index. (First edition entitled Metafisica del Sesso [Rome: Edizioni Mediterranee, 1969].)

Nature of sex as expressed in customs and religions around the world explored.

1-49* Fille de joie: the book of courtesans, sporting girls, ladies of the evening, madams, a few occasionals and some royal favorites. New York: Grove, 1967. 448 pp., illus.

1-50 FRUMKIN, ROBERT. "English and American sex customs." In The encyclopedia of sexual behavior, edited by Albert Ellis and Albert Abarbanel, 350-65. New York: Hawthorn, 1961.
Concise survey of sex beliefs and customs among English speakers.

1-51 GELB, NORMAN. The irresistible impulse: an evocative study of erotic notions and practices through the ages. New York: Paddington, 1979. 208 pp., index, bib., illus.
Overview of attitudes to sex in the Western world throughout history.

1-52 GLYNN, PRUDENCE. Skin to skin: eroticism in dress. New York: Oxford University Press, 1982. 157 pp., index, illus. (some col.).
Study of the erotic message in clothing.

1-53* GONZALEZ-CRUSSI, F. On the nature of things erotic. New York: Harcourt Brace Jovanovich, 1988.

1-54 GOODLAND, ROGER. A bibliography of sex rites and custom: an annotated record of books, articles, and illustrations in all languages. London: George Routledge, 1931. 752 pp., pref.
Classic bibliography of works published before 1930.

1-55 GREGERSON, EDGAR. Sexual practices: the story of human sexuality. New York: Franklin Watts, 1983. 320 pp., bib., index, map, illus.
Survey of the historical and cultural diversity of sexual behavior and belief.

1-56 HARDING, M. ESTHER. Woman's mysteries: ancient and modern: a psychological interpretation of the feminine principle as portrayed in myth, story, and dreams. Introduction by C.G. Jung. New York: Bantam, 1971. 299 pp., index, figs.
Role and image of women around the world explored.

1-57* HENRIQUES, FERNANDO. Love in action: the sociology of sex. New York: Dutton, 1964. 444 pp., illus.
Sex practices and beliefs around the world.

1-58* HENRIQUES, SEYMOUR. Prostitution and society, a survey. 3 vols. [vol. 1, The pretence of love (primitive, classical and Oriental worlds; vol. 2, The immoral tradition (Western world); vol. 3 Modern sexuality]. New York: Grove, 1963; London: Panther, 1970. Bib., illus.
World history of prostitution from ancient times to today.

1-59 HOLLANDER, ANNE. Seeing through clothes. New York: Viking, 1978. 504 pp., bib., index, illus.
　　　　Clothed and naked human form in Western art and history surveyed.

1-60 HORNER, THOMAS MARLAND. Eros in Greece: a sexual inquiry. New York: Aegean Books, 1978. 127 pp., bib.
　　　　Overview of modern Greek attitudes to sex: includes appendix on ancient Greece.

1-61* HOSKEN, FRAN P. The Hosken report: genital and sexual mutilation of females. Lexington, Mass.: Women's International Network News, 1979. 360 pp., bib.
　　　　Detailed survey of traditions of female genital mutilations around the world.

1-62 HOUQUE, PARTICK. Eve, Eros, Elohim: la femme, l'erotisme, le sacre. Collection Femme. Paris: Denoel/Gonthier, 1982. 270 pp., bib.
　　　　Study of the role of women in religion and sex.

1-63 HUMANA, CHARLES. The keeper of the bed: a study of the eunuch. London: Arlington Books, 1973. 202 pp., illus., bib.
　　　　Historical survey of the role of the eunuch in European and Asian societies.

1-64 HUNT, MORTON M. The natural history of love. New York: Knopf, 1959. 416 pp., index, bib.
　　　　Study of the concept of love in the West.

1-65 KERN, STEPHEN. Anatomy and destiny: a cultural history of the human body. Indianapolis: Bobbs-Merrill, 1975. 307 pp., index, bib., illus.
　　　　Attitudes to the human body in history.

1-66 KHAYAT, JACQUELINE. Rites et mutilations sexuels. Paris: Guy Authier, 1977. 188 pp., map, bib.
　　　　Survey of the practices of sexual mutilation in many cultures.

1-67 KIRBY, E.T. "Ritual sex: anarchic and absolute." Drama Review 25, no. 1 (March 1981): 1-8, bib.
　　　　Study of performance aspects of orgies in several cultures.

1-68* KNOLL, LUDWIG, and JAECKEL, GERHARD. Lexikon der Erotik. Zurich: Schweizer, 1975. 419 pp., index, illus. (some col.).
　　　　Sexology dictionary.

1-69* LA CROIX, PAUL. History of prostitution among all the peoples of the world; from the most remote antiquity to the present day. 3 vols. [vol. 1, Antiquity, Greece and Rome; vol. 2, Antiquity, Rome

and the Christian era; vol. 3, Christian era.] Translated by Samuel Putnam. Chicago: Covici, 1926. 3 vols., ill. (First edition published in German in one volume under pseudonym Pierre Dufour [Berlin: Lagenscheidt, 1925].)

1-70* LANVAL, MARC. Les mutilations sexuelles. 1936.

1-71 LAURENT, GISELE. Les societes secretes erotiques. Algiers: S.P.E., ca. 1962. 126 pp., illus., bib.
 Impressionistic view of secret sex customs.

1-72 LEWANDOWSKI, HERBERT. Ferne Lander—fremde Sitten: eine Einfuhrung in die vergleichende Sexualethnologie. Stuttgart: Hans E. Gunther, 1958. 340 pp., index, illus. (some col.).
 Ethnology of sex customs in the Americas, Africa, India, Japan, and the South Seas.

1-73 LEWINSOHN, RICHARD. A history of sexual customs. Translated by Alexander Mayce. New York: Harper and Row, 1971. 424 pp., index, illus., figs.
 Survey history of sex, mostly in the Western world.

1-74 LIEBBRAND-WETTLEY, ANNEMARIE, and LEIBBRAND, WERNER. Formen der Eros. 2 vols. [vol. 1, Vom Antiken Mythos bis zum Hexenglauben; vol. 2, Von der Reformation bis zur Sexuellen Revolution.] Munich: K. Alber, 1972. Bib.
 Scholarly survey of sexuality in the Western world.

1-75* LINNER, BIRGITTA. Sex and society in Sweden. Preface by Lester Kirkendall. New York: Harper & Row, 1972. 225 pp., illus., bib.

1-76 LO DUCA, J.M., ed.. Dictionnaire de Sexologie (Sexologia-Lexikon). Paris: Pauvert, 1962. 567 pp., illus.
 Dictionary of eroticism with many illustrations of erotic art.

1-77 _____. Supplement A-Z. Paris: Pauvert, 1965. 420 pp., illus.
 See above entry.

1-78 _____. Das moderne Lexikon der Erotik von A-Z. 10 vols. Munich: Kurt Desch, 1969. Illus.
 Dictionary of erotology with many illustrations.

1-79 MACDOUGALD, DUNCAN. "Phallic foods." International Journal of Sexology 5, no. 4 (May 1952): 206-8.
 Phallic shaped foods as an element of European customs described.

1-80 MANTEGAZZA, PAOLO. The sexual relations of mankind. Translated by Samuel Putnam; edited with introduction by Victor Robinson. New York: Eugenics, 1935. 335 pp.
 Study of sex customs around the world.

1-81* MARSHALL, DONALD STANLEY, and SUGGS, ROBERT C., eds.
 Human sexual behavior: variations in the ethnographic spectrum.
 New York: Basic Books, 1971. 302 pp., bib.

1-82 MARTELLI, JUAN CARLOS, and SPINOSA, BEATRIZ, eds. El Erot-
 ismo en la moda. Buenos Aires: Nueva Senda, 1973. 126 pp.,
 illus., bib.
 Analytical look at eroticism in clothing, particularly in recent
 decades.

1-83 MEREDITH, OSCAR. The lure of lust: the saga of man's ceaseless
 search for sexual excitement. London: Tallis, 1969. 188 pp.,
 bib., illus.
 Survey of sex customs in Western culture.

1-84 MORALI-DANINOS, ANDRE. Histoire des relations sexuelles ("Que
 Sais-Je?" le point des connaissances actuelles, No. 1074). Second
 edition. Paris: Presses universitaires de France, 1965. 126 pp.,
 bib.
 History of sex customs in Europe.

1-85 MULLER, JOSEF. Das sexual Leben der alten Kulturvolker. Leip-
 zig: T. Grieben, 1902. 143 pp.
 Sexual customs in Egypt, the ancient Near East, Asia, Greece,
 and Rome described.

1-86 MURSTEIN, BERNARD I. Love, sex, and marriage through the
 ages. Foreword by William M. Kephart. New York: Springer,
 1974. 637 pp., bib., index.
 Thorough survey of sex and love in the West (with some com-
 ments on Asia and Africa).

1-87 NELLI, RENE. Erotique et civilisation. Paris: Weber, 1972. 245
 pp., illus., bib.
 Some themes in the history of sexuality in Western culture, with
 emphasis on myths, beliefs, and expressions of love.

1-88 NEVINS, M.D. The sexually obsessed. Van Nuys, Calif.: Genell,
 1965. 160 pp., bib.
 Sensationalistic account of sex worship and customs in the West-
 ern world, with moralistically judgmental text.

1-89 PARTRIDGE, BRUNO. A history of orgies. New York: Crown,
 1960. 247 pp., index, bib.
 Description of traditions of orgiastic behavior from the ancient
 Greeks to modern times.

1-90 PLANETE. "L'amour a' refaire." [Special number of the review
 Planete.] Paris: Nouvelle Societe Planete, 1971.
 Special issue concerned with a wide range of topics related to
 human sexuality and including many articles on sex customs around the
 world.

1-91* PLOSS, HERMANN HEINRICH; BARTELS, MAX; and BARTELS, HEINRICH. Femina Libido Sexualis. Edited by Eric John Dingwall. New York: Medical Press of New York, 1965. 318 pp., illus.
Detailed study of the role of women around the world, including their sex lives.

1-92 _____. Woman: an historical, gynaecological and anthropological compendium. Edited by Eric John Dingwall. 3 vols. London: W. Heinemann, 1935. 543 pp., illus., figs., index, bib.
Study of the role of women around the world. Information is clearly dated in light of present knowledge.

1-93 Praeputii Incisio: a history of male & female circumcision with chapters on hermaphrodism, infibulation, eunuchism, Priapism and divers other curious and phallic customs. New York: Panurge Press, 1931. 311 pp.
Interesting survey history of circumcision and castration customs.

1-94* REVILLA, FEDERICO. El sexo en la historia de Espana. Plaza y Janes: Esplugas de Llobregat, 1975. 315 pp., bib.
Chronological survey history of Spanish sex customs.

1-95* REYBURN, WALLACE. Bust-up. New York: Prentice-Hall, 1972. 106 pp.
History of the brassiere.

1-96* RODOLPHE, JEAN. Mit den funf Sinnen. Gesicht, Gefuhl, Gehor, Geschmack, Geruch. Ein erotisches Bilderbuch. Hanau and Munich: Karl Schustek, 1968. 567 pp.
Picture book visually exploring the erotic elements of the senses.

1-97 ROSENBERGER, JOSEPH. The history of oral sex practices. 2 vols. Brooklyn: Valiant, 1971. 320 pp., illus.
Sensationalistic and titillating overview of oral sex practices around the world.

1-98 ROSS, STEPHANIE. "Bizarre sex practices." Hustler, (September 1981?): 33-34, figs.
Undocumented account of sex practices around the world.

1-99 ROUGEMONT, DENIS DE. Love in the Western world. New York: Harper Colophon, 1956. 336 pp., index.
Study of the concept of love and its expression in Europe.

1-100 RUDOFSKY, BERNARD. The unfashionable human body. Garden City, N.Y.: Anchor Press/Doubleday, 1971. 288 pp., illus., index.
Study of some of the odd elements in the development of clothes and history of attitudes to nudity.

1-101 RUSSELL, EDWARD. El Erotismo entre los Europeos. Colleccion informe. Barcelona: Petronio, 1976. 192 pp.

1-102 SALTUS, EDGAR EVERTSON. Historia Amoris: a history of love ancient and modern. New York: Brentano's, 1906. 278 pp.
Role of love and sex in Western history discussed.

1-103 SCHIDROWITZ, LEO, ed. Sittengeschichte des Intimsten: Bett, Korsett, Hemd, Hose, Bad, Abtritt. Vienna: Kulturforschung, ca. 1929. 319 pp., illus., bib.
Series of articles looking at role of beds, intimate apparel, etc., in the Western world.

1-104* SCHWARTZ, KIT. The female member: being a compendium of facts, figures, foibles, anecdotes about the loving organ. New York: St. Martin's Press, 1988. 224 pp.

1-105 ____. The male member. New York: St. Martin's Press, 1985. 195 pp., bib., index.
Compilation of facts and beliefs about the male phallus.

1-106 SCOTT, CRAIG. Pagan sex/puritan sex. North Hollywood: Brandon House, 1966. 186 pp.
Survey of miscellaneous sex customs around the world.

1-107* SCOTT, GEORGE RYLEY. All that is strange in sex. London: Luxor, 1963.
Strange sex practices from all parts of the world described.

1-108 ____. Curious customs of sex and marriage. New York: Ace, 1960. 320 pp., bib., index.
Customs of love and sex around the world.

1-109 SCOTT-MORLEY, A. Encyclopedia of sex worship. 4 vols. London: Walton, 1967. Index, illus.
Illustrated encyclopedia of sexual practices and beliefs.

1-110 SELDON, GARY. "When sex was (sometimes) sinful." Cosmopolitan 190, no. 2 (Feb 1981): 198-99+, illus. (some col.).
Study of America's sexual history.

1-111 SIMONS, G.L. A history of sex. London: New English Library, 1970. 188 pp., bib.
Thematic look at the various ways sex has influenced cultures, with chapters on sex in history, religion, art, etc.

1-112 ____. The illustrated book of sexual records. 1974. Reprint. New York: Bell, 1982. 192 pp., figs., illus.
Miscellaneous collection of facts and beliefs about sex, emphasizing the bizarre, humorous, etc.

1-113 SMITH, BRADLEY. The American way of sex: an informal illustrated history. New York: Gemini Smith, 1978. 254 pp., bib., index, illus. (some col.).
History of American sex mores and practices.

1-114 STONE, LAWRENCE. "The strange history of human sexuality: sex in the West." New Republic (July 8 1985): 25-37, illus., bib.
Concise, but thorough overview of the Western concept of sexuality, emphasizing changes in the definition of licit and illicit behaviors.

1-115 STRAGE, MARK. The durable fig leaf: a historical, cultural, medical, social, literary, and iconographic account of man's relations with his penis. New York: Morrow, 1980. Index.
Thematic look at the history of attitudes and beliefs about the phallus.

1-116 SULEIMAN, SUSAN RUBIN. The female body in Western culture. Cambridge, Mass.: Harvard University Press, 1986. 389 pp., illus., bib.
Collection of essays from a feminist perspective on the female body in Western culture; a few focus on art.

1-117 TABORI, PAUL. Dress and undress: the sexology of fashion. London: New English Library, 1969. 223 pp.
Erotic aspects of clothing surveyed.

1-118 _____. A pictorial history of love. London: Spring Books, 1966. 320 pp., index, illus.
Love in the Western world as depicted in art and popular culture.

1-119 TANNAHILL, REAY. Sex in history. New York: Stein and Day, 1980. 478 pp., bib., illus., index.
Popular, well-researched survey of the history of sexual practices and beliefs.

1-120 TAYLOR, GORDON RATTRAY. Sex in history: society's changing attitudes to sex throughout the ages. New York: Ballantine, 1954. 320 pp., bib., index.
Study of sexual attitudes and practices in the West.

1-121 TOMPKINS, PETER. The eunuch and the virgin: a study of curious customs. New York: Clarkson N. Potter, 1962. 304 pp.
Overview of the history and role of the eunuch.

1-122 TOSCHES, NICK. "Strippers." Penthouse 15, no. 11 (July 1984): 70-74+, illus.
History of striptease dancers in the Western world.

1-123 TRIMMER, ERIC S., ed. The visual dictionary of sex. New York: A&W, 1977. 320 pp., bib., index, illus. (some col.).

Well-illustrated survey of sex beliefs and customs with sections on art.

1-124 TULLMANN, ADOLF. Das Liebesleben der Kulturvolker: eine Darstellung des sexuellen Verhaltens in hochentwickelten Gemeinschaften. Stuttgart: Hans E. Gunther, 1962. 341 pp., bib., index, illus.
Sex customs around the world thematically arranged.

1-125 UNWIN, J.D. Sex and culture. London: Oxford University Press, 1934. 676 pp., bib., index.
Study of sexual customs and beliefs worldwide.

1-126 VRIES, THEUN DE. Aantrekkelijk. Erotiek in Mode. The Hague: NVSH, 1966. 112 pp., bib, index, illus.
Discussion of eroticism in clothing and body ornament.

1-127* WAKE, CHARLES STANILAND. Sacred prostitution and marriage by capture. S.l.: Privately Printed, 1929. Reprint. New York: Big Dollar Books, 1932.

1-128 WEDECK, HARRY EZEKIEL. Love potions through the ages: a study of amatory devices and mores. New York: Citadel; Philosophical Library, 1963. 336 pp., bib., illus.
Interesting study of the belief in and use of love and sex devices, potions, etc., around the world.

1-129 WOOD, ROBERT. "Ancient civilizations, sex life in." In The encyclopedia of sexual behavior, edited by Albert Ellis and Albert Abarbanel, 119-31. New York: Hawthorn, 1961.
Survey of sex life in Greece, Rome, and India, and among the Hebrews.

1-130* WORTLEY, RICHARD. A pictorial history of striptease: 100 years of undressing to music. Secaucus, N.J.: Chartwell, 1976. 160 pp., index, illus. (some col.), por. (some col.).

1-131 YOUNG, WAYLAND. Eros denied: sex in Western society. New York: Grove, 1964. 415 pp., index, illus.
Highly controversial when published, classic study of European attitudes to sex and erotica, with chapters on art.

Chapter 2
Sex and Religion

People are frequently surprised to discover that much of the world's erotic art was produced for religious reasons. In many ways the study of the history of erotic art is a study of religion. This can be seen most clearly when considering the erotic sculptures on medieval Indian temples or sexual votive figures from the ancient world. The entries listed below focus on the meaning of sexuality in world religions, while works that are more narrowly focused are listed in the appropriate later chapters (for instance, entries on Islam can be found in the "West Asia" chapter). Because so many religions utilize sexual symbols and images, a large portion of the entries listed here include erotic illustrations and sometimes discuss erotic art.

Interest in this topic began in the nineteenth century (see the chapter on phallicism) and has seen a renewal of interest since the mid-1960s. Unfortunately, until the mid-twentieth century most publications on sex in religion were written from a "Christian" point of view, which generally means that the text condemns religious practices that have adopted a more positive attitude to sexual activity than the historically orthodox Christian approach (for example, Howard's Sex and religion). That the Judeo-Christian view of human sexuality has not always been as negative as many people assume is the primary tenet of Akerly's The x-rated Bible, Horner's Sex in the Bible, and others. Since the 1930s more objective comparative religion studies have illuminated our understanding of sex in religion, including Cutner's popular A short history of sex worship, Goldberg's classic study The sacrd fire: story of sex in religion, and Parrinder's thorough survey Sex in the world's religions.

Much of what was considered witchcraft and black magic in medieval Christian Europe was simply the continued belief in and expression of pre-Christian nature worship, which included a strong component of fertility worship and sexual celebration. Frequently, authors have approached the subject of sex and religion through the exploration of the relationships between witchcraft, magic, and sex. Some authors have condemned witchcraft and magic, while others sought to explain objectively or even promote them.

2-1 AKERLEY, B.E. The x-rated Bible: an irreverant survey of sex in the Scriptures. Austin: American Atheist Press, 1985. 428 pp., index.
 Detailed revelation of the topic of sex in the Bible.

2-2 ANDERSON, ROBERT D. "Witchcraft and sex." Sexual Behavior 2, no. 9 (September 1972): 8-14.
 Study of sex in Western witchcraft lore.

2-3* BALDISAN, JAMES ROBERT. A manual of sex and sun worship rituals. Albuquerque: Gloucester Art Press, 1979. 64 pp., illus.

2-4* BRIFFAULT, ROBERT. Sex in religion. London, 1929.

2-5 BROWN, SANGER. Sex worship and symbolism. Boston: Badger, 1922. Reprint. New York: AMS, 1972. 149 pp., bib., index, figs.
 Dated, moralistic commentary on the expression of sex worship in history.

2-6 COHEN, CHAPMAN. Religion and sex: studies in the pathology of religious development. London: Foulis, 1919. Reprint. New York: AMS Press, 1975. 286 pp.
 Essays on the nature of the origin of religion and the role of sex worship. One chapter on "Sex and Religion in Primitive Life."

2-7 CULLING, LOUIS T. A manual of sex magik. St. Paul, Minn.: Llewellyn Pub., 1971. 147 pp., illus.
 How-to guide and background to sex and magic.

2-8 CUTNER, H. A short history of sex worship. Foreword by Maurice Canney. London: Watts, 1940. 222 pp.
 Popular survey of major traditions of sex worship in Europe and the East.

2-9* DEMAY, CHRISTIAN. "Sexe et magie." Union, 22 (April 1974): 42-49.

2-10 ELIOT, ALEXANDER. "Lovers and bearers of divine seed." In Myths. New York: McGraw-Hill, 1976, 182-213, illus.
 Survey of world mythology includes this discussion of love, sex, and divine spirits.

2-11 FARREN, DAVID. Sex and magic. New York: Simon and Schuster, 1975. 191 pp., index.
 Modern practitioner discusses the beliefs and practices that link magic and sex.

2-12 GAMBLE, ELIZA BURT. God-idea of the ancients or sex in religion. New York: Putnam, 1897. 339 pp., intro.
 Relatively objective early study of sex worship in ancient religions of the Near East and Europe.

2-13* GOLDBERG, BEN ZION. The sacred fire: story of sex in religion. New York: Liveright, 1930. Reprint. New York: University Books, 1958. (Also published as Sex in religion.)
Classic study of sex in religions of the West.

2-14 GRANT, KENNETH. Cults of the shadow. London: Muller, 1975. 244 pp., illus., index, bib., gloss.
Explanation of occult and magical beliefs and practices in Africa, India, and the West.

2-15 HAEBERLE, ERWIN J. "Sex in religion." In The sex atlas. New York: Seabury Press, 1978, 316-31.
Concise survey of the role of sex in the world's religions.

2-16 HANNAY, JAMES BALLANTYNE. Sex symbolism in religion. Appendix by George Birdwood. London: Privately printed for the Religious Evolution Research Society, 1922. 644 pp., index, figs., illus.
Detailed study of sex symbolism in world religions, with useful illustrations.

2-17 HORNER, THOMAS MARLAND. Sex in the Bible. Rutland, Vt.: Tuttle, 1974. 188 pp., index.
Discussion of sexual topics in the Bible.

2-18 HOWARD, CLIFFORD. Sex and religion: a study of their relationship and its bearing upon civilization. London: William & Norgate, 1925. Reprint. New York: AMS Press, 1975. 201 pp.
Moralistic essays relating to the topic of sexuality.

2-19 HUDSON, ABISHA. The masculine cross and ancient sex worship. New York: Asa K. Butts, 1874. 70 pp., figs.
Study of ancient sex worship, including a short section on the California Indians.

2-20 _____. Sex mythology: including an account of the masculine cross. Preface signed under pseudonym Sha Rocco. London: Privately printed, 1898. 64 pp.
Early discussion of sex in world religions.

2-21 JAMES, EDWIN OLIVER. The cult of the Mother-Goddess: an archaeological and documentary study. London: Thames and Hudson, 1959. 300 pp., bib., index.
Survey of the mother goddess around the world.

2-22* KNIGHT, RICHARD PAYNE. The worship of Priapus, an account of the fete of St. Cosmo and Damiano, celebrated at Isernia in 1780, in a letter to Sir Joseph Banks ... in which is added, some account of the phallic worship, principally derived from a discourse on the worship of Priapus. Edited by Hargrave Jennings. London: Privately printed, 1883.

2-23* LANGER, M.D. GEORG. Die Erotik in der Kabbala. Prague: Josef Flesch, 1923. 167 pp.

2-24* LAURENT, EMILE, and NAGOUR, PAUL. Magica Sexualis, mystic love books of black arts and secret sciences. North Hollywood: Brandon House, 1966.

2-25 LONG, D.W. Sex, sin or sacrament. Social Behavior Series. North Hollywood: Columbia News, n.d. 192 pp., bib.
 Popular account of religion and sex in the Ancient and Western worlds.

2-26 LONGWORTH, T. CLIFTON. The devil a monk would be: a survey of sex and celibacy in religion. London: Herbert Joseph, 1936. 143 pp., bib., illus.
 Sexual symbols in pre-Christian and Christian religions discussed.

2-27 _____. The Gods of love: the creative process in early religion. Westport, Conn.: Associated Bookseller, 1960. 273 pp., bib., index, figs.
 Study of fertility and sex worship in early religions.

2-28 _____. The worship of love, a study of nature worship throughout the world. London: Torchstream, 1954. 271 pp., index, bib., illus.
 Dated but still useful study of sex rites and nature worship in religions from around the world.

2-29* La magie sexuelle populaire. Collection l'erotisme populaire. Paris: Maisonneuve et Larose.

2-30 MARCIREAU, JACQUES. Histoire des rites sexuels. Paris: Robert Laffont, 1971. 353 pp., bib., illus.
 Survey of sex worship rites, especially in the ancient world and in Asia.

2-31 MARR, GEORGE SIMPSON. Sex in religion, an historical survey. London: G. Allen & Unwin, 1936. 285 pp., bib., index.
 Survey of religious attitudes to sex.

2-32 The masculine cross: or a history of ancient and modern crosses and their connection with the mysteries of sex worship: also an account of the kindred phases of phallic faiths and practices. N.p.: Privately printed, 1904. 128 pp.
 Study of phallic forms and symbols in religions.

2-33 MASTERS, R.E.L. Eros and evil: the sexual psychopathology of witchcraft. New York: Julian, 1962. 322 pp., index, bib.
 Sexual elements in witchcraft and demonality explored.

2-34 NEFF, DIO URMILLA. "The divine embrace." Yoga Journal, 37
 (March-April 1981): 10-20, bib., illus.
 Discussion of sex and religion and how to make sex a spiritual
 path.

2-35 PAINE, LAUREN. Sex in witchcraft. New York: Taplinger, 1972.
 186 pp., bib., index, illus.
 Thematic study of sex in the Western concept of witchcraft.

2-36 PARRINDER, EDWARD GEOFFREY. Sex in the world's religions.
 New York: Oxford University Press, 1980. 263 pp., index, bib.
 Thorough, well-written study of sex in religions of all times and
 around the world.

2-37 PRESTON, JAMES J., ed. Mother worship: theme and variation.
 Chapel Hill: University of North Carolina Press, 1982. 360 pp., in-
 dex, illus.
 Studies of mother goddesses around the world.

2-38 RUNEBERG, ARNE. Witches, demons and fertility magic: analysis
 of their significance and mutual relations in West-European folk reli-
 gion. Helsingfors, 1947. Reprint. Norwood, Pa.: Norwood Edi-
 tions, 1974. 273 pp.
 Aspects of sex and Western witchcraft explored.

2-39* SOREL, J. Erotisme de la Bible. Paris, n.d.
 Study of the sexual aspects of the Holy Bible.

2-40* STEIGER, BRAD. Sex and satanism. New York: Ace, 1969. 187
 pp., bib.

2-41 VERBEEK, YVES. La sexualite dans la magie. Geneva: Editions
 Versoix, 1978. 249 pp., bib., illus.
 Survey of sex in early religion and discussion of its influence on
 Western concepts of magic and witchcraft.

2-42 WALKER, GEORGE BENJAMIN. Sex and the supernatural: sexuality
 in religion and magic. London: MacDonald, 1970. 128 pp., bib.,
 illus.

2-43 WEIR, JAMES. Religion and lust: or the psychical correlation of
 religious emotion and sexual desire. Third ed. Chicago: Chicago
 Medical Book, 1905. 338 pp., pref., bib. (Originally published as
 The psychical correlation of religious emotion and sexual desire
 [Louisville, Ky.: Courier-Journal Job Printing, ca. 1897].)
 Sex in religions, particularly phallic worship discussed.

Chapter 3
Phallicism

The nineteenth century was a time of intense interest in the study of religion. One widely held theory was that all known major religions grew out of what came to be known as "phallic worship." This concept, called phallicism or phallism, referred to more than the worship of male genitalia. Phallic worship encompassed any expression of sex worship (including vulvic worship, also known as vulvism or ktenism), worship of any sexual symbol (in the broadest Freudian meaning of the term, including, for example, tree or snake worship), fertility worship, or almost any kind of nature worship. Studies of phallicism focused on the Old Testament, Hindu India, Shinto Japan, and other "pagan" religions. It can be argued that this fascination with phallic worship was as much an excuse to discuss sex and look at sexual images as it was serious religious scholarship.

Almost all the entries listed below were published between 1830 and 1930. A few nineteenth century authors made the study of phallicism a specialty and we see their names on numerous publications (frequently utilizing pseudonyms); people like Sanger Brown, Th. Burke, Jacques Dulaures, Hargrave Jennings, Richard Payne Knight, Lee Alexander Stone, Charles Wake, and Hodder Westropp. It appears that the theory of phallic worship was abandoned by scholars after the emergence of Freudian psychology and the revelations of comparative religion studies. Almost every pre-World War II author listed below accepted the notion that phallic worship was a primitive stage of religious development and its virtually total eradication from Western culture was a clear "sign" that Christianity was the true religion. These authors often expressed an ambiguous attitude, showing a fascination with Hindu "sex worship," for instance, yet denigrating its associated beliefs and practices.

In recent decades interest in phallic worship has continued but with a more objective approach that seeks to reveal and understand that form of religious expression (see Berger and Vanggaard, for instance). These modern authors use much the same information as their nineteenth century predecessors, but without the condemnatory editorializing. It is the reports of and illustrations of phallic (and vulvic) monuments and votive objects that makes the entries listed below useful to those interested in the history of erotic art.

3-1 ABARBANEL, ALBERT, and WILBUR, GEORGE B. "Phallicism and sexual symbolism." In The encyclopedia of sexual behavior, edited by Albert Ellis and Albert Abarbanel, 819-26, bib. New York: Jason Aronson, 1973.
 Historical and psychological interpretation of phallic symbols.

3-2* ACHELIS, T. "Uber phallische Gebrauche und Kulte." Zeitschrift fur Sexualwissenschaft und Sexualpolitik, 1919 (?).

3-3* ANONYMOUS. Idolatria de los organos sexuales. Madrid, 1916.

3-4 BERGER, C.G. Our phallic heritage. New York: Greenwich Book Pub., 1966. 216 pp., figs., illus.
 Phallic symbolism in many aspects of Western civilization explored.

3-5* BOUDIN, JEAN CHRISTIAN MARC FRANCOIS JOSEPH. Etudes anthropologiques consideration sur le culte et les pratiques religieuses de divers peuples anciens et modernes: culte du phallus: culte du serpent. Paris: V. Rozier, 1864.

3-6 BROWN, SANGER. Sex worship and symbolism of primitive races: an interpretation. Introduction by James Leuba. Boston: R.G. Eadger, 1922. 145 pp.
 Study by psychiatrist of the worship of procreative power. Asserts that the mentally ill think like primitives.

3-7 BURKE, THE. (?). Cultus Arborum: a descriptive account of phallic tree worship with illustrative legends: superstitions, usages, etc., exhibiting its origin and development amongst the Eastern and Western nations of the world from the earliest to modern times: with a bibliography of works upon and referring to phallic cultus. N.p.: Privately printed, 1890. 111 pp., bib.
 Study of the worship of trees as phallic symbols.

3-8 _____ (?). Ophiolatreia: a account of the rites and mysteries connected with the origin, rise, and development of serpent worship in various parts of the world, enriched with interesting traditions, and a full description of the celebrated serpent mounds and temples, the whole forming an exposition of one of the phases of phallic, or sex worship. N.p.: Privately printed, 1889. 103 pp.
 Study of sex and sex symbol worship around the world.

3-9 _____ (?). Phallic objects, monuments and remains: illustrations of the rise and development of the phallic idea: (sex worship): and its embodiment in works of nature and art. N.p.: Privately printed, 1889. 76 pp., illus.
 Pamphlet on phallic imagery of large objects, like buildings, etc.

3-10 CAMPBELL, ROBERT ALLEN. Phallic worship: an outline of the worship of the generative organs. St. Louis: R.A. Campbell, 1887. 204 pp., figs.
 Description of phallic symbols in Western civilization.

3-11* DAVEY, W.[R.P.]. Semitic phallicism, preceded by a sketch of non-Semitic phallicism. Cambridge, Mass.: Harvard University Press, 1908.

3-12* DULAURES, JACQUES ANTOINE. Les cultes Priapiques. 1825. Reprint. Paris: Losfeld, 1953.
 Early study of phallic cults in the ancient and Western worlds.

3-13* _____. The gods of generation. Translated by A.F. Niemoeller. New York: Panurge, 1933. 283 pp. (First edition, Paris, 1905.)
 History of phallic cults from Ancient cultures to modern times.

3-14* HAMILTON, WILLIAM. Worship of Priapus plus phallic worship. With R.P. Knight; edited by Hargrave Jennings. London: George Redway, 1885.

3-15 HARTLAND, EDWIN SIDNEY. "Phallism." In Encyclopedia of religions and ethics, edited by James Hastings, 9: 815-30. Edinburgh: Clark, 1971.
 Summary of the nature of phallic worship.

3-16* HOWARD, CLIFFORD. Sex worship: an exposition of the phallic origins of religion. Washington, D.C.: Privately printed, 1898.

3-17 JAMES, R.D. "Phallism." In Funk & Wagnall's standard dictionary of folklore mythology and legend, edited by Maria Leach, 863-68. New York: Funk & Wagnalls, 1972.

3-18* JENNINGS, HARGRAVE. Illustrations of phallism, consisting of ten plates of remains of ancient art, with descriptions. London, 1885.

3-19* _____. Phallicism: celestial and terrestrial, heathen and Christian: its connection with the Rosicrucians and the Gnostics and its foundation in Buddhism. London, 1884. 298 pp., index.

3-20 _____. "Worship of Priapus." In The power of a symbol, by Lee Alexander Stone, 103-17. Chicago: Covici, 1925.
 Reprint of nineteenth century study of phallic worship with typically moralistic commentary.

3-21 JERVEY, EDWARD D. "The phallus and phallus worship in history." Journal of Popular Culture 21, no. 2 (1987): 103-15, illus.
 Limited overview of phallicism in history based on a few well-known sources.

3-22* KNIGHT, RICHARD PAYNE. A description of the worship of Lingam-Yoni in various parts of the world and in different ages, with an account of Ancient and modern crosses, particularly of the Crux Ansata, and other symbols connected with the mysteries of sex worship. London, 1889.

3-23 . A discourse on the worship of Priapus, and its connection with the mystic theology of the Ancients [to which is added an essay on the worship of the generative powers during the Middle Ages of Western Europe]. London: Privately printed, 1865. 254 pp. (text), index, figs. (1st edition, 1786).
 Study of phallic worship in Ancient and Medieval cultures of Europe and Asia.

3-24 KNIGHT, RICHARD PAYNE, and WRIGHT, THOMAS. Sexual symbolism: a history of phallic worship. Introduction by Ashley Montagu. New York: Julian Press, 1957. 196 pp., illus.
 Reprints two essays by these authors: A discourse on the worship of Priapus (1786) and The worship of the generative powers (1866).

3-25 KRAMER, A. "Phallosgebilde bei Franzoischen Kampfern." Zeitschrift fur Sexualwissenschaft 5, no. 12 (March 1919): 376-78, illus.
 Description of a stone or wood phallus possibly made by French soldiers during the World War I.

3-26 SCOTT, GEORGE RYLEY. Phallic worship: a history of sex and sex rites in relation to the religions of all races from Antiquity to the present day. London: Werner Laurie, 1941. 255 pp., bib., index, figs., illus.
 Thorough study of phallic worship all over the world.

3-27 SIMPSON, HENRY TRAIL. Archaeologia Adelensis, a history of the Parish of Adel (Yorks). London: Allen, 1879. 297 pp., figs., illus.
 Topic of phallic worship and how it is expressed in early English culture is explored on pages 154-88.

3-28 STONE, LEE ALEXANDER. The power of a symbol. Chicago: Pascal Covici, 1925. 301 pp., illus.
 Collection of essays on phallicism: Jennings's "The worship of priapus," Buckley's "Phallicism in Japan," and Dupouy's "Prostitution in antiquity."

3-29* . The story of phallicism. 2 vols. Chicago: Pascal Covici, 1927. Reprint. New York: AMS Press, 1976.

3-30 STRELITZ, PAUL. "Der Phalluskultus." Geschlecht und Gesellschaft 6 (1911): 433-53, illus.; 500-513, illus.; 555-61, illus.
 Study of phallic cults in history, especially in India and the ancient world.

3-31 VANGGAARD, THORKIL. Phallos: a symbol and its history in the male world. Translated from Danish by the author. New York: International University Press, 1972. 208 pp., index, illus.
 Psychoanalytic study of phallic symbols.

3-32 WALL, O.A. Sex and sex worship (phallic worship): a scientific treatise on sex, its nature and function, and its influence on art, science, architecture, and religion—with special reference to sex worship and symbolism. St. Louis: C.V. Mosby, 1919. 608 pp., illus.
 Unscholarly look at examples of phallic worship from around the world.

3-33 WESTROPP, HODDER M. Primitive symbolism: as illustrated in phallic worship or the reproductive principle. London: Redway, 1885. Reprint. New Delhi: Kumar Bros., 1970. 68 pp., intro.
 Study of phallicism in European history.

3-34 WESTROPP, HODDER M., and WAKE, CHARLES STANILAND. Ancient symbol worship. Influence of the phallic idea in the religions of Antiquity. New York: Bouton, 1875. Reprint. New York: Humanities Press, 1972. Third ed. Introduction, added notes, and appendix by Alexander Walker. New Delhi: Kumar Bros., 1970. 98 pp., illus.
 Essays on the development of phallism in ancient European, Middle Eastern, and Asian religions.

3-35* _____. Worship of Priapus. New York: Bouton, 1874.

Chapter 4
Art, Sex, and Psychology

Sexology is the term used to designate both physiological and psychological study of human sexuality. Psychologists and psychiatrists have a special interest in both sex and art, as exemplified by the work of Sigmund Freud. Mental health professionals can use drawings and paintings by patients to help diagnose problems and may utilize artistic activity as a form of therapy. Further, those trained in psychology/psychiatry may direct their expertise to analyze works of art in order to speculate on such topics as an artist's motivation, subconscious expression, etc. The items included in this chapter were selected because they specifically focus on erotic art, in distinction to the many psychoanalytic studies of art that may mention sexuality in a much broader analysis. Each entry listed below seeks to develop generalizations about the psychological nature of sexual expression in art and offer interpretations of individual works, artists, and whole traditions that go beyond standard historical, iconographic, or stylistic analysis.

While most of the entries listed below were published between the late 1950s and the early 1970s, pioneering studies in this area predate Freud: Colin Scott's "Sex and art" (1896) and Gustav Naumann's Geschlecht und Kunst (1899). By the 1960s knowledge of human sexual behavior had advanced sufficiently to justify the publication of a comprehensive reference work on sexology, The encyclopedia of sexual behavior, edited by Ellis and Abarbanel (updated in a 1973 edition). This compilation of articles authored by prominent experts, includes a number of articles specifically on erotic art that have been individually listed in the relevant chapters of this bibliography. Only one author, Pierre Cabanne in the Psychologie de l'art erotique, has attempted a book-length survey of Western erotic art emphasizing the psychological aspects of a representative sampling of works.

4-1* AULNOYES, FRANCOIS DES. Histoire et philosophie de l'erotisme. Paris: Pensee Moderne, 1958. 99 pp., illus.

4-2 CABANNE, PIERRE. La psychologie de l'art erotique. Paris: Edition Samogy, 1971. 240 pp., illus. (some col.), index.
 Psychological interpretations of certain themes and styles in the history of European erotic art.

4-3 CHOISY, MARYSE. Kunst und sexualitat. Kunst und Kommunikation, no. 7. Cologne: Westdeutscher, 1962. 98 pp., figs.
Sexual meaning of art is discussed.

4-4* COMFORT, ALEX. Darwin and the naked lady: discursive essays on biology and art. London: Routledge, Kegan Paul, 1961. 174 pp., bib., illus.
Includes discussion of the psychological meaning of certain examples of erotic art.

4-5 ELLIS, ALBERT. "Art and sex." In The encyclopedia of sexual behavior, edited by Albert Ellis and Albert Abarbanel, 161-79, bib. New York: Jason Aronson, 1973.
Partly historical, partly psychological study of the nature of erotic art.

4-6 ELLIS, ALBERT, and ABARBANEL, ALBERT. The encyclopedia of sexual behavior. 2 vols. New York: Hawthorn Books, 1960. Index.
Series of articles on all aspects of human sexuality, including several on topics related to erotic art.

4-7 GOITEN, LIONEL. Art and the unconscious. Preface by Lipchitz. New York: United Book Guild, 1948. Unpaged, bib., illus.
Psychological investigation into the motivations and meanings of art, including some mention of sexual aspects.

4-8 NAUMANN, GUSTAV. Geschlecht und Kunst: Prolegomena zu einer physiologischen Aesthetik. Leipzig: H. Haessel, 1899. 193 pp.
Psychological interpretation to the relation between sex and art.

4-9 SCOTT, COLIN A. "Sex and art." American Journal of Psychology 7, no. 2 (Jan 1896): 153-226, figs.
Study of the psychological basis of the relationship between art and sex.

Chapter 5
Art, Pornography,
and Censorship

The subject of pornography is a perenially controversial one. Begin-
ning in the latter half of the nineteenth century, when mass production of
sexually explicit materials proliferated, the term pornography has been
used to label certain things as illicit, undesirable, unhealthy, or even
dangerous. During the last twenty-five years two U.S. presidential com-
missions and a special British commission (Longford Report) have "invest-
igated" the subject of pornography ostensibly to determine whether it
poses a threat to society.

The arts community is often caught up in social and legal battles relat-
ing to the appearance of sexual imagery in art, sometimes facing efforts to
censor the display of erotic art and even preventing artists from dealing
with sexuality in their work. This situation is not new: historical perspec-
tives on the censorship of the visual arts is provided in Clapp's Art censor-
ship and Carmilly-Weinberger's Fear of art.

There has been an enormous amount of material written on the subject
of pornography, and many newspapers and magazines have dealt with this
topic in the last few decades. It is not the purpose of this bibliography to
provide access to all this material; Byerly and Rubin's Pornography: the
conflict over sexually explicit materials in the United States, an annotated
bibliography is a remarkably thorough effort in that direction. The items
listed below have been selected because they address the relationships
between art, pornography, and censorship. Most at least purport to be
objective studies of the nature of pornography, although the reader is
forewarned that most are really intended to offer justifications for pre-
conceived notions for or against erotica/pornography. Perhaps the most
useful works are those that seek to explore the nature of the concept of
pornography and attempt to delineate a distinction between what is often
called "legitimate erotica" and pornography, Peckham's Art and pornogra-
phy is a classic study of this type; other interesting works are by Chesi,
Emde-Boas, Howard, Huer, Moroz, Steinem, and Webb. Unfortunately, too
many items that seem from their titles to offer historical perspectives are
in fact merely excuses for sexual illustrations. One important exception is
Walter Kendrick's The secret museum: pornography in modern culture.

Art, Pornography, and Censorship

Few people are neutral when it comes to the subject of pornography, and this chapter includes examples of materials on all sides of the controversy. Some of the entries support the existence of sexually explicit materials: they argue that such material is useful and healthy and that efforts to censor pornography are too damaging to artistic and political freedom. The most articulate of these are by Dhavan and Davies, Michelson, Phelps, Rockman, Simons, and, especially, Tynan. Conversely, many of the entries are unambiguously critical, sometimes suggesting draconian measures seeking to eliminate totally what the authors see as pornography. Works hostile to pornography published prior to about 1975 are based primarily on philosophic, religious, or moralistic arguments (for example, see Drakeford or Holbrook), while in the last ten years harsh indictments against pornography have been presented by several radical feminist authors, including Dworkin, Griffin, and Lederer, among others: the latter base their arguments on a combination of feminist philosophy and controversial scientific research. Women artists and feminists concerned about pornography, but disturbed by the forces of censorship, present interesting perspectives in Caught looking by the Feminist Anti-Censorship Taskforce Book Committee.

A few entries view the subject of pornography as it relates to a specific profession, such as items for librarians: see, for example, Daily's article in the Encyclopedia of library and information science and Pope's Sex and the undecided librarian.

It can be said that virtually every entry throughout this bibliography includes someone's definition of erotica, particularly as it is shown to be "clearly" distinct from pornography. That almost none of these definitions agree reflects the ambivalence in modern society to the existence of sexual imagery.

5-1* ALAIMO, GIUSEPPE. Erotismo, sessualita e pornografia. Storia dell'erotismo, no. 3. Turin: MEB, 1974. 189 pp., bib., illus.

5-2 ALLEN, GINA. "What those women want in pornography." Humanist 38 (November–December 1978): 46–47, por.
 Essay on women's objections to most pornography produced commercially today.

5-3 BARBER, DULAN FRIAR. Pornography and society. London: Charles Skilton, 1972. 192 pp., bib.
 Study of the role of pornography in modern society.

5-4* BEARCHELL, C. "Administrative artbusters." Body Politic 105 (July 1984): 12.

5-5* BEBOUT, R. "From porn and erotica back to sex." Body Politic 97 (October 1983): 15.

5-6* BLAKELY, MARY KAY. "Is one woman's sexuality another woman's pornography." Ms Magazine, April 1985.

5-7 BOND, DAVID J. "Andre Pieyre de Mandiargues; some ideas on art." Romantic Review 70, no. 1 (January 1979): 69-79.
 Analysis of critical commentary by de Mandiargues on the arts, including erotic art.

5-8* BROPHY, BRIGID. The Longford threat to freedom. Foreword by Barbara Smoker. London: National Secular Society, 1972. 12 pp., por.

5-9* BRUNEAU, MARIE-FLORINE, and ORENSTEIN, GLORIA F. "Sexuality, violence and pornography" [special issue]. Humanities in Society 7, nos. 1-2 (Winter-Spring 1984).

5-10 BYERLY, GREG, and RUBIN, RICK. Pornography: the conflict over sexually explicit materials in the United States: an annotated bibliography. New York: Garland, 1980. 152 pp., index.
 Thorough bibliography on the subject of pornography and censorship.

5-11 CARMILLY-WEINBERGER, MOSHE. Fear of art: censorship and freedom of expression in art. New York: Bowker, 1986. 249 pp., bib., index, illus.
 Chapter 4 is entitled "Is it art or erotica?"

5-12* CAULDWELL, DAVID O. Pornography. Torrance, Calif.: Banner, 1968.

5-13* CHESI, GERT. Erotik zwischen Kunst und Pornographie. Schwaz: Private Printing of Galerie Hermitage, ca. 1969. 111 pp., bib., illus.

5-14 CHLUMSKY, MILAN. "Estheticite, erotisme et pornographie." Revue d'Esthetique 1-2 (1978): 191-213.
 Discussion of the nature of aesthetics, eroticism, and pornography.

5-15 CLAPP, JANE. Art censorship: a chronology of proscribed and prescribed art. Metuchen, N.J.: Scarecrow Press, 1972. 582 pp., bib., index, illus.
 Study of the history of censorship in art, including the subject of sex in art.

5-16 COBURN, JUDITH. "Can you make a case for pornography?" Mademoiselle 88 (January 1982): 56.
 Discussion of the nature of pornography, feminist efforts to suppress it, and censorship.

5-17 COLLIER, JAMES LINCOLN. "Pornography and censorship." New York Times Magazine, 18 April 1970 (?): 14-15.
 Essay defending the right of 'pornography' to exist.

5-18* COPP, DAVID, and WENDELL, SUSAN. Pornography and censor-
 ship. Buffalo: Prometheus, 1982. 350 pp.

5-19 CORMAN, MATHIEU. Outrage aux moeurs. Brussels: Tribold,
 n.d. 166 pp., index, illus.
 Discussion of the nature of censorship and the arts.

5-20 DAILY, JAY E. "Erotica." In Encyclopedia of library and informa-
 tion science. New York: Marcel Dekker, 1972, 164-84, bib.
 Guidelines for librarians dealing with sexually oriented mater-
 ials, with discussion of the nature of erotica.

5-21 DALMAS, LOUIS. "Une sexualite democratissee et naturelle." Art
 Press 22 (January-February 1976: 12-17, illus.
 Observations and reactions to porno movies by a wide range of
 celebrity respondents.

5-22 DAVIS, MURRAY S. Smut: erotic reality/obscene ideology. Chi-
 cago: University of Chicago Press, 1983. 313 pp., bib.
 Philosophical considerations on the nature of erotica and porno-
 graphy.

5-23* DENBY, DAVID, et al. "Pornography: love or death." Film Comment
 20, no. 6 (November-December 1984): 29-49, por.
 12 essays on all sides of the pornography controversy by socio-
 logists, feminists, lawyers, etc.

5-24 DHAVAN, RAJEEV, and DAVIES, CHRISTIE, eds. Censorship and
 obscenity. Totowa, N.J.: Rowman and Littlefield, 1978. 187 pp.,
 bib., index, illus.
 Series of provocative articles, many of which question the al-
 legedly harmful effects of pornography.

5-25* DOBBS, K. "Eros on Yonge Street—impressions of the Dorothy Came-
 ron trial." Canadian Saturday Night 81 (February 1966): 18-21,
 illus.

5-26* DRAKEFORD, JOHN W. Pornography: the sexual mirage. Nashville:
 Nelson, 1973. 189 pp.

5-27 DWORKIN, ANDREA. Pornography: men possessing women. New
 York: Perigee, 1979. 300 pp., bib., index.
 Develops a strong case against pornography from a radical fem-
 inist perspective.

5-28* EMDE BOAS, CONRAD VAN. Essays in erotiek. Amsterdam: Polak
 and Van Gennep, 1969.

5-29 ———. Inleiding tot de Studie van de Pornografie. The Hague:
 NVSH, 1966. 57 pp., bib.
 Nature of the concept of pornography is explored.

5-30 _____. Obsceniteit en Pornografie Anno 1966. The Hague: NVSH, 1966. 75 pp., bib., illus.
 Survey of the types of pornography available in the mid-'60's.

5-31 _____. Pornografie en Beeldende Kunst. The Hague: NVSH, 1966. 43 pp. (text), illus.
 Discusses the relationship between erotic art, pornography, and the public's perceptions of these.

5-32 ENGLISH, DEIDRE. "The politics of porn." Mother Jones 5, no. 111 (April 1980): 20-23+.
 Analysis of feminist anti-pornography efforts.

5-33 ERNST, MORRIS L. "Sex and censorship." In Sex in the arts: a symposium edited by John Francis McDermott and Kendall B. Taft. New York: Harper, 1932.
 Censorship of erotic imagery in art is explored.

5-34* FEMINIST ANTI-CENSORSHIP TASKFORCE BOOK COMMITTEE. Caught looking: feminism, pornography and censorship. Edited by Kate Ellis et al. New York: Caught Looking, Inc., 1987. Second edition [Seattle: Real Comet Press, 1988], 96 p., illus., bib.
 Collection of essays and visual images reflecting on the relationship between pornography and women from the viewpoint of the Feminist Anti-Censorship Taskforce.

5-35* FAUST, BEATRICE. Women, sex, and pornography: a controversial and unique study. New York: Macmillan, 1980. 239 pp., index, bib.

5-36 GARVER, THOMAS H. "Bedroom or operating room? . . . some personal thoughts on eroticism and pornography." In Eros and photography, edited by Donna-Lee Philips, 21-22. San Francisco: Camerawork/NFS Press, 1977.
 Musings on the concepts of eroticism and pornography in photography and cinema.

5-37* GILLETE, PAUL J. An uncensored history of pornography. Los Angeles: Holloway House, 1965.

5-38* GILMORE, DONALD H. Sex and censorship in the visual arts. San Diego: Greenleaf, 1970.

5-39* GLYNN, THOMAS. La pornographie Danoise. Actualites sexuelles. Paris: G. Fall, 1970. 110 pp.

5-40* GORDON, GEORGE N. Erotic communications: studies in sex, sin, and censorship. Humanistic Studies in the Communication Arts. New York: Hastings House, 1980. 338 pp., bib., index, illus.

5-41 GORSEN, PETER. Das Prinzip Obszon: Kunst, Pornographie und
 Gesellschaft. Hamburg: Rowolt, 1969. 172 pp., bib., index,
 illus., figs.
 Study of the nature of the concept of obscenity in art.

5-42 GRABNER-HALDER, ANTON, and LUTHI, KURT, eds. Der befreite
 Eros: ein Dialog zwischen Kunstlern, Kritikern, und Theologen.
 Mainz: Matthias Grunewald, 1972. 212 pp., illus.
 Anthology of papers on the topics of censorship, pornography,
and erotic art from a number of points of view.

5-43* GRAYCK, THEODORE. "Pornography as representation: aesthetic
 considerations." Aesthetic Education 21, no. 4 (Winter 1987): 103-
 122.

5-44* GRIFFEN, SUSAN. Pornography and silence: culture's revenge
 against nature. New York: Harper and Row, 1981.
 Strong condemnation of pornography from a radical feminist per-
spective.

5-45 GUHA, ANTON-ANDREAS. Sexualitat und Pornographie: die Organi-
 sierte Entmundigung. Frankfurt: Fischer, 1971. 219 pp., bib.,
 illus., figs.
 Study of the nature of the concept of pornography.

5-46 GUYOTAT, PIERRE. "Legende." Art Press 22 (January-February
 1976: 8-9, illus.
 Comments on the nature of pornography.

5-47* HANS, MARIE FRANCOISE. Les femmes, la pornographie, l'erot-
 isme. Paris: Sevil, 1978. 390 pp.

5-48* HART, J. "Reflections on pornography." Partisan Review 52, no.
 4 (1985): 414-20.

5-49 HOLBROOK, DAVID, ed. The case against pornography. Open
 Court, Ill.: Library Press, 1973. 294 pp., bib.
 Collection of essays presenting a variety of criticisms of porno-
graphy.

5-50 HOWARD, MAUREEN. "Forbidden fruits: dirty postcards and Cez-
 anne's apples—what is the difference between pornography and the
 erotic?" Vogue 173, no. 3 (March 1983): 384-86+, illus.
 Discussion of the nature of pornography and social attitudes to-
ward pornography, censorship, and eroticism.

5-51* HUER, JON. Art, beauty, and pornography: a journey through
 American culture. Buffalo, N.Y.: Prometheus Books, 1987. 239
 pp., bib., index, illus.

5-52 HUGHES, DOUGLAS A., ed. Perspectives on pornography. New
 York: St. Martin's Press, 1970. 223 pp., index.
 Investigation of the concept of pornography and its implications.

5-53 HYGHE, RENE, et al. "Was ist Kunst-und wann ist Kunst Obszon?;
 Kunst vor dem Richter" [theme issue]. Littera: Dokumente/Berich-
 te/Kommentare 4 (1964): 1-144, illus.
 Conclusions of a symposium on the nature of the obscene in art.

5-54 JARRETT, JAMES L. "On pornography." Journal of Aesthetic Edu-
 cation 4, no. 3 (July 1970): 61-67.
 Philosophical discussion of the nature of pornography.

5-55 KATZMAN, MARSHALL. "Obscenity and pornography." Medical
 Aspects of Human Sexuality 3, no. 8 (July 1969): 77-83, illus. (some
 col.).
 Discussion of the concept of the obscene and pornography, es-
 pecially how they apply to art.

5-56* KEMP, EARL, ed. The illustrated presidential report of the Com-
 mission on Obscenity and Pornography. San Diego: Greenleaf Clas-
 sics, 1970.
 Report by a top level commission on the question of whether
 pornography is a danger to society.

5-57* KENDRICK, WALTER. The secret museum: pornography in modern
 culture. New York: Viking, 1987.
 Historical study of changing attitudes to sexually explicit mater-
 ials.

5-58 KENEDY, R.C. "Second thoughts" Art and Artists 5, no. 2
 (August 1970): 6+.
 Essay trying to define obscenity in social terms.

5-59* KORTZ, D. "Porn symposium: eroticism vs porn, by an ex-practi-
 tioner." Take One 4 (May-June 1973): 28-29.

5-60 KRONHAUSEN, EBERHARD, and KRONHAUSEN, PHYLLIS. Porn-
 ography and the law: the psychology of erotic realism and hard
 core pornography. 1959. Rev. ed. Foreword by J.W. Ehrlich;
 introduction by Theodor Reik. New York: Ballantine, 1964. 416
 pp., bib., index.
 Psychologists discuss the nature of erotic expression in the arts
 and legal and psychological issues involved.

5-61 KRONHAUSEN, PHYLLIS, and KRONHAUSEN, EBERHARD. "Porno-
 graphy, the psychology of." In The encyclopedia of sexual beha-
 vior, edited by Albert Ellis and Albert Abarbanel, 848-59. New
 York: Hawthorn, 1961.
 Study of the nature of erotica and pornography from a psycho-
 logical perspective.

5-62* LAWRENCE, D.H. Pornography and obscenity. New York: Knopf,
 1930. 32 pp.

Famous novelist's personal experiences and thoughts about efforts to censor literature and art.

5-63* LEDERER, LAURA, ed. Take back the night: women on pornography. New York: William Morrow, 1980. 359 pp., index, bib.
Anthology of articles strongly condemning pornography.

5-64 LEVITT, EUGENE E. "Pornography: some new perspectives on an old problem." Journal of Sex Research 5, no. 4 (November 1969): 247-59.
Pornography from a sociological perspective discussed.

5-65 LONGFORD. Pornography: the Longford report. London: Coronet Books, 1972. 520 pp., bib., index.
Report of an English government commission investigating pornography.

5-66 MANN, JAY. "The effects of erotica." Sexual Behavior 3, no. 2 (February 1973): 23-29.
Review article providing overview to this topic.

5-67 MARCUSE, LUDWIG. Obszon, Geschichte einer Entrustung. Munich: Paul List, 1962. 407 pp., index.
Case studies of censorship in history.

5-68* MATISSE, SYLVANO. Pornography expose: eroticism and pornography down the ages. London: Diamond Star, 1972.

5-69 MELLY, GEORGE. "Pornography and erotica." Art and Artists 5, no. 2 (August 1970): 4.
Essay attempting to distinguish between erotic art and pornography.

5-70* MICHELSON, PETER. The aesthetics of pornography. New York: Herder and Herder, 1971. 247 pp.
Rational defense of what is commonly called "pornography."

5-71 MILLET, CATHERINE. "La pornographie contre les monopoles du sexe." Art Press International 2 (November) 1976: 5-7.
Discussion of the nature of pornography and its relationship to art.

5-72 _____. "Pour la pornographie? Reponses a l'enquete." Art Press 22 (January-February 1976): 4-17, illus.
Views of the nature of pornography and its relationship to art as voiced by scholars and journalists.

5-73 MORAWSKI, S. "Art and obscenity." Journal of Aesthetics 26, no. 2 (Winter 1967): 193-207.
Philosophical discussion of the difference between the erotic and the pornographic.

5-74* MOROZ, GEORGE ANTON. "Prolegomenon to an aesthetician's view of 'erotic-art,' 'obscenity,' and 'pornography.'" Ph.D. dissertation, University of Illinois at Chicago Circle, 1979. 371 pp., bib.

5-75* NEW YORK TIMES. The report of the Commission on Obscenity and Pornography. Introduction by Clive Barnes. New York: Bantam, 1970. 700 pp.
 Government commission report on obscenity and pornography.

5-76* "Obscene prints." Justice of the Peace 116 (8 November 1952): 710-11.

5-77* O'DAIR, BARBARA. "Sex, love and desire: feminist debate over the portrayal of sexuality." Alternative Media, Spring 1983, 12+.

5-78 "On the third domain-art, pornography, and aesthetic experience." Journal of Aesthetic Education 4, no. 3 (July 1970): 5-8.
 Essay tries to distinguish clearly between pornography and erotic art.

5-79 PAUVERT, JEAN-JACQUES. "La litterature pornographique et les contradictions de la censure." Art Press 22 (January-February 1976): 10, illus.
 Publisher discusses problems of sexually explicit literature and censorship.

5-80 PECKHAM, MORSE. Art and pornography, an experiment in explanation. New York: Basic Books, 1969. 306 pp., index, illus.
 Thorough discussion of the relationship between art and pornography.

5-81 PHELPS, DONALD. "A second look at pornography." Kulchur 1, no. 3 (1961): 57-73.
 Early defense of sexually oriented literature and other media.

5-82* PLESSMAN, DAVID. "A history of pornography." Human Response 1, no. 1 (September 1974): 56-66+.

5-83 POPE, MICHAEL. Sex and the undecided librarian: a study of librarians opinions on sexually oriented literature. Metchuen, N.J.: Scarecrow, 1974. 209 pp., bib.
 Study of librarian's views on the acquisition and public access to sexually oriented literature.

5-84* "Porn erotica debate goes on." Berkeley Barb 30, no. 3 (15 November 1979: 6.

5-85* "Porn vs. erotica, feminist definition." Berkeley Barb 30, no. 1 (16 October 1979: 9.

5-86 REICHARDT, JASIA. "Censorship, obscenity and context." Studio International 172, no. 883 (November 1966): 222-23.
 Problems of obscenity, erotic art, and the law are discussed.

5-87 RESEARCH REPORT. "Which sex gets the most erotica?" <u>New Humanist</u> 89 (October 1973): 202.
 Report on psychological study of male and female reactions to visual erotica.

5-88* RIST, RAY C., ed. <u>The pornographic imagination</u>. New Brunswick, N.J.: Transaction Books, 1975.

5-89* RIST, RAY C., comp. <u>The pornography controversy</u>. New Brunswick, N.J.: Transaction Books, 1973.

5-90 ROCKMAN, A. "Reflections on the erotic in art." <u>Canadian Arts</u> 22, no. 4 (September–October 1965: 30–37, illus. (some col.).
 Essay on the diminishing distance defining the difference between erotic art and pornography.

5-91 SCHECHNER, RICHARD. "Pornography and the new expression." <u>Atlantic</u> 219, no. 1 (January 1967): 74–78.
 Essay exploring the role of sex in modern arts and culture.

5-92 SCHIWY, GUNTHER. <u>Strukturalismus und Zeichensysteme</u>. Munich: Beck, 1973. 178 pp., bib., index.
 Philosophy book with section on censorship and erotic art.

5-93* SIMONS, G.L. <u>Pornography without prejudice: a reply to objectors</u>. London: Abelard–Schuman, 1972. 169 pp., bib., illus.

5-94* SMITH, C. "Myth of erotica." <u>Branching Out</u> 7, no. 1 (1980): 39–41, illus.

5-95 SOLLERS, PHILIPPE. "Porno an zoro." <u>Art Press</u> 22 (January–February 1976): 5, illus.
 Discussion of the nature of pornography.

5-96 SONTAG, SUSAN. "The pornographic imagination." In <u>Styles of radical will</u>. New York: Farrar, Straus, and Giroux, 1969, 35–73.
 Philosophical thoughts on the nature and forms of pornography.

5-97* SPRAGUE, WILLIAM EDWIN. <u>Sex, pornography, and the law</u>. San Diego: Academy, 1970.

5-98* STEIN, D.L., and PARIS, E.N. "Pornography: menace or safety valve?" <u>Chatelaine</u> 51 (May 1978): 26.

5-99 STEINEM, GLORIA. "Erotica and pornography: a clear and present difference." <u>MS Magazine</u> 7, no. 5 (November) 1978: 53–54+, illus.
 Feminist author suggests a useful distinction between erotica and pornography.

5-100* STREBLOW, LOTHAR. Erotik, Sex, Pornographie. Munich: Lichtenberg, 1968.

5-101* TYNAN, KENNETH. "In praise of hard core." In The sound of two hands clapping. New York: Holt, Rinehart and Winston, 1975.
Author seeks to refute the idea that pornography is only worth defending when it has artistic value.

5-102* _____. "Pornography? And is that bad?" Performing Arts 6, no. 4 (Fall 1969): 4-5.

5-103* WEBB, PETER. "Erotic art and pornography." In The influence of pornography on behaviour, edited by Jaffe and Nelson. London: Academic Press, 1982.

5-104 WEBSTER, PAULA. "Pornography and pleasure." Heresies 3, no. 4 (1981): 48-51, illus.

5-105 WHITE, WILLIAM. "On collecting dirty books: some notes on censorship." American Book Collector 17 (March 1967): 20-26.
Collector's personal appreciation of erotic literature and the problems raised by censorship.

5-106 YAFFE, MAURICE, and NELSON, EDWARD C., eds. The influence of pornography on behavior. New York: Academic Press, 1982.
Set of articles looking at the subject of pornography from several perspectives: censorship, psychology, education, law, and erotic art.

Section 2
General Surveys

Chapter 6
Erotic Art Surveys

As any publisher knows, the word "sex" or "erotic" in a title creates interest and frequently increases sales. As this chapter amply demonstrates, many publications have titles that suggest that they are surveys of erotic art, covering a range of cultures and/or time periods. Too often, however, the promise of the title is not born out by the contents. While there are erotic art surveys with useful scholarly text, surveys that rationally organize the material presented, and surveys with interesting selections of quality illustrations, there are unfortunately few with all these characteristics and many with none. Included in this chapter are entries that cover more than one of the geographic/temporal categories that define the later chapters of this bibliography. In order to assemble the entries in this chapter, it was necessary to recognize the disparity in quality of publications and to seek to identify those that would be most beneficial for the study of erotic art.

There have been few serious scholarly attempts to provide thorough surveys of erotic art, with both well-researched text and illustrations of significant works of art. At the beginning of the twentieth century Germanic scholars Eduard Fuchs and Cary von Karworth studied what was, until then, the forbidden subject of sex in art. Karworth's Die Erotik in der Kunst and Fuch's L'element erotique dans la caricature, Geschichte der Erotischen Kunst, and Die grossen Meister der Erotik were pioneering works which, while focusing almost exclusively on Europe and illustrating relatively tame material by contemporary standards, have yet to be eclipsed in the insight of their analyses. Few art historians followed in their footsteps, and by the mid 1960s a summary of what was known about erotic art authored by Mario Praz et al. in the "Sex and Erotica" essay in the Encyclopedia of World Art, volume 12, indicated that little had been added to our knowledge of erotic art.

From the mid-1940s to the mid-1970s a spate of books "surveying" erotic art were published: but almost all covered only Western culture, few could be considered scholarly works, and some were strangely idiosyncratic in their perspective on the subject. Examples from this period include items by Arce Robledo, Bacon, Bataille, Brusendorff and Henningsen, Fels, Gerhard, Jakonvsky, Lo Duca, and Richards. Distinctly notable for its exhaustive coverage is the ten-volume Bilder-Lexikon der Erotik published in 1961, which not only included two volumes on Literatur und Kunst but was illustrated throughout with examples of erotic art.

Serious scholarship on erotic art in the last few decades has general-
ly taken the form of anthologies with chapters written by different auth-
ors. These anthologies are generally not intended to be comprehensive in
their coverage but offer diverse and disparate views of the subject. The
first of these was Studies in erotic art (1970) by Theodore Bowie et al.,
which included studies on ancient Greek, Renaissance, Peruvian, Japanese,
and modern erotic art. Two years later saw the publication of Woman as
sex object: studies in erotic art, 1730-1970, which offered interpretations
of several common European art images from the then burgeoning feminist
art historical perspective. In recent years scholarly anthologies include
Der Garten der Luste, edited by Berger and Hammer-Tugendhat, and Eros
in the mind's eye edited by Donald Palumbo.
 A significant milestone was reached with the publication of the art
historical survey, The erotic arts, edited by the primary contributor Peter
Webb, an English art historian. Webb's book is the closest thing to a text
book on erotic art to date, as it seeks to cover all the major periods of
erotic art. Unfortunately, the quality of the text from the different auth-
ors is somewhat uneven and the small black and white illustrations are fre-
quently disappointing. About the same time, Bradley Smith's Erotic art of
the masters (covering Europe and Asia in the eighteenth, nineteenth, and
twentieth centuries) offered a coffee-table quality book with fine illustra-
tions and informative text. The most comprehensive visual survey is pro-
bably provided in the Kronhausen's two-volume Erotic art, which is de-
signed like an exhibition catalog with minimal text. Richard Bentley's
Erotic art, which surveys European erotic art history, comes closest to
combining quality illustrations with a useful, if simplistic, text.
 Another approach to erotic art surveys limits the scope of the study
to specific countries or media. Among the works that look at a specific
country, some reveal the existence of erotic art in surprising areas, not-
ably Banach's books on Poland, Domingo on Spain, and Flegon's study of
Russian erotic art. Media based works include Andrew Tilly's Erotic
drawings (covering post-Renaissance Europe) and Kuntz's Erotische Gra-
phik von der Antike bis Heute.
 Few museums or collectors of erotic art are able to assemble collec-
tions that survey the full extent of erotic art and fewer still allow those
collections to become known to the public. Museum collections are almost
never publicized or made accessible in print. Typically, erotic art collec-
tions only become visible when included in auction catalogs, with examples
listed below from the Philips (New York) Gallery sale of the Kronhausen
collection, Bonhams (London), and Malter (Los Angeles) galleries, and the
multivolume catalogs from the annual D.M. Klinger sales. There have, how-
ever, been exceptions to this emphasis on "secret" collections. Most not-
able is the former collection of the psychologists Phyllis and Eberhard
Kronhausen, which was shown in several countries in Europe in controver-
sial exhibitions in the 1960s and early 1970s and formed the basis of the
short-lived Museum of Erotic Art in San Francisco. The Kronhausen's
wanted to encourage interest in erotic art, not only displaying their collec-
tion but also authoring a number of publications (which typically were cat-
alogs with little text). On a less ambitious scale, Charles Martignette of
Boston has publicized his collection of erotica through exposure in several
articles in Playboy and other magazines. Lawrence Gichner of the Wash-
ington, D.C. area, has a collection that has been the source of illustrations

in many publications. Gichner has presented himself as a connoisseur/-scholar by self-publishing a series of books, mostly on Asian erotic art. In Europe, the Simon and Peyrefitte collections have been presented in books and articles.

An alternative approach to the historical survey are works that speculate on the nature of erotic art wherever it appears. In many cases such works aver that there are significant distinctions between erotic art and pornography (see also the "Art, Pornography, and Censorship" chapter). While the historical surveys are generally authored by art historians, essays on the nature of erotic art may be written by sexologists, psychologists, sociologists, philosophers, etc. A diversity of views can be gained by reading works like those by Bataille, Baynes, Bredt, Jeantet-Roosan, Jung, Robinson, Spink, and Wallace.

6-1* ARBOUR, R-M. "La peau comme dessein." Revue d'Esthetique 11 (1986): 74-90, ill.

 Asserts that the human skin and its sensations is analogous to the erotic dimensions of art.

6-2 ARCE ROBLEDO, CARLOS DE. Eros blanco: arte y costumbres eroticas en occidente desde la prehistoria hasta nuestros dias. Barcelona: Sagitario, 1976. 383 pp., illus., bib.

 Survey of Western erotic art from prehistoric to modern times. Includes some images not commonly reproduced elsewhere.

6-3 BACON, JACK. Eros in art. Los Angeles: Elysium, 1969. 49 pp., illus. (some col.), index.

 Visual survey of erotic art interspersed with explicit photographs and accompanied by very little text.

6-4 BANACH, ANDRZEJ. Les "Enfers" domaine Polonais. Bibliotheque internationale d'erotologie, no. 17. Paris: J.-J. Pauvert, 1966. 244 pp., illus.

 Study of Polish sexual customs and erotic art.

6-5 _____. Erotyzm po Polsku. vol. 1. Warsaw: Wydownictwa Artystyctne i Folmowe, 1974. 205 pp., illus.

 Thematic study of eroticism in modern Polish art, including photography and film.

6-6 BATAILLE, GEORGES. Les armes d'eros. Bibliotheque internationale d'erotologie, no. 6. Paris: J.-J. Pauvert, 1961. 249 pp., illus. (some col.), index.

 History of erotic art in the West, emphasizing sadomasochistic images.

6-7 _____. Eroticism. London: J. Calder, 1962. 306 pp., illus. First edition, Paris: Editions de Minuit, 1957.

 Theories regarding the role of eroticism in art and culture are offered.

6-8* BAUCHMAN, ERIC ABRAM. "The humanness of man as manifest in the erotic art of ancient, medieval, Renaissance, and modern periods of Western civilization." Manuscript in the Institute for Sex Research Library, Bloomington, Indiana, 1969.

6-9 BAYNES, KEN. "Part three: sex." In Art in society. Woodstock, N.Y.: Overlook Press, 1975. 288 pp.
 Common sexual themes and symbols found in the world's art mentioned.

6-10* BELL, CYRUS. "Saucy pictures you're not allowed to see." Saturday Tit-Bits (London), 28 November 1970.

6-11* BELUON, J.J. Waar je Kijkt . . . Erotiek. Amsterdam: Weten schappelijke Pers (?), 1967. 244 pp., illus.

6-12 BENTLEY, RICHARD. Erotic art. New York: Gallery Books, 1984. 176 pp., bib., index, illus. (some col.).
 Survey of the history of erotic art in the Western world from the ancient Greeks to the present day, emphasizes the period from the medieval to the early nineteenth century.

6-13 BERGER, RENATE, and HAMMER-TUGENDHAT, DANIELLA, eds. Der Garten der Luste: zur Deutung des Erotischen und Sexuellen bei Kunstlern und ihren Interpreten. Cologne: Dumont, 1985. 199 pp., illus. (some col.), bib.
 Four essays on aspects of Western erotic art from late medieval to modern times.

6-14* BERTE, G. Amulettes phalliques. Menton, 1914.

6-15 BESSY, MAURICE. Imprecis d'erotisme. Bibliotheque internationale d'erotologie, no. 7. Paris: J.-J. Pauvert, 1961. 172 pp., illus.
 Exploration of different sex roles and images in European art history.

6-16 Bilder-Lexikon der Erotik. 10 vols. [vols. 1-2, Kulturgeschichte; vols. 3-4 Literatur und Kunst; vols. 5-6 Sexualwissenschaft; vols. 7-8 Erganzungsband; vols. 9-10 Nachtragsbande]. Hamburg: Institut fur Sexualforschung in Wien, 1961. Illus. (some col.).
 Well-illustrated encyclopedic coverage of human sexuality and erotica.

6-17 BONHAMS. Erotic arts [Sale no. 23974; 9 December 1987]. London: Bonhams, 1987. 28 pp., ill.
 Auction catalog including post-Renaissance erotic art, Japanese Shunga, and miscellaneous erotica. Includes suggested bidding range.

6-18 BOURGERON, JEAN-PIERRE. Les masques d'eros: les objets erotiques de collection a systeme. Paris: Editions de l'Amateur, 1985. 237 pp., illus.

Catalog of the Simon collection of erotica, including mostly late nineteenth and twentieth century objects.

6-19　BOWIE, THEODORE et al. Studies in erotic art. New York: Basic Books, 1970. 395 pp., illus.
　　　　Collection of essays on various aspects of erotic art, including chapters on ancient Greek and Rome, pre-Hispanic Peru, Japan, the Italian Renaissance, and Picasso.

6-20　BREDT, ERNST WILHELM. Sittliche oder unsittliche Kunst?: eine historische Revision. Munich: R. Piper, 1910. 129 pp., illus.
　　　　Study of some erotic elements in the history of European art.

6-21　BRUSENDORFF, OVE, and HENNINGSEN, POUL. Erotikens Historie: fra Oldtiden til den Galante Tid. Copenhagen: Thaning & Appels, n.d. 256 pp., illus. (some col.).
　　　　Survey of European erotic art from Greece to the eighteenth century.

6-22　_____. Love's picture book: the history of pleasure and moral indignation, vol. 1, From the days of classic Greece until the French Revolution. Translated by H.B. Ward. New York: Lyle Stuart, 1960. 159 pp., illus., figs.
　　　　Historical survey of erotic art in the West.

6-23　_____. Love's picture book: the history of pleasure and moral indignation, vol. 2, From the French Revolution to the present time. Translated by Elsa Gress. New York: Lyle Stuart, 1960. 159 pp., illus.
　　　　Nineteenth and twentieth century erotic art surveyed.

6-24　_____. Love's picture book: the history of pleasure and moral indignation, vol. 3, Exotic horizons. Translated by H.B. Ward. New York: Lyle Stuart, 1960. 159 pp., illus., figs.
　　　　Erotic art and customs in non-European traditions.

6-25　_____. Love's picture book: the history of pleasure and moral indignation, vol. 4, Eroticism in a new light. Translated by H.B. Ward. New York: Lyle Stuart, 1960. 151 pp., illus.
　　　　Speculations about the nature of erotic art and sex customs.

6-26　BURLAND, COTTIE. Erotic antiques or love is an antic thing. Foreword by Harriet Bridgeman. Selkirkshire, Scotland: Lyle Publications, 1974. 128 pp., illus.
　　　　Catalog of photos of erotica with brief accompanying text. Mostly Oriental and art deco objects.

6-27*　Chefs d'oeuvre de l'erotisme.
　　　　Collection of articles from French magazine Curiosa.

6-28　CONRAD, PETER. "Potent images." Times Literary Supplement, 20 February 1976, 190-91, illus.

Review of Webb's book on erotic art includes comments on the nature of erotic art.

6-29* CYMBAL, MARIE. "Erotic art comes out of the closet." Financial Post Moneywise Magazine, May 1986, 12.
Report on rise of appearance of erotic art at auctions and art sales.

6-30 DOMINGO, XAVIER. Erotica Hispanica. Bibliotheque internationale d'erotologie. Paris: Ruedo Iberico, 1972. 324 pp., illus. First edition, Paris: J.-J. Pauvert, 1967.
Historical and iconographic study of the history of erotic art in Spain.

6-31 DUFRENNE, M. "Esthetique erotique." Revue d'Esthetique 11 (1986): 7-15, illus.
Discusses the relationship between the aesthetic and the erotic, offering definitions of each, and concluding that though at times they coexist each is a discrete concept.

6-32 EDITIONS AUX CAMELIAS. Le secret dans l'image. Rome: Les Presses des Arts Graphiques Danesi, 1946. 26 pp., illus.
Short overview of Western erotic art.

6-33 EITNER, LORENZ. "The erotic in art." In Fundamentals of human sexuality, edited by Katchadourian and Lunde. New York: Holt, Rinehart, Winston, 1975.
Survey focusing primarily on Western erotic art with commentary on sex in art and the controversy of pornography.

6-34* Eros: Monatschrift fur erotische Kunst. Vienna: Frisch, 1919 (or 1921)-.
Periodical dedicated to displaying erotic art. May have covered only then contemporary modern art.

6-35 "Eros in Sweden: First International Exhibition of Erotic Art." Time 91 (17 May 1968): 74, illus.
Review of erotic art exhibition of Kronhausen collection in Sweden.

6-36 "Eros und Tod" [theme issue]. Kunst und Kirche 2 (1987).
Collection of articles on the themes of eroticism and death in Western culture and art, especially as seen in the last 100 years.

6-37 [Erotic Art Issue.] Art and Artists 5, no. 5 (August 1970).
Dozen articles on varying aspects of erotic art, mostly modern.

6-38 [Erotic Art Issue.] Galerie, July-August 1972. 110 pp., illus. (some col.).
Topical exploration of erotic art as handled by several different cultures.

6-39 "Erotica on tour." Newsweek, 16 September 1968, 105.
 Discussion of the efforts of the Kronhausen's to collect and ex-
 hibit their collection of erotic art.

6-40 "Erotiques" [theme issue]. Revue d'Esthetique 1-2 (1978).
 Articles on eroticism in the arts, particularly literature.

6-41 FELS, FLORENT. L'art et amour. Paris: Editions Arc-en-Ciel,
 1952. 226 pp., illus. (some col.), bib.
 Erotic art from all parts of the world to the eighteenth century.

6-42 _____. Eros ou l'amour peintre. Monte Carlo: Editions du Cap,
 1968. 321 pp., illus. (some col.).
 Historical survey and thematic study of images of lovers and sex
 in Western art.

6-43 FLEGON, ALEC. Eroticism in Russian art. London: Flegon Press,
 1976. 468 pp., illus. (some col.), figs., index.
 History of nudity and eroticism in Russian and Soviet Union his-
 tory. Primarily a series of artist's biographies.

6-44 "Forbidden images." Art and Artists 223 (April 1985): 32-33.
 Review of erotic art exhibition at the Maclean Gallery in London.
 Show includes works from Asian and European art history.

6-45 FUCHS, EDUARD. L'element erotique dans la caricature: un docu-
 ment a l'historie des moeurs publiques. Vienna: Stern, 1906. 258
 pp., illus. (some col.). (Erlauterungen, 16-page supplement pub-
 lished in Leipzig, 1912.)
 Pioneering study of erotic caricature in Western art.

6-46 _____. Geschichte der erotischen Kunst, Erweiterung und Neube-
 arbeitung des Werkes das erotische Element in der Karikatur mit
 Einschluss der ernsten Kunst. Munich: A. Langen, 1908. 412 pp.,
 illus. (some col.). Reprint. 3 vols. Munich: Langen, 1912; New
 York: AMS Press, 1972.
 Early, pioneering historical and iconographic study of erotic art
 in Europe. Concentrates on ancient and medieval periods.

6-47 _____. Die grossen Meister der Erotik: ein Beitrag zum Problem
 des Schopferischen in der Kunst. Munich: Albert Langen, ca. 1932-
 35. 185 pp., illus. (some col.).

6-48 FURSE, J. "Love: sacred and profane." Arts Review 38 (31 Jan-
 uary 1986): 45-46.
 Review of exhibition held at the Plymouth Arts Centre, England.

6-49 Genders: art, literature, film, history. Austin: University of Tex-
 as Press, 1988-.
 Recently established periodical focusing on issues relating to
 sexuality and gender, includes articles on the arts.

6-50* GERHARD, POUL. The pillow book, or a history of naughty pic-
 tures. London: Words and Pictures, 1972.

6-51 _____. Pornography in fine art from ancient times up to the pre-
 sent. Los Angeles: Elysium Press, 1969. 186 pp., intro.
 Summary overview of history of erotic art with emphasis on fam-
 ous nineteenth and twentieth century artists.

6-52 _____. Pornography or art? London: Words and Pictures, 1971.
 160 pp., illus.
 History of erotic art focusing on specific artists.

6-53 GICHNER, LAWRENCE. "Objets d'sex." Oui, 1978 (or 1979), 119,
 illus. (col.).
 Selection of unusual objects from Gichner's collection of erotic
 art.

6-54 GIL TOVAR, FRANCISCO. Del Arte Llamado Erotico. Barcelona:
 Plaza & James, 1975. 134 pp., gloss., bib.
 General observations on the nature of sex, the erotic, porno-
 graphy, and erotic art.

6-55 GINZBURG, RALPH. Les "Enfers": panorama de l'erotisme domaine
 de langue Anglaise. Bibliotheque internationale d'erotologie, no. 2.
 Preface by Theodor Reik. Paris: J.-J. Pauvert, 1959. 206 pp.,
 illus.
 Survey of English and American erotic customs and art.

6-56 GLYNN, EUGENE. "We know what was behind the fig leaf, yet we
 don't see it." Art News 72, no. 10 (December 1973): 46-47, illus.
 Review of an exhibition of erotic art that included Japanese
 prints and nineteenth and twentieth century Western art.

6-57 GORDON, GEORGE N. Erotic communications: studies in sex, sin, &
 censorship. New York: Hastings, 1980. 338 pp., illus., index.
 Historical and sociological look at erotica, includes chapters on
 the history of erotic art.

6-58 GRAY, ELIZABETH. "Museum of Erotic Art." Sexual Freedom 14:
 9+, illus.
 Review of the then new Museum of Erotic Art and its holdings.

6-59 HAEBERLE, ERWIN J. The sex atlas: a new illustrated guide. New
 York: Seabury Press, 1978. 509 pp., illus., index, bib.
 Text on sexuality includes many erotic art illustrations and sec-
 tions on aspects of erotica.

6-60* HASKELL, FRANCIS. "Eroticism and the visual arts." Censorship
 3, no. 1 (Winter 1967).

6-61 HEILMANN, WERNER, ed. Johann Wolfgang von Goethes: Sammlung erotischer Gemmen und frivoler Epigramme. Exquisit Kunst, no. 243. Afterword by M. d'Arclos. Munich: Heyne, 1981. 79 pp., illus.
 Drawings in the manner of ancient gems with erotic scenes accompanied by short epigrams.

6-62 HESS, THOMAS B., and NOCHLIN, LINDA. Woman as sex object: studies in erotic art, 1730-1970. New York: Newsweek, 1972. 257 pp., index, illus.
 Anthology of studies of aspects of European erotic art as they relate to the depiction of women.

6-63 "Hidden art in Italy." Boston Globe, Sunday, 15 March 1981.
 Discussion of the erotic art in Italian museums that is generally closed to the public.

6-64 HOFMAN, WERNER. Nana: Mythos und Wirklichkeit. Hamburg: Kunsthalle, 1973. 64 pp., illus.
 Theme of voluptuous female in Western culture is explored in catalog accompanying exhibition held from 19 January to 1 April 1973.

6-65 HURWOOD, BERNHARDT J., ed. The whole sex catalogue. Introduction by Phyllis and Eberhard Kronhausen. New York: Pinnacle Books, 1975. 319 pp., bib., illus., figs.
 Wide range of topics concerning sexuality, with sections on the arts. Provides brief overviews and information on acquiring further information.

6-66* ISHKIN, RUTH. "Sexual imagery in art-male and female." Womanspace Journal 1, no. 1 (Summer 1973).

6-67 JAKOVSKY, ANATOLE. Eros du dimanche. Bibliotheque internationale d'erotologie, no. 13. Introduction by Lo Duca. Paris: J.-J. Pauvert, 1964. 243 pp., illus.
 Exploration of erotic folk art and sexual images in popular culture.

6-68 JEANTET-ROOSAN, C. "Pourquoi les Anges n'ont-ils pas de sexe?" Opus International 88 (Spring 1983): 38-40, illus.
 Contends that sexuality in works of art are subconscious expressions of the artists, discusses hidden sexual elements in the arts, and presents ways to recognize sexual allusions.

6-69 JUNG, GUSTAV. "Das erotische Element in Kunst und Dichtung." Zeitschrift fur Sexualwissenschaft 11 (1924-25): 277-88, 297-301.
 Discussion of eroticism in art, particularly from a psychological point of view.

6-70* KARWORTH, CARY VON. Die Erotik in der Kunst: ala Manuscript nur fur Subskribenten Gedruckt. Vienna: C.W. Stern, 1908.
 Pioneering early study of erotic art.

6-71 KELAMI, ALPAY, and BIEWALD, DICTER, eds. Art and andrology 1: on the occasion of the 3rd International Symposium of Operative Andrology: Bilder, Skulpturen, Objekte. Foreword by Michael Wewerka. Berlin: Galerie Wewerka Edition, 1984. 79 pp., illus. (some col.).
 Studies of the androgenous figure in the history of art.

6-72* KLIMKOWSKY, ERNST WERNER. Geschlecht und Geschichte: Sexualitat im Wandel von Kultur und Kunst. Essay by Max Brod. Teufen: A. Niggli & W. Verkauf, 1956. 208 pp., illus., bib.

6-73* KRONHAUSEN, EBERHARD. "Erotic art by children." Hustler 5, no. 4 (October 1978): 73-75.

6-74 KRONHAUSEN, EBERHARD, and KRONHAUSEN, PHYLLIS. The First International Exhibition of Erotic Art. Copenhagen (?): Kronhausen Books, ca. 1968. 30 pp. (text), illus.
 Exhibition catalog from a show of erotic art from all parts of the world.

6-75 KRONHAUSEN, PHYLLIS. Erotic art calendar. Varberg, Sweden: E.P. Holm, 1969. 12 pp., illus. (col.).
 Calendar of examples of erotic art.

6-76 _____. A gallery of erotic art. New York: Bantam, 1974. Unpaged, illus.
 General survey of the history of erotic art, mostly illustrations.

6-77 KRONHAUSEN, PHYLLIS, and KRONHAUSEN, EBERHARD. Erotic art: Sammlung Kronhausen. Geneva: Societe d'Etudes Financieres, 1969. Unpaged, illus.
 Catalog of an exhibition of the Kronhausen's collection of erotic art.

6-78 _____. Erotic art: a survey of erotic fact and fancy in the fine arts. New York: Bell, 1968. 312 pp., illus. (some col.).
 Text discusses the First International Exhibition of Erotic Art and provides a visual survey of the major periods of erotic art.

6-79 _____. Erotic art 2. New York: Grove Press, 1970. 274 pp., illus. (some col.), index.
 Second volume of visual survey of erotic art.

6-80 _____. The International Museum of Erotic Art. San Francisco: The Museum, 1973. 64 pp., illus. (some col.).
 Catalog of selections from the collection of the Museum of Erotic Art.

6-81 KUNTZ, EDWIN. Erotische Graphik von der Antike bis Heute. Bonn: H.M. Hieronimi, 1966. 296 pp., illus., index.
 History of erotic prints and drawings in European art.

6-82 LAEMMEL, KLAUS. "Sex and the arts [Chapter 18]." In The Sex-
ual Experience, edited by Benjamin Saddock, Harold Kaplan, and
Alfred Freedman, 527-66, bib. Baltimore: Williams & Wilkins, 1976.
Commentary on the role of sexuality in the arts, with illustra-
tions of erotic art.

6-83 LARKIN, DAVID, ed. Temptation: paintings of sexual invitation.
Introduction by Virgil Pomfret. Toronto: Peacock Press, 1975.
96 pp., illus. (col.).
Short introductory essay on the concept of temptation followed
by a collection of images that supposedly express that concept.

6-84 LEWANDOWSKI, HERBERT. Les "Enfers": panorama de l'erotisme:
domaine de langue Allemande. Bibliotheque international d'eroto-
logie, no. 9. Paris: J.-J. Pauvert, 1963. 244 pp., illus.
Survey of German sex customs, beliefs, and erotic art.

6-85* Der liebe Lust. Vol. 1-2, Vier erotische Bilderfolgen aus dem Bie-
dermeier. Die Bibliophilen Taschenbucher, nos. 114, 149. Dort-
mund: Harenberg, 1979-80.

6-86 LO DUCA, GIUSEPPE (J.-M.). Eros im Bild: die Erotik in der Euro-
paischen Kunst. Munich: Kurt Desch, 1968. 288 pp., illus. (some
col.).
Study of several themes in European erotic art from ancient
times to the modern period.

6-87 _____. Die Erotik in der Kunst. Die Welt des Eros. Essay by
Georges Bataille. Munich: Kurt Desch, 1965. 399 pp., illus., in-
dex, bib.
Iconographic themes in European erotic art surveyed.

6-88 _____. A history of eroticism. Bibliotheque internationale d'erot-
ologie. Adapted from the French by Kenneth Anger. London: Rod-
ney Book Service; Paris: J.-J. Pauvert, 1961. 246 pp., illus., index.
Survey of sex practices and erotic art in history (primarily
European).

6-89 MCLEAN, WILLIAM. Contribution a l'etude de l'iconographie popu-
laire de l'erotisme: recherches sur les bandes dessinees et
photo-histoires de langue Francaise dites "pour adultes" et sur les
graffiti de Parie et de ses aentours. Collection l'erotisme popu-
laire, vol. 1). Paris: Maisonneuve & Larose, 1970. 200 pp., illus.

6-90* MACLEAN GALLERY. Forbidden images. Introduction by Peter
Webb. London: Maclean Gallery, 1985.
Exhibition catalog for a show of Western and Eastern erotic art.

6-91 MALTER, JOEL L. and Co. Auction XIII. Los Angeles: Malter,
1980. 28 pp., illus.
Auction catalog of a large collection of erotica.

6-92* MARCOTTE, M. "Art erotique et bien commun." Relations 51
(July-August 1970): 215-17.

6-93* _____. "Erotisme, morale et esthetique." Relations 348 (April
1970): 110-13.

6-94* _____. "Face a l'erotisme: l'artiste et sa conscience." Relations
361 (January 1971): 181-84, bib.

6-95* MARTIGNETTE, CHARLES. "The collector." Boston Magazine 74
(June 1982): 18.
 Feature on a major collector of erotic art.

6-96* _____. [Charles Martignette.] Miami 33 (March 1982): 17.

6-97 _____. "Provocative perioa pieces." Playboy 27, no. 10 (October
1980: 131-35, illus. (col.); 30, no. 1 (January 1983): 122-5, illus.
(col.).
 Selections from the collection of Charles Martignette.

6-98 MOLLERSTROM, STEN. Kar Konst. Stockholm: Trevi, 1979. 208
pp., index, illus.
 Thematic and historical survey of images of lovers in art his-
tory. Includes a few explicitly sexual images: also has sections on
bestiality and one on Picasso.

6-99 MULLINS, EDWIN B. The painted witch: how Western artists have
viewed the sexuality of women. New York: Carroll & Graf, 1985.
230 pp., illus. (some col.), index.

6-100* "Musee secret de l'erotisme" [special issue]. Fascination, 1978-80.
 Issue contains articles on various aspects of erotic art.

6-101 New School for Social Research. Erotic art. Foreword by Paul
Moscsanyi. New York: New School Art Center, 1973. 56 pp.,
illus.
 Catalog of an exhibition of erotic art held from 30 October to 19
December 1973, mostly covers modern art.

6-102* NICHOLSON, M.J. Art and sex. London, 1930.

6-103 OBERBECK, S.K. "Women in art." Sexual Behavior 2, no. 3 (March
1972): 46-55, illus.
 Study of the female image in Western art, especially as those
images relate to female sexuality.

6-104 PALUMBO, DONALD. Eros in the mind's eye: sexuality and the fan-
tastic in art and film. Contributions to the Study of Science Fiction
and Fantasy, no. 21. Westport, Conn.: Greenwood Press, 1986.
290 pp., illus., bib., index.
 Anthology of articles ranging from Renaissance art to sex in con-
temporary cinema. Over half the articles are on cinema.

6-105 "A passion for collecting: erotic art comes out of the closet and into the auction rooms." Economist 302 (10 January 1987): 78.
 Comment on the increasing appearances of erotic art at major art auctions.

6-106* PEYREFITTE, ROGER. Un musee de l'amour. Monaco: Editions du Rochjer, 1972. 192 pp., illus. (some col.).
 Selections of illustrations from the author's erotic art collection.

6-107 "Peyrefitte's 'Inferno.'" Adelina 14, no. 6 (July 1980): 50-53, illus. (col.).
 Selections from the erotic art collection of French writer Roger Peyrefitte.

6-108 PHILIPS GALLERY. The Kronhausen collection of erotic art: sale no. 189: to be sold at Auction Saturday, March 31, 1979 at 2:00 P.M. New York: Philips Gallery, 1979. Unpaged, index, illus.
 Catalog of the auction sale of the Kronhausen collection of erotic art.

6-109 PRAZ, MARIO, et al. "Sex and erotica." In Encyclopedia of world art. New York: McGraw-Hill, 1966, columns 887-918, illus., bib.
 Thorough survey of sex in art from prehistoric times through to contemporary art.

6-110 "Provocative period pieces." Playboy 31, no. 1 (January 1984): 114-17, illus. (col.).
 Examples of erotic art displayed.

6-111 RICHARDS, ABE, and IRVINE, ROBERT. An illustrated history of pornography. New York: Athena, 1968. 288 pp., figs., illus.
 Survey of erotica through the ages.

6-112 RISSELL, JOHN. "The London pornocrats." Art in America 53, no. 5 (October-November 1965): 125-31, illus.
 Discussion of erotic art that has been exhibited in London, often without many people knowing about those exhibitions.

6-113* ROBINSON, WILLIAM J. "Obscene pictures and sexology." Journal of Sexology and Psychoanalysis 1, no. 6 (November 1923): 564-65.

6-114 ROBSJOHN-GIBBINGS, T.H. "Eros at home." Architectural Digest 34 (April 1977): 22, por., figs.
 Musings on sensuosity and eroticism in home decoration throughout history.

6-115* "Royal blush." Topper 3, no. 1 (August 1963): 20-24.
 Survey of erotic playing cards.

6-116 SCHIFF, GERT. Images of horror and fantasy. New York: Harry N. Abrams, 1978. 159 pp., bib., index, illus. (some col.).
 Includes a chapter on "Sex/Sadism" (pp. 79-97).

6-117 "The secret of an actor." Adelina 14, no. 7 (August 1980): 86-89,
 illus. (col.).
 Photo essay on the erotic art collection of the late French enter-
 tainer Michel Simon.

6-118 SEUFERT, REINHARD, ed. The porno-photographia. Los Ange-
 les: Argyle Books, 1968. 168 pp., illus.
 Odd collection of art and photography with sexual content, pri-
 marily from the post-Renaissance and modern periods.

6-119* Sex orgies illustrated. Collector's Publications, 1969.

6-120* Sexorgies in pictures (through the ages). 2 vols. Copenhagen:
 Point Press, 1967.

6-121 SMITH, BRADLEY. Erotic art of the masters: the 18th, 19th, and
 20th centuries. Introduction by Henry Miller. Secaucus, N.J.:
 Lyle Stuart, 1974. 207 pp., illus. (some col.), bib.
 Lavishly illustrated survey of erotic art from Asia and the West
 of the last three centuries.

6-122 SMITH, HOWARD, and COX, CATHY. "Bawdy bidding." Village
 Voice 24 (19 February 1979): 32, illus.
 Report on the sale of the Kronhausen collection of erotic art by
 the Philips auction house.

6-123 SOLOW, EDIE. Erotic rareties, 1760-1980. New York: Erotics
 Gallery, 1980. 64 pp., illus., bib.
 Catalog of objects from Asia and the West.

6-124 SPINK, WALTER M. The axis of eros. New York: Penguin Books,
 1973. 191 pp., index, illus.
 Philosophical musings concerning sexual imagery, contrasting
 that of the East with that of the Western world.

6-125* STERUP-HANSEN, DAN. Mand Kvinde. Vaerlose: Grafodan, 1980.
 32 pp., illus.

6-126 TARSHIS, JEROME. "A museum should be a museum." Art News
 73, no. 9 (November) 1974: 41-42, por.
 Short report on the troubles facing the Museum of Erotic Art in
 San Francisco.

6-127 TILLY, ANDREW. Erotic drawings. New York: Rizzoli, 1986. 80
 pp., illus. (some col.).
 Introductory essay on eroticism in Western art is followed by a
 selected catalog of drawings from the eighteenth to the twentieth cen-
 turies.

6-128 VALENTINE, LOUIS. "L'Erotismo e l'umorismo dell'amore; venduto all'asta il museo segreto di Peyrefitte." Bolaffiarte 10, no. 87 (March 1979): 48-51, illus. (some col.).
Selections from the erotic art collection of Roger Peyrefitte.

6-129 VOGEL, LISE. "Erotica, the academy and art publishing; a review of Woman as sex object: studies in erotic art, 1730-1970, New York, 1972." Art Journal 35, no. 4 (Summer 1976): 378-85.
Detailed article by article analysis of the book Woman as sex object by a critic who views each study in terms of its relationship to feminist philosophy.

6-130 VOLTA, ORNELLA. Le vampire: la mort: le sang: la peur. Bibliotheque internationale d'erotologie, no. 8. Paris: J.-J. Pauvert, 1961. 236 pp., illus.
Study of the concept of eroticism and the image of death.

6-131 WAETZOLDT, STEPHAN. "Metaphern der Sinnlichkeit." In Bilder vom Menschen in der Kunst des Abendlandes. Berlin: Mann, 1980, 343-53, illus. (some col.).
Brief essay and catalog of erotic sensuality in images of nude or nearly nude figures in Western art.

6-132 WALLACE, V.H. "Sex in art." International Journal of Sexology 2, no. 1 (August 1948): 20-26.
Sexologist's views on the nature of erotic art, focusing on certain periods of Western art.

6-133 "Wanna come up and buy my etchings?" Playboy 26, no. 11 (November 1979): 302-3, illus. (col.).
Reproductions of some works from the auctioned Kronhausen collection of erotic art.

6-134 WEBB, PETER, ed. The erotic arts. Boston: New York Graphic Society, 1975. 514 pp., illus., bib. Revised edition with additional material and photographs. New York: Farrar, Straus, Giroux, 1983.
Scholarly survey history of erotic art written by Webb and other specialists. Includes an extensive bibliography.

6-135* _____. "The role of sex in art education." Artscribe 4 (September-October 1976): 20-21.

6-136* WOODCOCK, GEORGE. "Eros and Thanatos: love and death in the arts." Queen's Quaterly 92, no. 4 (1985): 679-90.

6-137 WULFFEN, ERICH. Sexualspiegal von Kunst und Verbrechen. Dresden: Paul Aretz, n.d. 444 pp., figs., index.
Erotic themes in German arts discussed.

Chapter 7
Iconography and Symbolism

Another category of erotic art survey focuses on a certain theme, subject, or symbol rather than historical sequence or geography. Many of the entries listed throughout this bibliography take a subject or thematic view of erotic art, but this chapter includes items that focus exclusively on iconographic or thematic concerns in the art of a number of cultures or periods.

Erotic art is itself, obviously, a subcategory within the world of art; as defined for this bibliography it concerns the theme of sex in art. A closely related theme is that of love in art. While not every study of love in art includes discussion of physical love, a number that do are listed in this chapter: works by Breuer-Bergmann, Cartland, Gibbs-Smith, Lahr, the Parkers, Powell, and Whittet. Only slightly more distinctly sexual are works on the depiction of kissing and courting in art, including Failing's article "The art of kissing," Universe Book's visual catalog The kiss, Mehta's thorough Kama-Chumbana: the love-kiss in the East and the West, and Laver's "The art of seduction."

Interest in overtly sexual symbols developed largely as a result of the nineteenth century fascination with phallicism (see the chapter on "Phallicism" in this bibliography). As researchers discovered that sexual symbols are frequently significant in religion and commonly seen in art, they began to catalog and interpret those images. By the 1920s several books were published that summarized what was known about those religious symbols: Hannay's Sex symbolism in religion and Goldsmith's Life symbols as related to sex symbolism.

Most of the early erotic symbol studies grew out of the burgeoning field of psychology at the turn of the century. Particularly under the influence of Freud, sexual symbolism seemed to be a rich area for research. Such studies emphasize psychoanalytic interpretation over art historical concerns. Examples include Aigremont's study of the seashell as vulva symbol in literature and art, Eisler on the fish as sex symbol and the Schultze and von Gallera books on the erotic symbolism of the foot, shoe, hand, and finger. Havelock Ellis summarized what was known by the early 1930s on this subject in his now classic Studies in the psychology of sex, volume 5. Since World War II publications on this topic have increasingly been authored by art researchers.

Iconography and Symbolism

Some images are unambiguously related to sexuality, like prostitutes (see entries on history of prostitution in "Customs" chapter) and brothels (see Eros article on "Brothels in art" in this chapter), fertility figures and deities (Devereux, Murray, and Sankalia), the androgyne (Knott and Zolla), or the devil (see Villeneuve). The sexual meaning of more abstractly symbolic images is only revealed by careful research. Among images frequently seen in art, that have been determined to be sexual in meaning are unicorns (see Bar-Illan), frogs (Deonna), and seashells (Hunger). Especially in Western Christian art, sexual expression was heavily cloaked in obscure symbolism, the decipherment of which has interested modern art historians (see Rawson in this chapter and a number of entries in later chapters on European art). To date there has not been a definitive catalog of sexual subjects and symbols in art, but Boullet's Symbolisme sexuel dans les traditions populaires, Michel's L'art et le sexualite, and Vloten Elderinck's Liefde en Zinnelijkheid have offered at least partial surveys of erotic iconography.

7-1 AIGREMONT, S. "Muschel und Schnecke als Symbole der Vulva Ehemals und Jetzt." Anthropophyteia 6 (1909): 35-50.
 Seashells and snail shells as vulvic images in art and literature discussed.

7-2 BAR-ILLAN, DAVID. "The unicorn as a phallic symbol." Eros 1, no. 3 (Autumn 1962): 28-31, illus.
 Brief explanation of the phallic significance of the myth of the unicorn.

7-3* BEINART, LOUIS. La signification du symbolisme conjugal.

7-4 BOULLET, JEAN. Symbolisme sexuel dans les traditions populaires. Bibliotheque internationale d'erotologie, no. 5. Paris: J.-J. Pauvert, 1961. 240 pp., illus.
 Dictionary of sexual symbols in art.

7-5 BREUER-BERGMANN, HELMUT. Die Welt der Liebenden. Weltkultur im werden. Berlin: Edition Weltkultur, 1975. 135 pp., bib., ill. (some col.).
 Collection of images of love in art, together with sayings and poems about love.

7-6 "The brothel in art." Eros 1, no. 3 (Autumn 1962): 49-63, illus. (some col.).
 Images of prostitution in Western and Japanese art.

7-7 CARTLAND, BARBARA. Book of love and lovers. New York: Ballantine Books, 1978. 160 pp., index, illus. (some col.).
 Popular and famous images of love and lovers in Western art.

7-8 DEONNA, WALDEMAR. "The woman and the frog" [a translation]. Gazette de Beaux Arts 40 November 1952: 290-92, illus.

Discussion of the frog image as a symbol of the sexual life of women in folk belief, literature, and art.

7-9 DEVEREUX, GEORGES. Baubo, la vulve mythique. Paris: Jean-Cyrille Godefroy, 1983. 199 pp., figs., illus.
Psychological study of the vulvic image from around the world, especially the image of a female exposing her genitals.

7-10 EDEN, MARY. "The philosophy of the bed." The Saturday Book 18 1958: 250-67, illus.
The uses and meanings of the bed in Western culture is explored.

7-11 EISLER, ROBERT. "Der Fisch als Sexualsymbol." Imago 3, no. 2 (April 1914): 165-96, figs.
Study of the fish as a sexual symbol in history.

7-12 ELLIS, HAVELOCK. "Erotic symbolism." In Studies in the psychology of sex, Vol. 5 by Havelock Ellis. Philadelphia: F.A. Davis, 1929: 1-114.
Classic study of erotic symbols.

7-13 FAILING, PATRICIA. "The art of kissing." Art News 82, no. 2 (February 1983): 94-99, illus. (some col.).
Summary survey of the meaning and depiction of the kiss in Western art.

7-14 GIBBS-SMITH, CHARLES. "Ladies in love." Saturday Book 24 (1964): 87-107, illus.
Depictions of women in love from fine art and popular culture sources.

7-15 GOLDSMITH, ELIZABETH EDWARDS. Life symbols as related to sex symbolism. New York: Putnam, 1924. 455 pp., gloss, index, illus.
Study of symbols that appear in many cultures, emphasizing those with sexual connotations.

7-16 GOTZ, BERNDT. "Mannliche und weibliche Symbole an altem Hausrat." Zeitschrift fur Sexualwissen und Sexualpolitik 18 (1931-32): 29-36, illus.

7-17 HANNAY, JAMES BALLANTINE. Sex symbolism in religion. 2 vols. Appreciation by George Birdwood. London: Privately printed for Religious Evolution Research Society, 1922. Index, figs., illus.
Study of phallic and other symbols in religion.

7-18 HUNGER, HEINZ. "Die Muschel als Sexualsymbol." Sexualmedizin 8, no. 7 (July 1979): 291-92, illus.
Study of the seashell as a sexual symbol.

7-19 The kiss. New York: Universe, 1976. 104 pp., illus. (some col.).
Images of kissing in world art.

7-20 KNOTT, R. "Myth of the androgyne." Artforum 14 (November 1975): 38-45, bib., figs., illus.
 Study of the image of the human with qualities of both sexes.

7-21 LAHR, JANE, and TABORI, LENA. Love: a celebration in art and literature. New York: Stewart, Tabori, & Change, 1982. 239 p., foreword, intro., index, ill. (col.).
 Lavishly illustrated examples of the theme of love in art.

7-22 LAVER, JAMES. "The art of seduction." Saturday Book 29 (1969): 52-63, illus.
 Theme of seduction in literature and art is explored.

7-23 MEHTA, RUSTAM JEHANGIR. Kama-Chumbana: the love kiss in the East and the West. Bombay: Taraporevala, 1962, 1969. 115 pp., bib., illus.
 History and social meaning of kissing discussed with many illustrations from Western and Eastern art.

7-24 MICHEL, MARIANNE ROLAND. L'art et la sexualite. Collection via, no. 24. Tournai: Casterman, 1973. 218 pp., illus.
 Survey of the basic subjects and iconography of Western erotic art.

7-25 MOTT, RUFUS. "Love in the Bible." Eros 1, no. 4 (Winter 1962): 2-13, illus.
 Illustrations of the most commonly depicted scenes of sexuality from the Old Testament.

7-26 MURRAY, M.A. "Female fertility figures." Journal of the Royal Anthropological Institute 64 (1934): 93-100, illus.
 Article suggests a means of classifying mother goddess figures.

7-27 PARKER, DEREK, and PARKER, JULIA. The compleat lover. New York: McGraw-Hill, 1972. 256 pp., index, illus. (some col.).
 Themes of love in art and literature.

7-28 POWELL, JIM. "Art: l'amour in sculpture; an enduring theme tangibly expressed." Architectural Digest 39 (November 1982): 170-75, ill. (col.).
 Some examples of depictions of couples in love.

7-29* RAWSON, PHILIP. "Oblique erotic symbolism." Paper delivered at the Erotic Arts Section of the 1977 Conference of the Association of Art Historians, 1977.
 Erotic symbolism hidden in metaphor is discussed.

7-30 ROBINSON, IRA E., and CLUNE, FRANCIS J. "Sexual symbolism and archeology." Psychoanalytic Review 56, no. 3 (1969): 468-80, ref.
 Discussion of possible sexual symbolism in certain kinds of archaeological finds.

7-31 SANKALIA, H.D. "The nude goddess in human art." Marg 31, no. 2
(March 1978): 5-12, figs., illus.
 Study of mother goddess figures in prehistoric and ancient cultures of Europe and Asia.

7-32* SCHULTZE, S., and FREIHERR VON GALLERA. Beitrage zur Hand-
und Finger-Symbolik und Erotik. Leipzig, 1913.

7-33* _____. Fuss- und Schuh-Symbolik und Erotik. Leipzig, 1909.

7-34* SCUTT, R.W.B., and GOTCH, CHRISTOPHER. Art, sex and sym-
bol: the mystery of tattooing. Cranberry, N.J.: Barnes, 1975.

7-35 VILLENEUVE, ROLAND. Le Diable: erotologie de Satan. Bibliothe-
que internationale d'erotologie, no. 10. Paris: J.-J. Pauvert, 1963.
244 pp., illus., bib.
 Images of devils and witches, etc., in Western culture explored.

7-36* _____. Le Diable dans l'art: essay d'iconographie comparee a
propos des rapports entre l'art et Satanisme. Paris: Editions
Donoel, 1957.

7-37 VLOTEN ELDERINCK, D. PH. VAN. Liefde en Zinnelijkheid: De
Sexuelle zeden in Woord en Beeld. Delft: Elmar, n.d. 200 pp.,
illus.
 Themes in Western art related to love and sex.

7-38 WHITTET, GEORGE SORLEY. Lovers in art. London: Studio Vista,
1972. 160 pp., index, illus.
 Worldwide, historical survey of the image of lovers and love in art
history.

7-39 ZOLLA, ELEMIRE. The androgyne: reconciliation of male and fe-
male. Illustrated library of sacred imagination. New York:
Crossroad, 1981. 96 pp., bib., illus. (some col.), figs.
 Survey of the belief in and depiction of the androgenous human
throughout history.

Chapter 8
Nudes

The nude human form has been a major subject of art throughout history, being especially popular in ancient Greece, the Renaissance, and the twentieth century. While there are those who object to any depiction of naked figures in art because they consider them to be a form of "pornography," most people recognize that nudity itself is not necessarily overtly sexual. Kenneth Clark in his now classic book The nude did, however, suggest that all great nudes in art have a touch of the erotic. A full bibliography on the nude in art would be a major publication by itself, so the entries in this chapter are of necessity selective. The items listed below are included because they either provide a varied visual survey of nudes and/or give some attention to the erotic aspects of the nude figure. Most are catalogs with short introductions followed by numerous reproductions, but a few, like Clark's book mentioned above, provide a substantive text.

Surveys of the nude in art (primarily, but not exclusively limited to Western art) are provided by Bammes, Baruch, Brophy, Cinotti, Clark, Cormack, Field, Greenburg, Jacobs, Levey, Levy, Lucie-Smith, Mentone, Relouge, Romi, and Stokes. While most of these surveys show predominantly female nudes, works by Salgues, Vaudoyer, and Zwang concern only the female figure. The role of the disrobing and nude female in Western culture and art is considered in books on the history of the striptease by Aulnoyes and Chevalier. In contrast, surveys of male nudes have been authored by Aymar, Bayerthal, Loville, and Walters, with the Loville and Walters books being especially interesting because of their thoughtful texts. Geographically based surveys include a look at nudes in French art by Lejard, in Japanese art by Sasaki, and American art by Bode, the Brooklyn Museum, and Gerdts. Three items that directly discuss the relationship between the nude and sexuality are "Sex and human beauty" by Beigel, the exhibition catalog Eros en de Vruchtbaarheid in de Kunst, and "The nude as symbol" by Lefebve.

8-1 AULNOYES, FRANCOIS DE. Histoire et philosophie du strip tease: essai sur l'erotisme au music-hall. Preface by Emond Heuze. N.p.: Pense Moderne, 1957. 104 pp. (text), illus.
 History of the striptease seen as an extension of the tradition of the female nude in Western culture.

8-2* AYMAR, BRANDT. The young male figure: in paintings, sculptures, and drawings, from ancient Egypt to the present. New York: Crown, 1970. 247 pp., bib., illus.

8-3* BAMMES, GOTTFRIED. Der Akt in der Kunst. Leipzig: E.A. Seemann, 1975. 17 pp., illus. (some col.).

8-4* BARUCH, HUGO. Famous nudes by famous artists. London: Modern Art Gallery, 1946. Ill.

8-5* BAYERTHAL, FRIEDRICH LEO. Der nackte Mensch in der Kunst. Cologne: M. DuMont Schauberg, 1964.

8-6 BEIGEL, H.G. "Sex and human beauty." Journal of Aesthetics and Art Criticism 12, no. 1 (September 1953): 83-92, ref.
 Nature of the aesthetic and erotic feelings aroused at the sight of the naked human body explored.

8-7* BODE, CARL. "Marble men and brazen ladies." In The anatomy of American popular culture, edited by Carl Bode, 92-105. Berkeley: University of California Press, 1959.

8-8* BROOKLYN MUSEUM. The nude in American painting. Brooklyn: Brooklyn Museum, 1961.

8-9* BROPHY, JOHN. The face of the nude: a study in beauty. New York: Tudor, 1968. 160 pp., illus. (some col.).

8-10 CHEVALIER, DENYS. Metaphysique du strip-tease. Bibliotheque internationale d'erotologie, no. 3. Paris: J.-J. Pauvert, 1961. 209 pp., illus.
 Study of the striptease considered in its sociological and aesthetic aspects with reference to the image of the female disrobing in art.

8-11* CINOTTI, MYA. The nude in painting. Translated by M.D. Clement. Uffici Press, 195?. 64 pp., illus.

8-12 CLARK, KENNETH. The nude: a study in ideal form. Garden City, N.Y.: Doubleday, 1959. 575 pp., illus.
 Classic study of the nude in Western art.

8-13* CORMACK, MALCOLM. The nude in Western art. Oxford: Phaidon, 1976. 96 pp., illus. (some col.).

8-14* CROPSEY, CHARLES, and BROWNER, JILL. The shameless nude. Los Angeles: Elysium, 1963. 136 pp., illus. (some col.).

8-15 DE LOVILLE, FRANCOIS, ed. The male nude: a modern view. New York: Rizzoli, 1985. 170 pp., intro.
 Book accompanying an exhibition of images of the male nude in twentieth century art.

8-16 DENVIR, BERNARD. "The social history of nudism." Saturday
 Book 26 (1966): 168-84, illus.
 General survey of the nude in European art.

8-17 Eros en de Vruchtbaarheid in de Kunst. Eros et la fecondite dans
 l'art. Antwerp: Koninklijk Museum voor Schone Kunsten, 1977. 92
 pp., illus.
 Catalog of an exhibition, primarily images of female nudes.

8-18 FIELD, D.M. The nude in art. New York: Excalibur, 1981. 128
 pp., illus. (some col.).
 Study of nudes in world art.

8-19 GERDTS, WILLIAM H. The great American nude: a history in art.
 New York: Praeger, 1974. 224 pp., bib., index, illus. (some col.).
 History of nudes in American art.

8-20* GREENBURG, DAN. Porno-graphics: [the shame of our art muse-
 ums]. New York: Random House, 1969. 22 pp., illus. (col.).

8-21* JACOBS, MICHAEL. Nude painting. Mayflower Gallery Series.
 Smith, 1979. 79 pp., bib., illus. (col.).

8-22 LAVER, JAMES. "Models and muses." Saturday Book 15 (1955):
 143-59, illus.
 Nude female as a subject in Western art.

8-23 LEFEBVE, MAURICE. "The nude as symbol." In Facets of Eros,
 edited by F. Joseph Smith and Erling Eng, 101-15. The Hague:
 Nijhoff, 1972.
 Philosophical consideration of the image of the nude.

8-24* LEJARD, ANDRE. Le nude dans la peinture francaise. Paris: Edi-
 tions du Chene, 1947.
 French paintings of the female nude.

8-25* LEVEY, MICHAEL. The nude. London: Trustees of the National
 Gallery, 1972. Ill.
 Booklet on the nudes in the National Gallery.

8-26 LEVY, MERVYN, ed. The artist and the nude: an anthology of
 drawings. New York: Potter, 1965. 155 pp., illus. (some col.).
 Drawings of the nude in Western art from the eighteenth century
 to today.

8-27 LUCIE-SMITH, EDWARD. The body: images of the nude. New
 York: Thames and Hudson, 1981. 176 pp., illus. (some col.).
 History of the nude throughout European history.

8-28 MANZELLA, DAVID B. "Nude in the classroom." American Journal
 of Art Therapy 12, no. 3 (April 1973): 165-82, illus.
 Discussion of the role of the nude in art education.

8-29* MENTONE, FREDERICK H. The human form in art. London: Naturist, 1944.

8-30* RELOUGE, JOSEF EGON, ed. The nude in art. Introduction by Bodo Cichy; English translation by Mervyn Savill. London: Batsford, 1959. 262 pp., illus. (some col.).

8-31* ROMI. La conquete du nu. Paris: Editions de Paris, 1957.

8-32 SALGUES, YVES. "La femme et son corps." Jardin des Arts 193 (December 1970): 22-33, illus. (some col.).
History of the female nude in art.

8-33 SASAKI, S. [Representation of nudes in Japanese style painting.] Mizue 871 (October 1977): 46-47, illus. (In Japanese; summary in English.)
Nudes in Japanese painting of the last 100 years.

8-34* SENGUPTA, JAYSHREE. "The appetite for erotica." Times of India (Sunday Review) 26 (11 September 1982): 1-4.

8-35 STOKES, Adrian. Reflections on the nude. London: Tavistock, 1967. 64 pp.
Lectures on aspects of the nude in Western art.

8-36 STRATZ, CARL HEINRICH. Die Rassenschonheit des Weibes. Stuttgart: Ferdinand Enke, 1911. 443 pp., illus., figs.
Ethnographic study of the 'beautiful' female form throughout the world.

8-37 _____. Die Schonheit des weiblichen Korpers. Stuttgart: Ferdinand Enke, 1898. 489 pp., index, illus., figs., illus. (col.).
Classic study of female physical beauty.

8-38* VAUDOYER, JEAN-LOUIS. The female nude in European painting. New York: Abrams, 1957. 22 pp. (text), illus. (some col.).
Picture book of female nudes.

8-39 WALTERS, MARGARET. The nude male: a new perspective. Harmondsworth: Penguin, 1978. 352 pp., index, illus.
Study of the nude male throughout Western art history.

8-40* ZWANG, GERARD. Le sexe de la femme. Paris: La Jeune Parque, 1974. 412 pp., bib., illus.

Chapter 9
Fetishes

A sexual fetish may be defined as the specific (nonhuman) object on which a person may focus erotic interest. Psychologists tell us that people may develop a fetishistic attachment to almost anything, but common examples are clothing or leather fetishes. That concept of fetishism is here broadened to include particular sexual activities that are generally held in Western culture to be abberant. There are many technical publications on fetishism written by and for psychologists and psychiatrists that are not included in this bibliography, but one item that is directed to the general public and which includes numerous illustrations is Podolsky and Wade's Erotic symbolism: a study of fetishism in relation to sex.

Fetishists are sexual specialists who give rise to distinctly identifiable subcategories of erotic literature and art. It appears that fetishism, while not unique to Western culture, is peculiarly prevalent in the West for reasons best left to experts in human behavior. The entries in this chapter include publications that survey the depiction in art of sexual fetishes. Some of these entries are serious scholarly studies, while others are merely excuses to display those fetishes in word and picture.

While it is true that there is no common agreement on what beliefs and activities should be considered fetishes (for one person's passion can be considered a fetish by another person), certain images do frequently appear in art that depict sexual behavior outside the boundaries of what most people would call "normal" sex. Few authors have sought to survey fetishistic images in art, but one attempt can be found in Villeneuve's thematically arranged visual compilations Fetichisme et amour and Le museee de fetichisme.

Serious scholarly attention has been directed to the study of the female breast in art since the turn of the century when Witkowski's pioneering work on primarily medieval and Renaissance European art and culture was published: Les seins a l'eglise, Les seins dans l'histoire, and Tetoniana, anecdotes historiques et religieuses sur les seins et l'allaitement. Vigman explores the origins of this fascination with breasts in "The cult of the bust and its callypian counterpoint." That attitudes regarding the female bust have varied through history is addressed in articles by Lees and Sachs. A more worldwide perspective on this subject is provided by Levy's The moons of paradise and Romi's Mythologie du sein.

Images of violence are, of course, common in the history of art, such as depictions of wars, hunting, etc. This fascination with what is often called the darker side of the human psyche has its expression in the sexual realm as sadism and masochism, predominantly in the activity known as flagellation. That much of Western art in concerned with violent images has been frequently discussed, but the sexual implications generally only tangentially considered. Georges Bataille has focused on this intersection of sex and violence (see the "Customs" and "Surveys" chapters of this bibliography), and Roland Villeneuve illustrates particularly gruesome examples in Le musee de supplices. For the last three centuries there has been a subcategory of erotic literature for those interested in sadomasochism, works that were often illustrated. The appearance of flagellation in art is surveyed in Haverly's privately printed 3-volume Selected studies of sadism in art, Schertel's Der Komplex der Flagellomanie, and as catalogs of reproductions in Bellow's Art album of flagellation and Flagellanten published by D.M. Klinger.

There are other fetishes that have been the subject of publications. Clothing fetishes are covered in books by Ackroyd, Grumley, Kunzle, Laurent, and Rossi. Beastiality, not infrequently found in Western and Asian art, is visually surveyed by Villaneuve in Le musee de la bestialite and explored by others. The sexual aspect of the enema, which seems to have been particularly popular in rococo France, are explored in Schertel's Gesass Erotik and Barton-Jay's The enema as an erotic art.

9-1* ACKROYD, PETER. Dressing up: transvestism and drag, the history of an obsession. New York: Simon and Shuster, 1979.

9-2* Animals as sex partners.

9-3* BARTON-JAY, DAVID. The enema as an erotic art and its history. Brattleboro, Vt.: Barton-Jay Projects, 1984. 336 pp., illus.

9-4 "Beasts and erotica." Hustler 7, no. 9 (March 1981): 51-53, illus. (col.).
 Collection of objects depicting aspects of beastiality.

9-5 BELLOW, HORACE. Art album of flagellation: photos and drawings from the collection of Horace Bellow. 2 vols. in 1. New York: Privately printed, 1937. Illus.
 Collection of images from flagellation fiction.

9-6* Bizarre classix. vol. 1. New York: Belier Press, 1976.
 Collection of early photos of flagellation.

9-7 DENNY, JON. "Oui's Little Fanny Fact Book." Oui 1977 or (1978): 93-101, illus. (col.).
 Photo article on the female posterior and customs regarding same.

9-8* Embarassing adventures of Dorothy, private cabinet of sadistic art. New York: Juniper Press, ca. 1938-40. Unpaged, illus.
 Sadomasochistic illustrations from erotic fiction.

9-9* Flagellanten: Darstellungen aus 3 Jahrhunderten. Nuremburg: DMK, n.d. 80 pp., illus.
 Images of flagellation from three centuries of European art.

9-10 GRUMLEY, MICHAEL. Hard corps: studies in leather and sado-masochism. New York: Dutton, 1977. Unpaged, illus.
 Photos of people whose sexual preferences include the wearing of leather clothing and sadomasochistic practices.

9-11 HAVERLY, ERNEST. Selected studies of sadism in art. New York: Privately printed. Unpaged, illus.
 Illustrations from sadomasochistic literature.

9-12* KUNZLE, DAVID. Fashion and fetishism: a social history of the corset, tight-lacing, and other forms of body sculpture in the West. Totowa, N.J.: Rowman and Littlefield, 1982.

9-13* LAURENT, JACQUES. The great book of lingerie. New York: Vendome Press, 1986. 272 pp., illus. (some col.).

9-14 LEES, HANNAH. "The ever-changing bosom." Sexual Behavior 2, no. 7 (July 1972): 11-15, illus.
 Study of the image of the bosom in Western history.

9-15 LEVY, MERVYN. The moons of paradise: some reflexions on the appearance of the female breast in art. London: A. Barker, 1962. 145 pp., index, illus.
 Comments on the appreciation and appearance of the female breast in literature and art, mostly in Europe but also in Asia.

9-16 PALMER, JESSICA. Doses of strap oil. N.p.: Unicorn Pub., ca. 1940s. Unpaged, illus.
 Sadomasochistic images from erotic literature.

9-17 PODOLSKY, EDWARD, and WADE, CARLSON. Erotic symbolism, a study of fetishism in relation to sex. New York: Epic, 1960. 127 pp., illus.
 Survey of common fetishes, including their cultural expressions.

9-18 ROMI. Mythologie du sein. Bibliotheque internationale d'erotologie, no. 16). Introduction by Giuseppe Lo Duca. Paris: J.-J. Pauvert, 1965. 244 pp., illus.
 Study of the female breast in social customs and art.

9-19 ROSSI, WILLIAM A. The sex life of the foot and shoe. New York: Saturday Review Press, 1976. 265 pp., bib., index, illus.
 Feet as erotic objects in Western culture is explored.

9-20 SACHS, BERNICE C. "This bosom business, Part 1: changing emphasis on the breasts." Medical Aspects of Human Sexuality 3, no. 4 (April 1969): 49-56, illus. (some col.).
Study of attitudes to the female breast in European culture.

9-21* "Sadomasochism: its expression and style." ZG Magazine (London) 1980.

9-22* SCHERTEL, ERNST. Gesass Erotik. Pergamon, ca. 1970. 304 pp. First edition published in the 1930s.
Classic study of the erotic aspects of the enema.

9-23* _____. Der Komplex der Flagellomanie. Pergamon, ca. 1970. 288 pp., index, illus. (some col.). First edition ca. 1932.
Classic study of flagellation.

9-24 TOSCHES, NICK. "Titillation." Penthouse 13, no. 9 (May 1982): 129-33, illus. (some col.).
Tongue-in-cheek article on the significance of female breasts in history.

9-25* TRIMBLE, JOHN. Female bestiality. Monogram Books, 1969. 232 pp., illus. (some col.).

9-26 VIGMAN, FRED K. "The cult of the bust and its callypian counterpoint." International Journal of Sexology 6, no. 4 (May 1953): 210-11.
Discussion of the appreciation of the breast and the buttocks in Greek and later Western cultures.

9-27* VILLENEUVE, ROLAND. Fetichesme et amour. Paris: Editions Azur, 1968.

9-28 _____. Le musee de la bestialite. Paris: Editions Azur, 1969. 280 pp., bib., illus. (some col.).
Thorough survey of the human-animal contact theme in erotic art.

9-29 _____. Le musee du fetichisme. Paris: Henri Veyrier, 1973. 301 pp., illus., bib.
Illustrated, thematic overview of depiction of fetishistic images in art and popular culture.

9-30* _____. Le musee des supplices. Paris: Editions Azur; C. Offenstadt, 1968. 367 pp., illus. (some col.).
Images of torture and sadomasochism in history.

9-31 WITKOWSKI, GUSTAV JOSEPH. Les seins a l'eglise. Paris: A. Malone, 1907. 383 pp., illus.
Breasts in religious literature and art explored.

9-32 _____. Les seins dans l'histoire: singularites recueillies. Paris: A. Maloine, 1903. 351 pp., illus.

Historical look at the attitudes toward and depiction of the female breast in Western culture, illustrated with famous art objects. Follows iconographic themes, such as the breast flowing with liquid, Roman Charity, etc.

9-33* _____. Teutoniana, anecdotes historiques et religieuses sur les seins et l'allaitement: comprenant l'histoire du d'ecolletage et du corset. Paris: A. Maloine, 1898. 390 pp., illus.

Chapter 10
Homosexual Erotic Art

Homosexuality has existed in many cultures in one form or another throughout history. The Christian West has been especially harsh in its condemnation of homosexuality, including several historical periods when the punishment for being a homosexual was death. Even in the mid 1980s the role of homosexuals in art is still a controversial subject. A number of authors have suggested that certain artists were homosexuals and proposed that their art demonstrates it, albeit if only in a very subtle way. One survey of possibly homosexual artists is Emmanuel Cooper's The sexual perspective: homosexuality and art in the last 100 years in the West. A more philosophical analysis of homosexual expression in art is postulated by Hal Fischer in "Toward a Gay Semiotic." But explicit sexual art depicting homosexual activity is not so well known, even though it can be found not infrequently in ancient Greek, Chinese, Japanese, and modern art. Most of the erotic art surveys listed earlier in this bibliography do not include a single image of male homosexuality. Female lovers are commonly shown, but these works are almost never by lesbians. The closest thing to a survey of homosexual erotic art is Felix Falkon's A historic collection of gay art. However, useful collections of images can be found in a number of books by Becker and Beurdeley that are well-illustrated histories of homosexuality. Many publications for homosexuals include the work of illustrators (there has been no attempt to list those periodicals in this bibliography) who specialize in gay erotic imagery. John Barrington has assembled a selection of the work of the best known of these artists in Contemporary homo-erotic art (see also entries in the "Art (General)" and "Comics" chapters of the Modern Section of this bibliography). Unfortunately, very little has been written about lesbian erotic art and artists. There are, however, a number of feminist and lesbian periodicals that discuss and illustrate lesbian art, examples being the article by Henry in Off our backs entitled "Images of lesbian sexuality" and Jacqueline Lapidus's book Yantras of womanlove.

10-1 ALEXANDER, MICHAIL. "Homosexuality and arts." International Journal of Sexology 8, no. 1 (August 1954): 26-7.
 Essay on the participation of homosexuals in all the creative arts.

10-2* BARRINGTON, JOHN S. Contemporary homo-erotic art. London:
 S&H, 1974.
 Reproductions of illustrations from gay magazines.

10-3 BECKER, RAYMOND DE. The other face of love. Translated by
 Margaret Crosland and Alan Daventry. New York: Bell, 1964. 209
 pp., illus. (French edition is Bibliotheque internationale d'eroto-
 logie, no. 12 [Paris: J.-J. Pauvert, 1964].)
 Study of homosexuality around the world as depicted
 in art.

10-4* _____. Sex in the mirror: a study of homosexuality. Biblio-
 theque internationale d'erotologie. Paris: J.-J. Pauvert, ca. 1962.
 Illustrated study of homosexuality throughout history.

10-5 BEURDELEY, CECILE. L'amour bleu. Translated by Michael Tay-
 lor. New York: Rizzoli, 1978. 304 pp., bib., illus. (some col.).
 Study of the attitudes toward male homosexuality in the West
 from antiquity to the present as evidenced in art and literature.

10-6* COOPER, EMMANUEL. "Erotic art." Him Magazine 52 (November
 1982).

10-7* _____. The sexual perspective: homosexuality and art in the last
 100 years in the West. London: Routledge and Kegan Paul, 1986.
 324 p., illus.

10-8* DUAY, G. "The old erotica." Gay 2, no. 65 (6 December 1971):
 65.

10-9 FALKON, FELIX LANCE. A historic collection of gay art. Preface
 by G.G. Stockay; foreword by Don Gilmore. San Diego: Green-
 leaf, 1972. 224 pp., illus.
 Images of homosexuals in art, especially in the modern period.

10-10 FISCHER, HAL. "Toward a gay semiotic." In Eros and photo-
 graphy, edited by Donna-Lee Phillips, 39-41. San Francisco: Cam-
 erawork/NFS Press, 1977.
 Thoughts on gay expression in art.

10-11* HENRY, A. "Images of lesbian sexuality." Off Our Backs 13, no.
 4 (April 1983): 10.

10-12* HUNTER, J. "The new erotica." Gay 2, no. 65 (6 December 1971):
 8.

10-13 LAPIDUS, JACQUELINE. Yantras of womanlove. Images by Cor-
 inne Tee; introduction by Margaret Sloan-Hunter. Tallahassee,
 Fla.: Naiad Press, 1982. 61 pp., illus.
 Collection of poems and artistic photographs of lesbian love-
 making.

10-14* STRETCH, CHRIS. "Men's images of men." The Leveller (London) (30 October-12 November 1981).
On male pin-ups.

Chapter 11
Literature

The history of erotic literature is older than writing itself. Stories, poems, epigrams, plays, novels, etc., concerned with aspects of human sexuality are found in virtually every culture whether in oral or written form. Certain periods of history have been especially rich in erotic literature, for instance ancient Greece and Rome, early China, Renaissance Italy, and eighteenth- and nineteenth-century France. Erotic literature is not only a major element of the milieu in which erotic art exists, but is the iconographic source for many visual images and may stimulate the creation of erotic art by commissioning illustrations to accompany text. Research into the history of erotic literature is extensive and would make for a massive bibliography. In this chapter entries have been included because they provide an overview of the history of erotic literature and discuss tangentially or directly the role of erotic illustrations for that literature.

There have been collectors of erotic literature since Roman times, if not earlier, and certain individuals since the Renaissance assembled significant holdings of this category of material. Most of these private collections of literary erotica became incorporated into institutional libraries beginning in the latter part of the eighteenth century. In an effort to record the existence of this genre of literature, beginning in the mid-1800s a number of compilers have endeavored to assemble major bibliographies. Among those bibliographies published in the nineteenth century are works by Fraxi (pseudonym for Ashbee), Hayn (psuedonym for Hugo Nay), and d'I (Gay Jules). Reprints of their bibliographies have been published in the twentieth century, and additional bibliographic research has been produced by Apollinaire, Fleuret and Perceau, Perceau, Reade (pseudonym for Alfred Rose), and Walton. The most recent such study is Kearney's The private case: an annotated bibliography of erotic materials in the British Museum Library. A critical study of seventy-eight of these erotic bibliographies and catalgues can be found in Deakin's Catalogi librorum eroticorum.

With only a few exceptions, much of the world's early erotic literature is lost to us, not infrequently destroyed during periods of extreme censorship. In many cases only fragments exist from what must have been a very large body of work. However, the literary erotica written since the European Renaissance is much better known and has been the focus of many studies, such as Jennifer Birkett's recent The body and the dream; French erotic fiction 1464-1900. Surveys of particular interest because

they discuss or reproduce erotic illustrations include books by Englisch, Fusco, Ginzburg, Hyde, Lewis, Loth, Marchand, Marteau, and Rund. As reference sources Wedeck's Dictionary of erotic literature and Pia's Dictionnaire des oeuvres erotiques provide concise information on authors, illustrators, themes, etc.

Much of the debate on pornography concerns sexual explicitness in literature, and many of the entries listed in the "Art, Pornography, and Censorship" chapter of this bibliography may also be useful for information on modern erotic literature. Gordon and Bell's analysis of modern erotic literature listed below is particularly interesting.

Beginning in the eighteenth century there have been artists who have made illustrating for erotic literature a specialty, for example, Binet in the eighteenth century, Gaverni in the nineteenth, and Fini in the twentieth. Works on individual artists are listed in appropriate later chapters of this bibliography, but below are included three works that provide surveys of erotic illustrations with numerous reproductions: the catalog Erotica rarisma, Bourgeois's Erotisme et pornographie dans la bande dessinee, and Grimley's Erotic illustrations.

11-1* APOLLONAIRE, GUILLAUME; FLEURET, FERNAND; and PERCEAU, LOUIS. L'enfer de la bibliotheque nationale: icono-bio-bibliographie descriptive, critique et raisonnee, complete a ce jour detous les ouvrages composant cette celebre collection. Paris: Mercure de France, 1913. 415 pp. Reprint (of 1918 edition with slight title change). Geneva: Slatkine Reprints, 1970.
Descriptive bibliography of the erotica in the French national collection.

11-2* ASHBEE, HENRY SPENCER (pseudonym Pisanus Fraxi). Catena Librorum Tacendorum: being notes bio-biblio-icono-graphical and critical on curious and uncommon books. London: Privately printed, 1885. Limited to 250 copies. 593 pp., index, illus. Reprint. Limited to 395 copies. London: Skilton, 1960. 2d reprint. New York: J. Bussel, 1962.
Third book in a series of erotica bibliographies of nineteenth-century materials.

11-3* _____. Centuria Librorum Absconditorum: being notes bio-biblio-iconographical and critical on curious and uncommon books. London: Privately printed, 1879. 593 pp. (Reprints as item above.)
Second in series of bibliographies including nineteenth-century erotica.

11-4* _____. The encyclopedia of erotic literature, being bio-biblio-icono-graphical and critical, on curious and uncommon books. New York: Documentary Books, 1962.
Reprint of three volumes of bibliography of erotica published in the nineteenth century.

11-5 _____. Index Librorum Prohibitorum: being notes bio-biblio-i-cono-graphical and critical on curious and uncommon books. London: Privately printed, 1877. 542 pp., intro, index, illus.
First in a series of bibliographies of banned books: entries sometimes include descriptions of erotic illustrations.

11-6 BIRKETT, JENNIFER. The body and the dream: French erotic fiction 1464-1900. London: Quartet Books, 1983. 211 pp., bib., illus.
History of and excerpts from French erotic literature.

11-7* DEAKIN, TERENCE C. Catalogi Librorum Eroticorum: a critical bibliography of erotic bibliographies and book catalogues. London: Cecil and Amelia Woolf, 1964.
Description of 78 bibliographies of erotic literature.

11-8 Dictionnaires des oeuvres erotiques: domaine francais. Preface by Pia Pascal. Paris: Mercure de France, 1971. 532 pp., illus., index.
Dictionary of erotic literature and its illustration.

11-9 DIXON, REBECCA. "Bibliographical control of erotica." In An intellectual freedom primer, edited by Charles H. Busha. Littleton, Colo.: Libraries Unlimited, 1977.
Review article on classic erotica publications.

11-10 ENGLISCH, PAUL. Geschichte der erotischen Literatur. Stuttgart: Julius Puttmann, 1927. 695 pp., por, illus.
Study of erotic literature includes some facsimile reproductions of illustrations.

11-11* _____. Irrgarten der Erotik: eine Sittengeschichte uber das gesamte Gebiet der Welt-Pornographie. Leipzig: Lykeion, Kulturwissenschaftliche, 1931. 333 pp., bib., index, illus. (some col.). Reprint. Magstadt: Bissinger, 1965.

11-12* Erotica Rarissima. Utrecht, 1981. 65 pp., illus. (some col.).
Catalog of illustrations from erotic literature.

11-13 FOXON, DAVID. Libertine literature in England 1660-1745. New York: University Books, 1965. 70 pp., intro., index, app., ill.
Survey of English erotic literature includes a chapter on the history of the "Aretine postures."

11-14* FRYER, PETER. Secrets of the British Museum. New York: Citadel, 1968. 160 pp. (First published under the title, Private case-public scandel.)

11-15 FUSCO, DOMENICO. Erotismo e pornografia nel romanzo Francese moderno. Turin: Berruto, 1948.
Bibliography of erotic literature includes mention of illustrations.

Literature

11-16* GAY, JULES (pseudonym M. le C. d'I***). Bibliographie des ouv-
 rages relatifs a l'amour aux femmes, au marriage, et des livres
 facetieux pantagrueliques, scatalogiques, satyriques, etc. 4
 vols. 4th ed. (?). Paris: J. Lemonnyer and Lille: Stephane Be-
 cour, 1894-1900. (First edition with slightly variant title [1861];
 2d ed. with slightly variant title [Paris: Jules Gay; Brussels: A.
 Merton & Fils, 1864]; 3d ed. 6 vols. [Turin: Jules Gay & Fils; Lon-
 don: B. Quaritch, 1871-73.].)
 Bibliography of French language erotica of pre-twentieth cen-
 tury.

11-17 GELLATLY, PETER, ed. Sex magazines in the library collection: a
 scholarly study of sex in serials and periodicals. Monographic
 supplement to the Serials Librarian. New York: Haworth, 1980.
 144 pp., index.
 Collection of essays discussing problems raised by sex maga-
 zines in the library environment.

11-18 GINZBURG, RALPH. An unhurried view of erotica. Introduction
 by Dr. Theodor Reik; preface by George Nathan. New York:
 Helmsman Press, 1958. 128 pp., bib., index.
 History of erotic literature in English with mention of illustra-
 tions.

11-19 GORDON, MICHAEL, and BELL, ROBERT R. "Medium and hard-
 core pornography: a comparative analysis." Journal of Sex Re-
 search 5, no. 4 (November 1969): 260-68.
 Study of modern erotic literature, its nature and format.

11-20 GRIMLEY, GORDON, ed. Erotic illustrations. New York: Grove,
 1973. 184 pp., illus.
 Survey of erotic book illustration, emphasizing eighteenth and
 nineteenth century French examples.

11-21* HAYN, HUGO, and ROSE, ALFRED. Bibliotheca Germanorum Ero-
 tica & Curiosa. 9 vols. 3d ed. Munich: G. Muller, 1912-14.
 Reprint. Hanau: Mueller and Kiepenheuer, 1968. (Vol. 9,
 Erganzungsband, by Paul Englisch [1929].) (First edition with
 slightly different title by Hayn in 1875 or 1885.)
 Bibliography of German erotica of pre-20th century.

11-22 HYDE, H. MONTGOMERY. A history of pornography. 1964. Re-
 print. New York: Dell, 1966. 246 pp., app., bib., index.
 History of erotic literature includes mention of erotic art.

11-23* KEARNEY, PATRICK. A history of erotic literature. London:
 Macmillan, 1982. 192 pp., illus. (some col.), bib., index.

11-24 _____, compiler. The private case: an annotated bibliography of
 the private case erotica collection in the British (Museum) Lib-
 rary. Introduction by Gershon Legman. London: J. Landesman,
 1981. 354 pp., index.

Detailed bibliography of the erotic literature in the collection of the British Museum Library with some discussion of the history and nature of the collection.

11-25 LEGMAN, GERSHON. The horn book: studies in erotic folklore and bibliography. New York: University Books, 1964. 565 pp., index.
Study of erotic folk literature.

11-26* LEWIS, ROY. Browser's guide to erotica. New York: St. Martin's Press, 1982. 192 pp.

11-27 LOTH, DAVID. The erotic in literature: a historical survey of pornography as delightful as it is indiscreet. New York: Julian Messner, 1961. 256 pp., index, bib.
History of erotic literature in relation to historico-social developments.

11-28 Man and woman: a sociological study: excerpts from the erotic classics published around the world. City of Industry, Calif.: Collector's Publications, 1968. 106 pp., illus.
Commentary and excerpts from erotic literature with examples of illustrations.

11-29 MARCHAND, HENRY L. The French pornographers: including a history of French erotic literature. New York: Book Awards, 1965. 288 pp., intro.
Survey of French erotic literature.

11-30 MARTEAU, PIERRE. Om Erotisk og Galant Litteratur. Copenhagen: Preben Witt, 1948. 111 pp., illus., bib., index.
Study of erotic literature since the eighteenth century. Illustrated with examples of title pages, illustrations, and bookplates.

11-31 PERCEAU, LOUIS. Bibliographie du Roman erotique au XIXe. 2 vols. Paris: Georges Fourdrinier, 1930. Index.
Bibliography of erotic literature from the nineteenth century to 1929.

11-32* ROSE, ALFRED (pseudonym Rolf S. Reade). Registrum Librorum Eroticum: Vel (sub nac specie) Duborium: Opus Bibliographicum et Praecipue Bibliothecariis Distinatum. 2 vol. Edited by W.J. Stanislaus. London: Privately printed (in limited edition of 200 copies), 1936. Reprint (under Rose's real name with English translation of initial title). New York: J. Brussel, 1965.
Bibliography based on earlier lists plus entries of items held by the erotica collection of the British Library.

11-33* RUND, JEFF. Libertine literature. New York: Parke-Bernet Gallery, 27 April, 1971.
Scholarly catalog of French eighteenth and nineteenth century erotic illustrations.

Literature

11-34* THOMPSON, ROGER. Unfit for modest ears: a study of pornogra-
 phic, obscene and bawdy works written or published in England in
 the second half of the seventeenth century. Totowa, N.J.: Row-
 man and Littlefield, 1979. 233 pp.

11-35* WALTON, ALAN HULL. Bibliographia Sexualis. 3 vols. ca. 1963.
 Bibliography of sexually related materials from ancient times to
 the mid twentieth century.

11-36 WEDECK, HARRY E. Dictionary of erotic literature. New York:
 Philosophical Library, 1962. 556 pp., bib., illus.
 Classical erotic themes in European literature.

Chapter 12
Sex Devices

A special category of material culture consists of devices and contrivances (often called toys in modern parlance) designed to affect sexual activity. These may be devices to control sexual behavior (like medieval chastity belts or the antierection gadgets of the nineteenth century), or to enhance sexual pleasure (like dildoes and penis rings). Sex devices widely used in one culture and/or period may be seen as ineffectual, ridiculous, or even dangerous in another. The largest number of sex devices have been developed in Asia, where they are frequently depicted in Indian and Chinese erotic art. Sometimes the objects are made from expensive materials and richly decorated by skillful artists. Included in this chapter are items that discuss one or more type of sex device. Few of the entries can even remotely be described as scholarly studies; most merely describe (often humorously) and illustrate the objects: some explain how they are used. The notable exceptions to this generalization are the several books on chastity belts by Bonneau, Dingwall, and Grapow, and Levine and Kunzle's study of the eroticism of lingerie. Tabori's The humor and technology of sex provides a useful historical and regional survey of such devices, particularly in section 3, entitled "The Toys of Sex," as probably does the privately printed catalog Erotica contrivances.

12-1 ASTRACHAN, ANTHONY. "Patented sex (unusual patented gadgets)." Playboy 23 (September 1976): 113-15, illus.
 Actual patented American sex devices shown.

12-2 BONNEAU, ALCIDE. Padlocks and girdles of chastity. 1892. Reprint. New York: Privately printed, 1928. 78 pp., illus.
 History of the chastity belt.

12-3 DINGWALL, ERIC JOHN. The girdle of chastity: a medico-historical study. London: George Routledge, 1931. 171 pp., index, illus.
 Study of the history of the use of the chastity belt.

12-4* DODSON, VICTOR. Auto-erotic acts and devices. Los Angeles: Medco Books, 1967. 160 pp., gloss., bib.

Masturbation and exhibitionism featured, with discussion of devices used.

12-5* Erotica contrivances. Privately printed, 1922. 54 pp.

12-6 GRAPOW, FRANZ. "Der Keuschheitsgurtel." Geschlecht und Gesellschaft 6 (1911): 289-97, figs.
Overview of chastity belts in history.

12-7 KELLY, EDWARD. "A new image for the naughty dildo?" Journal of Popular Culture 7, no. 4 (Spring 1974): 804-9.
Essay on the history of the dildo and its present popularity.

12-8 KUNZLE, DAVID. "The corset as erotic alchemy: from Rococo Galanterie to Montaut's Physiologies." In Woman as sex object: studies in erotic art, 1730-1970, edited by Thomas B. Hess and Linda Nochlin, 90-165, illus. New York: Newsweek, 1972.
Images of the corset in European art explored.

12-9 LEVINE, ESAR. Chastity belts: an illustrated history of the bridling of women. New York: Panurge Press, 1931. 288 pp.
Survey of the use of the chastity belt.

12-10* MASSEY, FREDERICK. "A new look at sex toys." Sexology 40, no. 4 (November 1973): 6-10.

12-11* PROBERT, CHRISTINA. Lingerie in Vogue since 1910. New York: Abbeville.

12-12 RAINBIRD, EVELYN. The illustrated manual of sexual aids. N.p.: Minotaur Press, 1973. 104 pp., illus.
Sex aids in history and their modern versions.

12-13 ROLES, STEVEN. "The mechanics of loving: sexual aids are not a cure-all but they can put couples on the road to sexual satisfaction." Nova, March 1974, 60-61.
Article describes the use of sex aids.

12-14 ROSENBLUM, MAJ.-BRITT. "Vibrators: turning on to pleasure." Mademoiselle 87 (January 1981): 92+.
Article describing the history and use of the vibrator.

12-15 RUBEN, W.S. "Intimate sex toys for thrilling love play." Sexology 41, no. 10 (May 1975): 39-42, illus.
Description of many modern sex devices.

12-16* Sex devices.

12-17 TABORI, PAUL. The humor and technology of sex. New York: Julian Press, 1969. 538 pp., bib., illus.
Section 3 on "The Toys of Sex" details the gadgets and mechanical devices men and women have used through the ages.

12-18* TOSCHES, NICK. "Erotic notions." <u>Penthouse</u> 16 (October 1984):
 140.
 On sex implements of the Victorian and Edwardian eras.

12-19 WILSON, JIM. "Sexual mechanix." <u>Penthouse</u>, January 1980, 117–
 21, illus. (col.).
 Tongue-in-cheek article on supposed sex devices.

Section 3
The Ancient World

Chapter 13
Ancient (General)

The phrase "ancient world" (or antiquity) is generally used to describe the earliest cultures and civilizations of Europe, the Mediterranean basin, and the Near East prior to the rise of Christianity. For the purposes of this bibliography it encompasses prehistoric Europe, the ancient Near East, Egypt, Greece, and Rome (each of these cultures is covered in the following chapters of this section of the bibliography). Several centuries of scholarly research into the history, arts, daily lives, etc., has lead to considerable understanding of the sexual beliefs and behaviors of this period.

Background

What is known about sexuality in the ancient world is derived largely from studies of male-female relationships, the prevalence of homosexuality, the emergence of the institution of marriage, the development of various forms of prostitution, and the sexual aspects of religion. The inspiration for undertaking studies of these topics has come from two sources. One is Old Testament studies, which seek to understand and compare the lives of the Hebrews with those of the other peoples of the Near East. These studies are written mainly by people with a decidedly "Christian" orientation, which means that many authors make disparaging moralistic editorial comments about the non-Hebraic cultures and religions. The other source of information is derived from the academic field of classical studies, which focus on Greece and Rome. More has been written about the sex lives of the Greeks and Romans than any other ancient cultures, in publications that tend to be the most rigorously scholarly.

Cenac-Moncaut's Histoire de l'amour dans l'antiquite chez les Hebreux, les Orientaux, les Grecs et les Romains (1862) is one of the earliest studies of ancient sexuality. More narrowly focused surveys include Furstauer's Eros in alten Orient, which provides valuable information on the sexual aspects of Near Eastern, Egyptian, and Minoan cultures, and a number of works on Greece and Rome. Schlichtegroll's Liebesleben im klassischen Altertum is an early (1909) study that is frequently referred to by later publications on the same topic. Other surveys of Greece and Rome include two books published in the 1930s, Brusendorff's Erotikens historie; fra Graekenlands oldtid til vore dage and Hopfner's more scholarly Das sexualleben der Griechen und Romer, and more recent studies by Boer,

Ancient (General)

Hartle, and Thompson. Valuable reference sources are Vorberg's Glass-arium eroticum, which provides a dictionary of erotic terms from antiquity (and includes numerous illustrations) and Verstraete's "Homosexuality in ancient Greek and Roman civilization: a critical bibliography."

Subject-oriented surveys of ancient sexology focus primarily on two related topics – prostitution and sex in religion. The ancient world had numerous categories of prostitutes, including what has come to be called sacred prostitution (wherein sex acts are performed as part of religious devotions). Among the most useful of the studies of prostitution are Edmund Dupouy's now classic study originally published as La prostitution dans l'antiquite in 1887, Frichet's more biographical Fleshpots of antiquity (1934), and Pomeroy's Goddesses, whores, wives, and slaves: women in classical antiquity (1975).

Many of the polytheistic religions of the ancient world included a strong sexual component that could take several forms, such as mother goddess worship, fertility worship, phallic worship, sexually active deities, sacred prostitution, etc. The prevalence of the mother goddess in early religions is fully explored in Neumann's The Great Mother: an analysis of the archetype. Among the most popular deities were those who controlled aspects of human sexuality, gods such as Ashtar, Aphrodite, Priapus, and others. Most of the entries in the "Sex and Religion" chapter of this bibliography give considerable attention to those deities, as well as several studies listed below, including Grigson's The goddess of love: the birth, triumph, death and return of Aphrodite. Other useful surveys include Rosenblum's unique study of the role of venereal disease in antiquity The plague of lust and Dingwall's overview of phallic mutilation in Greece and Rome entitled Male infibulation.

Art

Antiquity produced a significant portion of the world's erotic art. Not all cultures produced erotic art; from Egypt we have few extant examples, but especially rich is the output of Greece and Rome. This ancient erotic art is in a wide range of media, including sculpture, reliefs, wall and vase paintings, jewelry, etc. A more detailed description of the art will be provided in the chapters that follow in this section of the bibliography.

Surveys of ancient erotic art show up in two different periods. When Pompeii and Herculaneum were rediscovered in the eighteenth century, the excavators found a considerable amount of erotic art. Those objects, which ended up in several "secret museums," together with theretofore unknown pieces in private collections, stimulated an interest in ancient erotic art in the latter half of the nineteenth century. A number of entries in the "Greek" and "Roman" chapters of this bibliography are essentially catalogs of those "secret collections". The book by Birt and Vorberg's works from the late nineteenth and early twentieth century illustrate many of the finest objects and provide a summary of what was known about the art at that time. After several decades in which little was added to the literature on ancient erotic art, recent decades seen considerable publishing activity on this subject. The mid 1960s saw the publication of two works that sought to provide thematic surveys of ancient erotic art, Brusendorff and Henningsen's A history of eroticism, vol. 1, Antiquity, and Rabenalt's considerably more iconographically thorough Mimus eroticus.

Lavish pictorial books on Greek and Roman art appeared in the 1970s and 1980s, including Mulas's Eros in antiquity and Mountfield's Greek and Roman erotica. Recent scholarly attention to the subject is exemplified by Brendel's analytical "The scope and temperament of erotic art in the Greco Roman world" and Catherine Johns's impressively thorough Sex or symbol: erotic images of Greece and Rome.

Background

13-1 BOER, WILLEM DEN. Eros en Amor: Man en Vrouw in Griekenland en Rome. The Hague: Bert Bakker, 1962. 170 pp.
Survey of sex beliefs and customs in Greece and Rome.

13-2 BRUSENDORFF, OVE. Erotikens historie: fra Graekenlands Old-tid til Vore Dage. Vol. 1. Edited by Christian Rimestad. Copenhagen: Universal, 1936. 423 pp., illus.
Greek and Roman sex customs surveyed through ancient literature and erotic art.

13-3* CENAC-MONCAUT, JUSTIN EDUARD MATTHIEU. Histoire de l'amour dans l'antiquite chez les Hebreux, les Orientaux, les Grecs et les Romains. Paris: Amyot, 1862. 392 pp., bib.

13-4 DINGWALL, ERIC JOHN. Male infibulation. London: John Bale, 1925. 147 pp., illus., figs.
Primarily a study of Greek and Roman infibulation practices, but also mentions such traditions in other parts of the world.

13-5 DUPOUY, EDMOND. La prostitution dans l'antiquite, dans ses rapports avec les maladies veneriennes: etude d'hygiene sociale. Paris: Meurillon, 1887. 219 pp., illus.

13-6 _____. "Prostitution in Antiquity." In The power of a symbol, by Lee Alexander Stone, 149-301. Chicago: Covici, 1925.
Translation of his classic study of prostitution in ancient times (see previous entry).

13-7 FORBERG, FRED CHARLES. Manual of classical erotology (de figuris veneris). 2 vols. Manchester: Privately printed for Viscount Julian Smithson and Friends, 1884. Index, illus. (Earlier French edition [Paris: Isidore Liseux, 1882]; reprinted with slightly variant titles [New York: Medical Press, 1963, 1964; North Hollywood, Calif.: Brandon House, 1965; and New York: Grove Press, 1966].)
Ancient love practices and beliefs surveyed based largely on literary references.

13-8 FRICHET, HENRY. Fleshpots of antiquity: the lives and loves of ancient courtesans. New York: Panurge Press, 1934. 240 pp., bib. (Limited to 2000 copies and original plates destroyed; later edition translated from the French with an introductory essay and

95

notes by A.F. Niemoeller [Girard, Kansas: Holdeman-Julius, 1947].)
Study of ancient prostitution and aphrodisiacs, focusing on the biographies of certain well-known individuals.

13-9 FURSTAUER, JOHANNA. Eros im alten Orient: eine vergleichende Darstellung der Erotik der Volker im alten Orient. Stuttgart: Hans E. Gunther; Wiesbaden: R. Lowit, 1965. 340 pp., bib., index, illus., figs.
Sex life of ancient Egypt, Near East, and Crete described.

13-10 GRIGSON, GEOFFREY. The Goddess of love: the birth, triumph, death and return of Aphrodite. New York: Stein and Day, 1977. 256 pp., illus., index, bib.
Detailed study of myths, meaning, and the image of Aphrodite in Western culture.

13-11 HARLTE, HEINRICH. Rom und Hellas Warnen: Erotik und Entartung in den Antiken Kulturen. Munich: Turmer, 1972. 195 pp., bib., illus.
Overview of sexual customs, practices, and beliefs in the ancient world.

13-12 HOPFNER, THEODOR. Das Sexualleben der Griechen und Romer: von den Anfangen bis ins 6. Jahrhundert nach Christus. Prague: J.G. Calve, 1938. Reprint. New York: AMS Press, ca. 1970s. 455 pp.
Study of ancient sex customs and beliefs.

13-13* KNIGHT, RICHARD PAYNE. Le culte de Priape et ses rapports avec la theologie mystique des Anciens. Brussels: E. Losfeld, 1883. 222 pp., illus.

13-14 NEUMANN, ERICH. The Great Mother: an analysis of the archetype. Bollingen Series, no. 47. Translated from German by Ralph Manheim. Princeton: Princeton University Press, 1955. 381 pp., bib., index, illus.
Scholarly study of the earth mother goddess figure in the ancient world.

13-15 POMEROY, SARAH B. Goddesses, whores, wives and slaves: women in classical Antiquity. New York: Schocken, 1975. 265 pp., index, illus.
Social history of women in the Greek and Roman worlds.

13-16 ROSENBLUM, JULIUS. The plague of lust, being a history of venereal disease in classical antiquity, and including: detailed investigations into the cult of Venus and phallic worship. . . . 2 vols. Paris: Carrington, 1901. Index. (First edition [Halle, 1845]; 1901 edition by Carrington, limited to 500 copies, and British Bibliophiles Society [Brussels] are translated from the sixth German edition; reprinted by Frederick Publications, 1955.)

Early scholarly study of sex practices and venereal disease in Greece and Rome.

13-17* ROUSSELLE, ALINE. Porneia: on desire and the body in antiquity. Family, Sexuality and Social Relations in the Past Times Series). Oxford: Basil, Blackwell, n.d. 256 pp.

13-18 SCHLICHTEGROLL, CARL FELIX VON. Liebesleben im Klassischen Altertum. Das Liebesleben aller Zeiten und Volker, no. 2. Leipzig: Leipziger, 1909. 423 pp., bib.
Greek and Roman sex beliefs and practices described.

13-19 THOMPSON, LAWRENCE S. "Prolegomena to pornography in Greek and Roman antiquity." In Sex Magazines in the Library Collection, edited by Peter Gellatly, 9-16. New York: Haworth Press, 1981.
Role of sex in the ancient world and its expression in the arts discussed.

13-20 VERSTRAETE, BEERT C. "Homosexuality in ancient Greek and Roman civilization: a critical bibliography." Journal of Homosexuality 3, no. 1 (Fall 1977): 79-89.
Bibliography of books and articles on homosexuality.

13-21* VORBERG, GASTON. Ars Erotica Veterum: das Geschlechtsleben in Altertum. Stuttgart: J. Puttman, 1926. 222 pp., illus. (some col.). Reprint. Hanau and Munich: Muller and Kiepenheuer, 1968.
Selection of illustrations of erotic art from Greece and Rome followed by several essays on sex in the Ancient Near East, Greece, and Rome. Combines the author's Ars Erotica Veterum and Uber das Geschlechtsleben im Altertum.

13-22 _____. Glossarium Eroticum. Stuttgart: [J. Puttman?], 1932. 730 pp., illus.
Profusely illustrated dictionary of ancient erotic terms.

13-23 WOOD, ROBERT. "Ancient civilizations, sex life in." In Encyclopedia of sexual behavior, vol. 1, edited by Albert Ellis and Albert Abarbanel, 119-131, bib. New York: Hawthorn, 1961.
Concise survey of major features of sexuality in the ancient world.

Art

13-24* BIRT, THEODOR. De amorum in arte antiqua simulacris et de pueris minutis apud antiquos in deliciis habitis. Marpurgi: Elwert, 1892.

13-25* BLOCH, IWAN. Der Ursprung des Syphilis. 2 pts. in 1 vol. Jena: Fischer, 1901-11.

Part 2 has a detailed discussion of ancient "obscene" wall and vase paintings.

13-26 BRENDEL, OTTO J. "The scope and temperament of erotic art in the Greco Roman world." In Studies in Erotic Art, by Theodore Bowie et al., 3-108, illus. New York: Basic Books, 1970.
Interpretative survey of the object types and iconography of ancient erotic art.

13-27 BRUSENDORFF, OVE, and HENNINGSEN, POUL. A history of eroticism. Vol. 1, Antiquity. New York: Lyle Stuart, 1963. 96 pp., illus.
Sexual themes in Greek and Roman art explored.

13-28* DE LA CHAUSSE, M.A. "Sur les statues de Priape, qui decouvrent la turpitude du paganisme." Ph.D. dissertation.

13-29 DEONNA, JULES C.P.W. "Quelque monuments antiques Trouves en Suisse." Anzeiger fur Schweizerische Altertumskunde (Indicateur d'Antiquites Suisses), n.s. 1, 12 (1910): 7-21.
Discusses the erotic significance of the rooster in ancient art and culture.

13-30* FRIESE, FRANZ. "Liebe, Kunst und Liebekunst: Griechen, Etrusker und Roemer." Sexualmedizin 9, no. 8 (April 1980): 353-55, illus.

13-31 JOHNS, CATHERINE. Sex or symbol: erotic images of Greece and Rome. Austin: University of Texas Press (in co-operation with British Museum Publications), 1982. 160 pp., illus. (some col.), index, bib.
Thorough, scholarly study of ancient erotic art of Greece and Rome.

13-32 KLINGER, D[OMINIK] M. Erotic art of the Antique. Vol. 7. Nuremburg: DMK, 1983. 88 pp., illus. (some col.), bib.
Brief introductory text on erotic Egyptian terra-cottas followed by a catalog of 97 illustrations of ancient erotic art.

13-33* KRENKEL, W.A. "Erotica 1: Der abortus in der Antike." Wissenschaftliche Zeitschrift der Universitaet Rostock 20 (1971): 443-52.

13-34* LOPEZ BARBADILLO, JOAQUIN. Museo de Napoles, gabinete secreto. Madrid: Akal, 1977. 122 p., ill. (Reprint of 1921 revised translation of C. Famin's Peintures, bronzes, et statues--erotiques formant la collection du cabinet secret du Musee Royal de Naples.)

13-35 MOUNTFIELD, DAVID. Greek and Roman erotica. New York: Crescent Books, 1982. 96 pp., illus. (col.).
Illustrations of erotic art with explanatory commentary.

13-36 MULAS, ANTONIA. Eros in antiquity. New York: Erotic Art Book
 Society, 1978. 153 pp., bib., illus. (col.).
 Book of color photographs of Greek and Roman erotic art.

13-37 RABENALT, ARTHUR M. Mimus Eroticus: die erotische Schaus-
 zenik in der Antiken Welt. Hamburg: Kulturforschung, 1965. 383
 pp., bib., illus.
 Survey of themes and subjects of ancient erotic art.

13-38* VERDE. Guide pour la Musee Royal Bourboun. 2 vols. Trans-
 lated by C.C.J. Naples, 1831-32.

13-39* VORBERG, GASTON. Antiquitates Eroticae: Erganzungsband zu
 dem Werke Museum Eroticum Neopolitanum. 1911.

13-40* _____. Eroticism in antiquity in small sculptures and ceramics.
 Schmiden: Freyja, 1920.

13-41 _____. Luxu and Voluptate. Schmiden bei Stuttgart: Freyja,
 1966. Unpaged, illus.
 Compilation of three of Vorburg's studies of ancient erotic art,
 including "Museum Eroticum Neapolitanum," "Antiquitates Eroticae," and
 "Die Erotik der Antike in Kleinkunst und Keramik."

Chapter 14
Prehistoric

The oldest known art objects depict nude female figures whose sexual characteristics are considerably exaggerated. These so-called "Venus" figures are generally held to be an expression of a belief in fertility worship by Paleolithic communities in central Europe. The existence of the sculptures, produced almost 30,000 years ago, demonstrates that erotic art is as old as the history of art itself.

Much of our understanding of the prehistoric period is based on archaeological analysis of the art—small-scale sculptures, decorated utilitarian objects, paintings and engravings on rock surfaces, etc. Speculation about the meaning of the images depicted varies among experts, some suggesting that sexual symbolism may play a significant role. The diversity of views can be readily seen by comparing Bahn's "No sex, please, we're Aurignacians," which refutes the view that certain motifs are vulvic images, with Friese's article on sex symbols in cave paintings. Recently Begouen and Clottes have reported on an engraving dated to approximately 15,000 B.C., which appears to depict a couple engaged in intercourse, the earliest example of explicitly sexual art in history.

14-1 BAHN, PAUL G. "No sex, please, we're Aurignacians." Comment by P. Faulstich. Rock Art Research 3, no. 2 (1986): 99-120.
 Study of motifs found in Aurignacian art, which some researchers have seen as vulva forms but which Bahn feels should not be so identified.

14-2 BEGOUEN, ROBERT, and CLOTTES, JEAN. "Un cas d'erotisme prehistorique." La Recherche 15, no. 157 (July-August 1984): 992-95, illus., bib.
 Report on rock engravings that may be the oldest (12,000-10,000 B.C.) images of sexual activity in the history of art.

14-3 COLLUM, VERA CHRISTINA CHUTE. The Tress Iron-Age Megalithic monument (Sir Robert Mond's excavation): its quadruple sculptured breasts and their relation to the Mother-Goddess cosmic cult. London: Oxford University Press, 1935. 123 pp., bib., illus.

Excavation report including images of female breasts on pottery and other objects.

14-4 FRIESE, FRANZ. "Abschied von der Jagdmagie; Ratsel um die 'Sexsymbole' der steinzettlichen Hohlenkunst." Das Kunstwerk 30 (February 1977): 38-44, illus.
Possible use of sex symbols in Magdelanian cave painting explored.

14-5 HEIBRONNER, PAUL. "Some remarks on the treatment of the sexes in Paleolithic art." International Journal of Psycho-Analysis 19, no. 4 (October 1938): 439-47, figs.
Study of sexual imagery in Paleolithic art.

14-6* RICHTER, RICHARD. "Palaolitische Sexualdarstellungen und ihre Bedeutung fur die Geschichte der Sexualforschung." Quartar 6, no. 2 (1954): 77-84.

Chapter 15
Ancient Near East and Egypt

Ancient Near East

The ancient Near East is most commonly known as the world in which the Old Testament Hebrews lived. The Bible provides commentary about the non-Hebraic peoples in the region, usually depicting them in a negative light, almost always condemning them because of their supposedly abominable sexual behavior (the story of Sodom and Gomorrah is a good example). In truth, there was a diversity of sexual customs and beliefs, and this region established certain sexual themes that influenced the entire ancient world, including the ritual of sacred marriage, the practice of sacred prostitution, belief in deities of fertility and sexuality, and others. As part of the sexual culture of the region, there was apparently a large body of erotic literature, but only a few types of erotic art.

A comprehensive survey of sexuality in the ancient Near East has yet to be written, although Raphael Patai in Sex and family in the Bible and the Middle East offers an overview of sexuality for the early period from a biblical perspective and Ilse Seibert's Woman in the ancient Near East provides an interesting discussion of the role of women: as wives, mothers, daughters, priestesses, prostitutes, etc. The important role that sex played in Near Eastern religion is expressed in several ways. Most sources include discussion of deities of fertility who controlled some aspect of human sexuality: the most widely worshipped was Ishtar (Astarte). These deities were frequently depicted in suggestive poses or with sexual symbols as small sculptures that have been described by Neuville and Pritchard. Special categories of men (most importantly kings) were linked to spiritual powers through ritual sexual relationships with certain goddesses (via their priestesses). This ritual of sacred marriage has been discussed by Van Buren and Kramer. Commoners and aristocrats alike could worship at the shrines of certain deities by having sex with temple prostitutes. This system of sacred prostitution was frequently associated with the drinking of beer and sometimes involved the use of erotic votive plaques, a topic discussed in articles by Sams and Trumpelmann.

Ancient Near East and Egypt

Egypt

The ancient Egyptians are best known through their funerary art, yet there is substantial evidence to demonstrate that Egyptian culture was not as exclusively concerned with death as many people think. The Egyptians, who were often accused of lasciviousness by neighboring peoples, appreciated the sensual pleasures of life and had a rich tradition of erotic literature. The role of sexuality in Egypt has been surveyed in articles by Bardis, Manniche, and Reutersward. Egyptian artists, however, produced little erotic art. One notable exception is a papyrus that has been reproduced in Omlin's Der Papyrus 55001 und seine satirisch-erotischen Zeichnungen und Inschriften. Other examples of erotic visual imagery include the use of the phallic and vulvic forms in hieroglyphic script as discussed by Brugsh and small sculptures of ithyphallic minor deities in the later periods of the empire.

Phallic worship played a significant role in Egyptian religion as noted by G.D. Hornblower who, in two articles, has provided some examples of the use of phallic images as offerings and as symbols. The fertilizing power of the phallus seems to have been exemplified by the god Min, an agricultural deity who became associated with Amun-Re as revealed by the research of French archaeologist Henri Gauthier, published in the early 1930s.

Ancient Near East

15-1* EBELING, ERICH. "Liebeszauber im Alten Orient." Mitteilungen der Altorientalischen Gesellschaft (Leipzig) 1, no. 1 (1925): 1-56.

15-2 KRAMER, SAMUEL NOAH. The sacred marriage rite: aspects of faith, myth, and ritual in ancient Sumer. Bloomington: Indiana University Press, 1969. 170 pp..
Literary study of the sacred marriage rites of the early ancient Near East.

15-3 NEUVILLE, RENE. "Statuette erotique du Desert Judee." Anthropologie 43, nos. 5-6 (1933): 558-60, illus.
Mother goddess figure described.

15-4 PAPAI, RAPHAEL. Sex and family in the Bible and the Middle East. Garden City, New York: Doubleday, 1959. 282 pp., bib., index.
Study of sex and family life in the ancient Near East.

15-5 PRITCHARD, JAMES BENNETT. Palestinian figurines in relation to certain goddesses known through the literature. American Oriental Series, no. 24. New Haven, Conn.: American Oriental Society, 1943. 99 pp. (text), figs.
Female figurines of ancient mother-goddesses surveyed.

15-6 SAMS, G. KENNETH. "Beer in the city of Midas." Archaeology 30, no. 2 (March 1977): 108-15, figs., illus.

Article suggests a direct connection between beer drinking and ritual sexual activity in the ancient Near East.

15-7* SEIBERT, ILSE. Woman in Ancient Near East. Translated by Marianne Herzfeld; revised by George A Shepperson). London: George Prior; Leipzig: Edition Leipzig, 1974. 109 pp., illus. (some col.), bib.

15-8* SEYRIG, HENRI. Deux simulacres antiques des organes sexuels. Paris: Librairie Orientaliste Paul Geuthner, 1966. 6 pp.

15-9 TRUMPELMANN, LEO. "Eine Kneipe in Susa." Iranica Antiqua 16 (1981): 36-44, plan, figs., illus.
 Description of the excavation of a tavern and associated erotic art objects unearthed.

15-10* VAN BUREN, ELISABETH DOUGLAS. "The sacred marriage in early times in Mesopotamia." Orientalia (Rome), n.s. 13 (1944): 1-72.

Egypt

15-11* BARDIS, PANOS D. "Sex life in ancient Egypt." Sexology 33, no. 4 (November 1966): 248-50.

15-12 BRUGSH, H.K. "Die Phallus-Gruppen in der hieroglyphischen Schrift." Zeitschrift fur Aegyptische Sprache und Altertumskunde 1 (1863): 21+, figs.
 Phallic hieroglyph and its meaning explained.

15-13 EBERS, G.M. "Min." Zeitschrift fur Aegyptischen Sprache und Altertumskunde 6 (1968): 71-72.
 Discussion of the phallic god Min.

15-14 GAUTHIER, HENRI. Les fetes du dieu Min. Recherches d'archeologie de philologie et d'histoire, vol. 2). Cairo: Institut Francais d'Archeologie Orientale, 1931. 315 pp., illus.
 Detailed study of the religious beliefs and practices relating to the phallic god Min.

15-15 _____. Le personnel du dieu Min. Recherches d'archeologie de philologie et d'histoire, vol. 3. Cairo: Institut Francais d'Archeologie Orientale, 1931. 132 pp., index.

15-16 HORNBLOWER, G.D. "Further notes on phallism in Ancient Egypt." Man 27 (article no. 97) (August 1927): 150-53, illus.
 Phallic images in ancient and modern Egypt briefly surveyed.

15-17 _____. "Phallic offerings to Hat-hor." Man 26 (article no. 52) (May 1926): 81-83, illus.
 Images of phallic offerings described.

15-18 MANNICHE, LISE. "Some aspects of ancient Egyptian sexual life."
 Acta Orientalia 38 (1977): 11-24, figs., illus.
 Relates important sexual practices and beliefs.

15-19 OMLIN, JOSEPH A. Der Papyrous 55001 und seine satirisch-ero-
 tischen Zeichnungen und Inschriften. Catalogo del Museo Egizio
 di Torino. 1st ser., Monumenti e Testi, no. 3. Turin: Edizioni
 d'Arte Fratelli Pozzo, 1973. 121 pp., bib., illus. (col.).
 Study of a papyrus showing a variety of sex acts.

15-20* REUTERSWARD, OSCAR. Ritual love-making and punishment in
 Egyptian myths. Translated by Moira Linnarud. Lund: Edition
 Sellem, 1975. 75 pp., illus.

15-21* RIEFSTAHL, ELIZABETH. "An enigmatic faience figure." Miscell-
 anea Wilbouriana, 1972.

Chapter 16
Greece

Background

The sexuality of the ancient Greeks, so different from that which developed in Christian Europe, has both fascinated and disturbed people for centuries. Greek sexuality, at various times and places, encompassed sacred prostitution, ritual orgies, homosexuality, worship of sex deities, and other behavior long since abandoned by European cultures. The ambivalence felt toward the ancient Greeks can be clearly noted in the bibliographic entries listed below.

Since the Renaissance the study of the ancient Greeks has been a major focus of scholarly research, which has included studies of sexuality. Surveys of the role of sex in Greek culture first appear in the nineteenth century in books on sex in the ancient world (see the earlier chapter "Ancient (General)"), but the classic scholarly study of this subject is Hans Licht's (pseudonym for Paul Brandt) Sexual life in ancient Greece published in 1932, while more recently Flaceliere has offered the more popularized Love in ancient Greece. Narrower in scope, yet providing interesting, if controversial analyses is Eva Keuls's The reign of the phallus: sexual politics in ancient Athens.

The role of homosexuality in Greece, especially in Athens, is a controversial topic. Generations of classicists, many of whom are in awe of Greek culture, have had difficulty understanding or accepting that form of sexuality. That there was a tradition of love relationships between young men and youths among Athenians cannot be denied: there is, among other sources, supporting evidence of vase paintings depicting homosexual relationships. Heinrich Hossli pioneered research into this subject by publishing Eros: die Mannerliebe der Griechen in 1836. Since then research has unearthed more information, which has been incorporated in Kenneth Dover's thoroughly documented Greek homosexuality and Felix Buffiere's Eros adolescent, largely based on literary sources. Another concept important to the Greeks, but not shared by Christian Europe, was the belief that the sexual ideal is achieved in the hermaphrodite, the human figure with the best features of both the male and the female, a subject explained by Delcourt in Hermaphrodite: mythes et rites de la bisexualite dans l'antique classique.

Greece

The polytheistic religion of the Greeks included deities and minor spiritual beings who themselves lead active sex lives. Any book on Greek religion or myth will discuss the stories of the loves of Zeus or the promiscuity of nymphs and satyrs. Further, some deities controlled aspects of human sexuality, including Aphrodite, Eros, Priapus, etc. Many of the sources listed in the "Sex and Religion" chapter and the "Ancient (General)" chapter of this bibliography discuss the sexual aspects of Greek religion as does Delvoye's study of fertility goddesses and works by Herter on Priapus listed below.

Art

In both qualitative and quantitative terms the Greeks made a major contribution to the history of erotic art. That art takes the form of stone or clay sculptures, painting on pottery, bronze mirror engravings, etc., while literary fragments suggest that erotic murals also existed. Although rarely displayed, a number of museums have significant holdings of Greek erotic art (see Vermeule on vases at the Boston Museum of Fine Art). Only in the last few decades have those objects become available to an audience wider than just a select group of scholars. Until Paul Brandt's Die Erotik in der Griechischen Kunst (1928), only a few books published in very limited runs showed illustrations of Greek pieces (see "Ancient (General)"). By the early 1960s both Greifenhagen and Marcade had offered well-illustrated surveys; then Boardman and LaRocca in 1975 produced Eros in Greece, a coffee-table-style book with lavish color photos.

Greek pottery was typically painted with naturalistic scenes in a number of styles. These scenes depicted myths, legends, daily life—virtually anything related to the Greek world, including images of sexual activity. This erotic pottery must have been produced in large quantities judging from the number of pieces that have survived. A number of scholars have researched collections of erotic pottery to conduct iconographic studies of the sexual images: Albert, Boardman, Hoffman, Kilmer, Shapiro, Sutton, and Vermeule.

Background

16-1 BRANDT, PAUL (pseudonym Hans Licht). Sexual life in ancient Greece. Translated from German by J.H. Freese. New York: Barnes and Noble, 1932. 557 pp., index. (Later edition, New York: American Anthropological Society, 1934; reprint edition New York: Barnes and Noble, 1963.)
 Scholarly study of sexual beliefs and practices in Greece.

16-2 BUFFIERE, FELIX. Eros adolescent: la pederastie dans la Grece antique. Paris: Societe d'Edition "Les Belles Lettres," 1980. 703 pp., index, map.
 Study of Greek homosexuality from literary sources.

16-3* DE LA CHAUSSE, M.A. Sur les statues de Priape, qui decouvrent la turpitude du paganisme. Ph.D. dissertation.

16-4 DELCOURTE, MARIE. Hermaphrodite: myths and rites of the bi-
sexual figure in classical antiquity. Translated by Jennifer Nich-
olson. London: Studio, 1961. 136 pp., figs., bib. (First edi-
tion, Paris: Preses Universitaires de France, 1958.)
 Study of the concept of the hermaphrodite in ancient Greece,
including the depiction of bisexual figures in art.

16-5 DELVOYE, C. "Rites de fecondite dans les religions Pre-Hellen-
iques." Bulletin Correspondence Hellenique 70 (1946): 120-31,
figs., illus.
 Early fertility goddesses featured.

16-6 DOVER, KENNETH JAMES. Greek homosexuality. London: Duck-
worth, 1978. 244 pp., bib., index, gloss., illus. (some col.).
 Thorough, scholarly study of Greek homosexuality using as
primary evidence, among other things, erotic art.

16-7 FLACELIERE, ROBERT. Love in Ancient Greece. Translated by
James Cleugh. London: Muller; New York: Crown, 1962 224 pp.,
illus. (First edition, Paris: Hachette, 1960; later edition, New
York: MacFadden-Bartell, 1964; reprint edition, Westport, Conn.:
Greenwood, 1973.)
 Discussion of general attitudes to love and sex in Greece.

16-8* FREL, JIRI. "Griechischer Eros." Listy Filologicke 86 (1963):
61-64.

16-9* GISORS, PIERRE. "L'amour dans la Grece Antique." Union 33
(March 1975): 14-21.

16-10* HERTER, HANS. De Dis Atticis Priapi Similibus. Chicago: Ares,
1980. 63 pp., illus., bib., index. (Reprint of dissertation sub-
mitted to Universitat Fridericiae Guilelmiae Rhenanae, Bonnae,
1926.)

16-11 _____. De Priapo. Religionsgeschichtliche Versuche und Vor-
arbeiten, vol. 23. Giessen: Alfred Topelmann, 1932. 334 pp.,
illus., bib., index.
 Classic study of worship of Priapus in the ancient world.

16-12* HOSSLI, HEINRICH. Eros: die Mannerliebe der Griechen, ihre
Beziehungen zur Geschichte, Erziehung, Literatur und Gesetzge-
bung aller Zeiten. 2 vols. Glarus; St. Gallen, 1836-38.

16-13 KEULS, EVA C. The reign of the phallus: sexual politics in ancient
Athens. New York: Harper & Row, 1985. 452 pp., bib., index,
illus., figs.
 Feminist interpretation of Athenian male-female relationships,
using literature and art as important evidence.

Greece

Art

16-14 ALBERT, WOLF-DIETER. Darstellungen des Eros in Unteritalien.
Studies in Classical Antiquity, no. 2. Amsterdam: Rodopi, 1979.
251 pp., illus.
Study of winged eros on Greek pottery from south Italy.

16-15 BOARDMAN, JOHN. "Curious eye cup." Archaologischer Anzeiger
3 (1976): 281-90, illus.
Discussion of a ceramic vessel with genital base.

16-16 BOARDMAN, JOHN, and LAROCCA, EUGENIO. Eros in Greece.
New York: Erotic Art Book Society, 1975. 174 pp., bib., index,
illus. (col.).
Photographic study with commentary on Greek erotic art.

16-17* BRANDT, PAUL (pseudo. Hans Licht). Die Erotik in der Griech-
ischen Kunst. Zurich, 1928.

16-18* GREIFENHAGEN, ADOLF. Griechische Eroten. Berlin: De Gruy-
ter, 1957. 89 pp., illus.

16-19 HOFFMAN, HERBERT. Sexual and asexual pursuit—a structuralist
approach to Greek vase painting. Occasional Paper, no. 34.
Foreword by Edmund Leach. London: RAI, 1977. 17 pp. (text),
index, bib., illus., figs., diag.
Anthropological structuralist analysis of motifs in Greek
painted askoi, some with sexual imagery.

16-20 KILMER, MARTIN. "Genital phobia and depilation." Journal of
Hellenistic Studies 102 (1982): 104-12, illus.
Study of the depiction of female genitalia in Greek vase paint-
ing.

16-21 MARCADE, JEAN. Eros Kalos: essay on erotic elements in Greek
art. Geneva: Nagel, 1962. 167 pp., illus. (col.).
History of the sexual themes in Greek art.

16-22 SAFLUND, GOSTA. Aphrodite Kallipygos. Acta Universitatis Stock-
homiensis, Stockholm Studies in Classical Archaeology, no. 3.
Stockholm: Almquist and Wiksell, 1963. 90 pp., index, illus.
Study of the seminude female figure, including discussion of
erotic aspects.

16-23 SHAPIRO, H.A. "Courtship scenes in Attic vase-painting." Amer-
ican Journal of Archaeology 85, no. 2 (April 1981): 133-43, illus.
History of the development and decline of the subject of homo-
sexual lovers in Athenian ceramics.

16-24* SUTTON, ROBERT FRANKLIN. "The Interaction between men and women portrayed on Attic red-figure pottery." Ph.D. dissertation, University of North Carolina, Chapel Hill, 1981. 564 pp., bib., illus.
 Detailed study of images of men and women dipicted on pottery; includes scenes of erotic activity.

16-25* _____. "Social aspects of eroticism on Attic red-figure pottery." Paper read at the 80th General Meeting of the Archaeological Institute of America, Vancouver, B.C., December 1978. 12 pp.

16-26 VERMEULE, EMILY T. "Some erotica in Boston." Antike Kunst 12, no. 1 (1969): 9-16, figs., illus.
 Overview of a collection of erotic Greek vases in the Bostom Museum of Fine Art.

Chapter 17
Rome

There is a popularly held belief that the Roman Empire fell because of moral decay, a view promulgated by decades of novels and movies filled with scenes of glutonous feasts, wild orgies, and horrendous cruelties. Though historians continue to debate the causes of the disintegration of the Roman world, to suggest that unrestrained sexual activity was the norm in Roman times is simplistic, for Roman sexuality encompassed a diverse range of beliefs and behavior. This diversity is what creates much of the fascination with a Rome that can accommodate a social system that elevated the family unit to religious significance and a political system that produced some of the most depraved political leaders known to history.

Scholarly interest in Roman history and life has been strong since the Renaissance, invigorated each time a new archaeological discovery is made, as happened in the latter half of the eighteenth century when Pompeii and Herculaneum were first revealed. For instance, Hancarville in the 1780s presented the most sensationalistic excesses of the emperors in the form of stories illustrated with prints in the style of ancient gem reliefs in Monumens de la vie privee des douze cesars and did the same with stories of the mystery cults that Roman women frequently followed in Monumens du culte secret des dames Romaines. Given the quantity of unearthed historical records, literature, and art that explicitly document aspects of the nature of Roman sexuality, classicists could not avoid considering the subject. While almost any text on the history and culture of Rome will at least mention aspects of sexuality in ancient Rome, only a few surveys of the subject have been published. Otto Kiefer's Sexual life in ancient Rome first published in 1934 is still the most scholarly work on this topic, although his emphasis is on the social roles of men and women rather than on the details of their sex lives. More directly concerned with sex and less rigidly academic are Pierre Grimal's Love in ancient Rome and Edgar Pike's book of the same title.

Art

The Romans continued many of the traditions of the Greeks, including the belief in sexual deities and the production of erotic art. For instance, the Romans adopted Priapus as a garden god, who they depicted as an ithy-

phallic buffoonish character. Roman erotic art tended to bronze and stone sculptures, amulets, murals, and molded reliefs in Aretino ware pottery, rather than the vase paintings favored by the Greeks. Much of the extant Roman erotic art came from Pompeii and Herculaneum, resort towns known as pleasure centers (with large red light districts) for wealthy Romans (for that reason, the proliferation of erotic art at those sites may be uncharacteristic for the Empire as a whole). The erotic objects excavated at Pompeii and Herculaneum ended up in special museum collections known as "secret cabinets" that until recently were not open to the public. Almost all surveys of Roman erotic art are simply catalogs of objects in those "closed collections." The earliest illustrated catalog was Famin's Musee Royal de Naples, peintures, bronzes et statues erotiques du cabinet secret, published in 1836 and reprinted several times in the last 150 years. Fiedler did the same with another collection in his Antike erotische Bildwerke in Houbens Romischen Antiquarium zu Xanten (1839). Later in the century came the Catalogo del Museo Nazionale di Napoli, raccolta pornographica (1866), Barre's Herculaneum et Pompei (1877), and then Lacour's Le Musee Secret de Naples (1914). Each of these catalogs provided drawings that varied considerably in quality and detail. By the 1960s growing interest in erotic art stimulated the publication of books with photographs of these objects, many of which are listed in the "Surveys" and "Ancient (General)" chapters of this bibliography. Specifically Roman in scope are three books: Jean Marcade's Roma Amor, which surveys, with photographs of varying quality, many of the erotic murals that decorated homes and brothels in Pompeii; Eros in Pompeii: the secret rooms of the National Museum of Naples, by Michael Grant, a catalog with lavish color photographs, and Erika D'Or's guidebook to the recently opened erotica collection, Pompeii Vietata.

Background

17-1 GRIMAL, PIERRE. Love in ancient Rome. Translated by Arthur Train. New York: Crown, 1967. 306 pp., intro.
 Survey of love and sex in Roman history.

17-2 [HANCARVILLE, PIERRE F.H.] Monumens de la vie privee des douze Cesars, d'apres une suite de pierres et medailles, gravees sous leur regne. Capri: Sabellius, 1782. 212 pp., illus.
 Sex lives of the emperors as told through illustrations purportedly based on ancient art.

17-3 [_____.] Monumens du culte secret des dames Romaines, pour servir de suite aux monumens de la vie privee des XII Cesars. Capri: Sabellius, 1784. 98 pp., illus.
 Using illustrations supposedly based on ancient originals, worship of Priapus and other sexual deities explained.

17-4 KIEFER, OTTO. Sexual life in ancient Rome. Translated from German by Gilbert and Helen Highet. London: Routledge, 1934. 379 pp., index, illus. First American edition, New York: Dutton, 1935; reprints of original edition, Routledge, 1941; Calcutta: Stan-

dard Literature, 1951; New York: Barnes and Noble, 1951, 1953, 1956, 1962, 1964; London: Abbey Library, 1971, 1976; New York: AMS Press, 1975.
Social study of the role of the sexes in Rome.

17-5 PIKE, EDGAR ROYSTON. Love in ancient Rome. London: Frederick Muller, 1965. 285 pp., index, illus.
Sexual beliefs and practices of Rome are featured.

17-6* PLANSON, E., and LAGRANDE, A. "Un noveau document on the syncretismes dans les religions Gallo-Romaines: le groupe de divinities des Bolards." Review of Archaeology, n.s. 2 (1975): 267-84.

17-7 VEYNE, PAUL. "Homosexuality in ancient Rome." In Western Sexuality, edited by Aries and Bejin, 26-35. New York: Basil Blackwell, 1985.
Discusses the legal, moral, and behavioral aspects of homosexuality in Roman times.

Art

17-8 AUDIN, A., and JEANCOLAS, L. "Le medaillon des amours de Mars et Venus." Bulletin des Musees et Monuments Lyonnais, 4, no. 1 (1969): 17-19, figs., illus.
Description of a fragment of a Roman pot with a lovemaking scene.

17-9 BARRE, [M.] LOUIS. Herculaneum et Pompei, recueil general des peintures, bronzes, mosaiques, etc., Vol. 8, Musee Secret. Illustrations by H. Roux Aine. Paris: Firmin Didot Freres, 1877. 230 pp., figs.
Erotic images from Museum cataloged in single volume.

17-10* Catalogo del Museo Nazionale di Napoli, Raccolta Pornographica (Phallic Collection). Naples, 1866.

17-11* D'OR, ERIKA. Pompeii vietata. Naples: Edizioni Pompeiane, ca. 1980.
Italian guidebook to erotica from Pompei.

17-12 FAMIN, [STANISLAS MARIE] CESAR. Musee Royal de Naples, peintures, bronzes et statues erotiques du Cabinet Secret. Paris: Abel Ledoux, 1836. 159 pp., figs. (some col.). Second edition, Paris: Cercle du Livre Precieux, 1957. Published in English as The Secret Museum of Naples, being an account of the erotic paintings, bronzes and statues contained in that famous "Cabinet Secret" [London, 1872]; Spanish edition published as Museo de Napoles: gabinete secreto: pinturas, bronces y estatuas eroticas [Madrid: Unica Edicion, 1977].

Catalog of erotic art from ancient Roman times in Naples Museum collection.

17-13 FIEDLER, FRANZ. Antike erotische Bildwerk in Houbens Antiquarium zu Xanten. Xanten: Wesel, 1839. 28 pp., illus. (col.).
Roman erotic art in the collection of Ph. Houben of Xanten.

17-14 GRANT, MICHAEL. Eros in Pompeii: the secret rooms of the National Museum of Naples. Description of the Collection by Antonio de Simone and Maria Teresa. New York: William Morrow, 1975. 171 pp., bib., illus. (col.).
Study of Roman erotic art with full color photographs and commentary.

17-15* LACOUR, JULES. Le Musee Secret de Naples, et Le culte des organes generateurs. Brussels: Imprimerie Centrale, 1914. 175 pp., figs.
Catalog of Roman erotic art.

17-16 MARCADE, JEAN. Roma Amor. Geneva: Nagel, 1965. 131 pp., illus. (col.).
Discussion of the history and major themes of Roman erotic art.

17-17 SHIRLEY, D.L. "Secret Room." Art News 73, no.1 (January 1974): 79.
Brief announcement of the opening of the "secret room" of Naple's Museo Archaeologico to the public.

17-18 TURNBULL, PERCIVAL. "The phallus in the art of Roman Britain." Institute of Archaeology Bulletin 15 (1978): 199-206, figs., illus.
Phallic images in Roman art featured.

Section 4
Asia

Chapter 18
Asia (General)

Asia, inhabited by over half of the world's population, is a continent of diverse lands and peoples. Broad historical developments and the influence of several major religions give Asia a unique cultural imprint. Sex life in Asia is quite different from that found in European cultures. The integration of sexuality in social and religious life helps to explain the quantity and quality of erotic art produced by Asian artists for many centuries.

Background

Ever since Sir Richard Burton first wrote about Oriental sex customs in the nineteenth century, many books and articles have been published describing Eastern sexuality. In general, they find sex life in the Orient to be more open and accepted than in the Christian West, which helps explain why so many Western authors have shown a special interest in the subject. It is difficult to find sexual practices or beliefs that are universally followed in Asia, yet it is clear that much of Asian sexuality has been influenced by the great religions of the region: Islam, Hinduism, Buddhism, Taoism, and Shintoism. All, except for some minor sects, allow for an active, varied sex life, typically encouraging such practices as polygamy, emphasizing the pleasing of one's partner, and the utilizing sex as a means of achieving spiritual development.

Most of the surveys listed in the "Customs" chapter of this bibliography devote considerable attention to Asia, but in addition a number of texts specifically focus on that continent. German interest in this subject has been especially strong, because of scholarly and cultural connections between Germany and certain areas of Asia (especially China). One of the earliest surveys was Englisch's Sittengeschichte des Orients (1932), later van Bolen's Erotik des Orients (1955) and Tullmann's Das Liebesleben des fernen Ostens (1974). A parallel interest in the English-speaking world has long existed. Contemporaneous with Englisch's work was Hirschfeld's Curious sex customs in the Far East; the world journey of a sexologist (1935). Scott wrote Far eastern sex life (1943) focusing on China and Japan at a time when that part of the world was a center of world conflict. In the late 1950s and early 1960s several books were published that have become popular classics on this subject. Edwardes authored The jewel in the lotus: a historical survey of the sexual culture of the east in 1959 and The cradle of erotica: a study of Afro-Asian sexual expression

119

and an analysis of erotic freedom in social relationships with R.E.L. Masters in 1963. Burton's late nineteenth-century terminal essay to his translation of The Arabian nights was published as Love, war and fancy: the social and sexual customs of the east in 1964. The late 1970s again saw several works published on Asian sex customs and practices - Oriental sex manners by Levy and Sexual secrets: the alchemy of ecstasy by Douglas and Slinger (a source for both the philosophical background to and practical how-to information on Oriental sex practices).

Detailed studies of specific aspects of Asian sex customs have been published. These include Cleugh's study of the institution of the harem, the Maces on Asian marriage customs, and Karsch-Haack's volume on homosexuality in the Orient.

Art

Asia has produced much of the world's erotic art. This includes miniature paintings of the Near East, Persia, and India, sculpture in stone and wood in the Indian subcontinent, and paintings and prints from China and Japan. General surveys on erotic art almost always include many Asian examples (see the "Art Surveys" chapter), but only a few books have been published attempting to survey the erotic art of Asia. The most thorough of these is Erotic art of the East: the sexual theme in oriental painting and sculpture (1968), edited by Rawson. A more summary treatment of the subject can be found in Rawson's Oriental erotic art (1981). Douglas and Slinger focus on Oriental erotic paintings in The pillow book; the erotic sentiment and the paintings of India, Nepal, China & Japan (1981). Each of these books have excellent color reproductions, as well as a well written text.

Background

18-1 BOLEN, CARL VAN. Erotik des Orients; eine Darstellung der Orientalischen Hochkulturen. Teufen: Bucher des Lebens, 1955. 261 pp., illus., bib.
Study of sex customs in Asia.

18-2 _____. Erotik des Orients; das Liebesleben der Orientalischen Hochkulturen: Indien, Persien, die Arabischen Volker, China, und Japan. Munich: Heyne, 1967. 236 pp.

18-3 BURTON, RICHARD. Love, war and fancy: the customs and manners of the East, from writings on the Arabian Nights. Edited, with introduction, by Kenneth Walker. New York: Ballantine, 1964. 288 pp.

18-4 DEHOI, ENVER F. L'erotisme des "Mille et Une Nuits." Bibliotheque internationale d'erotologie, no. 4. Paris: J.-J. Pauvert, 1961. 228 pp., illus.
Near Eastern eroticism in Indian, Persian, and European art, literature, and popular culture discussed. Includes a dictionary of terms.

18-5 DOUGLAS, NIK, and SLINGER, PENNY. Sexual secrets; the alchemy of ecstasy. New York: Destiny Books, 1979. 383 pp., gloss., bib., index, figs.
 Background information and how-to advice for Oriental sex techniques and beliefs.

18-6 EDWARDES, ALLEN. The jewel in the lotus: a historical survey of the sexual culture of the East. Introduction by Albert Ellis. New York: Julian, 1959. Reprint. New York: Lancer Books, 1965, 1967. 293 pp., bib.
 Study of sexual customs of Asia (especially west Asia).

18-7 EDWARDS, ALLEN, and MASTERS, R.E.L. The cradle of erotica: a study of Afro-Asian sexual expression and an analysis of erotic freedom in social relationships. New York: Julian Press, 1963. 362 pp., bib., index.
 General survey of sexual customs and beliefs in India, China, and Japan.

18-8* ENGLISCH, PAUL. Sittengeschichte des Orients. Berlin: Kiepenheuer, 1932. 392 pp., illus.
 Sex customs throughout Asia from the Near East to Japan surveyed.

18-9 HIRSCHFELD, MAGNUS. Curious sex customs in the Far East; the world journey of a sexologist. New York: Grosset & Dunlop, 1935. 325 pp., pref., app., index. (Translation of Die Weltreise eines Sexualforschers, originally published in U.S. under title Men and Women; English version by O.P. Green with title Women East & West.)
 Study of Asian sex customs, emphasizing the unusual and the sensational.

18-10* LEVY, HOWARD S. "Erotic sex customs in the Orient." Sexology 40, no. 5 (December 1973): 15-19.

18-11* _____. "Girl watching Oriental style." Sexology 41, no. 5 (December 1974): 32-34.

18-12 LEWIS, GERALD P. "Erotic tips from the exotic East." Sexology 40, no. 9 (April 1974): 44-46, illus.
 Very simplistic overview of Oriental sex customs.

18-13 MACE, DAVID ROBERT, and MACE, VERA. Marriage East and West. Garden City, N.J.: Dolphin; Garden City, N.J.: Doubleday, 1960. 392 pp., bib., index.
 Study of marriage rites in Asia as compared to that in the West.

18-14 WU LIEN-TEH. "Orient, sex life in the." In The encyclopedia of sexual behavior, edited by Albert Ellis and Albert Abarbanel, 794-801, ref. New York: Hawthorn, 1961.
 Survey of Asian sex beliefs and customs.

Asia (General)

Art

18-15 BRZOSTOSKI, JOHN. "Erotic art of the East by P.S. Rawson."
 Arts 44 (November 1969): 14+.
 Book review that includes useful summary of major traditions of
 Asian erotic art.

18-16 DOUGLAS, NIK. The art of love; erotic scenes from the ancient
 cultures of India, Nepal, China and Japan [Exhibition 28 November-
 21 December 1979]. Beverly Hills: Kreitman Gallery, 1979. 64
 pp., bib., illus.
 Erotic art of India, Nepal, China, and Japan illustrated in exhi-
 bition catalog.

18-17 DOUGLAS, NIK, and SLINGER, PENNY. The pillow book; the ero-
 tic sentiment and the paintings of India, Nepal, China & Japan.
 New York: Destiny, 1981. 142 pp., bib., illus. (col.).
 Overview of major traditions of Asian erotic art.

18-18 GLUCK, JAY. "Far East, sex in the art of the." In The ency-
 clopedia of sexual behavior, edited by Albert Ellis and Albert
 Abarbanel, 412-21, bib. New York: Jason Aronson, 1973.
 Part historical, part psychological study of Asian erotic art.

18-19 KLINGER, D.M. Erotische Kunst in China, Japan, Indien und Arab-
 ien. Vol. 3. Nuremburg: DMK, 1982. 159 pp., illus. (some col.).
 Short essays introduce sections on the erotic art of India,
 China, Japan, and the Middle East with 174 black and white and 66
 color illustrations.

18-20 _____. Erotic art in China, Japan, India, and Arabia. Vol. 3a.
 Nuremburg: DMK, 1983. 172 pp., illus. (some col.), bib.
 Short essays introduce sections of erotic art of India, China,
 Japan, and the Middle East with 255 black and white and 26 color
 illustrations.

18-21 _____. Erotic art in China, Japan, India, and Arabia. Vol. 3b.
 Nuremburg: DMK, 1984. 99 pp., illus. (some col.), bib.
 Brief introductory essays precede collections of 278 black and
 white and 49 color illustrations of the erotic art of India, China, and
 Japan.

18-22 LENEMAN, OSCAR A.Z. Love: a fairy tale for grown-up children.
 Dobbs Ferry, N.Y.: Morgan and Morgan, 1983. 58 pp., illus. (col).
 Simple story is told using examples of Asian erotic art.

18-23 RAWSON, PHILIP, ed. Erotic art of the East: the sexual theme in
 Oriental painting and sculpture. Introduction by Alex Comfort.
 New York: Putnam's; Prometheus, 1968. 384 pp., bib., index,
 illus. (col.).
 Detailed studies of Asian erotic art by a number of authorities.

18-24 _____. Oriental erotic art. New York: A & W, 1981. 176 pp.,
index, illus. (some col.).
Overview of oriental erotic art.

18-25 SANKALIA, H.D. "Nude goddess or 'Shameless Woman' in Western
Asia, India, and South-Eastern Asia." Artibus Asiae 23, no. 2
(1960): 111-23, illus., figs.
Discussion of widespread theme of nude or seminude female
figure in parts of Asia.

Chapter 19
West Asia and
the Islamic World

Background

After the establishment of Islam the face of Near Eastern sex life changed profoundly. As the "Ancient Near East" chapter of this bibliography indicates, the Near East once was a center of sex worship and the production of images of female goddesses whose influence on human sexuality was powerful. However, Islam established new codes of sexual conduct and severely restricted art production. The result is that for much of the Near East it is not possible to speak of erotic art, although erotic poetry and dance are important elements of local culture, with the major exception of miniature paintings primarily from Persia that illustrate stories, poetry, and the life of the ruling classes.

One primary source on Near Eastern sex life is The perfumed garden by Sheikh Nefzawi, first translated into English by Sir Richard Burton. This text is the Near Eastern equivalent of India's Kama Sutra, a compilation of established sexual practices and beliefs, written during the Middle Ages. Twentieth-century studies of sex life east of India include ben Nahum's The Turkish art of love, Stern's The scented garden: anthropology of the sex life in the Levant, and Ibn Hazm's The ring of the dove: a treatise on the art and practice of Arab love.

Art

Only one book has attempted to survey the erotic miniature paintings of Persia, Sarv e naz: an essay on love and the representation of erotic themes in ancient Iran (1967) by Robert Surieu explores the themes that appear in the works and offer interpretations of their meaning within the culture of the period. In an article entitled "Antimontopf, Nadel und Langshalsflasche als erotische Symbole im Islam" Wallbrecht describes the use of flasks and jars as erotic motifs in Persian painting.

Background

19-1* ALLGROVE, GEORGE. Love in the East. London: Gibbs and Phillips; Panther Books, 1964). 159 pp., illus.

19-2 BOUHDIBA, ABDELWAHAB. Sexuality in Islam. Translated by
 Alan Sheridan. New York: Routledge and Kegan Paul & Methuen,
 1986. 288 pp., bib. (French edition, Paris: Presses universi-
 taires de France, 1975.)
 Survey of sex beliefs and practices in the Islamic religion.

19-3 IBN HAZM, ALI IBN AHMAD. The ring of the dove: a treatise on
 the art and practice of Arab love. Translated by Arthur John
 Arberry. London: Luzac, 1953. 288 pp., index.
 Study of Arabic customs of love and sex.

19-4 KLAUSNER, SAMUEL Z. "Islam, sex life in." In The encyclopedia
 of sexual behavior, edited by Albert Ellis and Albert Abarbanel,
 545-57. New York: Hawthorn, 1961.
 Concise survey of Islamic sex beliefs and customs.

19-5 NAHUM, PINHAS BEN. The Turkish art of love. New York: Pan-
 urge, 1933. 262 pp.
 Study of Ottoman-period sex life: highly moralistic author's
 commentary.

19-6 NEFZAWI, SHAYKH. The perfumed garden of Shaykh Nefzawi.
 Translated by Richard F. Burton; edited and with an introduction
 and additional notes by Alan Hull Walton. New York: Putnam's
 Sons, 1964. 256 pp., bib. (First English language edition by
 Cosmopoli for the Kama Sutra Society of London and Benares,
 1886.)
 Arabian love treatise which has seen many editions since Burton
 translated it in the nineteenth century.

19-7* SA'DAWI, NAWAL. The hidden face of Eve: women in the Arab
 world. Translated and edited by Sherif Hetata; foreword by
 Irene L. Gendzier. Boston: Beacon Press, 1982. 212 pp., bib.
 (First edition, London: Zed, 1980.)

19-8 STERN, BERNARD. The scented garden: anthropology of the sex
 life in the Levant. Translated by David Berg. New York: Amer-
 ican Ethnological Press, 1934. 443 pp., illus.
 Illustrated study of sex life in Turkey and the Islamic world.

Art

19-9 MANDEL, GABRIELE. Oriental erotica. Translated by Evelyn
 Rossiter. New York: Crescent Books, 1983. 80 pp., illus.
 (col.).
 Survey of Islamic sexual beliefs and erotic art.

19-10* NEFZAVI, SCHEIK. Der duftende Gartendes. Nuremburg: DMK,
 ca. 1985.
 Illustrations from a rare French/Arabic edition of The Perfumed
 Garden originally published in 1850.

19-11 SURIEAU, ROBERT. Sarv e naz: an essay on love and the repre-
 sentation of erotic themes in ancient Iran. Translated by James
 Hogarth. Geneva: Nagel, 1967. 185 pp., illus. (some col.).
 Erotic themes in Persian miniatures are explored.

19-12 WALLBRECHT, G. BERRER. "Antimontopf, Nadel und Langshals-
 flasche als erotische Symbole im Islam," Pantheon 37 (July 1979):
 275-82, figs., illus. (some col.).
 Iconographic study of flasks and jars as erotic motifs and
symbols in Persian painting.

Chapter 20
South Asia

The nations of the Indian subcontinent and southeast Asia are here included under the heading of South Asia. This is a region that has had a long history of erotic art largely motivated by philosophic and religious concepts. For millenia India has culturally and politically dominated this region and, as the entries of this chapter clearly indicate, this is especially true in regard to sex customs and erotica. For that reason the essay focusing on India below also serves as general background for the entire region, followed by brief mention of other countries in the region.

India

Indian erotic art has had a special appeal to the West for almost two centuries. This interest has generated more published works on Indian eroticism and erotic art than for any other single culture. The fascination, sometimes mixed with repulsion, seems to arise from the intimate relation between religion and sex in India. The British were never very comfortable with Indian sexuality and took many steps to repress it, an effort that has resulted in ambivalent attitudes toward the subject by both European and modern Indian writers. Few are totally condemnatory, yet a tone of either apology or rationalization pervades virtually all the published works listed below. Only recently have some Indian scholars defended ancient Indian sex practices as legitimate and healthy, especially when compared to the history of European difficulties with this aspect of life.

Background

Many words have been written attempting to explain to outsiders India's attitudes to human sexuality. Most books and articles on this subject trace the evolution of religion in India and, quoting profusely from important Hindu and Buddhist texts, try to explain how sexual beliefs and activities can be a central feature of religious practice. In fact, many of the works in the "Sex and Religion" chapter of this bibliography devote large sections to India. Perhaps the first outsider to write a sex study specifically on India was an anonymous member of the Royal Asiatic Society of London who published Sex life in India in 1909. Meyer's Sexual life in ancient India (1953) and Thomas's Kama kalpa: Hindu ritual of love (1960) have become the classic sources in this field, but there are similar surveys

by Allgrove, Banerji, Chakraberty, Chand, Fiser, Lal, Schmidt, Shah, Sur, Werner, and Windsor. Some of the most distinguished scholars of South Asian cultures have addressed aspects of the subject, such as John Woodroffe in Shakti and shakta: essays and addresses.

Almost all general works on sex customs and beliefs in India depend on a number of famous historical texts as their sources, the most well-known being the Kama sutra, but also including the Ananga ranga, the Koka shastra, and the Rati rahasya. These are the writings of Hindu sages, who, at various times in Indian history, endeavored to codify proper sexual behavior within Hindu philosophy. Generations of Hindus have been profoundly influenced by these books. Some of the texts were first translated into English by Sir Richard Burton. A good overview of the role of these writings in Indian history can be found in Ancient Indian erotics and erotic literature by De, Classical Indian erotology by Krishnanada, and History of Indian erotic literature by Bhattacharyya.

Many editions of translations of the Kama sutra and related literature have been produced, any of which should prove satisfactory to the general reader, while scholars may be particularly interested in comparing editions (see the Humanities Press edition [1982] for a "print history" of English translations of the Kama Sutra.) Especially useful for those interested in erotic art are editions illustrated with photos of Indian sculpture and painting relevant to the text (for example, The love teachings of the Kama sutra and de Smedt's The Kama sutra: erotic figures in Indian art).

. Studies focusing on certain historical periods or specific aspects of sexual custom are often especially helpful. In the early 1930s Sinha and Basu published History of prostitution in India, a massive study of that topic. Both Bose in The Post-Chaitanya Sahajiha cult of Bengal (1930) and Dimock in The place of the hidden moon: erotic mysticism in the Vainava-Sahasiya cult of Bengal (1966) have closely scrutinized influential cults. The sex lives of the ruling elites have received the attention of Jarmani and Dass and of Saltore, while Shyam Shashi has produced an ethnographic study of tribal groups.

Phallic worship, which has an ancient history in India, is an important element of Hindu devotion, because the lingam (penis) and yoni (vulva) are symbols of the male and female principles of the universe. The nineteenth-century preoccupation with the topic of phallicism resulted not only in many general studies (listed in the "Phallicism" chapter of this bibliography), but also works specifically on India, including an article by Sellon and a book by Burke. More recently, Verni has authored Il culto del lingam. Phallicism is an element of Hindu belief and is related to the creative aspects of the deities, particularly Siva and Krishna. Two books from the mid-1970s explore this aspects of Indian religion: Siva; the erotic ascetic by O'Flaherty and the two-volume Saivism and the phallic world by Bhattacarya. Probably equally as ancient as phallicism is the worship of mother goddesses, who came to play a significant role in Hinduism; their history and nature is revealed in Bhattacharya's The Indian mother goddess.

Art

The prevalence of sensuousness and eroticism in Indian sculpture and painting is such that almost any thorough survey of Indian art must at least acknowledge, if not fully explore, the existence of erotic art. It is indeed

difficult not to recognize the erotic component of Hindu art, what with the nearly ubiquitous presence of voluptuous dancing shaktis, enticing asparas (nymphs), full-bodied mithuna, and the explicitly active maithuna. Most of the entries listed in the "Art Surveys" chapter of this bibliography include sections on India. The only text to fully explore the breadth of Indian erotic art is Rawson's contribution on India in Erotic art of the east (see the "Asia (General)" chapter) and his visual overview of the subject Erotic art of India. There are, as well, some works that attempt a philosophical explanation (rather than an art historical survey) for the existence of India's erotic art, such as Kramrish's "Reflections on the house and body of God," and Adam's The tree of love: an interpretation of Indian art.

The earliest Indian erotic art is documented by Chakrabarti and Glantz in an article entitled "Erotic terracottas from Lower Bengal," C.C. Das Gupta's "Female fertility figures," and Sankalia's "The nude goddess in Indian art." Besides these early small-scale pottery pieces and a folk art tradition alive to this day, the bulk of Indian erotic art was produced in two periods--the Hindu and Jain temple sculptures of the medieval era (sixth-twelfth centuries) and the miniature paintings of the post-1500s. Most surveys of Indian erotic art address only one of these two traditions.

Hindu temples are monumental masses of stone intended as the focus of religious devotion, rather than as large enclosing spaces. Exterior surfaces are richly textured with sculpted figural and decorative designs. Beginning as early as the sixth century in the north and extending to as late as the seventeenth century in the south, certain temples were decorated with scenes of sexual activity. It was during the tenth to twelfth centuries that the finest and most well known of the erotic temples were built (by the twelfth century more puritanical attitudes had developed that suppressed any further expression of this tradition). A number of surveys focus on the erotic temples of India, and each follows a similar format--a short essay attempting to explain the existence of these erotically decorated edifices followed by a series of illustrations showing the sculptures from varying distances and in close-up detail. Such works have been authored by Anand, Danielou, Desai, Fouchet, Gichner, Lal, Lannoy, and Leeson.

After the Islamic invasions another outlet for erotic art arose in the royal courts. The miniature painting tradition of Persia was brought into India by the Muslim rulers in the sixteenth century. Indian artists soon adopted the medium and under royal patronage produced works portraying the sensual and sometimes erotic nature of the life of the ruling elite. Later, Hindu religious scenes were done in this medium, often emphasizing the racier aspects of the avatars of the gods. Examples of the former are explored in Kangra paintings on love by Randhawa and the latter are described by Anand in "The best of lovers-the Krishna Lila." There do not appear to be any studies exclusively focusing on the erotic paintings of India, but most erotic art surveys and many of the books mentioned in this chapter have numerous examples of this art tradition.

Tantrism

The clearest expression of the Indian ability to integrate sex and religion are the Hindu and Buddhist Tantric sects. Partly as a response to the austerity of early Buddhism, a number of religious cults grew in popularity during the first millenium A.D. Among these were the Tantric

sects, which trace their philosophy to the earliest Vedic scriptures but only became widely popular in the second half of the first millenium A.D. Tantrism consists of a complex philosophy, expressed in mystical devotional practices, utilizing aural and visual symbols. Among the teachings of many Tantric sects is the belief that human sexuality can be utilized as a path to enlightenment, if properly performed. Basically, the message is that the universal harmony of all things (towards which all individuals should seek) is a result of the union of all bi-polar complementaries, including the male and the female principles.

Detailed studies of Tantrism by Western scholars were first produced at the turn of the century and the subject has continued to be the focus of considerable interest. Unfortunately, most of the early studies ignored or glossed over the erotic element in Tantric belief. It was not until the 1970s that a number of books were published which attempted to explain Tantrism to nonpractitioners. These books generally incorporate earlier research on the cults while endeavoring to make clear how Tantrism can reconcile the sensate with the spiritual. Rawson's Tantra: the Indian cult of ecstasy and Colaabavala's Tantra: the erotic cult provide overviews of Tantric philosophy and practice. Tantra rites of love, with an introduction by Gabrielle Mandel, suggests that Tantric concepts can be seen in erotic miniature paintings. Less scholarly, but very useful, are the numerous books also published in the 1970s that offer how-to lessons in following Tantric practices. Among the most thorough and serious of these are works by Devi, Douglas, Garrison, Arvino and Kale, Moffett, Saraswati, Thirleby, and Tripathy.

Within Tantric worship meditation, sounds (mantras), and images (yantras) are utilized. Tantric art may be totally abstract and geometric, deriving meaning from the symbolism of colors and forms, or naturalistic, depicting deities conjoined with their female or male counterpart. Ajit Mookerjee and Philip Rawson have written extensively on this topic, and their works are the most respected in the study of Tantric art. Other than the publications of those two scholars, most articles on Tantric art are reviews of exhibitions that are periodically held in major museums in Europe and America.

Khajuraho

Among the most significant of the centers of Indian erotic sculpture is the site of Khajuraho in north central India (Madhya Pradesh state). This was the capital of the Chandella dynasty beginning in the tenth century where temples of both the Hindu and Jain religions were constructed, considered by some authorities as among the finest examples of medieval Indian architecture. Probably because of the influence of certain cults with strong erotic-mystic beliefs, some of the temples were decorated with scenes of couples and groups engaged in a wide range of sexual activities, as well as the less explicit but decidedly sensual isolated figures of dancers and musicians. This fluorescence of art and erotic expression was short lived and by the twelfth century had largely ceased.

Books and articles ranging from detailed scholarly studies to simple collections of photographs have been published on Khajuraho. Background to the site is provided by Goetz in "The Historical background of the great temples of Khajuraho," Chandra's "The Kaula-Kapalika cults at

Khajuraho," and Vidya's Khajuraho: a study in the cultural conditions of Chandella society. Most works on Khajuraho consist of a brief introductory essay speculating on the reason for the erotic sculptures, sometimes with scholarly documentation but always philosophical in nature, and many photos of the sculptures: books by Agarwal, Anand, Deva, Dhama and Chandra, Florey, Lal, Seth, Vijayatunga, and Zannas. A recent conference of Indian scholars on Khajuraho has added considerable to the body of information on this site.

Konarak

Another famous site is that of Konarak in Orissa, a state with a long tradition of erotic folk art. At Konarak is the remains of a remarkable Sun Temple, dubbed by the British the Black Pagoda, a part of which is in the form of a huge stone chariot or processional wagon. As at Khajuraho, the temple includes many sculptures showing human sexual activity in a very explicit presentation. Robert Ebersole's Black pagoda gives an overview of the background of the site and its structures. However, most books and articles on Konarak attempt to offer an explanation for the erotic art found there. The most notable are Anand's "The great delight, an essay on the spiritual background of the erotic sculptures at Konarak" and Konarak, the commentary by Alan Watts in Eliot Elisofon's book of photographs of the site Erotic spirituality: the vision of Konarak, and Lal's Miracle of Konarak.

Bangladesh

Sattar has provided a survey of sex customs in Bangladesh, The sowing of seeds: the sociology of primitive sex (1978), and Bhattacharyya has described an image of Parvati associated with a lingam in "Apitakuca image from Kagajipara, Bangladesh."

Indonesia

The far-flung influence of Indian erotic imagery is indicated by O'Connor's article on an Indic lingam image in Hindu Indonesia and the distribution of lingams in Asia ("Note on a mukhalinga from Western Borneo," Artibus Asiae, 1967).

Nepal

Tantric sects have remained active in Nepal even though their influence in India waned centuries ago. The stone temples of India become translated to wood in Nepal, as did the temple sculpture. Polychrome sculptures of gods and goddesses grace the exterior of the temples, among which are erotic scenes, usually representating the lovemaking of celestial beings. These sculptures have been described and illustrated in Rita-Lila; an interpretation of the Tantric imagery of the temples of Nepal by Giuseppe Tucci and Erotic themes of Nepal by Majurpuria and Devi.

South Asia

Tibet

Tibet is famous for its small-scale sculptures in bronze that show gods engaged in celestial intercourse with their own female aspect and religious paintings on cloth (tankas). The former are discussed in Brice Mattieussent's article "Un art erotique: la 'thanaka' Tibetaine." The prevalence of phallic imagery in Tibetan art is explored by Richardson in "Phallic symbols in Tibet" and Rinpoche's "Phallic symbols".

General

Background

20-1 BHATTACARYA, BRAJAMADHABA. Saivism and the phallic world.
 2 vols. New Delhi: Oxford University Press, 1975. Map, bib.,
 index, illus.
 Study of the worship of Siva, including the phallic aspects.

20-2* GUYOT, FELIX [C. Kerneiz]. Hatha yoga, amour et sexualite.
 Paris: Jules Tallandier, 1946.

20-3 LAL, KANWAR. Kanya and the Yogi. Delhi: Arts & Letters, 1970.
 104 pp., illus., gloss., index.
 Explanation of the bhoga as alternative path to that of yoga,
 noting that women were rejected in the latter, but intregal to the
 former.

20-4 O'FLAHERTY, WENDY DONIGER. Siva: the erotic ascetic. Ox-
 ford: Clarendon Press, 1973. 386 pp., bib., index, illus. (Re-
 print of earlier Oxford University Press edition under the title
 Asceticism and eroticism in the mythology of Siva.)
 Scholarly study of Siva, especially his erotic aspects (i.e., as
 Kama).

20-5 RINPOCHE, RECHUNG. "Phallic symbols." Bulletin of Tibetol-
 ogy 10, no. 1 (5 March 1973): 60-62.
 Literary sources for the worship of the lingam in the Indian
 sub-continent.

20-6 SCHWARZ, ARTURO. L'arte dell'amore in India e Nepal: la dimen-
 sione alchemica del mito di Siva. Rome: Laterza, 1980. 427 pp.,
 illus. (some col.), index.
 Study of the philosophy, religion, and cultural expression of
 love (including sex) in traditional south Asia.

20-7 SHAH, JELAL M. "India and Pakistan, sex life in." In The Ency-
 clopedia of sexual behavior, edited by Albert Ellis and Albert
 Abarbanel, 528-37, ref. New York: Hawthorn, 1961.
 Survey of sexual customs and beliefs in south Asia.

20-8 VERNI, PIERO. Il culto del lingam. Universo sconosciuto.
 Milan: Sugar Co., 1976. 204 pp., map, figs., illus., bib.
 Study of the Shiva/phallic worship in the Indian subcontinent.

20-9 WOODROFFE, JOHN. Shakti and Shakta: essays and addresses.
 6th ed. London: Luzac, 1965. 732 pp. (First edition, 1929.)
 Classic study of male and female energy in Hindu beliefs.

Tantrism

20-10 BRZOSTOSKI, JOHN. "Tantra art, etc." Arts Magazine 44, no. 5
 (March 1970): 35-38, illus. (some col.).
 Discussion of color symbolism in Tantric art.

20-11* COLAABAVALA, F.D. Tantra: the erotic cult. Delhi: Orient
 Paperbacks, 1976.

20-12 CONIL-LACOSTE. MICHEL. "For the happy few, and gurus, too:
 Tantras and Mantras." Art News 69 (March 1970): 34-35.
 Exhibition review with brief explanation of meanings behind
 Tantric paintings.

20-13 DEVI, KAMALA. The Eastern way of love: Tantric sex and erotic
 mysticism. New York: Simon and Schuster, 1977. 160 pp.,
 gloss., bib., figs. (some col.).
 Explanation of the sexual practices of Indian tantrism.

20-14 DOUGLAS, NIK. Tantra yoga. Delhi: Munshiram Mandharlal,
 1970. 125 pp., bib., illus. (some col.).
 Overview of Tantric beliefs and practices, well illustrated with
 art and modern photos of practitioners.

20-15* Erotic pleasure: Tantra. Ill. (col.).

20-16 GALLEGO, J. "Cronica de Paris: Tantrismo." Goya 96 (May
 1970): 362-63, illus.
 Exhibition review with an explanation of Tantric art.

20-17 GARRISON, OMAR V. Tantra: the yoga of sex. Introduction by
 Charles Sen. New York: Causeway, 1964. 252 pp., gloss., bib.,
 index.
 Explanation of the meaning and practice of Tantric Yoga.

20-18* KALE, ARVINO, and KALE, SHANTA. Tantra: the secret power of
 sex. Bombay: Jaico, 1976.

20-19 KRISHMAN, S.A. "Matter & spirit: editorial." Lalit Kala Contem-
 porary 12-13 (April-September 1971): 4-7, figs.
 General discussion of the principles of Tantric art.

20-20 MAZUMDAR, NIRODE. "On Tantra art." Lalit Kala Contemporary
 12-13 (April-September 1971): 33-34.
 Discussion of Tantric imagery.

20-21 MOFFETT, ROBERT KNIGHT. Tantric sex. New York: Berkley,
 1974. 174 pp., intro.
 Explanation of Tantric beliefs and practices compared with
 analogous ideas in Western culture.

20-22 MOOKERJEE, AJIT. "Tantra, art as a path to spiritual self-fulfill-
 ment." Graphis 22, no. 127 (1966): 442-53+, illus. (some col.).
 Very clear explanation of Tantric art with many color ex-
 amples.

20-23 _____. Tantra art: its philosophy and physics. New Delhi:
 Ravi Kumar, 1966. 125 pp., illus. (some col.), bib.
 Meaning behind Tantric art fully explored.

20-24 _____. "Tantra art in search of life divine." Lalit Kala Contem-
 porary 12-13 (April-September 1971): 8-10, illus. (some col.).
 Basic tenets of Tantra discussed, especially those expressed in
 art.

20-25 _____. Yoga art. With contribution by Philip Rawson. Boston:
 New York Graphic Society, 1975. 208 pp., illus. (some col.).
 Beautifully illustrated book with discussion of Tantric images.

20-26 MUMFORD, JOHN. Sexual occultism: the sorcery of love in prac-
 tice and theory. St. Paul, Minn.: Llewellyn, 1975. 178 pp., bib.,
 illus. (some col.), figs.
 Discussion of sexual practices of Tantric cults.

20-27 NARAYAN, BADRI. "The significance of Tantric imagery today."
 Lalit Kala Contemporary 12-13 (April-September 1971): 35-36,
 illus.
 Discussion of the influence of Tantric art on contemporary arts
 in India.

20-28 PALSIKAR, S.B. "Thoughts on Tantra." Lalit Kala Contemporary
 12-13 (April-September 1971): 13-14.
 Nature of some Tantric images discussed.

20-29 RAWSON, PHILIP. The Art of Tantra. Greenwich, Conn.: New
 York Graphic Society, 1973. 216 pp., illus. (some col.), gloss.,
 bib., index.
 Thorough survey of Tantric art.

20-30 _____. Tantra. London: Arts Council of Great Britain, 1971.
 130 pp., illus. (some col.), bib.
 Catalog of exhibition of Tantric objects.

20-31　　　　　. Tantra: the Indian cult of ecstasy. New York: Avon;
Bounty, 1973. 128 pp., illus. (some col.).
　　Explanation of Tantra and its sexual symbolism.

20-32　　　　　. "Tantra art." Studio 176, no. 906 (December 1968): 256-
59, illus. (some col.).
　　Review of exhibition of Tantric art.

20-33　SARASWATI, JANAKANANDA. Yoga, Tantra and meditation in your
daily life. Translated by Sheila La Farge. New York: Ballantine,
1976. 112 pp., index, figs., illus.
　　Practical guide to Tantric yoga.

20-34　SOULIE, BERNARD. Tantra: erotic figures in Indian art. Gene-
va: Miller Graphics, 1982. 96 pp., illus. (col.).
　　Aspects of Tantric belief and erotic art explored.

20-35　SOUZA, F.N. "Tantra Art: a review article." Studio 172, no. 884
(December 1966): 306-11, illus. (some col.).
　　Review of Mookerjee's Tantra Art serves to summarize the sub-
ject for general readers.

20-36　Tantra rites of love. Introduction by Gabrielle Mandel; edited by
Laura Casalis; translated from Italian by Katherine Benita Wells.
New York: Rizzoli, 1979. 93 pp., illus. (col.).
　　Picture book of Indian miniatures with short explanatory intro-
duction on the meaning of Tantra.

20-37*　THIRLEBY, ASHLEY. Tantra: the key to sexual power and plea-
sure. New York: Dell, 1978. 192 pp., bib.

20-38　WASSERMANN, EMILY. "Tantra." Artforum 8 (January 1970): 46-
50, illus.
　　Brief explanations for a small number of Tantric paintings.

Art

20-39　ANAND, MULK RAJ. Kama Kala: some notes on the philosophical
basis of Hindu erotic sculpture. Geneva: Nagel, 1958. 45 pp.
(text), illus. (some col.).
　　History of and explanation for erotic art of India and neighbor-
ing cultures, particularly medieval sculptures.

20-40　　　　　. "Of Kamakala: some notes on the philosophical basis of
Hindu erotic sculpture." Marg 10, no. 3 (June 1957): 45-64, figs.,
illus.
　　Religion and philosophical concepts central to understanding
erotic art of Indian sub-continent discussed.

20-41　DANIELOU, ALAIN. "An approach to Hindu erotic sculpture."
Marg 2, no. 1 (1948 ?): 79-89+, illus. (Reprinted in International
Journal of Sexology 6, no. 3 [February 1953]: 144-48.)

South Asia

20-42 _____. L'erotisme divinise. Paris: Editions Buchet/Chastel,
1962. 115 pp., illus.
Brief, illustrated discussion of various aspects of eroticism in
Hindu beliefs as evidenced by art.

20-43 _____. La sculpture erotique Hindoue. Paris: Editions Buchet/-
Chastel, 1973. 243 pp., illus.
Study of erotic sculpture with illustrations arranged by sub-
ject/iconography.

20-44* DOUGLAS, NIK, and SLINGER, PENNY. The erotic sentiment in the
paintings of India and Nepal. Rochester, Vt.: Inner Traditions
International, 1988. 96 pp., ill. (some col.).

20-45 GICHNER, LAWRENCE E. Erotic aspects of Hindu sculpture.
N.p.: Privately printed, 1949. 56 pp., illus., bib.
Collector's study of Hindu erotic sculpture, illustrated pri-
marily with examples from India.

20-46 HEARD, GERALD. "Erotics and religion, art of Greater India sur-
veyed in Los Angeles exhibition." Art News 49 (April 1950): 16-
20+.
Author suggests that the dichotomy of religion and eroticism is
not universal, but can be seen in the erotic art of the Indian sub-
continent.

20-47 MITTERWALLNER, GRITLI V. "Evolution of the Linga." In Dis-
courses on Siva, edited by Michael Meister, 12-31, figs., illus.
Philadelphia: University of Pennsylvania Press, 1984.
Attempt to describe the stylistic development of the lingam in
the history of India and neighboring countries.

Bangladesh

20-48 BHATTACHARYYA, D. "Apitakuca image from Kagajipara, Bangla-
desh." Artibus Asiae 36, no. 1-2 (1974): 89-96, illus.
Study of a sculpture of Parvati associated with a stone lingam
(phallus).

India

Background

20-49 ANANDA, M.R. and DANCE, LANCE, ed. Kama Sutra of Vatsya-
yana. Atlantic Highlands, N.J.: Humanities Press, 1982. 268
pp., illus.
Illustrated edition of the classic sex text of India.

20-50 BANERJI, SURES CHANDRA. Crime and sex in Ancient India.
Calcutta: Naya Prokash, 1980. 183 pp., gloss., bib., index, illus.

Study of ancient sex life including a chapter on erotic art (pp. 128-37).

20-51 _____. Erotica in Indian dance. New Delhi: Cosmo Publications, 1983. 171 pp., figs., illus.
Thorough study of the erotic aspects of traditional dance.

20-52 BHATTACHARYYA, NARENDA NATH. History of Indian erotic literature. New Delhi: Munshiram Mandharlal, 1975. 135 pp., bib., index.
Study of history of revered texts on sexual matters.

20-53 _____. The Indian mother goddess. New Delhi: Manohar, 1977. 319 pp., index.
Thorough study of the mother goddess in the Hindu religion.

20-54 BOSE, MANINDRA MOHAN. The Post-Chaitanya Sahajiya cult of Bengal. Calcutta: University, 1930. 320 pp., index.
Study of a Krishna cult focusing on erotic practices.

20-55* BRIGGS, J. Pop-Up Kama Sutra.
Book of pop-up illustrations based on traditional Indian erotic paintings.

20-56 BURKE, Th. Phallic miscellanies: facts and phases of ancient and modern sex worship, as illustrated chiefly in the religions of India. N.p.: Privately printed, 1891. 102 pp.
Study of sexual aspects of Indian religions.

20-57* CHAKLADAR, HARAN CHANDRE. Studies in Vatsyayana's Kamasutra: social life in ancient India. Calcutta: Greater India Society, 1929. 212 pp., illus.

20-58* CHAKRABERTY, CHANDRA. Sex life in ancient India, an explanatory and comparative study. Calcutta: Firma K.L. Mukhopadhyay, 1963. 167 pp.

20-59 CHAND, KHAZAN. Indian sexology. New Delhi: S. Chand, 1972. 449 pp., illus.
Overview of sexual customs and practices in India.

20-60* DANGE, SADASHIV AMBADAS. "The Vedic Mithuna (concept and practice)." Journal of the Oriental Institute 25, nos. 3-4 (March-June 1976): 197-212.

20-61 DASS, JARMANI, and DASS, RAKESH BHAN. Maharani: (love adventures of Indian Maharani's and Princesses). New Delhi: S. Chand, 1972. 259 pp., por.
Descriptions of the nature of the sex life of the rulers of India.

20-62 DE, SUSHIL KUMAR. Ancient Indian erotics and erotic literature. Calcutta: Mukhopadyay, 1959. 109 pp., index.

Survey of revered historical texts regarding sex and inter-personal relationships.

20-63 DIMOCK, EDWARD C. The place of the hidden moon: erotic mysticism in the Vaisnava-Sahasiya cult of Bengal. Chicago: University of Chicago Press, 1966. 299 pp., bib., index.
Study of a Hindu sect following erotic practices.

20-64 FEHLINGER, H. "Vom Geschlechtsleben der Inder." Zeitschrift fur Sexualwissenschaft 7 (1920-21): 313-24.

20-65 FISER, IVO. Indian erotics of the oldest period. Praha: Universita Karlova, 1966. 139 pp., index.
Scholarly study of early Vedic writings on sexual matters.

20-66* GATEWOOD, LYNN E. Devi and the spouse goddess: women, sexuality, and marriage in India. Riverdale, Calif.: Riverdale Co., 1985. 206 pp.

20-67 GHOSH, DEVA PRASHAD. Kama Ratna: Indian ideals of feminine beauty. New Delhi: R&K, 1973. 69 pp. (text), figs., illus.
Study of changing concepts of feminine beauty in Indian history.

20-68 JHA, AKHILESHWAR. Sexual designs in Indian culture. New Delhi: Vikas, 1979. 185 pp., bib., index.
Sociocultural study of sex and the arts in India.

20-69 KALAYANA MALLA. Ananga Ranga: the Hindu art of love. Translated and annotated by F.F. Arbuthnot and Richard F. Burton. New York: Medical Press, 1964. 144 pp., index, illus.
Classic treatise on love and sex. Includes pharmacopeia "Ars Amoris Indica" by H.S. Gabers and S. Rama.

20-70 KALYANAMALLA. Ananga Ranga. Translated and edited by Tridibnath Ray; foreword by Girindrashekhar Bose. 4th rev. ed. Calcutta: S. Ghattack for the Medical Book Co., 1956. 183 pp.
See above.

20-71 KANNOOMAL. "Some notes on Hindu erotics." Rupam 4 (October 1920): 20-27, illus. (some col.).
Discussion of Hindu erotic literature.

20-72 KHOSLA, GOPAL DAS. Pornography and censorship in India. New Delhi: Indian Book Co., 1976. 168 pp., intro.
Study of sexual expression in India and the historic attempts to suppress it. Includes chapters on history of eroticism, Tantrism, and erotic sculptures on Hindu temples.

20-73 KIRILI, A. "Lingaistics." Art In America 70, 5 (May 1982): 122-27, illus.

Sculptor describes and explains his fascination with the linga in Indian culture.

20-74* KOCH, OSCAR. Der Indianische Eros. Berlin: Continent, 1925. 122 pp., illus.

20-75 The Koka Shastra: being the Ratirahasya of Kokkoka: and other Medieval Indian writings on love. Translated, with introduction by Alex Comfort; preface by W.G. Archer. New York: Stein and Day, 1964. 171 pp., map.
Medieval sex text translated and discussed.

20-76 KOKKOKA. The Hindu secrets of love: Rati Rahasya of Pandit Kokkoka. Translated from Sanskrit by S.C. Upadhyaya; foreword by V. Raghavan. Bombay: D.B. Taraporevala, 1965. 140 pp., gloss., bib., illus. (some col.).
Ancient sex treatise written 830-960 A.D.

20-77 _____. Ratirahasya: Geheimnisse der Liebe-Kunst. Schmiden and Stuttgart: Franz Decker, 1960. 190 pp., gloss.
Sanskrit treatise on love and sex.

20-78* KRISHNANADA, SWAMI RAM. Classical Indian erotology. Translated, revised, and corrected by Sitafam Anand. City of Industry, Calif.: Collector's Publications, ca. 1968. 186 pp. (First edition, Paris: Olympia, 1958.)

20-79 LAL, KANWAR. The Religion of love. Delhi: Arts and Letters, 1971. 102 pp., index, ref., gloss., illus. (some col.).
Study of Indian religions and their concepts of sex and love.

20-80 The love teachings of the Kama Sutra: with extracts from Koka Shastra, Ananga Ranga and other famous Indian works on love. Translated from Sanskrit by Indra Sinha. New York: Crescent Books, 1908. 192 pp., gloss., bib., illus. (col.).
Classical sex writings accompanied by relevant illustrations from erotic paintings.

20-81* MARGLIN, FREDERIQUE APFFEL. "Wives of the God-King: the rituals of Hindu temple courtesans." Ph.D. dissertation, Brandeis University, 1980. 537 pp.

20-82 MEMBER OF THE ROYAL ASIATIC SOCIETY OF LONDON (Yato Dharma Stato Java?). Sex life in India. Calcutta: Medical Book, 1952. 123 pp. (First edition, 1909 under title Marriage ceremonies and Priapic rites in India and the East.)
Survey of sex customs and practices.

20-83 MEYER, JOHANN JAKOB. Sexual life in ancient India: a study of the comparative history of Indian cultures. 2 vols. in 1. New York: E.P. Dutton, 1930. Index.
Social study of love, marriage, and sex.

20-84* PISHAROTI, K.R. "Sex life in ancient India–some thoughts." Journal of the Bhandarkar Oriental Research Institute 23 (1942).

20-85 SALETORE, RAJARAM NARAYAN. Sex in Indian harem life. New Delhi: Orient Paperbacks, 1978. 181 pp.
 History of the royal harems of India.

20-86 _____. Sex life under Indian rulers. Delhi: Hind Pocket Books, 1974. 252 pp.
 History of sex life of Indian ruling elites.

20-87 SCHMIDT, RICHARD. Beitrage zur Indischen Erotik: das liebes-lebendes Sanskritvolkes. 2d ed. Berlin: Hermann Barsdorf, 1911. 168 pp. (First edition issued in 6 parts [Leipzig: Lotus, 1902].)
 General survey of Hindu sexual customs and practices.

20-88 SELLON, EDWARD. "On the phallic worship of India." Memoirs Read Before the Anthropological Society of London 1 (1863–64): 327–34.
 Discussion of the nature of phallic worship in India.

20-89 SHASHI, SHYAM SINGH. Night life of Indian tribes. Delhi: Agam Prakashan, 1978. 110 pp., illus.
 Ethnographic survey of the sex customs and practices of a number of peoples of India.

20-90 SINHA, S.N., and BASU, NRIPENDRA KUMER. History of prosti-tution in India. Introduction by B.M. Barua. 2 vols. Calcutta: Bengal Social Hygiene Assn., 1933. Bib., index, illus.
 Study of prostitution in India, both ancient (vol. 1) and modern (vol. 2).

20-91 SUR, ATUL KRISHNA. Sex and marriage in India; an ethnohis-torical survey. Bombay: Allied, 1973. 194 pp., bib., gloss., index.
 Survey of sex customs in India.

20-92 THOMAS, PAUL. Kama Kalpa: Hindu ritual of love. Bombay: D.B. Taraporevala, 1956. 151 pp., index, illus., figs.
 Illustrated study of Indian customs and practices regarding love and sex.

20-93 VATSYAYANA (called Mallanaga). Art of love: the second book of Kama Sutra. New York: Medical Press, 1962. 62 pp., illus. [1st edition 1937].
 Parts of the Kama Sutra.

20-94 _____. The Kama Sutra of Vatsyayana. Translated for the Hin-doo Kama Sutra Society by Richard Burton. Benares and New York: Society of the Friends of India, 1883. 181 pp., illus. [A "print history" of the many editions of the Kama Sutra published in

Europe and modern India is provided by the Humanities Press (1982) edition].

Early treatise on proper lovemaking, includes advice on a wide range of subjects, from sex techniques to personal hygiene, etc. (Other editions illustrated with reproductions of erotic art: Calcutta: Medical Book Co., 1943; Bombay: Taraporevala, 1961; London: Skilton, 1963; Delhi: Asia Press, 1967; New Delhi: R.K. Publishing House, 1967; Delhi: Kayenkay Agencies, 1971; Agra: Tiimes Paperback Books, 1974; London: Spring Books, 1980; Atlantic Highlands, N.J.: Humanities Press, 1982.)

20-95*　WERNER, B. Indisches Liebesleben. Berlin: Oestergaard, 1928. 312 pp., illus.

20-96　WINDSOR, EDWARD. The Hindu art of love. New York: Panurge, 1932. 276 pp.

Study of traditional Indian sex life, treating dominant themes in separate chapters.

Art

20-97*　ADAM, MICHAEL. The tree of love: an interpretation of Indian art. London: Village Press, 1973. 32 pp., illus.

20-98　AGRAWALA, PRITHVI. Mithuna: the male-female symbol in Indian art and thought. New Delhi: Munshiram, 1982. 105 pp. (text), bib., index, ill.

Thorough study of the mithuna image with a chapter on "Mithuna as Maithuna" that discusses the image of the sexually active couple.

20-99　ANAND, MULK RAJ. "The best of lovers-the Krishna Lila." Marg 31, no. 2 (March 1978): 20-48, illus. (some col.).

Study of the myths of the loves of Krishna.

20-100　BACH, HILDE. Indian love paintings. New York: Crescent Books, 1985. 159 pp., bib., illus. (col.).

Survey of the theme of feminine beauty and eroticism in Indian miniature paintings.

20-101*BANERJEE, ADRIS. "Lingams of Jalpaiguri." Our Heritage 14, no. 1 (January-June 1966): 13-22, bib.

20-102　BRISSON, CHRISTOPHER. "The erotic statues of India." Sexology 40, no. 6 (January 1974): 23-25, illus.

Simplistic overview of Indian erotic sculpture.

20-103　BUSSABLI, MARIO. Eros Indiano. Rome: Bulzoni, 1972. 108 pp. (text), figs., illus., bib.

Study of the sexual aspects of traditional Indian sculpture, especially the decoration of medieval temples.

20-104 CHAKRABARTI, DILIP K., and GLANTZ, KALMAN. "Erotic terra-
cottas from Lower Bengal." Journal of Ancient Indian History 5,
nos. 1-2 (1971-72): 149-54, illus.
Study of Sunga-Gupta molded plaques showing erotic scenes.

20-105 CLOTHIER, PETER. "India's erotic art." Hustler 5, no. 3 (Sep-
tember 1978): 68-71, illus. (col.).
Reproductions of a group of late nineteenth-century erotic art.

20-106 DAS GUPTA, C.C. "Female fertility figures." Man 36 (article no.
246) (October 1936): 183-84, illus.
Terracotta female figure discussed.

20-107 DAVIDSON, J. LEROY. "Mannerism and neurosis in the erotic art
of India." Oriental Art, n.s., 6, no. 3 (Autumn 1960): 82-90, illus.
Discussion of theories to explain the existence of Indian erotic
art.

20-108 DESAI, DEVANGANA. "Erotic sculpture." Illustrated Weekly of
India 96, no. 24 (15 June 1975): 22-25, illus.
Considers reasons suggested for the existence of erotic sculp-
ture on medieval temples and offers author's interpretation.

20-109 _____. Erotic sculpture of India; a socio/cultural study. Fore-
word by Niharrangjan Ray. New Delhi: Tata McGraw-Hill, 1975.
269 pp., gloss., index, map, figs., illus.
Scholarly study of ancient and medieval erotic art.

20-110 _____. "Relevance of Tantrism to erotic temple sculpture." In
Madhu; recent researches in Indian archaeology and art history;
Sri M.N. Deshpande Felicitation Volume, edited by M.S. Nagaraja
Rao, 201-5, illus. New Delhi, 1981.
Explanation of possible relationship between Tantric beliefs
and erotic images on medieval temples.

20-111* DHARMA RAO, THAPI. Devalayalamida Butu Bommalenduku.
1962. 128 pp., por., bib.
Study of erotic temple sculptures. Written in Telegu.

20-112 DONALDSON, THOMAS. "Propitious-apotropaic eroticism in the
art of Orissa." Artibus Asiae 37, nos. 1-2 (1975): 75-100, illus.,
gloss.
Detailed study of the maithuna image.

20-113 FISCHER, KLAUS. Erotik und Askese in Kult und Kunst der Inder.
Cologne: Dumont, 1979. 292 pp., map, figs., index, bib., illus.
Study of the image of the maithuna in Indian art and the theme
of love/sex in both Hindu and Islamic Indian culture.

20-114 FOUCHET, MAX-POL. The erotic sculpture of India. Translated
by Brian Rhys. New York: Criterion, 1959. 95 pp., intro., illus.
Explanation for erotic aspects of Hindu art.

20-115* KAUL, MANOHAR. "Genesis of erotics in Indian sculpture."
Roopa-Lekha 52, nos. 1-2 (1981): 72-76.

20-116 KRAMRISH, STELLA. "Reflections on the house and body of God."
Marg 10, no. 3 (June 1957): 19-23, figs., illus.
Relation of sculpture to buildings in Indian art discussed.

20-117 Krishna; the divine lover: myth and legend through Indian art.
Boston: David R. Godine Publications, 1983. 218 pp., illus. (some
col.), gloss., index, bib.
Anthology of scholarly studies of various aspects of Krishna,
including the erotic stories.

20-118 LAL, KANWAR. The cult of desire: interpretation of erotic sculp-
ture in India. 2d ed. New Hyde Park, N.Y.: University, 1967.
104 pp. (text), illus.
Thorough discussion of the erotic element of temple sculptures.

20-119 _____. Temples and sculptures of Bhubaneshwar. Delhi: Arts
and Letters, 1970. 124 pp., bib., index, figs., plan, map, illus.
Survey of site at Bhubaneshwar, including the erotic sculptures
on the Temple of Lingaraja.

20-120 LANNOY, RICHARD. The eye of love: in the temple sculptures of
India. New York: Grove, 1976. 160 pp., illus.
Study of Indian temple erotic sculpture.

20-121 LEESON, FRANCIS. Kama Shilpa: a study of Indian sculpture de-
picting love in action. Bombay: D.B. Taraporevala, 1962. 133
pp., gloss., bib., index, illus.
Study of Indian erotic sculpture.

20-122* MARMORI, GIANCARLO. Le citta dellamore. Anthology by Elena
Guicciardi; appendix on Indian sex life by Alain Danielou. Parma:
F.M. Ricci, 1976. 161 pp., illus.

20-123 Masterpieces of the female form in Indian art. Introduction by
Rustam Jehangir Mehta. Bombay: D.B. Taraporevala, 1972. 56
pp., bib., illus.
Study of the image of the sensuous female in Indian art.

20-124 MENEN, AUBREY. "The temple belles of India." Holiday 45, no. 2
(February 1969): 48-49+, illus., por.
Unscholarly analysis of erotic temple sculptures suggesting
that they were "billboard" advertisements for temple prostitutes.

20-125 MITTER, PARTHA. Much maligned monsters: history of European
reactions to Indian art. Oxford: Clarendon Press, 1977. 351
pp., index, bib., map, plan, illus.
Discussion includes sections on European interest in India's
erotic art.

20-126 MODE, HEINZ. The woman in Indian art. Translated from German by Marianne Herzfeld; revised by D. Talbot Rice. New York: McGraw-Hill, 1970. 51 pp., bib., gloss., map, illus. (some col.), figs.
Study of the role of women in Indian art, including "woman as lover."

20-127 PANIGRAHI, KRISHNA CHANDRA. "Obscene sculptures of Orissan temples." Proceedings of the Indian History Congress (9th session) 4 (1945): 94-97.
Brief study of erotic sculptures at a number of sites in Orissa.

20-128 RANDHAWA, MOHINDAR SINGH. Kangra paintings on love. New Delhi: National Museum, 1962. 209 pp., bib., index, illus. (some col.).
Iconography and background to images of love.

20-129 RAWSON, PHILIP. Erotic art of India. New York: Universe, 1977. Unpaged, illus. (col.).
Introduction to Indian sexual beliefs and practices as evidenced by erotic miniatures.

20-130 ROY, UDAI NARAIN. Salabhanjika in art, philosophy, and literature. Allahabad: Lokbharti, 1979. 96 pp., index, bib., illus.
Sensuous female figure in Indian sculpture surveyed.

20-131 SANKALIA, H.D. "The nude goddess in Indian art." Marg 31, no. 2 (March 1978): 4-10, illus. (some col.).
Study of a common theme in Indian art.

20-132* SANYALA, NARAYAN. Erotica in Indian temples. Calcutta: Navana, 1984. 158 pp., illus., map, bib., index.

20-133 SELLON, EDWARD. "On the phallic worship of India." Memoirs Read Before the Anthropological Society of London 1 (1863-64): 327-34.
Lingam-yoni stone image in India is discussed.

20-134 SEN, GEETI. "Sex and fantasy in India." Times of India (Sunday Review), 6 May 1984, 1+, ill.
Discusses the sensual/erotic aspects of the paintings of four contemporary Indian artists in the light of India's erotic art history.

20-135* "Sexual motifs in Indian painting." Vivekananda Kendra Patrika 11, no. 1 (February 1982): 24-26.

20-136 SMEDT, MARC DE. The Kama-Sutra; erotic figures in Indian art. New York: Crescent Books, 1980. 108 pp., illus. (col.).
After brief introduction on Indian sexual practices and beliefs, provides an illustrated version of the Kama Sutra.

20-137 SOULIE, BERNARD. Tantra: erotic figures in Indian art. Geneva: Miller Graphics, 1982. 96 pp., illus. (col.).
Aspects of Tantric beliefs and Indian erotic art explored.

20-138 SRIVASTAVA, A.K. "Siva-Linga with Ganas, a new find from Mathura." Artibus Asiae 43, no. 3 (1981-82): 236-38, illus.
Phallic pillars during the Kushan period described (includes very poor illustrations).

20-139* SRIVASTAVA, MAHESH CHANDRA PRASAD. Mother Goddess in Indian art, archaeology, and literature. Delhi: Agam, 1979. 231 pp., index, bib., illus.
Study of Indian mother goddesses and their imagery in art.

20-140 VOGEL, CLAUS. Tempel der Liebesleben. Wiesbaden: Reichelt, 1963. 203 pp., bib., illus.
Background and possible meaning of sexual sculptures at Khajuraho, Konarak, etc.

Khajuraho

20-141 AGARWAL, URMILA. Khajuraho sculptures and their significance. Delhi: S. Chand, 1964. 220 pp., bib., figs., illus.
General survey of the site and discussion of the iconography of images found there.

20-142 ANAND, MULK RAJ. "Homage to Khajuraho." Marg 10, no. 3 (June 1957): 2-5 (text), plan, illus.
Brief discussion of sculptures at Khajuraho.

20-143 ANAND, MULK RAJ; FABRI, CHARLES; and KRAMRISH, STELLA. Homage to Khajuraho. 2d ed. Bombay: Marg, 1962. 56 pp., plan, illus.
Thorough explanation of the site at Khajuraho.

20-144 CHAKRAVARTY, KALYAN KUMAR. The art of India: Khajuraho. New Delhi: Gulab Vazirani for Arnold-Heinemann Publications (India), 1985. 98 pp., bib., illus. (some col.).
Survey of temples at Khajuraho and their sculpture; includes discussion of the erotic art.

20-145 CHANDRA, PRAMOD. "The Kaula-Kapalika cults at Khajuraho." Lalit Kala 1 (April 1955): 98-107, illus.
Study of a cult which may provide the background to understanding the erotic sculptures at Khajuraho.

20-146* DAS, H.C. "Erotic art of Khajuraho temples." Paper presented at Art of Khajuraho Conference, Khajuraho (India), 12 February 1987.

20-147 DESAI, DEVANGANA. "Placement and significance of erotic sculp-
tures at Khajuraho." In Discourses on Siva, edited by Michael
Meister, 143-55, plan, notes, illus.. Philadelphia: University of
Pennsylvania Press, 1984:.
Suggests that the iconography and placement of figures on
temples are interrelated and indicates something about the meaning of
the sculptures.

20-148* DHAMA, B.L., and CHANDRA, S.C. Khajuraho. Rev. ed. Delhi:
Department of Archaeology, Manager of Publications, 1957. 36
pp., map, illus.

20-149 DIVYA, AMBIKA PRASAD. "Erotic art of Khajuraho—a perspec-
tive." Paper presented at Art of Khajuraho Conference, Kha-
juraho (India), 10 February 1987.

20-150 FLORY, MARCEL. Les tempels de Khajuraho. Preface by Raja
Rao. Paris?: Delpire, 1965. 162 pp., illus. (some col.), bib.
General photo study of site.

20-151 GANGOLY, ORDHENDRA COOMAR. The art of the Chandelas.
Edited and surveyed by A. Goswami. Calcutta: Rupa, 1957. 38
p. (text), illus.
Historical and cultural background to the sculptures at Kha-
juraho and other sites.

20-152 GOETZ, HERMANN. "The historical background of the great
temples of Khajuraho." Arts Asiatiques 5, no. 1 (1958): 35-47.
Thorough discussion of the erotic element of temple sculptures.

20-153 JAFFREY, MADHUR. "Seductive sculptures of Khajuraho." Asia
2, no. 2 (July-August 1979): 8-15, illus. (col.).
Personal commentary about erotic art at Khajuraho.

20-154* KALIDAS, RAJU. "Alignment of erotic sculptures in the temples of
Khajuraho and temple cars of Tamilnadu—a comparative study."
Paper presented at Art of Khajuraho Conference, Khajuraho
(India), 12 February 1987.

20-155 KRISHNA DEVA. "The temples of Khajuraho in Central India."
Ancient India 15 (1959): 43-65, bib., plan, illus.
Focuses on the architecture of the site, only passing mention of
sculptures.

20-156 KRISHNA DEVA, and NAYAL, B.S. Khajuraho. New Delhi: Direc-
tor General, Archaeological Survey of India, 1971. 44 pp., bib.,
map, illus.
Guide to the site with explanation of erotic sculptures.

20-157 LAL, KANWAR. Asparas of Khajuraho. Delhi: Asia Press, 1966.
31 pp. (text).

Image of the sensual female form as expressed at Khajuraho explored.

20-158 _____. Erotic sculptures of Khajuraho. Delhi: Asia Press, 1970. 75 pp. (text), illus.
Thorough discussion of the history and meaning of erotic sculptures.

20-159 _____. Immortal Khajuraho. New York: Castle, 1967. 253 pp. (text), bib., index, figs., plan, illus. (First edition, Delhi: Asia Press, 1965.)
Extensive study of Khajuraho and its erotic sculpture.

20-160 LEACH, EDMUND R. "The gatekeepers of heaven: anthropological aspects of grandiose architecture." Journal of Anthropological Research 39, no. 3 (Fall 1983): 243-64, illus., bib.

20-161 MEISTER, MICHAEL W. "Juncture and conjunction: punning and temple architecture." Artibus Asiae 41, nos. 2-3 (1979): 226-34, illus.
Contends that placement of sexual figures is related to architectural structure.

20-162 NATH, R. The art of Khajuraho. Columbia, Mo.: South Asia Books, 1980. 181 pp., map, figs., index, bib., illus.
Study of Khajuraho--the site, structures, background, and decoration. Text is distinctly "moralistic".

20-163 PANDE, G.C. "Erotic sculptures: problem or pseudo-problem." Paper presented at Art of Khajuraho Conference, Khajuraho (India), 9 February 1987.

20-164 PANT, SUSHILA. "The psycho-analysis of the erotic sculpture of Khajuraho." Paper presented at Art of Khajuraho Conference, Khajuraho (India), 10 February 1987.

20-165* RAIZADA, R.K. "Khajuraho in dollar market: socio-legal appraisal of obscenity." Journal of the Indian Law Institute 13, no. 2 (April-June 1971): 208-19.
Economic study of the role of Khajuraho in tourist industry and possible legal ramifications.

20-166 SETH, B.R. Khajuraho in pictures. Delhi: Asia Press, 1970. 22 pp. (text), illus.
Discussion of buildings and erotic sculpture at Khajuraho together with many photos, includes a section entitled "Why erotic sculptures?"

20-167* SPINK, WALTER M., and LEVINE, DEBORAH. Khajuraho: catalogue. State University of New York, 1968. 80p., illus.

20-168　TRIPATHI, CAKSHMI KANT. "The erotic scenes of Khajuraho."
Bharati: Bulletin of the College of Indology 3 (1959-60): 82-104,
illus.
　　　　Moralistic interpretation of the erotic sculptures.

20-169　VIDYA, PRAKASH. Khajuraho: a study in the cultural conditions
of Chandella society. Bombay: D.B. Taraporevala, 1967. 217
pp., bib., index, map, illus., figs., plan.
　　　　General study of site with sections addressing the topic of the
　erotic art.

20-170　VIJAYATUNGA, JINADASA. Khajuraho. Delhi: Ministry of Infor-
mation and Broadcasting, 1960. 20 pp. (text), illus.
　　　　Guide to the site.

20-171　ZANNAS, ELIKY. Khajuraho. Introduction by Jeannine Auboyer.
The Hague: Mouton, 1960. 227 pp. (text), index, illus. (some
col.), plan, map.
　　　　Study of site with many good illustrations.

Konarak

20-172　ANAND, MULK RAJ. "The great delight: an essay on the spiritual
background of the erotic sculpture of Konarak." Evergreen Re-
view 3, no. 9 (Summer 1959): 172-97, illus.
　　　　Explanation for the erotic sculptures at Konarak.

20-173　ANAND, MULK RAJ; MANSIMBA, M.; and FABRI, CHARLES. Kona-
rak. Bombay: Marg, 1968. 66 pp., figs., illus.
　　　　Study of the Sun Temple at Konarak, including discussion of the
　erotic sculptures.

20-174　EBERSOLE, ROBERT. Black Pagoda. Foreword by Niharranjan
Ray. Gainesville: University of Florida Press, 1957. 105 pp.,
bib., plan, illus.
　　　　Study of Konarak and associated temples.

20-175　ELISOFON, ELIOT, and WATTS, ALAN. Erotic spirituality: the vi-
sion of Konarak. New York: Macmillan, 1971. 125 pp., intro.,
illus., figs.
　　　　History of and commentary on the erotic sculptures at Konarak.

20-176　LAL, KANWAR. Miracle of Konarak. New York: Castle, 1967. 86
pp. (text), pref., map, plan, bib., illus.

20-177　MEHTA, RUSTAM JEHANGIR. Konarak: the sun-temple of love.
Bombay: D.B. Taraporevala, 1969. 46 pp. (text), illus.
　　　　Tourist guide to Konarak.

20-178　SPATE, O.H.K. "Konarak and Sindri: fertility ancient and mod-
ern." Meanjin 16, no. 4 (issue 71) (Summer 1957): 341-53.

Essay includes musings on the meaning of erotic sculptures at Konarak, suggesting a strong element of fertility worship.

Indonesia

20-179 O'CONNOR, S.J. "Note on a mukhalinga from Western Borneo." Artibus Asiae 29, no. 1 (1967): 93-98, figs., illus.
Study of a phallic stele, perhaps Indian in origin.

Malaysia

20-180 MEYER, A.B. "Uber die Perforation des Penis bei den Malayan." Mitteilungen der Anthropologischen Gesellschaft 7 (1878): 242-44.
Report on Asian use of ornaments and gadgets inserted under the skin of male genitalia.

Nepal

20-181 DHANASAMSERA JANGABAHADURA RANA, RATHI. Kamakalarahasya. Katmandu: Tribhuvanavisvavidyalaya, 1979. Limited to 500 copies. 174 pp. (text), bib., ill.
Tantric sculptures of Nepal discussed, including erotic pieces.

20-182 MAJURPURIA, TRILOK CHANDRA, and MAJURPURIA, INDRA. Erotic themes of Nepal: an analytical study and interpretations of religion-based sex expressions misconstrued as pornography. Katmandu: Shakuntala Devi, 1978. 268 pp., intro., illus. (some col.), map, bib. (Second edition, 1980-81.)
Thorough study of Nepali erotic art.

20-183 TUCCI, GIUSEPPE. Rita-Lila; an interpretation of the Tantric imagery of the Temples of Nepal. Translated by James Hogarth. Geneva: Nagel, 1969. 164 pp., illus. (some col.).
Sculptures and paintings of erotic themes from Nepalese temples surveyed.

Tibet

20-184 FORMAN, HARRISON. Through forbidden Tibet: an adventure into the unknown. New York: Longmans, Green, 1935; London: Jarrolds, 1936. 288 pp., foreword, index, illus.
On pages 107-9 is a brief description of an "obscene idolhouse."

20-185 MATTIEUSSENT, BRICE. "Un art erotique: la 'Thanaka' Tibetaine." Revue d'Esthetique 1-2 (1978): 57-72.
Discussion of Tibetan erotic bronzes.

South Asia

20-186 RICHARDSON, HUGH E. "Phallic symbols in Tibet." <u>Bulletin of Tibetology</u> 9, no. 2 (14 July 1972): 27-29.
 Study of phallic symbols.

Chapter 21
East Asia

The two great civilizations of East Asia, China and Japan, have each had traditions of erotic art from early in their history. Their sex customs, beliefs, and practices, as well as their erotica, are distinctly different, although in some eras interrelated.

China

The puritanical views of the modern Communist government of China mask an ancient and enduring erotic element in Chinese culture. Beginning in prehistory with the belief in earth and sky spirits copulating to invigorate the world and finding its fullest expression in Taoist philosophy, Chinese sex customs and practices provided fertile ground for the production of erotic art. By the time Europeans became aware of the existence of China's erotic art it had become a tourist item in the trading ports of the coast, diminishing the status and meaning it had once had for the Chinese.

Background

For much of its history Chinese sex life has been influenced by certain famous Taoist sex treatises. India's Kama Sutra is the most famous sex guide from an Asian culture, and its prescriptions for the ideal sex life fit in fully with the goals of Indian culture and Hindu beliefs. Similarly, the Taoist sex texts are codifications of very ancient beliefs in the importance of sex in leading a healthy life. In fact, this relationship between medicine and sex is a hallmark of Chinese eroticism. In Taoist belief human life is maintained and prolonged only by living in harmony with the universe, a process that includes keeping in proper relationship all manifestations of yin and yang. To do this the male (yin) must be complemented by the female (yang) and vice-versa. One essential means of doing this is by proper lovemaking. The revered texts usually take the form of a prolonged conversation between a ruler and a female who has great knowledge of Taoist philosophy, she describes how to use Taoist principles in lovemaking to achieve harmony and ultimately even immortality. Excerpts from the most famous of the texts can be found in Chinese erotism by de Smedt, a complete text provided by Ishihara and Levy in The Tao of sex, and a translation of Sou Nu King's classic in La sexualite taoiste de la Chine ancienne.

Surveys of Chinese sex life rely heavily for their information on those historical texts, but also turn to China's erotic literature and art. A number of books have been written describing the nature of Chinese sex life from ancient times to the modern day. These books generally attempt to incorporate scholarly thoroughness and yet try to capture something of that quality of poetry that infuses Chinese erotic art and literature. Lawrence Gichner's Erotic aspects of Chinese culture was an early effort to explain Chinese eroticism to the West. But it took R.H van Gulik, a man who had spent most of his life in China studying its people, to write the classic in this field Sexual life in ancient China: a preliminary survey of Chinese sex and society from circa 1500 B.C. to 1644 A.D. (1961). Exploring Chinese sex attitudes as expressed in the arts is Wou-Chan Cheng's Erotologie de la Chine; tradition Chinoise de l'erotisme. Almost a decade after van Gulik's work others followed: Beurdeley's The clouds and the rain, the art of love in China, Etiemble's Yun yu: an essay on eroticism and love in ancient China, Humana's The yin-yang; the Chinese way of love, Chou's The dragon and the phoenix: love, sex and the Chinese, and Chang's The Tao of love and sex: the ancient Chinese way to ecstasy.

Two particular customs are important for an understanding of Chinese eroticism and the art it spawns. Eunuchs have held an extraordinarily important position in Chinese history, and an exploration of their position leads further to an understanding of the roles of concubines, the polygamous household, and the power of sex in Chinese culture. Any of the survey books on eunuchs considered in the "Customs" chapter of this bibliography would include large sections on China's eunuchs. One work entirely on China is Mitamura's Chinese eunuchs: the structure of intimate politics. If Chinese erotic literature and art are any indication, then it is clear that the Chinese for many centuries had a fetishistic love of tiny feet on women. Among upper-class women this desired feature was assured by the practice of footbinding. From birth a woman would have her feet tightly bound in such a way that growth was stunted and deformed. The result of the practice was a foot so small and compact that the woman could not walk but had to be carried everywhere. Levy gives a thorough account of the custom in Chinese footbinding: the history of a curious erotic custom.

Art

One problem in defining Chinese erotic art is the prevalence of symbolism in Chinese art. Virtually every image can be said to have layers of symbolic meaning. A dragon flying in the sky with a cloud can be said to show celestial copulation between the male force (dragon) and female force (cloud). Similarly, jade is said to be the semen of the sky god. Thus, eroticism pervades much of Chinese art, yet is not often obvious or explicit. Rawson explores this idea in Tao: the Eastern philosophy of time and change.

The earliest examples of erotic art in China are Neolithic pots that have female breasts and phallic symbols incorporated into the forms. This tradition of utilitarian objects incorporating sexual imagery continues into the modern era as folk art items. Sex devices such as the dildo, penis ring, and "ben- wa" balls have played an important role in Chinese sex life for many centuries. Unfortunately, no book has focused on this subject, and surveys, while mentioning them briefly illustrate few.

It is the erotic print that receives the attention of scholar and connoisseur alike. Painting scenes of erotic activity is an old tradition in China. The literature abounds with descriptions of famous painters doing erotic work long before the time of Christ. Unfortunately, none of that work survives. The Taoist-inspired erotic paintings were destroyed under the regimes of certain Confucian-oriented rulers. During the late Ming and the Ch'ing periods, however, the tradition of erotic art was revived in the form of prints. Painters still worked in this genre, some reconstructing the paintings of antiquity that had been destroyed, but now the color print allowed a larger number of works to be produced.

Designed to accompany love poems or as marriage sex manuals, erotic prints tend to show members of the upper class engaged in all manner of lovemaking. The style of the prints de-emphasizes sexual anatomy; instead they place emphasis on the elegance of setting and leisureliness of action. Many books offering a history of the prints, an analysis of their form and meaning, and numerous colored illustrations have been produced. Again, it was van Gulik who first revealed this art to the West in a privately produced limited edition of Erotic prints of the Ming period, 3 vols. (1957). Later came Etiemble's Le livre de l'oreiller (1963), Beurdeley's Chinese erotic art (1969), and Franz-Blau's Erotic art of China: a unique collection of Chinese prints and poems devoted to the art of love (1977).

Japan

Multicolored Japanese prints of couples in sexual embrace are among the most well-known traditions of erotic art. Japanese sex customs and erotica are quite different from that of the Chinese, even if the technique of printmaking and the idea of the pillow book have their origins on the Chinese mainland. For example, while Chinese erotic art de-emphasizes the sex organs, Japanese prints show them as enormous. Further, Japanese erotica has a playfulness and humor almost unique in the world. That Japan has had at least two different traditions of erotic art makes it fertile ground for further research.

Background

The austere regimen of the leaders of Japan in the 1920s and 1930s together with the puritanical administration of the postwar occupation government has masked the eroticism that in traditional Japanese culture. Neither Shinto nor the type of Bhuddism that developed in Japan are inherently antagonistic to an active sexuality. Of course, the role of sex in Japanese culture varied by historical period and social class, but if the literature and art are any indication, the present situation in that country is only a dim reflection of what was true in the past. The same nation that formerly produced so much erotic art has, in the last few decades, forbidden its full reproduction in published materials, clearly indicating the extent of change.

Much of what has been written about the sexuality of Japan has been written by Japanese sociologists, historians, and sexologists. While this bibliography has concentrated on European language materials, the entries in this chapter include a selection of Japanese language materials. In a few

instances a Japanese author has also written in English or translations of Japanese works have been produced (for instance, note Hidaka's The Japanese art of lovemaking and Sex in Japan). Surveys on this topic by Western authors first appear at the turn of the century with Becker's now classic study of the Yoshiwara pleasure district of Tokyo entitled The sexual life of Japan and in the early 1930s with Krauss and Satow's scholarly overview Japanische Geschlechtsleben. In recent decades books and articles on this topic have tended to be sensationalistic, with titles like Levy's Oriental sex manners: a guide to the bizarre sexual morality of the East. To be noted are several relevant entries by eminent scholars in the Kodansha encyclopedia of Japan published in 1983.

Phallicism

Shinto, the indigenous religion of Japan, is largely an expression of the agricultural orientation of early Japan. Fertility worship is important in many agricultural societies because of the need to influence spiritually the yield of the earth. In Japan this fertility worship used phallic and vulvic imagery as a major element of Shinto rites. Stones in roadside shrines, floats used in processions, and reliquary objects all are obvious expressions of this belief in the magical powers of the image of the sex organs. Less obvious are abstract and symbolic images in stories, songs, poems, paintings, and sculptures that also make reference to fertility worship.
It is necessary to understand this phallic worship aspect of Japanese culture in order to explain the appearance of Japan's erotic art. Buckey's study of Japanese phallicism published in 1895, Phallicism in Japan, reflects Victorian interest in that aspect of world religion. Kato offered an explanation of the role of phallic worship in Japan's religious development in a 1924 article in the Transactions of the Asiatic Society of Japan. Following the World War II numerous studies of this subject have been made, including works by Casals, Nishioka, Richie, and Ito. A well-illustrated recent study of Japanese phallicism with an emphasis on the objects used in phallic worship is Czaja's Gods of myth and stone: phallicism in Japanese folk religion.

Dosojin

Small stone or wooden shrines were once a common sight along rural roads and footpaths. The shrines have various forms from simple marks on stones or trees to elaborately carved stones with text and figures in relief (even phallic-shaped versions existed). In certain areas these shrines depicted a man and a woman, a kind of primordial couple from Shinto mythology. This couple, known as the dosojin, are typically shown hugging each other lovingly, but in some cases they lie in sexual embrace. On one level the dosojin symbolize fertility and their embraces serve as an apotropaic force. While most publications on the dosojin are in Japanese, a summary article by Tokihiki in the Kodansha encyclopedia of Japan and Czaja's book on phallic worship provide useful information in English.

Shunga

The most well known of Japan's erotic art are the ukiyo-e ("floating world") prints known as shunga. Shunga means "spring pictures" and refers to scenes depicting sexual embraces. Most of the greatest print-makers produced shunga, and thus this erotic art constitutes a significant aspect of the total picture of Japanese art between the sixteenth and twentieth centuries. Any survey of ukiyo-e prints will at least mention the shunga, and thorough ones will devote a section to the subject, a good example being Lane's Images of the floating world: the Japanese print. Japanese prints are so popular to collectors and of such interest to schol-ars, both Oriental and Western, that a great deal of research has been done on them and many books and reference sources exist on the subject. By the end of the nineteenth century the shunga had ceased to be a significant category of the printmaker's output. Other than small porcelain tourist trade sculptures and the work of a few modern artists, the Japanese have produced little erotic art in this century.

Shunga have received considerable attention in publications, exhibi-tions, and collections. Survey studies of shunga have been numerous. In Japan most of the illustrations in such books are censored with a black rectangle placed over "offending" areas of anatomy. Authors of such ex-purgated studies include Hara, Hayashi, Kajiwara, Shibui, Tsuruya, and Yoshida. The earliest study in a European language seems to have been L'Estampe erotique du Japon by Francis Poncetton, although it is clear that shunga had reached Europe at least as early as the mid nineteenth century. More recently, two waves of publications on shunga have occurred -- in the early 1960s and the late 1970s. In 1961 Densmore published Les estampes erotiques Japonaises and three years later Grosbois's Shunga: images of spring: essay on erotic elements in Japanese art appeared as a volume in the Nagel series on erotic art. Tom and Mary Anne Evans produced a thorough, well-documented study of shunga under the title Shunga: the art of love in Japan in 1975. Picture books of prints, usually with at least a short essay on the subject, have been written by Winzinger, Lane, Illing, the Kron-hausens, and Soulie. Exhibitions with extensive catalogs have been held in Germany and New York.

Certain famous ukiyo-e artists prolifically produced shunga, and any book on these individuals will include some of their erotic work. However, a few books have been written specifically on the shunga of one or a small group of artists. As early as 1907 a collection of erotic prints by Moro-nobu, Harunobu, and Utamaro was published in Munich under the title Japanische Erotik. Marco Faglioli and Franz Hanfstaengl have written books on Utamaro and a Japanese book on the erotic prints of Harunobu appeared in 1975.

East Asia

General

Background

21-1 KARSCH-HAACK, FERDINAND. Das gleichgeschlechtliche Leben
 der Kulturvolker. Munich: Seitz & Schauer, n.d. 134 pp.
 Study of male homosexuality in the cultures of China, Japan,
 and Korea.

21-2 SCOTT, GEORGE RYLEY. Far Eastern sex life: an anthropolo-
 gical, ethnological and sociological study of the love relations,
 marriage rites and home life of the Oriental peoples. London:
 Gerald Swan, 1943. Reprint. New York: AMS, 1976. 198 pp.,
 bib., index.
 Survey of sex customs and beliefs in China and Japan.

21-3 TULLEMAN, ADOLF. Das Liebesleben des fernen Ostens. Stutt-
 gart: Gunther, 1964. 357 pp., illus., bib.
 Thematic look at sexual beliefs and customs in East Asia, tradi-
 tional and modern.

China

Background

21-4 BEURDELEY, MICHEL (in collaboration with Kristofer Schipper,
 Chang Fu-Jui, and Jacques Pampaneau). The clouds and the rain,
 the art of love in China. Translated from French by Diana Imber.
 London: Hammond, 1969. 209 pp., bib., illus. (some col.).
 Erotic literature and art in Chinese history discussed as they
 inform us about Chinese sex beliefs and practices.

21-5 CHOU, ERIC. The dragon and the phoenix: love, sex and the
 Chinese. New York: Arbor House, 1971. 222 pp., bib., illus.
 History of sex customs in China, with chapter on erotic art.

21-6 DENIS, ANTOINE. The perfect union: the Chinese methods. New
 York: Crescent, 1984. 80 pp., illus. (col.).
 Discussion of various topics relating to Chinese sex customs,
 beliefs and practices well illustrated with nineteenth century erotic
 prints.

21-7 ETIEMBLE, RENE. Yun Yu: an essay on eroticism and love in an-
 cient China. Translated by James Hogarth. Geneva: Nagel,
 1970. 172 pp., illus. (some col.).
 Essay on eroticism in Chinese culture illustrated with many
 prints.

21-8 GICHNER, LAWRENCE. Erotic aspects of Chinese culture. N.p.:
 Privately printed, 1957. 130 pp., bib., illus.
 Collector's study of Chinese erotic art and literature.

21-9 GULIK, ROBERT HANS VAN. Sexual life in ancient China: a preliminary survey of Chinese sex and society from circa 1500 B.C. to 1644 A.D. Leiden: E.J. Brill, 1961, 1974. 392 pp., index, illus. (some col.), figs.
 Encyclopedic history of sex customs.

21-10* HUMANA, CHARLES, and WU, WANG. Chinese sex secrets: a look behind the screen. New York: Wingate, 1971. 253 pp., illus., bib.
 In-depth exploration of traditional Chinese sex practices and beliefs, well illustrated.

21-11 _____. The Ying-Yang: the Chinese way of love. New York: Allen Wingate, 1971. 253 pp., illus. (col.), bib.
 Thorough study of Chinese eroticism.

21-12 _____. "Ying Yang: the Chinese way of love," Sexual Behavior 2, no. 6 (June 1972): 20-25.
 Synopsis of book listed above.

21-13 ISHIHARA, AKIRA, and LEVY, HOWARD S. The Tao of sex: an annotated translation of the twenty-eighth section of the Essence of medical prescriptions (Ishimpo). New York: Harper and Row, 1968. 325 pp., index, appendix, bib., figs.
 Famous Chinese medical text on sexual practices.

21-14 LEVY, HOWARD SEYMOUR. Chinese footbinding: the history of a curious erotic custom. Foreword by Arthur Waley; introduction by Wolfram Eberhard. New York: Walton Rawls, 1966. 352 pp., bib., index, illus.
 Thorough study of traditional practice of female footbinding.

21-15 MITAMURA, TAISUKE. Chinese eunuchs: the structure of intimate politics. Translated by Charles A. Pomeroy. Rutland, Vt.: Charles E. Tuttle, 1970. 176 pp.
 Study of the role of eunuchs in Chinese history.

21-16 MUSSAT, MAURICE. Sou Nu King: sexualite taoiste de la Chine ancienne. Introduction by Leung Kwok Po. Paris: Seghers, 1978. 221 pp., bib., illus.
 French translation of ancient medical text as it relates to sex, with commentary by Mussat. Illustrated with Chinese erotic prints.

21-17 PAMPANEAU, JACQUES (Jolan Chang). The Tao of love and sex: the ancient Chinese way to ecstasy. Foreword and postscript by Joseph Needham. New York: Dutton, 1977. 136 pp., bib., index, figs., illus.
 Explanation of Chinese Taoist beliefs in regard to healthy sexual practices.

21-18 _____. The Tao of the loving couple: true liberation through the Tao. New York: Dutton, 1983. 129 pp., index, bib., illus.
 How-to book relating Taoist beliefs to sexual practice.

21-19* PERCKHAMMER, HEINZ VON. The culture of the nude in China.
Berlin: Eigenbroder, 1928. 7 pp. (text), illus., bib., index.
Original photographs of young Chinese women.

21-20* Sex secrets from China. Monterey Park, Calif.: Chan's Corp.,
n.d. 64 pp.

21-21 SMEDT, MARC DE. Chinese erotism. Translated by Patrick
Lane. New York: Crescent Books, 1981. 96 pp., illus. (col.).
Discussion of Chinese beliefs and customs regarding sexual
activity, illustrated with reproductions of prints.

Art

21-22 BEURDELEY, MICHEL; SCHIPPER, KRISTOFER; FU-JUI, CHANG;
and PAMPANEAU, JACQUES. Chinese erotic art. Translated
from French by Diana Imber. Secaucus, N.J.: Chartwell Books,
1969. 215 pp., bib., illus. (some col.).
Chinese erotic art in its social and cultural mileiu.

21-23* ETIEMBLE, RENE. Le livre de l'oreiller. Paris: Au Cercle du
Livre Precieux, 1963.
Study of Chinese erotic prints. Preface of this book is re-
printed in next entry.

21-24 FRANZ-BLAU, ABRAHAM N. Erotic art of China: a unique collec-
tion of Chinese prints and poems devoted to the art of love. Post-
script by Rene Etiemble. New York: Crown, 1977. 160 pp.,
illus. (col.), bib.
Album book of illustrations of erotic prints.

21-25 GULIK, ROBERT HANS VAN. Erotic prints of the Ming period:
with an essay on Chinese sex life from the Han to the Ch'ing
Dynasty, B.C. 206-A.D. 1644. 3 vols. Tokyo: Privately printed,
1957. Limited to 50 copies. Index, illus. (some col.).
Three volumes on Chinese erotic prints. Volume 1 is the Eng-
lish text and illustrations; volume 2 is the Chinese text; and volume 3 is
a reproduction of a pillow book (love manual).

21-26* HAACK, HAROLD. Yin and Yang: Bilder aus chinesischen Hoch-
zeitsbuchern. Dortmund: Harenburg, 1984. 111 pp., illus.
(col.).

21-27 PAMPANEAU, JACQUES (Wou-ChanCheng). Erotologie de la Chine:
tradition Chinoise de l'erotism. Bibliotheque internationale d'erot-
ologie, no. 11. Introduction by F. Albertini. Paris: J.-J. Pau-
vert, 1963. 234 pp., app., bib., illus. (German edition with title
Die Erotik in China, Die Welt des Eros [Basel: Desch, 1966].)
History of Chinese customs regarding sex as expressed in art.

21-28 RAWSON, PHILIP, and LEGEZA, LASZLO. Tao: the Eastern philo-
 sophy of time and change. New York: Avon, 1973. 128 pp., illus.
 (some col.).
 Study of relationship between art and Taoist philosophy, in-
 cluding sexual aspects.

21-29* SHENEMAN, TOM. "Sexual symbolism in Ming erotic prints,"
 Near-Print (?), 2 May 1975.

21-30 ZHENG, CHANTAL. "La decouverte de l'erotisme a la Chinoise."
 La Recherche 17, no. 178 (June 1986): 848-49, illus.
 Male and female nude sculptures found in Han period tomb are
 discussed.

Japan

Background

21-31* ABE, MICHIYOSHI. Kyushu Sei Suhai Shiryo [Data on the worship
 of sex in Kyushu]. Oita: Hareruya Shoten, 1963.

21-32* BECKER, JOSEPH ERNEST. The sexual life of Japan: being an
 exhaustive study of the nightless city or, the history of Yoshiwara
 Yukwaku. New York: Privately printed, 1934. 386 pp., illus.
 (First edition, New York: American Anthropological Society, ca.
 1902; also published under title The Nightless City.)
 Classic study of Yoshiwara pleasure district.

21-33* BEURDELEY, MICHEL; CHUJO, S.; MUTO, M.; and LANE, RICH-
 ARD, eds. Le chant de l'oreiller: l'art d'aimer au Japon. Paris:
 Bibliotheque des Arts, 1977. 276 pp., illus., bib.
 Study of Japanese sex customs and beliefs as evidenced by
 legends, literature, and art from early times to the late nineteenth
 century.

21-34* FANTI, SILVIO. "They prefer sex to invention." Orient Digest
 12, no. 26 (March 1955).

21-35 FAWCETT, CHRIS. "Castle builders of Japan." A.D. 45, no. 6
 (June 1975): 356-59, figs., illus.
 Pleasure hotels built in modern Japan described.

21-36* FUJIBAYASHI, SADAO. Sei Fudoki [Sexual customs]. Minzoku
 Mingei Sosho [Folklore and Folk Art Series]. Tokyo: Iwasaki,
 1958.

21-37 GICHNER, LAWRENCE. Erotic aspects of Japanese culture.
 N.p.: Lawrence Gichner, 1953. 91 pp., illus., bib., index.

Connoisseur's study of erotic elements in Japanese culture and their expression in art.

21-38* GLUCK, JAY. "Rape me, it's an old Japanese custom." Orient Digest 3 (1954).

21-39* _____. "Ribbing the Gods in rural Japan." Thought (Delhi) 11, no. 38 (19 September 1959): 15-16.

21-40* HIDAKA, NOBORU. The Japanese art of lovemaking. New York: Vantage, 1980. 97 pp., illus.

21-41 _____. Sex in Japan. New York: Advantage, 1982. 105 pp., illus.

21-42* ITO, KENKICHI. Sei no Mihotoke [Buddhas of sex]. Tokyo: Zufushinsha, 1965.

21-43 KRAUSS, FRIEDRICH SALAMO, and SATOW, TAMIO. Japanische Geschlechtsleben: Abhandlungen und Erhebungen uber das Geschlechtsleben des Japanischen Volkes: folkloristische Studien. Introduction by G. Prunner. Hanau: Karl Schustek, 1965. 591 pp. (text), figs., index, gloss., bib.. (First edition, 1931).
Classic study of Japanese sex customs, including a section on erotic prints.

21-44 LEO, JOHN. "Waterbeds and willow worlds." Time 122 (1 August 1983): 71, illus. (col.).
Trends in contemporary sexual behavior in Japan are briefly featured.

21-45 LESOUALC'H, THEO. Erotique du Japon. Bibliotheque internationale d'erotologie, no. 19. Paris: J.-J. Pauvert, 1968. 245 pp., illus. (some col.).
Erotic aspects of Japanese culture and art surveyed.

21-46 LEVY, HOWARD S. Oriental sex manners: a guide to the bizarre sexual morality of the East. London: New English Library, 1972. Reprint. N.p.: Langstaff-Levy, 1978. 136 pp., app., illus.
Survey of sexual beliefs and practices in traditional Japan. Modern Japan partially covered in a series of appendices.

21-47 _____. Sex, love, and the Japanese. Washington, D.C.: Warm-Soft Village Press, 1971. 91 pp., bib., figs.
Survey of love and sex among the Japanese.

21-48 MARUKAWA, HITOO. "Sexual observances as a religious rite in Japan." Tenrei Journal of Religion, no. 2 (December 1959): 5-17, illus.
Study of religious sexual practices.

21-49* MITSUISHI, MUKUSABURO. Seishin to Sekibutsu [Sex gods and stone Buddhas]. Ueda Nagano Prefecture: Ueda Ogata Shiryo Kankokai, 1966.

21-50* OTA, SABURO. Sei Suhai [Sex worship]. Nagoya: Reimei, 1956.

21-51 RANGE, PETER ROSS. "Sex and the rising sun." Playboy, October 1982.
 Comments on contemporary Japanese sexual mores and practices.

21-52* RESEARCH SOCIETY OF EROTIC BOOKS. Nippon Empon Dai-Shu-sei [Bibliography of Japanese erotic; books from the Heian Period until today]. Tokyo: Uozumi, 1960.

21-53* "Sie-Teki Sairei ni Tsuite" [On sexual festivals and rites]. In Sei Fuzoku [Sexual Customs]. Vol. 3. Tokyo: Yuzankaku, 1959.

21-54* TAKAGI, SUSUMU. Seishin Fudoki [An encyclopedia of deities of sex]. Tokyo: Shinchosha, 1961.

21-55 TAKENORI, NOGUCHI. "Sex in Japanese folk culture." In Kodansha Encyclopedia of Japan. Vol. 17. Tokyo: Kodansha, 1983, 73-74.
 Brief discussion of sex folklore of Japan.

21-56* TOGENDO, MIYAMOTO. [Dictionary of Japanese erotic terms.] Tokyo: Research Association of Literary Data, 1925. 187 pp.

21-57* WAYAMA, TETSUKO. Inshi to Jashin [Obscene shrines and evil gods]. Tokyo: Hakubunkan, 1918.

Phallicism

21-58 BUCKEY, EDMUND. "Phallicism in Japan." In The Power of a symbol, by Lee Alexander Stone, 121-46. Chicago: Covici, 1925. (Reprint of Phallicism in Japan [Chicago: University of Chicago Press, 1895].)
 Descriptive study of phallic worship in Japanese religion and culture.

21-59* CASALS, U.A. A discoursive essay on phallicism: phallic symbolism and related manifestations in Japan. Manuscript, Kobe, 1952.

21-60 CZAJA, MICHAEL. Gods of myth and stone: phallicism in Japanese folk religion. Foreword by George de Vos. New York: Weatherhill, 1974. 294 pp., bib., index, illus., map.
 Thorough study of Shinto phallic worship.

21-61 KATO, GENCHI. A study of the development of religious ideas
 among the Japanese people as illustrated by Japanese phallicism.
 Transactions of the Asiatic Society of Japan, vol. 1, supp. 2d ser.
 (1924). 43 pp., ref., illus.
 Phallic deities and symbols in Japanese religion discussed.

21-62* NICHIOKA, HIDEO. [History of phallicism in Japan.] Tokyo:
 Myogi, 1958.

21-63* _____. Niho Seishin-shi [The history of Japanese phallicism].
 Tokyo: Takahashi, 1961.

21-64 RICHIE, DONALD, and ITO, KENKICHI. The erotic gods: phallic-
 ism in Japan. Tokyo: Zufushinsha, 1967. 253 pp., illus.
 Study of phallic and vulva images in Japanese culture.

Dosojin

21-65* ASHIDA, EIICHI. "Koshiji no Dosojin" [The Dosojin of Koshiji].
 Mingei Techo [Folk art notebook] 164 (January 1972): 8-15; 165
 (February 1972): 24-30; 166 (March 1972): 24-27.

21-66* GOTEMBA-SHI BUNKAZAI CHOSA IINKAI [Committee for the inves-
 tigation of the cultural properties of Gotemba City]. "Gotemba no
 Dosojin" [Dosojin of Gotemba]. Bunkazai no Shiori Dainishu [Cul-
 tural properties guide] 2 (1960): 1-46.

21-67* IKEDA, SANSHIRO. "Shinshu no Dosojin Kenkyu" [A study of the
 Dosojin of Shinshu]. Mingei 42 (November 1961): 6-21.

21-68* ITO, KENKICHI. Robo no Seizo: Sekushi Dosojin Junrei [Roadside
 sex images: pilgrimage to sexy Dosojin]. Tokyo: Zufushinsha,
 1965.

21-69* _____. Sei no Shakujin: Sotai Dosojin Ko [Stone gods of sex: on
 the couple Dosojin]. Tokyo: Yamato Keikokusha, 1965.

21-70* ITO, KENICHI, and ENDO, HIDEO. Dosojin no Furusato: Sei no
 Ishigami [The homeland of Dosojin: stone gods of sex]. Tokyo:
 Yamato Shubo, 1972.

21-71* KAWAGUCHI, KENJI. Dosojin no Furusato O Tazunete [Visiting the
 homeland of Dosojin]. Tokyo: Tokyo Bijutsu Kabushiki Kaisha,
 1968.

21-72* TAKEDA, HISAYOSHI. Dosojin. Tokyo: Arusu, 1941.

21-73 TOKIHIKI, OTO. "Dosojin." In Kodansha encyclopedia of Japan.
 Vol. 2. Tokyo: Kodansha, 1983, 132.
 Brief explanation of the nature of the Dosojin.

Art

21-74 BEURDELEY, MICHEL; CHUJO, SHINOBU; MUTO, MOTOAKI; and
LANE, RICHARD. The erotic art of Japan: the pillow poem.
N.p.: Leon Amiel, n.d. 275 p., intro., table, bib., illus. (some
col.).
 Anthology of traditional Japanese erotic literature illustrated
with examples of shunga.

21-75 BOWIE, THEODORE. "Erotic aspects of Japanese art." In Studies
in erotic art by Theodore Bowie et al., 171-230, illus. New York:
Basic Books, 1970.
 Survey of Japanese erotic art.

21-76* DENSMORE, MARIANNE. Les grands erotiques Japonais. Paris,
1962.

21-77* HARA, KOZO. Nihon Koshoku Bijutsu-shi [History of Japanese
erotic art]. Tokyo, 1930.

21-78* HIDAKA, NOBURU. Oshun: Japanese erotica. Great Neck, N.Y.:
Todd and Honeywell, 1981. 128 pp., illus.

21-79* Himerareta Chokoku-Shu [A collection of hidden sculptures].
Tokyo: Asoka Shobo, 1951.

21-80* Japanische Bluten. Der Welt des Eros. Geneva: Nagel, 1969.
119 pp., illus.

21-81* Nihon Empon Daishusei [Compendium of Japanese erotica]. Tokyo,
1954.

21-82* PONCETTON, FRANCOIS. Les erotiques japonais. Paris, 1925.

21-83* TAKAHASHI, TETSU. Hiho Emaki-ko [Secret heirloom picture
scrolls]. Tokyo, 1965.

Shunga

21-84* ANONYMOUS [possibly Julius Kurth]. Japanische Erotik: sechs-
undreissig Holzschnitte von Moronobu, Harunobu, Utamaro. Mun-
ich: R. Piper, 1907. 14 pp., illus.

21-85 ASHBERRY, JOHN. "Alien porn." New York 12, no. 26 (25 June
1979): 61, illus. (col.).
 Review of exhibition of shunga at Ronin Gallery.

21-86* DENSMORE, MARIANNE. Les estampes erotiques japonaises.
Paris: Cercle du Livre Precieux, 1961.

21-87 EVANS, TOM, and EVANS, MARY ANNE. Shunga: the art of love in
 Japan. New York: Paddington, 1975. 285 pp., illus. (some col.),
 bib.
 Thorough, scholarly study of the history of shunga.

21-88 FAGIOLI, MARCO. Utamaro, Koi no Hutosao. Florence: Nazionale
 Editore, 1977. 118 pp., bib., illus. (col.). (In English and Ital-
 ian.)
 Study of erotic prints in Japanese art history and Utamaro's
 output. While documenting the prints of a 3-volume series, only a
 handful are actually illustrated.

21-89 GROSBOIS, CHARLES. Shunga: images of spring: essay on erotic
 elements in Japanese art. Geneva: Nagel, 1964. 157 pp., pl.
 (col.), illus.
 Study of seventeenth and eighteenth century erotic prints.

21-90* HANFSTAENGL, FRANZ. Kitagawa Utamaro erotische Holzschnitte.
 Munich: Faksimile-Edition, ca. 1970.
 Erotic prints of the master Utamaro.

21-91 HARA, KOZO. Ukiyoe Higiga no Kansho [The sensuality in Ukiyoe].
 Tokyo: Amatoria-sha, 1951. 183 pp., illus.
 Discusses erotic prints in Japan.

21-92* Harunobu Furyo Enshoku Maneemon Higacho: Harunobu Ukiyo-e
 Shunga. 1975.

21-93 HAYASHI, YOSHIKAZU. Empon Kenkyu [Study of erotic books].
 12 vols. Tokyo: Yuko Shobo, 1965. Illus., map.
 Censored study of erotic prints.

21-94 HOKUSAI, KATSOSHIKA. The gifted Venus by Hokusai. Picture
 Book Series of the Shunga, no. 1. Translated from Japanese by
 Peter Dale. N.p.: Sei Sei Doh, 1980. 17 pp. (text), illus. (col.).
 Reproduction of original album of erotic prints.

21-95 ILLING, RICHARD. Japanese erotic art: and the life of the court-
 esan. New York: St. Martin's Press, 1978. Unpaged, illus.
 (col.).
 Brief introduction to erotic books and an album of examples.

21-96* KAJIWARA, KAGEHIRO. Seibijutsu Nyumon. 1969. 54 pp., pl.
 History of erotic prints.

21-97* KRONHAUSEN, PHYLLIS, and KRONHAUSEN, EBERHARD. Higa:
 images secretes. Paris: Collection Vertiges Souvenirs, 1980. 70
 pp., illus. (col.).
 Study of erotic prints of Japan.

21-98* LANE, RICHARD DOUGLAS. The erotic theme in Japanese painting
& prints. Vol. 1, The early shunga scroll. Tokyo: Gabun-do,
1979. 400 pp., illus. (col.).
Censored collection of erotic prints, with essays that originally
appeared in the Tokyo journal Ukiyo-E from 1968 to 1978.

21-99* _____. Erotica Japonica: masterworks of shunga painting. To-
kyo: Publications, 1978. 160 pp.

21-100 _____. "Shunga." In Kodansha encyclopedia of Japan. Vol. 7.
Tokyo: Kodansha, 1983, 187-88.
Detailed summary of the nature and history of shunga.

21-101* _____. Shunga books of the Ukiyo-E School. 1st-6th ser.
1973-82.

21-102 MANDEL, GABRIELE. Shunga: erotic figures in Japanese art.
Translated by Alison l'Eplattenier. New York: Crescent, 1983.
112 pp., illus. (col.).
Selection of erotic prints, especially series by Utamaro, Sho-
zan, Kuniyoshi, and Hokusai.

21-103* NAKANO, EIZO. Koga no Hidokoro [Hidden aspects of old paint-
ings]. 1968. 159 pp., bib.

21-104 Nihon empon Daishusei [Compendium of Japanese erotica]. Tokyo,
1959.

21-105* PONCETTON, FRANCOIS. L'Estampe erotique du Japon. Paris,
1927.

21-106* RAWSON, PHILIP. "Shunga: Images of Spring; Review." Ukiyo-E
Art 10 (1965).

21-107 RAYNOR, VIVIEN. "The Kronhausen collection of 18th to 19th cen-
tury shunga [Ronin Gallery]." New York Times, (15 August 1980),
C19.
Brief exhibition review.

21-108 RONIN GALLERY. Shunga: the erotic art of Japan: 1600-1979.
New York: Ronin Gallery, 1979. 64 pp., bib., illus. (some col.).
Exhibition catalog of shunga.

21-109 SHIBUI, KIYOSHI. Ars Erotica: old documents concerning human
life instincts and emotions as interpreted by Japanese artists, in
the 18th and earlier part of the 19th centuries. Tokyo: Kohanga,
Kenkyn Gakukai, 1933.
Reproductions of many types of prints, including erotic works.

21-110 _____. Catalogue des estampes erotiques du Japon. 2 Vols.
Tokyo: M. Otsuka, 1926-28. Illus. (some col.).

Catalog of early shunga with emphasis on the prints of Hishi-
kawa Morunobu.

21-111* Shunga: L'arte erotica popolare giapponese in 180 stampe dei suoi
artisti piu insigni. Milan: Marco Fagioli, 1980.

21-112 SOULIE, BERNARD. Japanese erotism. Translated by Evelyn Rossi-
ter. New York: Crescent Books, 1981. 96 pp., illus. (col.).
Picture book of erotic prints, accompanied with text of limited
usefulness.

21-113* "Das Spiel der Wolken und des Regens; Japanische erotische Zeich-
nungen." Wolkenkratzer Art Journal 1 (January-February 1987).

21-114* TSURUYA, FUJIO. Hizo Ukiyoe [Hidden treasures of Ukiyoe].
1969. 170 pp., illus. (some col.).

21-115* UKIYO-E. [Special Issues on Shunga.] Ukiyo-E: A Journal of the
Floating World, March 1977, May 1978, and September 1979.
(Partly in English.)

21-116* _____. "Ko-ga Hiden" [The Shunga tradition of Ukiyo-E]. Uki-
yo-E: A Journal of Floating World Art, March 1977. (Partly in
English.)

21-117 WINZINGER, FRANZ. Meisterwerke der erotischen Kunst Japans.
Munich: R. Piper, 1977. Unpaged, illus. (some col.), bib.
Picture album of fine reproductions of erotic art.

21-118* _____. Meisterwerke des Japanischen Farbholzschnitts. Ver-
offentlichungen der Albertina, no. 9. Graz: Akademische Druck-
und Verlagsanstalt, 1975. 40 pp., illus. (some col.), bib.

21-119 _____. Shunga: Meisterwerke der erotischen Kunst Japans:
[Ausstellung] Galerie im Pilatushaus 15.11 bis 24.12.1975. Katalog
31. Nuremburg: Der Albrecht Durer Gesellschaft, 1975. 18 pp.,
pl., illus. (some col.), bib.
Catalog of an exhibition of erotic prints.

21-120* YOSHIDA, TERUJI. Ukiyo-E Higa, Ukiyo-E Enga [Ukiyo-E Erotica].
2 vols. Tokyo, 1961-63.

Section 5
Ethnoart-Africa, Oceania, and the Native Americas

Chapter 22
Ethnoart (General)

Background

Over the last five centuries European adventurers, scientists, mis-
sionaries, and colonists set out to explore, exploit, settle, and transform
the lands and peoples of Africa, Oceania, and the Americas. From their
writings it is clear that they considered the "natives" they met to be
uncivilized folk who engaged in debauchery and sexual abandon. While
these observations offer more insights about the Europeans who made them
than the people they were meant to disparage, they do indicate the gulf
between the sexual beliefs and pratices of the so-called "primitive" people
and Christian Europe. The use of the term "primitive" as a label for the
peoples of Africa, Oceania, and the Americas is an unfortunate consequence
of Western prejudices and so has been avoided as much as possible in this
bibliography (enclosed in quotation marks when used). The commonly
heard phrase "primitive art" has herein been replaced by the more neutral
term "ethnoart."

Many of the peoples of Africa, Oceania, and the Americas did indeed
have a more positive attitude to sexuality than found in European culture.
Examples of virtually every kind of sexual activity imaginable can be found
somewhere in those regions, which is one reason why so many of the entries
listed in the chapter on "Customs" in this bibliography include information
on Africa, Oceania, and the Americas. Rituals and celebrations honoring
concepts of fertility were widespread (not uncommonly associated with the
use of phallic and vulvic symbols), as was the prevalence of erotic themes in
oral literature, music, drama, etc. In contrast, relatively little erotic
visual art was produced (with a few distinct exceptions) for reasons yet to
be understood.

Relatively few anthropologists have studied the sex lives of the
peoples of Africa, Oceania, and the Americas. This situation can be ex-
plained by considering the difficulty in eliciting this kind of information
from people, the discomfiture with sexuality experienced by Westerners no
matter how advanced their education, and the paucity of financial and other
resources set aside for this kind of research. Nevertheless, some ethno-
logists and anthropologists have explored this subject. Malinowski's
study of the Trobriand Islanders of Melanesia is considered the classic
example of its kind. An interesting recent publication is Gregor's Anxious
pleasures about the sex life of an Amazonian people.

Most of the books that purport to be surveys of the sexuality of "primitive" peoples were written at the beginning of this century, frequently the work of German scholars. This is probably because the rise of ethnography as a field of research in the nineteenth century stimulated a public interest in the "curious lives of strange peoples." Most of these publications are little more than compilations of fragments of information distilled from ethnographic research. The earliest of these surveys was Josef Muller's 1901 Das sexualle Leben der Naturvolker, followed by Brown and Leuba's The sex worship and symbolism of primitive races (1916), Crawley's Studies of savages and sex (1929), Reclus's Curious bypaths of anthropology (1932), Jacobus X's Untrodden fields of anthropology (ca. 1935), and Fehlinger's Sexual life of primitive people (1945). More recently published works in this vein are Henriques's La sexualite sauvage (ca. 1965) and Repolles Aguilar's El amor en los pueblos primitivos (1976). Grigson's Sexual practices (see "Customs" chapter) attempts to synthesize the anthropological literature on sexuality into a study of the types and distribution of sexual beliefs and behavior worldwide. More narrow in focus are two works published in 1911 by Berkusky and Karsh-Haack surveying the practice of homosexuality among "primitive" peoples.

Art

With the exception of pre-Columbian Peru, the corpus of ethnoart cannot be described as a rich source of erotic art, yet sexual imagery does exist and has, at least, been noted by scholars, if not thoroughly researched. The study of ethnoart is a relatively recent phenomenon. Few scholars were interested in the subject prior to World War II, with the exception of the research efforts by Franz Boas and his students undertaken early in this century. Thus, it is not surprising that there have been few works that survey eroticism in ethnoart. In the 1920s and early 1930's the popular use of Freudian psychology to analyze art is exemplified by Sydow's Primitive Kunst und Psychoanalyse, in which the author suggests a kind of sexual basis for much of ethnoart. With the exception of Sydow's book, it is not until the early 1970s that erotic ethnoart is addressed. Charriere's La signification des representations erotiques dans les arts sauvages et prehistoriques is primarily concerned with early ancient cultures but does include commentary on some "primitive" cultures. More scholarly and comprehensive are Hakansson's article "Art and dance, sex in primitive" from The encyclopedia of sexual behavior and the well-illustrated Primitive erotic art edited by Rawson. This latter work is an anthology of essays by scholars on each of the major regions of ethnoart, which in spite of inconsistent quality in text and illustration serves as the most thorough survey to date. Another book with the same title by Rome and Rome is a confusingly organized and largely undocumented visual survey of erotic ethnoart.

Background

22-1 BERKUSKY, H. "Homosexualitat bei Naturvolkern." Geschlecht
und Gesellschaft 6 (1911): 49-55.
Research into homosexuality among 'primitive' peoples, espe-
cially in North America.

22-2 _____. "Die Kunstliche Deformierung der Geschlechtleile bei den
Naturvolkern." Geschlecht und Gesellschaft 6 (1911): 307-20.
Early, detailed study of some unusual examples of genital de-
formation around the world.

22-3* BROWN, SANGER, and LEUBA, J.H. The sex worship and symbol-
ism of primitive races. Boston: R.G. Badger, 1916. 145 pp.

22-4 CRAWLEY, ERNEST. Studies of savages and sex. Edited by
Theodore Besterman. New York: Dutton, 1929. 300 pp., index.
Anthropological investigation into sex beliefs and practices
among peoples around the world.

22-5 FEHLINGER, HANS. Sexual life of primitive people. Translated
by Mr. and Mrs. S. Herbert. New York: United Book Guild, 1945.
133 pp., bib. (First edition, London, 1921.)
Study of aspects of sex and the stages of life in primitive
societies.

22-6 HENRIQUES, FERNANDO. La sexualite sauvage. L'Encyclopedie
Planete. Edited by Micheline Soulie; preface and notes by George
Devereaux. Paris: Editions Planete, ca. 1965. 253 pp., bib.,
illus.
Sex lives of "primitive" peoples compared to the West.

22-7 JACOBUS X. Untrodden fields of anthropology. 2 vols. New
York: Privately re-issued by the American Anthropological Soci-
ety, ca. 1935.
Study of sexual anatomy, practices, and "perversions" among
the peoples of Asia, America, Oceania, and Africa.

22-8 KARSCH-HAACK, FERDINAND. Das Gleichgeschlectliche Leben
der Naturvolker. Munich: Ernst Reinhardt, 1911. 668 pp., bib.,
illus.
Early, extensive study of homosexuality in the "primitive"
world.

22-9* MULLER, JOSEF. Das sexualle Leben der Naturvolker. Augs-
burg, 1901.

22-10 RECLUS, ELIE. Curious bypaths of anthropology: sexual savage
and esoteric customs of primitive peoples. New York: Privately
printed, Robin Hood House, 1932. 255 pp.
Discusses the sexual lives of a select number of "tribes," mostly
in the upper regions of the northern hemisphere.

22-11 REPOLLES AGUILAR, JOSE. El amor en los pueblos primitivos.
Barcelona: Rodegar, 1976. 423 pp., bib., illus.
Survey of sexual customs among many 'primitive' peoples.

22-12 ["Sexualite et Societes" issue.] Objets et Mondes 17, no. 1
(Spring 1977).
Collection of articles on aspects of sexuality from cultures
around the world.

Art

22-13 CHARRIERE, G. La signification des representations erotiques
dans les arts sauvages et prehistoriques. Collection l'erotisme
populaire. Paris: G.-P. Maisonneuve et Larose, 1970. 210 pp.,
figs., illus., bib., gloss.
Erotic art of early ancient cultures and some 'primitive'
peoples surveyed.

22-14 ENEL, CATHERINE. "Le sexe et l'objet; catalogue rassemble."
Objets et Mondes 17, no. 1 (Spring 1977): 47-66, illus.
Selection of objects from the Musee de l'Homme representing
several sexual themes in primitive art.

22-15 HAKANSSON, TORE. "Art and dance, sex in primitive." In The
encyclopedia of sexual behavior, edited by Albert Ellis and Albert
Abarbanel, 154-60, bib. New York: Jason Aronson, 1973.
Brief study of elements of erotic art in Africa, Oceania, and the
Americas.

22-16 JEFFREYS, M.D.W. "The penis-sheath, the Basenji and Bezoar."
South African Journal of Science 64, no. 8 (August 1968): 305-18,
ref.
Study of the diffusion of penis sheaths.

22-17 RAWSON, PHILIP, ed. Primitive erotic art. New York: Put-
nam's, 1973. 310 pp., map, bib., index, illus. (some col.).
Collection of essays providing geographical survey coverage of
the erotic art of the "primitive" world.

22-18 ROME, LUCIENNE, and ROME, JESUS. Primitive erotic art. Fri-
bourg and Geneva: Liber, 1983. 96 pp., illus. (col.).
Collection of short essays on miscellaneous aspects of 'primi-
tive' erotic art, well illustrated.

22-19 SYDOW, ECKART VON. Primitive Kunst und Psychoanalyse: eine
Studie uber die sexuele Grundlage der bildenden Kunste der Natur-
volker. Leipzig: Internationaler Psychoanalytischer, 1927. 182
pp., illus., index.
Strongly influenced by then current psychological theories,
study of sexuality in "primitive" culture and arts.

22-20 UCKO, PETER J. "Penis sheaths: a comparative study." Royal
 Anthropological Institute Proceedings for 1969, 1970, 24-67, map,
 illus., notes.
 Distribution and comparative study of the use of penis sheaths,
 primarily, but not exclusively, among Oceanic cultures.

22-21 VASTOKAS, J.M. "Artifact, history, and Eros: three approaches
 to native art." Artscan 31, no. 1 (Spring 1974): 87-89.
 Review of Rawson's Primitive Erotic Art provides overview of
 the subject and offers substantive criticisms of the approach to the
 subject taken by some authors.

Chapter 23
Africa

Background

There is great deal of mythology about the sexuality of black peoples in American and European popular culture, myths that are an aspect of derogatory racist attitudes. Although a wide range of sexual behavior can be found in Africa, few generalizations can be made about sexuality in the sub-Saharan part of the continent. Anthropologists and sociologist have extensively studied African cultures, but only a few have focused on sexuality. Most of the books that appear to be surveys of sex in Africa are merely "popularized" compilations of disparate information culled from general ethnographic studies, strong on social relationships between the sexes, veneral disease, the existence of prostitution, and sexual implications of clothing and ornamentation, while weak on sex practices and erotic art. The earliest of these surveys is Freimark's Das Sexualleben der Afrikaner published in 1914, a remarkably scholarly study for such an early date. Books by Felix Bryk in the 1930's and 1940's followed the format of Freimark's work, but included a number of illustrations (fuzzy black and white field photographs), followed by Pedrals's La vie sexuelle en Afrique noire (1950), Hambly's article in The encyclopedia of sexual behavior ("Africans, the sex life of"), Rachewiltz's Black eros (probably the most thorough in its coverage of the subject and with the best illustrations), and Costa-Clavell's Erotismo negro. The bibliographies in these books gives some idea of the literature of studies of sex in Africa, but especially recommended is the comprehensive Bibliography of Africana in the Institute for Sex Research, Indiana University, compiled by Roger Beck.

Art

Sub-Saharan Africa is an enormous region with hundreds of cultures, few of which have been studied by art scholars. Within the growing literature on African art, little has been said about erotic art. An article by Ladislav Segy published in an obscure periodical in the mid-1950s "African phallic symbolism" is still unsurpassed in its comprehensiveness and analysis of the subject. Excluding a special erotic art issue of the magazine African arts in 1982, only a few studies have been published: Archdeacon on Madagascar's "Erotic grave sculpture of the Sakalava and Vezo" and

articles by Dart, Wagner, and Wilcox on phallic imagery and rock art in southern Africa. The African arts special issue was assembled by Daniel Crowley who wrote an introduction to the issue and provided an article on West African bronzes ("Betises: Fon brass genre figures"), together with Bourgeois's study of Zairean initiation masks ("Yaka masks and sexual imagery"), Burt's exploration of the sexual meaning of body scarification and painting in western Kenya ("Eroticism in Baluyia Body Arts"), Cole's iconographic study of Nigeria's ("Sexual imagery in Igbo Mbari houses"), Garrard's look at Ghanaian miniature sculptures ("Erotic Akan goldweights"), and Kaunda's explanation of his modern wood carving ("Love pipe").

Background

23-1* BECK, ROGER B. A bibliography of Africana in the Institute for Sex Research, Indiana University. Bloomington: Indiana University, African Studies Program, 1979. 134 pp., bib.
 One of a series of bibliographies derived from the library holdings of the Institute.

23-2 BRYK, FELIX. Dark rapture: the sex-life of the African Negro. Introduction entitled "Critique of sexual anthropology" by J.D. Unwin. Forest Hills, N.Y.: Juno Books, 1944. 167 pp., illus.
 Compilation of ethnographic research on sexual customs among a large number of East African peoples.

23-3 _____. Voodoo-Eros: ethnological studies in the sex-life of the African aborigines. Translated by Mayne F. Sexton. New York: United Book Guild, 1964. 251 pp., index, illus.
 Study of sex practices in East Africa north of Lake Victoria.

23-4 DUROZOI, GERARD. "L'Eros Africain." Opus International 13-14 (November 1969): 46-48.
 Discussion of some erotic aspects of African culture.

23-5 ECHEWA, T. OBINKARAM. "African sexual attitudes." Essence 11, no. 9 (January 1981): 54+.
 Comments on traditional sex education in Africa.

23-6 FREIMARK, HANS. Das sexualleben der Afrikaner. Leipzig: Leipziger, 1914. 422 pp., intro.
 Discussion on African sex life with chapters on dance, clothes, ornament, etc.

23-7 HAMBLY, WILFRED DYSON. "Africans, the sex life of." In The encyclopedia of sexual behavior, edited by Albert Ellis and Albert Abarbanel, 69-74, ref. New York: Hawthorn, 1961.
 Survey of major elements of sexually in traditional and modern Africa.

23-8 HOWARD, JAMES (Javier Costa-Clavell, pseudo.). Erotismo negro.
 Barcelona: Ediciones Mundilibro, 1976. 254 pp., bib., index,
 illus. (some col.).
 Survey of sex customs in Africa, including considerable focus
 on circumcision and body arts.

23-9 KASHAMURA, ANICET. Famille, sexualite et culture: essai sur les
 moeurs sexuelles et les cultures des peuples des Grands Lacs
 Africains. Paris: Payot, 1973. 214 pp., bib., map.
 Survey of social and sexual customs in Africa.

23-10 LINDBLOM, GERHARD. "Afrikansk Erotik." In Afrikanska Strov-
 tag, Tva Ars Folklivsstudier. Vol. 1, Engelska och Tyska Ost-Afri-
 ka. Stockholm: Albert Bonniers, 1914, 108-16, illus.
 Chapter on sex customs mostly focuses on body art and orna-
 mentation.

23-11 PEDRALS, DENIS-PIERCE DE. La vie sexuelle en Afrique Noire.
 Paris: Payot, 1950. 188 pp., bib.
 Survey of sexual customs in Africa.

23-12 RACHEWILTZ, BORIS DE. Black eros: sexual customs of Africa
 from prehistory to the present day. London: George Allen & Un-
 win, 1964. 239 pp., map, index, bib., illus. (some col.), figs.
 Survey of sexual customs in Africa and their cultural expres-
 sions, emphasizes West and Central Africa, but includes information on
 all regions.

23-13* RUHMANN, H.K. "Der Phallus in Kult Brauchtum Afrikas." Ph.D.
 Dissertation, University of Vienna, 1956.

23-14* WINTER, J.A. The phallus cult amongst the Bantu. Cape Town,
 1914.

Art

23-15 ARCHDEACON, SARAJANE. "Erotic grave sculpture of the Saka-
 lava and Vezo." Transition 3, no. 12 (January-February 1964):
 11+, illus., por.
 Malagasy grave posts depicting copulating couples discussed.

23-16 BASTIN, MARIE-LOUISE. "Ukule, initiation des adolescentes chez
 les Tshokwe (Angola)." Arts d'Afrique Noire 57 (Spring 1986): 15-
 30, illus., bib.
 Includes discussion of male and female genital deformation rites
 and the use of images of lovemaking couples.

23-17 BOURGEOIS, ARTHUR P. "Yaka masks and sexual imagery." Afri-
 can Arts 15, no. 2 (February 1982): 47-50, illus. (some col.).
 Study of initiation masks with erotic imagery among the Yaka of
 Zaire.

23-18 BURT, EUGENE C. "Eroticism in Baluyia body arts." African Arts
 15, no. 2 (February 1982): 68-69.
 Asserts that there are sexual meanings to several types of
 body art in western Kenya, suggesting that conclusions may be appli-
 cable throughout Africa.

23-19 COLE, HERBERT M. "Sexual imagery in Igbo Mbari houses."
 African Arts 15, no. 2 (February 1982): 51-56, illus. (some col.).
 Mbari houses may include a number of categories of sexual
 images, which are described and illustrated.

23-20 CROWLEY, DANIEL J. "Betises: Fon brass genre figures." Afri-
 can Arts 15, no. 2 (February 1982): 56-58, illus.
 Descriptive study of a special category of miniature brass
 sculptures.

23-21 _____. "The erotic, the pornographic, and the vulgar in African
 arts." African Arts 15, no. 2 (February 1982): 46-47.
 Essay considers some aspects of sexual attitudes in Africa as
 they may relate to art.

23-22 DART, RAYMOND A. "Phallic objects in southern Africa." South
 African Journal of Science 26 (December 1929): 553-62, figs.
 Description of several stone phallic objects.

23-23* GALERIE KUNZI. [Fertility symbols in African art.] Oberdorf-
 Solothurn, Switzerland: Galerie Kunzi, 1982.
 Exhibition catalog.

23-24 GARRARD, TIMOTHY F. "Erotic Akan goldweights." African Arts
 15, no. 2 (February 1982): 60-62, illus. (col.).
 Study of a category of miniature brass sculptures.

23-25 KAUNDA, BERLINGS. "Love pipe." African Arts 15, no. 2 (Febru-
 ary 1982): 59, illus.
 Artist describes a wood sculpture he has created to express
 some of his ideas about sexuality.

23-26 SEGY, LADISLAV. "African phallic symbolism." Zaire 9, no. 10
 (December 1955): 1039-67, illus.
 Thorough analytical survey of eroticism in African art.

23-27 WAGNER, PERCY. "Note on a relic of the phallus cult among the
 M'Kahtla." Annals of the Transvaal Museum 7, no. 4 (1 June 1921):
 262, illus.
 Describes the erection of a tall pole representing the male
 phallus in circumcision rites in South Africa.

23-28 WILCOX, A.R. "So-called infibulation in African rock art." Afri-
 can Studies 37, no. 2 (1978): 203-26, figs., table. (First pub-
 lished in South African Archaeological Bulletin 27, nos. 1-2 (Sep-
 tember 1972): 83+.)

Chapter 24
Oceania

One of the mythic images of the South Seas is that the region is a sexual paradise. This view has had a powerful influence on European adventurers, writers, and travelers for several centuries. The mental picture of a place where healthy beautiful people engage in prolonged love-making anytime they want is, of course, not realistic, yet has some basis in fact as revealed by studies of anthropologists since the turn of the century, including the now controversial work of Margaret Mead on the Samoans.

Within the four regions of Oceania (Melanesia, Micronesia, Australia, and Polynesia) a diverse range of sexual customs and practices can be found, including what may be the closest thing to "free love" in a human society ever known. This range encompasses the highly complex and structured intergender relationships seen in Melanesian and Australian communities, best documented by Malinowski in his study of the Trobriand Islanders entitled The sexual life of savages in north-western Melanesia, and the sexual freedom apparently characteristic of central Polynesia, especially the Society Islands and the Marquesas (the primary source of the sexual paradise myth mentioned above). Polynesian sexuality is surveyed by Danielsson in Love in the South Seas and is further analyzed by Sahlins in Islands of history, and the Marquesas are discussed by Dening, Marshall, Menard, and Suggs.

Art

There is very little overtly sexual art from Oceania. Other than the appearance of ithyphallic figures in the Sepik River region of New Guinea few traditions of erotic art have been documented and little information published, although phallic stones found in Australia have been described by Balfour, Campbell, and Mountford; the use of gourds as penis sheaths (a kind of cod piece) in New Guinea has been discussed by Gell, Heiser, Jenkins, and Reisenfeld; vulvic and phallic images found on Easter Island are featured by Lee and Young.

Oceania

Background

24-1 DANIELSSON, BENGT. Love in the South Seas. Translated by
 F.H. Lyon. New York: Reynal, 1956. 240 pp., illus., index.
 Ethnographic study of love and sexual behavior among Poly-
 nesians.

24-2* DENING, GREG. Islands and beaches: discourse on a silent land:
 Marquesas 1774-1880. Honolulu: University Press of Hawaii,
 1980. 355 pp., illus., bib., index.

24-3 MALINOWSKI, BRONISLAW. The sexual life of savages in
 north-western Melanesia: an ethnographic account of courtship,
 marriage and family life among the natives of the Trobriand Is-
 lands, British New Guinea. 2 vols. New York: Horace Liveright,
 1929. Illus., plan, index.
 Classic anthropological study of the sex life of a Melanesian
 culture.

24-4 MARSHALL, DONALD S. "Too much sex in Mangaia." In Sexual
 deviance and sexual deviants, edited by Erich Goode and Richard
 Troiden, 26-38. New York: William Morrow, 1974.
 Study of types and levels of sexual activity on the island of
 Mangaia.

24-5 MENARD, WILMON. "Love Marquesan style." Sexual Behavior 2,
 no. 9 (September 1972): 53-56, illus.
 Study of modern Marquesan sex practices, mentions traditional
 behaviors.

24-6* SAHLINS, MARSHALL DAVID. Islands of history. Chicago: Uni-
 versity of Chicago Press, 1985. 180 pp., illus., bib., index.

24-7* SUGGS, ROBERT CARL. Marquesan sexual behavior (an anthro-
 pological study of Polynesian practices). New York: Harcourt,
 Brace, 1966. 251 pp., illus., bib.

Art

24-8 BALFOUR, H.R. "A phallic stone from Central Australia." Mankind
 4, no. 6 (May 1951): 246-49, illus.
 Description of phallic shaped stone artifact.

24-9 CAMPBELL, WILLIAM DUGALD. "A description of certain phallic
 articles of the Australian Aborigines." Man 21 (article no. 90) (Oct-
 ober 1921): 145-46, illus.
 Stone phalliforms described.

24-10 GELL, A.F. "Penis sheathing and ritual status in a West Sepik
 village." Man, n.s., 6, no. 2 (June 1971): 165-81, map, table, figs.
 Study of New Guinea penis sheaths.

24-11 HEISER, C.B. "Penis gourd of New Guinea." Annals of the Asso-
 ciation of American Geographers 63, no. 3 (September 1973): 312-
 18, figs., diag.
 Distribution study of gourd plants in New Guinea; includes dis-
 cussion of the spread of the use of penis sheaths.

24-12 JENKINS, D. "Tribe that kept its gourd." Far Eastern Economics
 Review 102 (24 November 1978): 34-35, illus.
 Story of failed effort by Indonesian government to get penis-
 sheath wearing Irian Jaya tribesmen to wear shorts instead.

24-13 LEE, GEORGIA. "Further comment: the cosmic komari." Reply
 by Paul G. Bahn. Rock Art Research 4, no. 1 (May 1987): 51-55,
 figs., bib.
 Study of vulva symbols found on many rock art sites on Easter
 Island.

24-14 MOUNTFORD, CHARLES P. "Phallic objects of the Australian Abo-
 rigines." Man 60 (article no. 118) (June 1960): 81, illus.
 Description of stone phallic sculptures.

24-15 _____ . "Phallic stones of the Australian Aborigines." Mankind 2,
 no. 6 (May 1939): 156-61.
 Description of phallic sculptures.

24-16 MOYLE, RICHARD M. "Sexuality in Samoan art forms." Archives
 of Sexual Behavior 4, no. 3 (May 1975): 227-47, bib.
 Sexual expression in Samoan performing arts is described.

24-17 REISENFELD, A. "Rattan cuirasses and gourd penis-cases in New
 Guinea." Man 46 (1946): 31-36.
 Description and distribution of defensive armor and penis
 sheaths in New Guinea.

24-18 YOUNG, J.L. "Remarks on phallic stones from Rapanui." Occasion-
 al Papers of the Bernice Pauahi Bishop Museum of Polynesian Eth-
 nology and Natural History 2, no. 2 (1904): 31-32, illus.
 Easter Island phallic stone sculptures described.

Chapter 25
North America

Background

Native North American cultures produced very little erotic art, though they generally held positive views of sexuality, had sexually related rituals, possessed a rich tradition of erotic literature, and practiced fertility worship. The best known aspect of their sexual customs is the berdache, a tradition found predominantly among certain Plains peoples where a social category allowed people to adapt the behavior of the opposite sex (usually a man who did not want to become a warrior). Surveys of Native American sexuality have been written by Glover, Voget, and Williams, the latter a well-researched scholarly study.

Art

The Native American erotic art that has been reported is limited to a few types of objects—phallic stone pestles found on the West Coast, some rock art and painted Southwest ceramics with scenes of copulation, and explicitly sexual figures on Cherokee pipes. Very little has been written on these objects, the only survey being the Native American section of Rawson's Primitive erotic art listed in the "Ethnoart (General)" chapter of this bibliography.

Background

25-1* GLOVER, JACK. The sex life of the American Indian. Wichita Falls, Texas, 1968. 95 pp., illus.

25-2* JOUVANCOURT, HUGUES DE. Eros Eskimo. Montreal: Editions la Fregate, 1969. 24 pp. (text), illus.

25-3 VOGET, FRED W. "American Indians, sex life of the." In The encyclopedia of sexual behavior, edited by Albert Ellis and Albert Abarbanel, 90-109, ref. New York: Hawthorn, 1961.
 Survey of major features of sex customs among the native peoples of North America.

North America

25-4* WILLIAMS, WALTER. The spirit and the flesh: sexual diversity in
 American Indian culture. Boston: Beacon Press, 1986.

Art

25-5 BROWN, R.S.; MURRAY, J.R.; and VAN HORN, D.M. "A probable
 stone phallic effigy from Calabas, California." Pacific Coast
 Quarterly 22, no. 4 (1986): 18-24, fig.

25-6* GUDGEON, W.E. "Phallic emblem from Atiu Island." Journal of the
 Prehistoric Society 13 (1904): 210-12.

25-7 WITTHOFT, JOHN. "An Ohio effigy pipe." Ohio Archaeologist,
 n.s., 3, no. 2 (April 1953): 10-13, illus.
 Description of phalliform animal effigy pipe.

Chapter 26
Latin America

Background

 The Pre-Columbian civilizations of Latin America are famous for their wealth, military power, complex social organization, spectacular art and architecture, and such practices as human sacrifice, but the details of daily life and sexuality are not so well known. These societies tended to be hierarchically organized and strictly controlled by temporal and religious systems that, on the whole, placed considerable limitations on sexual activity--some cultures, like the Incas, have been called puritanical in regards to sex by some scholars. It appears that little research has been conducted into the sex customs, beliefs, and practices in the Pre-Columbian world, although a few publications do shed light on this subject, including Guerra's The Pre-Columbian mind: a study into the aberrant nature of sexual drives. . . and the two-part article by Krumbach entitled "Sexualitat und erotik im alten Amerika" published in Sexualmedizin. The most thorough source on sexuality in Pre-Columbian Latin America is Federico Kauffmann Doig's Comportamiento sexual en el antiguo Peru (also published in German and, perhaps, in an English edition) that bases much of its text on analysis of the Mochican erotic pots discussed below.

Art

 Images of sexuality in Pre-Columbian art seem to be concentrated in certain geographic regions and historical periods. In the region we now call Central America erotic art takes several forms. The theme of the ithyphallic warrior seems to have been popular in western Mexico as expressed in a number of small-scale ceramic sculptures. Images of fertility were common with corn and particular animals being frequently used as symbols of fertility (examples are described by Balser and Boos). More rarely seen are images of the lovemaking of the gods. In the religions of this region, especially among the Maya, there appears to have been a ritual connection made between blood, pain, and the sexual organs, occasionally represented on vase paintings and stone reliefs. Recent research suggests that in some areas of Central and South America the sexual images may be related to the use of hallucinogenic drugs (see De Rios on "The Mochica of Peru"). Some examples of Mesoamerican erotic art can be found in a catalog of objects of a sexual nature held by the National Museum in Mexico

City, published in 1926 by Ramon Mena (many of these objects have rarely appeared in publications since then). Several of the items listed in the "Survey" chapter of this bibliography include examples of pre-Columbian erotic art, while the most comprehensive overview has been provided in Rawson's Primitive erotic art (listed in the "Ethnoarts (General)" chapter).

The most extraordinary tradition of erotic art in all of ethnoart is that found among the Mochica (Moche) and related cultures of pre-Hispanic Peru. Their tradition of burying the dead with pottery sculptures depicting daily life has given us a remarkably detailed account of their world. Among those pots are many that show scenes of sexual activity, almost all of which appear to be domestic scenes. Much has been written about the fact that by far the most frequently depicted activities are fellatio and anal intercourse. It is further intriguing to note that some authors have suggested that this erotic art was produced by women, which, if true, would be a tradition unique in history. These erotic pots are among the best-known examples of erotic art, largely because of their accessibility in museum and private collections and as a result of the books written about them. As far back as 1925 Arthur Posnansky was writing about the erotic pottery, but works with good illustrations only became available in the mid-1960s. Rafael Hoyle's Checan: essay on erotic elements in Peruvian art presented an overview of these pots, but unfortunately the text is punctuated with moralistic commentary and interpretation. Within a few years a more thorough and objective book, Interpretacion de la sexualidad en la ceramica del antiguo Peru by Oscar Urteaga Ballon, appeared but had very limited distribution as it was published by the Museo de Paleo-Patologia in Lima. Later came Feriz's well-researched article in Ethnos, Gebhard's statistically based iconographic study of a large collection of pots, a succinct overview by Hocquenghem, and the small format souvenir guide Pre-Inca erotic art. The work of scholars, like Christopher Donnan, to survey the art of Peru should shed further light on this tradition.

Background

26-1 BENSON, ELIZABETH P. The Mochica: a culture of Peru. New York: Praeger, 1972. 164 pp., map, bib., index, illus. (some col.).
 General study of the Mochica, including mention of the erotic art.

26-2 BRADY, JAMES E. "The sexual connotation of caves in Mesoamerican ideology." Mexicon 10, no. 3 (May 1988): 51-55, fig., bib.

26-3* GREGOR, THOMAS. Anxious pleasures: the sexual life of an Amazonia people. Chicago: University of Chicago Press, 1985. 223 pp., index, ill., fig., table.

26-4 GUERRA, FRANCISCO. The Pre-Columbian mind: a study into the aberrant nature of sexual drives, drugs affecting behavior, and the attitude towards life and death, with a survey of psychotherapy in Pre-Columbian America. New York: Seminar, 1971. 335 pp., bib., index, map, illus.

Detailed, scholarly study that includes exploration of sex beliefs and practices in the pre-Columbian world.

26-5 HAGEN, VICTOR W. VON. The desert Kingdoms of Peru. New York: New American Library, 1964. 190 pp., map, illus. (some col.).
Includes a section discussing the erotic pottery.

26-6 KAUFFMAN DOIG, FEDERICO. Comportamiento sexual en el antiguo Peru. Lima: Kompaktos, 1978. 189 pp., illus. (Also published in German and, perhaps, English.)
Survey of sex customs and practices in ancient Peru: includes discussion of erotic pottery.

26-7* KRUMBACH, HELMUT. "Sexualitat und Erotik im alten Amerika: Teil 1: Die magische Bedeutung des Koitus." Sexualmedizin 1 (1985): 50-52.

26-8* _____. "Sexualitat und Erotik im alten Amerika: Teil 2: Symbole der Fruchtbarkeit." Sexualmedizin 3 (1985): 160-65.

26-9* LARCO HOYLE, RAFAEL. Los Mochicas. 2 vols. Lima: Casa Editora "La Cronica" y "Variedades," 1939.

26-10 QUEZADA, NOEMI. Amor y magia amorosa entre los Aztecas: supervivencia en el Mexico colonial. Mexico City: Universidad Nacional Autonoma de Mexico, Instituto de Investigacoes Antropologicas, 1975. 162 pp., figs., table, bib.
Anthropological study beliefs and practices related to magic, fertility, love magic, etc.

Art

26-11 ANTHONIOZ, SYDNEY, and MONZON, SUZANA. "Les representations sexuelles dans l'art rupestre Bresilien." Objets et Mondes 17, no. 1 (Spring 1977): 31-38, figs., illus., bib.
Prehistoric cave art in Brazil discussed in relationship to the depiction of sexual imagery.

26-12* ARBOLEDA, M. "Representaciones artisticas de actividades homoeroticas en la ceramic Moche." Boletin de Lima 16-18 (1981): 98-107, illus., fig., bib.
Evidence from four ceramic pices indicate male homosexual activity in Mochican rituals.

26-13 BALSER, C. "Fertility vase from the Old Line, Costa Rica." American Antiquity 20, no. 4 (April 1955): 384-86, illus.
Bowl with sculpture depicting the mythological origins of women described.

26-14 BOOS, FRANK H. "Two Zapotec urns with identical unclassified
 figures display an unique maize fertility concept." Baessler—Ar-
 chiv, n.s., 16, no. 1 (1968): 1-8, figs.
 Genital shaped pottery discussed, noting that such sexual ima-
 gery is rare in Oaxacan pottery.

26-15* BRUNING, ENRIQUE. "Beitrage zum Studium des Geschlechtsleb-
 ens der Indianer im alten Peru." Anthropophyteia 6 (1909): 101-
 12.

26-16* _____. "Beitrage zum studium des Geschlechtslebens der Indian-
 er Perus betreffend." Anthropophyteia 8 (1911): 199-202.

26-17 COMPTON, C.B. "Cult of the female among the Tarascans." Maga-
 zine of Art 46 (February 1953): 75-79, illus.
 Female imagery in Tarascan pottery discussed.

26-18 DAVIS, W. "So-called jaguar-human copulation scenes in Olmec art."
 American Antiquity 43, no. 3 (July 1978): 453-57.
 Disputes interpretation of three sculptures that have been said
 to be mythical copulation scenes.

26-19 DONNAN, CHRISTOPHER B. Moche art and iconography. Los An-
 geles: UCLA Latin American Center Publications, 1976. 146 pp.,
 bib., index, illus.
 Survey of Mochican art mentions the erotic ceramics.

26-20* FERIZ, HANS. "Altindianische 'erotische' Grabfunde in Mittelamer-
 ika (Echt und Falsch)." Internationales Archive fur Ethnographie
 50, no. 2 (1966): 137-44, illus., bib.
 Survey study of pre-Columbian Central American ceramic and
 metalwork erotic images.

26-21 _____. "Erotische Grabfunde in Costa Rica." Kultuurpatronen:
 Bulletin Etnografisch Museum Delft 5-6 (1963): 236-43, illus.
 Description of an erotic object from a grave leads to a dis-
 cussion of erotic imagery in Pre-Columbian cultures.

26-22 _____. "Sinn und Bedeutung der erotischen Grabbeigaben in Alt-
 Peruanischen Graben." Ethnos 31 (1966): 173-81, illus., bib.
 Research into Mochican erotic pottery.

26-23 GEBHARD, PAUL H. "Sexual motifs in prehistoric Peruvian cera-
 mics." In Studies in erotic art, by Theodore Bowie et al, 109-70,
 illus. New York: Basic Books, 1970.
 Statistical study of motifs and themes in Mochican erotic pot-
 tery.

26-24 HOCQUENGHEM, ANNE-MARIE. "Les 'erotiques' et l'iconographie
 Mochica." Objets et Mondes 17, no. 1 (Spring 1977): 7-14, bib.,
 illus.
 Detailed study of Mochican erotic pottery.

26-25* _____ . "Les representations erotiques Mochicas et l'ordre And-
in." Bulletin de l'Institut Francais d'Etudes Andines 15, nos. 3-4
(1986): 35-47, fig., illus., bib.
 Interprets erotic imagery in terms of certain rituals of the
ceremonial calendar.

26-26 HOYLE, RAFAEL LARCO. Checan: essay on erotic elements in
Peruvian art. Geneva: Nagel, 1965. 146 pp., illus. (some col.).
 Dated but classic study of erotic pottery from the Mochican and
other cultures of Peru.

26-27 LEON, NICOLAS. "El Culto al Falo en el Mexico Precolumbiano."
Anales del Museo Nacional, Mexico, 2d ser., 1 (1903): 278-80, illus.
 Short article on a phallic stone monument acquired by the Na-
tional Museum at the turn of the century.

26-28 MENA, RAMON. Catalogo del salon secreto (culto al falo). 2d ed.
Mexico City: Museo Nacional de Arquelogia, Historia y Etnografia,
1926.
 Catalog of Pre-Columbian objects held by the National Museum
that are sexual in nature.

26-29* POSNANSKY, ARTHUR. "Die erotischen Keramiken der Mochicas
und deren Beziehungen zu okzipital-deformierten Schaden."
Deutsche Gesellschaft fur Anthropologie, Ethologie, und
Urgeschichte, Verhandlungen 2, no. 47 (1925).

26-30 Pre-Inca erotic art. Travel Companions; TC-1. Lima: ABC, 1978.
48 pp., illus. (some col.).
 Very small format pocket book primarily consisting of color
photographs accompanied by a text discussing the nature of erotic
ceramics in ancient Peru.

26-31 RIOS, MARLENE DOBKIN DE. "The Mochica of Peru." In Hallu-
cinogens: cross-cultural perspectives. Albuquerque: University
of New Mexico Press, 1984, 91-115, figs.
 Explores the relationship between sexual themes in art, the
use of hallucinogenic drugs, and shamanic ritual.

26-32 STRECKER, MATTHIAS. "Representaciones sexuales en el arte
rupestre de la region Maya." Mexicon 9, no. 2 (1987): 34-37.

26-33 URTEAGA BALLON, OSCAR. Interpretacion de la sexualidad en la
ceramica del antiguo Peru. Lima: Museo de Paleo-Patalogia, 1968.
406 pp., bib., illus., table.
 Profusely illustrated survey of erotic themes in traditional
Peruvian art (including media other than pottery).

Section 6
The Western World
(to the end of the
19th Century)

Chapter 27
Western World (General)

Background

With the fall of the Roman Empire and the rise of Christianity the nature of European civilization changed dramatically. No where can that change be better demonstrated than in the realm of sexuality, particularly in the relationship between religion and sex. The traditions of sexual deities, sacred prostitution, fertility and phallic worship, etc., were effectively, if not totally, suppressed in the first millenium A.D. In place of those pre-Christian practices, Christianity sought to redefine male-female relationships and severely limit acceptable sexual behavior. The persistence of certain pre-Christian customs and beliefs even to the present day indicates the struggle the Church has faced in establishing its control of the lives of the populus. The history of sexuality in Europe is not a story of linear development, but a chronicle of changing attitudes varying by historical era and national character. For the purposes of this bibliography the Western period is considered to extend from the Medieval age to the late nineteenth century.

There have been few surveys exclusively focusing on sexuality in European civilization, yet much has been written on the subject. Almost all the entries in the "Sex Customs" chapter of this bibliography are primarily concerned with Europe. In fact, users of this bibliography need to note that frequently books with titles suggesting cross-cultural coverage are really just about Europe (for example, Lucka's Eros: the development of the sex relation through the ages is a study of love and sex in Western civilization only). Among the useful surveys of European sexuality listed below are books by Brusendorff, Klimowsky, and Lucka. Of those three only Brusendorff includes valuable illustrations. Overviews of sex in national history are available for England (see Bloch, Fryer, and Stone) and France (see Marchand).

Art

Unlike many religions, the Christian church has never been a patron of erotic art and in most periods vigorously worked to suppress expressions of sex in art. Yet throughout Western history erotic art has been produced in one form or another, although it often had to be heavily camouflaged in obscure symbolism or references to biblical sources. Evidence of

early concerns about the role of sexuality in art can be found in Freed-
burg's discussion of the Renaissance humanist Molanus's views on the pro-
priety of nudity in art and Hoffmann's discussion of what the late Gothic
and the Renaissance thought about ancient erotic art. Thus, research into
European erotic art is subject to a great deal of controversy and dispute--
examples of this controversiality would include recent research asserting
that Christ's sexuality was emphasized in Renaissance depictions of the
baby Jesus or the proposition that much of European erotic art is sado-
masochistically oriented. Rare during the Renaissance, but more frequent
in subsequent centuries, were explicit depictions of sexual activities; unam-
biguously sexual imagery only becomes relatively common beginning in the
eighteenth century, developing into a significant category of art in the
nineteenth and twentieth centuries.

General surveys of erotic art, listed in the "Surveys" chapter of this
bibliography, usually are predominantly concerned with Europe (see the
books by Fuchs, for instance); in addition, a number of surveys focusing
exclusively on European erotic art also exist. In 1920 Witkowski published
Les licences de l'art Chretien which primarily covers the medieval age but
includes discussion of Renaissance and post-Renaissance art. Forty-five
years later Rabenalt's Mimus eroticus discusses sexual themes in Medieval
and Renaissance art. Almost simultaneously in the early 1970s appeared
Carr's nonscholarly collection of tame works by major artists European
erotic art, Lucie-Smith's succinct chronological overview Eroticism in West-
ern art, and Melville's thematically arranged Erotic art of the West. The
multivolume annual auction catalogs by D.M. Klinger provide a rich source of
illustrations.

Many publications on European erotic art focus on a specific topic
rather than offer overall surveys. These may be thematic or iconographic
studies, such as Baird on the rooster as an image of fertility, Kahr on the
story of Danae, Olds and Williams on images of love, Wille on love-for-sale,
etc. Others discuss object types, like Carrera and Marini on erotic
watches and Thomas on phallic votives or the art of individual nations, as in
Lorenzoni's books on England and France.

Background

 27-1 BLOCH, IWAN. Sexual life in England. London: Corgi, 1958.
542 pp., intro. (First edition in German, Berlin, 1901-3.)
 Survey of the history of sex life in England with chapters on
erotic art.

 27-2 BRUSENDORFF, OVE. Erotikens Historie: fra Graekenlands old-
tid til Vore Dage. Vol. 2. Edited by Christian Rimestad. Cop-
enhagen: Universal, 1937. 596 pp., illus.
 Themes and customs in the sex life of Europe in the Middle
Ages, Renaissance, Baroque, and Rococo periods.

 27-3 FRYER, PETER. Mrs. Grundy: studies in English prudery. New
York: London House and Maxwell, 1963. 368 pp., index, illus.
 Study of the development of English standards of "proper be-
havior."

27-4* GRAND-CARTERET, JOHN. Die erotik in der Franzosischen kari-
 katur. Vienna: C.W. Stern, 1909. Ill.

27-5 KLIMOWSKY, ERNST WERNER. Geschlecht und Geschichte: Sex-
 ualitat im Wandel von Kultur und Kunst. Essay by Max Brod.
 Teufen: A. Niggli, 1956. 208 pp., bib., index, illus.
 Study of European sex customs.

27-6 LUCKA, EMIL. Eros: the development of the sex relation through
 the ages. Translated, with introduction, by Ellie Schleussner.
 New York: Putnam's, 1915. 379 pp.
 Study of aspects of love and sex in Western civilization.

27-7* MARCHAND, HENRY L. The erotic history of France. New York:
 Panurge, 1933.

27-8 PERELLA, NICOLAS JAMES. The kiss sacred and profane: an in-
 terpretive history of kiss symbolism and related religio-erotic
 themes. Berkeley: University of California Press, 1969. 356
 pp., bib., index, illus.
 Meanings and variations of the kiss in the West (mostly Medieval
 to Baroque).

27-9 RADCLIFF-UNSTEAD, DOUGLAS, ed. Human sexuality in the Middle
 Ages and Renaissance. University of Pittsburg Publications on
 the Middle Ages and the Renaissance, no. 4. Pittsburg: Center
 for Medieval and Renaissance Studies, 1978. 193 pp., figs.
 Collection of papers on facets of sexuality in Medieval and
 Renaissance times.

27-10* SINISTRARI, LUIGI MARIA. Demonality or Incubi and Succubi.
 Paris: Isidore Liseux, 1879. 252 pp., index, bib.
 English translation with Latin original of study of witchcraft.

27-11 STONE, LAWRENCE JOSEPH. The family, sex and marriage in Eng-
 land 1500-1800. New York: Harper & Row, 1977. 800 pp., index,
 illus., bib.
 Scholarly, thorough study of the sociology of family and sex-
 uality in England.

27-12 VOLP, RAINER. "Ars amandi und ars moriendi." Kunst und Kirche
 2 (1987): 92-97, illus.
 Essay on the Western concepts of eroticism and death, espe-
 cially as expressed in Medieval manuscripts.

Art

27-13 BAIRD, L.Y. "Priapus Gallinaceous: the role of the cock in fer-
 tility and eroticism in classical antiquity and the Middle Ages."
 Studies in Iconography 7-8 (1981-82): 81-111.

Theme of the rooster as a symbol of Priapus in his fertility and erotic aspects is studied from its ancient origins to its medieval expressions.

27-14 BARRICK, MAC E. "Folk toys." Pennsylvania Folklore 29, no. 1 (1979): 27-34, bib., illus.
Within study of folk toys there is a brief discussion of erotic toys.

27-15 CARR, FRANCIS. European erotic art. London: Luxor Press, 1972. 128 pp., illus., index.
Not too explicit eroticism in the works of the great masters surveyed.

27-16 CARRERA, ROLAND. Hours of love. Lausanne: Scriptar, 1977. 143 pp., illus. (some col.).
Trilingual text provides a history of erotically decorated timepieces (and other 'curiosities'), including an analysis of art styles, etc.

27-17 FREEDBURG, D. "Johannes Molanus on provocative paintings." Journal of the Warburg and Courtauld Institute 34 (1971): 229-45.
Analysis of early discussion of the propriety of nudity in art.

27-18* GRAND-CARTERET, JOHN. Le decollete et le retrousse: quatre siecles de Gauloiserie, 1550-1870. Paris: E. Bernard, 1902. 73 pp., illus. (some col.).
Discussion of eroticism in women's clothes as seen in French art.

27-19 HOFFMANN, K. "Antikenrezeption und Zivilisationsprozess im erotischen Bilderkreis der fruehen Neuzeit." Antike und Abendland 24 (1978): 146-58, illus.
Research into the Early Renaissance reaction to ancient erotic art.

27-20 HOWARD, SEYMOUR. "Fig leaf, pudica, nudity, and other revealing concealments." American Imago 43, no. 4 (Winter 1986): 289-93.
Commentary on the use of fig leaves and other efforts to deny sexuality in Western art.

27-21 KAHR, MADLYN MILLNER. "Danae: virtuous, voluptuous, venal woman." Art Bulletin 58, no. 1 (March 1978): 43-55, illus., bib.
Study of the image of the Danae myth in Western art.

27-22 KASTEN, FRIEDRICH. "Homo bulla." Kunst und Kirche 2 (1987): 98-102, illus. (some col.).
Examination of the dance of death theme in Western art; includes examples of "Death and the maiden" images.

27-23 KLINGER, D[OMINIK] M. Erotische Kunst in Europa 1500-ca. 1935.
Vol. 1, 1500-1880. Nuremburg: DMK, 1982. 192 pp., illus. (some
col.).
 Introductory essay discusses some of the Western artists who
played a significant role in the history of erotic art followed by a
collection of 192 black and white and 33 color illustrations.

27-24 _____. Erotic art in Europe, 1500-1935. Vol. 1a, 1500-1880.
Nuremburg: DMK, 1983. 152 pp., illus. (some col.), bib.
 Short introductory essay precedes collection of 196 black and
white and 28 color illustrations.

27-25 _____. Erotic art in Europe, 1500-1935. Vol. 1b, 1500-1880.
Nuremburg: DMK, 1984. 136 pp., bib., illus. (some col.).
 Introductory essay on eighteenth century erotic illustrators
followed by a collection of 258 black and white and 34 color illustra-
tions.

27-26 _____. Erotic art in Europe 1500-1880, mit Kunstlerlexikon K-Z.
Vol. 12. Nuremburg: DMK, 1987. 88 pp., 16 col. pl., illus.
 Auction catalog of Renaissance and later erotic art. Includes
last part of four-part lexikon of artists and an index of named artists in
first twelve volumes of Klinger catalogs.

27-27 _____. Erotische Kunst in Europa, 1700-1880, mit Kunstlerlexi-
kon A-B. Vol. 9. Nuremburg: DMK, 1985. 93 pp., illus. (some
col.), bib.
 Includes part of an erotic artists lexikon (A-B) preceding a
collection of 218 black and white and 25 color illustrations.

27-28* _____. Erotische Kunst in Europa. Vol. 1: Mittelalter bis Grun-
derzeit. Neustadt: Aisch: DMK, ca. 1986.
 Selections of illustrations from the Klinger auction catalogs.

27-29 KUCHOWICZ, ZBIGNIEW. Milosc Staropolska: Wzory, Uczucio-
wosc, Obyczaje Erotyczne XVI-XVIII Wicku. Lodz: Wydawnictwo
Lodzkic, 1982. 595 pp., illus., bib.
 Study of the themes of love, marriage, and sex in the art of
Poland.

27-30 LORENZONI, PIERO. English eroticism. New York: Crescent
Books, 1984. 96 pp., illus. (col.).
 Study of seventeenth-twentieth century English erotic art with
emphasis on Thomas Rowlandson.

27-31 _____. French eroticism: the joy of life. New York: Crescent
Books, 1984. 104 pp., illus. (some col.).
 Survey of erotic art in France, especially erotic book illustra-
tions.

27-32 LUCIE-SMITH, EDWARD. Eroticism in Western art. New York:
Praeger, 1972. 287 pp., bib., illus. (some col.).
Erotic themes in Western art explored.

27-33* MARINI, G.L. "Orologi erotici: le ore dell'amore." Bolaffiarte 74
(1978): supp., 36-39, illus.
Study of erotic watches.

27-34 MELVILLE, ROBERT. Erotic Art of the West. World History of
Erotic Art Series. With a short history of Western erotic art by
Simon Wilson. New York: Putnam's, 1973. 318 pp., index, bib.,
illus. (some col.).
Thematic study of erotic themes in Western art.

27-35* MENARD, LEON. Histoire des antiquities de la ville de Nismes et
de ses environs. Nimes: Chez Aury, 1826.

27-36 OLDS, CLIFTON C., and WILLIAMS, RALPH G. Images of love and
death in late Medieval and Renaissance art. Ann Arbor: Univer-
sity of Michigan Museum of Art, 1976. 132 pp., bib., illus.
Thorough study of expressions of two of the most important
themes in the history of Western art.

27-37 RABENAULT, ARTHUR MARIA. Mimus Eroticus: das Venusische
Schauspiel im Mittelalter und in der Renaissance. 2 vols. Ham-
burg: Kulturforschung, 1965. Illus., figs.
Sexual themes in European culture and art in the Medieval and
Renaissance periods surveyed.

27-38 THOMAS, ERNEST S. "Phallic offerings." Man 28 (article no. 13)
(January 1928): 19-20, figs.
Discusses phallic offerings (for instance, erotic pastries) in
Post-Renaissance Europe.

27-39* WAETZOLDT, STEPHEN. "Metaphern der Sinnlichkeit." In Bilder
vom Menschen in der Kunst des Ablendlandes: Jubilaumsausstellung
der Preussischen Museen Berlin 1830-1980. Berlin: Mann, 1980,
341-45, illus.

27-40 WILLIE, HANS. "Wer Kauft Liebesgoetter." Niederdeutsche Bei-
trage zur Kunstgeschichte 11 (1972): 157-90, illus.
Theme of love for sale in Western art explored.

27-41 WITKOWSKI, GUSTAVE JOSEPH. Les licences de l'art Chretien.
Paris: Bibliotheque des Curieux, 1920. 164 pp., figs.
Profane and erotic imagery in European Christian art surveyed.

Chapter 28
Medieval

Known variously as the Medieval age, the Middle Ages, the Dark Ages, etc., the period from the fall of the Roman Empire to the beginning of the Renaissance is the era in which Christianity came to dominate European civilization. The transition from the old religions and customs to this new religion was not always smooth or uniformly achieved throughout the continent. The sexuality that played such a major role in Greek, Roman, and animistic religions was considered anathema to those who sought to establish the hegemony of Christianity. From literature and historic studies it is clear that there was a considerable gulf between the Church's teachings on sexuality and the practices of the masses. The continuing belief in fertility and phallic deities in Medieval Europe is explored in Thomas Wright's The worship of the generative powers during the Middle Ages. Typically, practicing clerics were sympathetic to local customs, but at times the Church could act viciously to eliminate what they proclaimed to be blasphemous beliefs, evil practices, witchcraft, etc. An early survey of Medieval sexuality was authored by Browe in 1932 entitled Beitrage zur sexualethik des mittelalters, but it was not until the 1960s that serious attention was paid to this subject. During the last twenty years surveys have been written by Brusendorff and Henningsen, Bullough & Brundage, Cleugh, Jeay, and Roy. Notable for its popularized account is Cleugh's Love locked out and the serious scholarship of Bullough.

Art

The Middle Ages encompass the art style periods when Christian art reached a zenith, largely concentrated on the great cathedrals. Considering the attitude of the church to sexuality, it is not surprising to discover that there were few opportunities for the production of erotic art. Yet sex did not disappear entirely from art, not even from the cathedrals. The Church, for instance, commissioned art that prominently displayed images of sinful behavior (particularly the Seven Deadly Sins, which includes "lust"), scenes of the punishments of hell, and depictions of some of the strongly sexual Old Testament stories. The ability of the Church to control the content of art was not total, a situation evidenced by the erotic themes found on the higher or more hidden parts of both the interiors and

exteriors of churches and cathedrals. Few publications have focused on
Medieval erotic art, but important contributions have been made by Montejo
and Mauny in articles and Weir and Jerman's recent scholarly book Images
of lust: sexual carvings on medieval churches. Many of the surveys listed
in the "Surveys" chapter and the "Western (General)" chapter include dis-
cussions and examples of medieval erotic art.

Misericords

A kind of folding seat built into the choir section of medieval churches
and cathedrals used by clerics is known as a misericord. Most of the time
the clergy stood during hours long services, but at times they could sit
down on the misericords. In many churches the underside of the seats
were carved with figures that display an extraordinary range of subjects,
including those of a scatological or sexual nature. The misericord carvings
may represent a kind of folk art whereby the religious strictures governing
the more public art of the church were not enforced and so more popular
images could be created. Early in this century Louis Maeterlinck pub-
lished Le genre satirique; fantastique et licencieux dans la sculpture Fla-
mande et Wallonne; les misericordes de stalles which reported on the more
risque Belgian examples of this type of erotica. Kraus's The hidden world
of misericords published in 1975 offers a more general survey of the themes
and meanings of misericord carvings.

Sheela-na-gigs

An indication of the syncretic process in the development of European
Christianity is evidenced by the existence of sheela-na-gigs. On many
Irish parish churches, near or above the main entrance, can be found relief
carvings of a nude female figure exposing her genitals. This apotropaic
image grew out of pre-Christian beliefs and only seems to have been fully
abandoned about 150-200 years ago. While rarely of high artistic merit,
the sheela-na-gigs (note that there are various ways to spell this) are an
interesting example of an erotic folk tradition. Long overlooked by scho-
lars, Jorgen Andersen's dissertation on the figures, published as The witch
on the wall, is a comprehensive documentation of the sheelas, offers cogent
analyses of their meaning, and provides a bibliography so thorough that
most items he lists are not incorporated into the entries listed below.
Discussion and criticism of some of Andersen's findings can be found in
articles by Rump and Moltke et al. Other related stone and wood Irish
sculptures are discussed by Andersen in "Temptation in Kilkea: erotic sub-
jects in medieval Irish art."

Background

28-1 BROWE, PETER. Beitrage zur Sexualethik des Mittelalters.
 Breslau: Muller and Seiffert, 1932. 143 pp.
 Sexual mores in the Middle Ages discussed.

28-2 BRUSENDORFF, OVE, and HENNINGSEN, POUL. A history of erot-
 icism. Vol. 2, The Middle Ages. New York: Lyle Stuart, 1965. 96
 pp., illus.
 Miscellaneous sexual themes in Western culture and art ex-
 plored.

28-3 BULLOUGH, VERN L., and BRUNDAGE, JAMES, eds. Sexual prac-
 tices and the Medieval Church. Buffalo: Prometheus Books, 1982.
 289 pp., index, bib.
 Anthology of studies on the sex life in the Middle Ages.

28-4 CLEUGH, JAMES. Love locked out: an examination of the irre-
 pressible sexuality of the Middle Ages. New York: Crown, 1964.
 320 pp., bib., index.
 Sex life in the Middle Ages surveyed.

28-5* HURWOOD, BERNHARDT T. "Devil in the flesh." Penthouse 5, no.
 4 (1970).
 Medieval attitudes towards sex and temptation discussed.

28-6* JEAY, MADELEINA. "Sur quelques coutumes sexuelles du Moyen
 Age." In L'erotisme au Moyen Age, edited by Bruno Roy, 123-41,
 illus. Montreal: Aurore, 1977.

28-7 JUNG, GUSTAV. "Sexuelle Anschauungen und Sitten des Mittel-
 alters." Zeitschrift fur Sexualwissenschaft 10 (1923-24): 264-92.

28-8 ROY, BRUNO, ed. L'erotisme au Moyen Age: etudes presentees au
 troisieme colloque de l'Institut d'Etudes Medievales. Communi-
 cations presentees a l'Universite de Montreal les 3 et 4 Avril 1976.
 Montreal: Editions de l'Aurore, 1977. 178 pp., illus.
 Anthology of papers on aspects of Medieval sexual behavior and
 expression.

28-9 WRIGHT, THOMAS. The worship of the generative powers during
 the Middle Ages. Covina, Calif.: Collectors Publications, 1967.
 196 pp., illus.
 Study of phallic worship in Medieval Europe.

Art

28-10 CHRISTENSEN, ERWIN O. "Unconscious motivations in Gothic
 art." Journal of Clinical Psychopathology and Psychotherapy 6,
 nos. 3-4 (January-April 1945): 581-99, figs.
 Psychological interpretations of some Medieval art.

28-11* FRIEDMAN, JOHN B. "L'iconographie de Venos et de son miroir a
 la fin du Moyen Age." In L'Erotisme au Moyen Age, edited by
 Bruno Roy, 51-82, illus. Montreal: Aurore, 1977.

Medieval

28-12* GAIGNEBET, C., and LAJOUX, J.D. Art profane et religion popu-
 laire au Moyen Age. Paris: Presses Universitaires de France,
 1985. 363 pp., ill. (some col.), bib., index.

28-13* MAUNY, R. "Les sculptures de la Roche-Clermault et de Deneze-
 sous-Doue. souterrains et deviations religieuses Medievales."
 Dossiers Archeology 2 (1973): 82-91, illus.
 Sexual imagery in sculpture produced during fourteenth to the
 sixteenth centuries discussed.

28-14 MONTEJO, MARIA INES RUIZ. "La tematica obscena en la icono-
 grafia del romanico rural." Goya 147 (November 1978): 136-46,
 illus.
 "Obscene" sculptures on the exteriors of churches described.

28-15 SHERIDAN, RONALD, and ROSS, ANNE. Gargoyles and grotes-
 ques: paganism in the Medieval Church. Boston: New York Gra-
 phic Society, 1975. Illus.
 Includes sections on images of "Fertility" and "Hermaphro-
 dites."

28-16 TARACHOW, SIDNEY. "Remarks concerning certain examples of
 late Medieval ecclesiastic art." Journal of Clinical Psychopath-
 ology 9, no. 2 (April 1948): 233-48, illus.
 Psychological interpretations of some Medieval art offered.

28-17* WEIR, ANTHONY, and JERMAN, JAMES. Images of lust: sexual
 carvings on Medieval churches. London: Batsford, 1986. 165
 pp., illus.

28-18 WITKOWSKI, GUSTAVE JOSEPH. L'Art profane a l'eglise, ses lic-
 ences symboliques, satiriques et fantaisistes. Contribution a
 l'etude archeologique et artistique des edifices religieux. 2 vols.
 Paris: J. Schemit, 1908. Illus.
 Cathedral by cathedral survey of the secular art (including
 scatalogical and sexual imagery), primarily sculptures, in churches of
 Europe (volume 1, France; volume 2, other countries).

Misericords

28-19* BOND, FRANCIS. Woodcarving in English churches: I. Mis-
 ericords: II. Stalls. London: Henry Frowde, Oxford University
 Press, 1910. 257 pp., illus.

28-20 KRAUS, DOROTHY, and KRAUS, HENRY. The hidden world of mis-
 ericords. New York: Braziller, 1975. 191 pp., illus., map.
 Study of misericords in European churches, includes some ex-
 amples with sexual imagery.

28-21 MAETERLINCK, LOUIS. Le genre satirique: fantastique et licen-
cieux dans la sculpture Flamande et Wallonne: les misericords de
stalles (art et folklore). Paris: Jean Schemit, 1910. 380 pp.,
figs., illus.
Study of Belgian misericords, some with sexual themes.

Sheela-na-gigs

28-22 ANDERSEN, JORGEN. "Temptation in Kilkea; erotic subjects in
Medieval Irish art." Konsthistorisk Tidskrift 40, nos. 3-4 (Dec-
ember 1971): 89-98, illus.
Study of stone and wood carvings of a sexual nature associated
with churches explored.

28-23 _____. The witch on the wall: Medieval erotic sculpture in the
British Isles. London: George Allen and Unwin, 1977. 172 pp.,
map, bib., index, ill, figs.
Thorough, scholarly study of the Sheela-na-gig. Includes a
comprehensive bibliography.

28-24 DOBSON, DINA PORTWAY. "Primitive figures on Churches." Man
30 (article no. 8) (1930); 31 (article no. 3) (1931). Illus.
Descriptions of male figures sometimes included under the term
Sheela-na-gig and a description of a typical sheela.

28-25 ETTLINGER, E. "Sheila-na-gigs." Folklore 85 (1974): 62-63.
Letter concerning the possible meaning of Sheela-na-gigs.

28-26 GODWIN, J.P. "Sheila-na-gigs and Christian Saints." Folklore 80
(Autumn 1969): 222-23.
Brief discussion of a Sheela-na-gig that may be associated with
St. Agatha.

28-27* MOLTKE, E; CARLSSON, F; ANDERSEN, J.; RUMP, E. "Debatt: the
Witch on the Wall og Ecclesia Universalis" [text in Danish]. Icono-
graphiske Post: Nordic Review of Iconography (Stockholm) 2
(1979): 48-51, illus.
Discussion of ecclesiastical sculpture including the Sheela-na-
gigs.

28-28* RUMP, E. "Sheela-Na-Gig diagnostik." Iconographiske Post
(Copenhagen) 9, no. 3 (1978): 38-41, illus.
Disputation of some conclusions in Andersen's thesis on the
Sheela-na-gigs.

Chapter 29
Renaissance and Baroque

Background

The control of the Church in European society significantly waned in the period from the fourteenth to the seventeenth century, especially for segments of the intellectual, economic, and political elites. The Renaissance fascination with antiquity, the fragmentation of Christianity engendered by the Reformation, and the Baroque veneration of aristocratic privilege, among numerous other factors, encouraged a diverse range of social and cultural experiments. Out of this atmosphere came distinctly different and sometimes conflicting standards of behavior--the peasant classes who followed their traditional practices which were frequently at odds with the ideals promulgated by the Church (see Quaife's Wanton wenches and wayward wives), the proliferating Christian sects that sought to enforce obeisance to their strict tenets, and the elites that sought increased freedom of action. Within this diversity can be found both sexual puritanism and the "free-love" philosophy of some radical Reformation groups (see Clasen's "Medieval heresies in the Reformation"). As regards sexuality, the changes of this era are especially evidenced by the reemergence of eroticism in the arts.

Information on the role of sex in these centuries can be found primarily in many of the surveys listed in the "Customs" and most of the entries in "Western (General)" chapters of this bibliography. One of the most influential studies on this period can be found in Fuch's Illustrierte Sittengeschichte vom Mittelalter bus zur Gegenwart, vol. 1, Renaissance (1909)

Art

The eroticism that had almost totally disappeared from Western art during the Medieval Age reemerged in the Renaissance and Mannerist periods and proliferated in the Baroque. Several factors influenced this development, including the rise of patronage by wealthy individuals rather than religious institutions, interest in emulating aspects of the Greek and Roman world, use of the risque mythological stories of antiquity as subject matter, the expansion of the roles of art in society, and, especially in the Baroque period, a fascination with personal, intense sensate experience. Most of the erotic art produced in this perid is rather tame by modern standards, but in its time was considered highly provocative. Producing

erotic art was a risky proposition for the artist who, with few exceptions, needed to cloak the sexuality of such work in a Christian aura of allegory, symbolism, etc., or face trial, imprisonment, or worse.

Many of the surveys listed in the "Surveys" and "Western (General)" chapters of this bibliography give considerable attention to Renaissance, Mannerist, and Baroque art. Of the surveys that focus exclusively on this period most are iconographic studies or limit their scope to a single medium. Examples of the former are Barolsky's study of humor in Renaissance art, Cheney's overview of mythological sources of erotica, De Jongh's article on the bird as a sexual symbol in Dutch art, Grootkerk on occult sexual symbolism, Kaufmann on mythical and legendary lovers, Konecny on the theme of Reason versus Lust, Miles on female nudity in the Early Renaissance, Morel on Priapic imagery, Saslow on Ganymede and homosexuality in the Renaissance, and Stewart on the theme of unequal lovers in Northern art. Dunand's Les amours des dieux serves as far more than a catalog of works depicting the loves of the ancient deities; it essentially provides a survey of the theme of lovemaking in Western art through the Mannerist period.

The development of printmaking techniques in this period is an important chapter in Western art history, and it seems that the most blatantly sexual images were produced as prints. Especially famous are the so-called Aretino prints, explicit illustrations by Raimondi associated with the erotic poetry of Pietro Aretino. Several scholarly studies of erotic prints have been published by Feure, Dunand, Lise, and Puppi. Lise's L'Incisione erotica del rinascimento is an especially thorough overview of the popular themes, schools of artists, and individual artists and patrons of erotic prints and, in a more succinct fashion, so is Puppi's article on Mannerist works. The Aretino prints are only incompletely understood because many of the originals were destroyed, while over the next several centuries numerous re-issues of dubious authenticity were released, a subject that has been investigated by Dunand, Lawner, and Webb.

Individual artists

It is during the Renaissance that the names of individual artists who produced erotic art begin to appear. Some erotic themes were so commonly used, like Leda and the Swan, that few artists did not handle them. Even certain styles seem to have encouraged a sensousness if not a touch of the erotic, as can be seen in Venetian Renaissance art where the fully nude female figure reentered the vocabulary of European art. Certain artists seem to have emphasized eroticism in their works, a trend that continued to grow in the following centuries until the late eighteenth and early nineteenth centuries when there are erotic art "specialists." Undeniably, the Renaissance, Mannerist, and Baroque artists who produced erotica generally did so for a very limited audience, in some cases making such works for their own pleasure or as gifts. The artist's individually noted in this bibliography--Aertsen, Alberti, Baglione, Bernini, Bosch, Campi, Carrachi, Graf, Grien, Michelangelo, Parmigianino, Raimondi, Rembrandt, Riccio, Rubens, and Titian--whether famous or obscure have been listed because there are one or more publications on the erotic aspects of their work.

Background

29-1 CLASEN, CLAUS-PETER. "Medieval heresies in the Reformation."
Church History 32, no. 4 (December 1963): 392-414.
Study of heresies, including those involving alternative sexual
behavior.

29-2 FUCHS, EDUARD. Illustrierte Sittengeschichte vom Mittelalter
bis zur Gegenwart. Vol. 1, Renaissance. Munich: Albert Langen,
1909. 500 pp., illus.
Profusely illustrated study of sex customs and practices during
the Renaissance period.

29-3 _____. Illustrierte Sittengeschichte vom Mittelalter bis zur
Gegenwart. Vol. 1, Renaissance: Erganzsband. Munich: Albert
Langen, 1910. 336 pp., illus.
Supplement to above entry.

29-4 QUAIFE, GEOFFREY ROBERT. Wanton wenches and wayward
wives: peasants and illicit sex in early seventeenth century Eng-
land. New Brunswick, N.J.: Rutgers University Press, 1979. 282
pp., bib., index, illus.
Study of the sexual practices of English peasants in the seven-
teenth century, demonstrating that prudery was far from the rule of
the day.

29-5* RUGGIERO, GUIDO. Boundaries of eros: sex crime and sexuality
in Renaissance Venice. New York: Oxford University Press, 1985.
352 pp.

Art

29-6* L'Amour dans la gravure des XVI et XVII siecles. Introduction by
Dominique Feure. Paris: Editions du Colombier, 1968. 99 pp.,
illus.

29-7 BAROLSKY, PAUL. Infinite jest: wit and humor in Italian Renais-
sance art. Columbia: University of Missouri Press, 1978. 224
pp., index, bib., illus.
Bawdy and erotic elements of Renaissance art discussed.

29-8* BUNCE, FREDERICK WILLIAM. "The parallel forms of erotic
painting and poetry in the sixteenth-century French court." Ph.D.
dissertation, Ohio University, 1973. 205 pp.

29-9 CHENEY, LIANA. "Disguised eroticism and sexual fantasy in six-
teenth- and seventeenth-century art." In Eros in the mind's eye,
edited by Donald Palumbo, 23-38, illus. New York: Greenwood,
1986.
Mythological sources of sexual imagery in Renaissance and Man-
nerist art are traced.

29-10 DE JONGH, E. "Erotica in Vogelperspektief." Simiolus 3 (1968-69): 22-74, illus.
Study of the sexual symbolism of the bird in seventeenth century Dutch art.

29-11 DIECKHOFF, REINER. "Liebeszauber—von der Erotiserung des Alltags im Spatmittelalter und der beginnenden Neuzeit." In Die Braut, vol. 1, edited by Gisela Volgert and Karin von Welck: 344-61, illus. Cologne: Josef-Haubrich-Kunsthalle, 1985.

29-12 DUNAND, LOUIS. "Les estampes dite decouvertes et couvertes." Gazette des Beaux-Arts 69 (April 1967): 225-38, illus.
Explanation of the process of censorship in sixteenth century (and later) prints by altering the plates.

29-13* _____. Les compositions de Jules Romain les amours des dieux graves par M.-A. Raimondi. Lyons: Albums du Crocodile, 1964.
Scholarly article on the Aretino prints.

29-14* _____. "Les rapports de l'amour et de l'argent dans les estampes 16. et 17. siecles." Bulletin des Musees et Monuments Lyonnais, 1969.
Study of theme of people exchanging money for sexual favors.

29-15 DUNAND, LOUIS, and LEMARCHAND, PHILLIPE. Les amours des dieux. Vol. 1, Les compositions de Jules Romain intitulees: gravees par Marc-Antoine Raimondi (suites estampes presentee dans un ensemble d'oeuvres d'art restituant le climat d'humanisme de la Renaissance). Lausanne: Institut d'Iconographie, 1977. 384 pp., illus., index.
Study of formal and iconographic background to the Raimondi erotic prints provides a history of the theme of lovemaking in Western art, particularly in the Renaissance.

29-16* _____. Les amours des dieux. Vol. 2, Les compositions de l'un des plus grands maitres de l'ecole Italienne (Dont le nom est alors revele) gravees par Jacopo Caraglio d'apres les dessins preparatoires de Rosso et de Perino del Vaga. Lausanne: Institut d'Iconographie, originally announced for release in the late 1970s or early 1980s, but apparently yet to be published.

29-17* _____. Les amours des dieux. Vol. 3, Le lascive et les compositions d'Augustin Carrache gravees par Pierre de Jode. Lausanne: Institut d'Iconographie, originally announced for release in the late 1970s or early 1980s, but apparently yet to be published.

29-18 GROOTKERK, PAUL. "Occult eroticism in fantastic art of the fifteenth and sixteenth centuries." In Eros in the mind's eye, edited by Donald Palumbo, 1-21, illus. New York: Greenwood, 1986.
Explores the symbolic images used to represent sex, lust, and other 'sins'.

29-19 KAUFMANN, THOMAS DA COSTA. "Eros et Poesia: la peinture a la cour de Rudolphe II." Revue de l'Art 69 (1985): 29-46, illus.
Discussion of mythic and legendary lovers of the ancient world depicted in Renaissance art.

29-20 KONECNY, LUBOMIR. "Hans von Aachen and Lucian: an essay in Rudolfine iconography." Leids Kunsthistorisch Jaarboek 1 (1982): 237-58, illus.
Iconographic study of the theme of "Reason versus Lust" in late sixteenth century art.

29-21 LAWNER, LYNNE. I modi nell-opera di Giulio Romano, Marcantonio Raimondi, Pietro Aretino e Jean-Frederic-Maximilien de Waldeck. Milan: Longanesi, 1984. 126 pp., illus.
Study of the various editions of the erotic prints that have accompanied Aretino's erotic love poetry.

29-22 LISE, GIORGIO. L'incisione erotica del Rinascimento. Milan: Carlo Emilio Bestetti, 1975. 136 pp., bib., illus.
Scholarly study of erotic prints of the Renaissance, tracing themes and schools of artists. Includes a lexikon of artist's names with short biographies, especially as it relates to their erotic art.

29-23 MARONE, SILVIO. "Homosexuality and art." With comment by Clifford Allen. International Journal of Sexology 7, no. 4 (May 1953): 175-90, illus.
Controversial study of the alleged homosexual qualities to be found in the works of Leonardo, Michaelangelo, and Raphael.

29-24 MILES, MARGARET R. "The Virgin's one bare breast: female nudity and religious meaning in Tuscan Early Renaissance culture." In The female body in Western culture, edited by Susan Rubin Suleiman, 193-208, illus., bib. Cambridge: Harvard University Press, 1986.
Interprets the significance of semi-nudity in the depiction of the Virgin.

29-25 MOREL, PHILIPPE. "Priape a la Renaissance; les guirlandes de Giovanni da Udine a la Farnesine." Revue de l'Art 69 (1985): 13-28, illus., bib.
Priapic imagery in Renaissance art is discussed.

29-26 PUPPI, L. "Erotismo e osceno nella produzione artistica del Manierismo." Psicon 8-9 (1976): 142-46, illus.
Artistic milieu of the drawings by Romano for Marcantonio is discussed.

29-27* SASLOW, JAMES M. Ganymede in the Renaissance: homosexuality in art & society. New Haven: Yale University Press, 1986. 256 pp., ill.

29-28 STEINBERG, LEO. The sexuality of Christ in Renaissance art and
 in modern oblivion. New York: Pantheon, 1984. (Most of the text
 and illustrations also published in special issue of October, 25
 [Summer 1983].)
 Controversial study of the frequent emphasis on the Christ
 child's genitals in the art of the Renaissance.

29-29 STEWART, ALISON G. Unequal lovers: a study of unequal couples
 in Northern art. New York: Abaris Books, 1978. 208 pp., index,
 bib., illus.
 Study of the theme of embracing and/or loving couples who are
 considerably different in age (usually older men and young women).

29-30* THOMAS, DONALD. "Master of Renaissance erotica." Penthouse 5,
 no. 6 (1970): 63-66, illus.

29-31* WEBB, PETER. "Giulio Romano, Marcantonio Raimondi, Pietro
 Aretino and the 'Sonnets.'" Paper delivered at the Erotic Arts
 Section of the 1977 Conference of the Association of Art Histor-
 ians, 1977.

29-32 ZERNER, HENRY. "L'estampe erotique au temps de Titien." In
 Tiziano e Venezia: Convegno internazionale di Studi: Venezia 1976.
 Vicenza: Neri Pozza, 1980: 85-90, illus.

Individual Artists

---Pieter Aertsen---

29-33 GROSJEAN, A. "Toward an interpretation of Pieter Aertsen's pro-
 fane econography." Konsthistorisk Tidskrift 43, nos. 3-4 (Decem-
 ber 1974): 121-43, illus.
 Sexual symbolism discussed in relation to Northern European
 art.

---Alberti---

29-34 HEDRICK, DONALD KEITH. "The ideology of ornament: Alberti
 and the erotics of Renaissance urban design." Word and Image 3,
 no. 1 (January-March 1987): 111-37, illus., figs.
 Explores the relationship between erotic obsessiveness and
 visual perspective in Alberti's work, focusing on his rational architec-
 ture and personal expressions on love in his fiction.

---Giovanni Baglione---

29-35 ZERI, FEDERICO. "Giovanni Baglione, Pittore Erotico." Antologia
 di Belle Arti 1, no. 4 (December 1977): 339-42, illus.
 Discusses two of Baglione's paintings, both with decidedly sex-
 ual character (Venus and Cupid, Joseph and Potiphar's Wife).

---Bernini---

29-36 HOWARD, SEYMOUR. "Identity formation and image reference in the narrative sculpture of Bernini's early maturity: Hercules and Hydra and Eros Triumphant." Art Quarterly, n.s., 2, no. 2 (Spring 1979): 140-71, illus.
Traces the erotic theme sources for several of Bernini's works, including the influence of Raimondi's prints.

---Hieronymous Bosch---

29-37 BEAGLE, PETER S. The Garden of Earthly Delights. New York: Viking, 1982. 127 pp., bib., illus. (some col.).
Detailed analysis of this famous painting includes discussion of possible sexual meaning.

29-38 HAMMER-TUGENDHAT, DANIELA. "Erotik und Inquisition zum 'Garten der Luste' von Hieronymus Bosch." In Der Garten der Luste, edited by Renate Berger and Daniela Hammer-Tugendhat, 10-47, illus. (some col.), bib. Cologne: Dumont, 1985.
Offers on interesting interpretation and discusses the erotic aspects of Bosch's famous painting.

---Vincenzo Campi---

29-39 WIND, BARRY. "Vincenzo Campi and Hans Fugger: a peep at Late Cinquecento bawdy humor." Arte Lombarda 47-48 (1977): 108-14, illus.
Campi's genre paintings seem to be full of suggestive erotic visual puns and sexual symbols.

---Carrachi---

29-40* DUNAND, LOUIS. "Les estampes composant 'le Lascivie' du graveur Augustin Carrache." Bulletin des Musees et Monuments Lyonnais, 1957.
Scholarly article on Carrachi's erotic prints.

29-41 _____. "A propos d'une estampe rare du Musee des Beaux-Arts de Lyon appartenant a la suite du 'Lascivie' d'Augustin Carrache." Bulletin des Musees Lyonnais 2, no. 1 (1957-61): 1-20, illus.
Catalog of Carrachis "erotic prints."

29-42 KURZ, OTTO. "Gli Amori dei Carraci: four forgotten paintings by Agostino Carrachi." Journal of the Warburg and Courtauld Institute 14, nos. 3-4 (1951): 221-33, illus.
Survey of the Carrachi works that show love scenes.

29-43 WIND, BARRY. "Annibale Carrachi's 'Scherzo': The Christ Church butcher shop." Art Bulletin 58 (March 1976): 93-96, illus.
Symbols of sexual desire in Carrachi's work are explored.

Renaissance and Baroque

---Urs Graf---

29-44* ANDERSSON, CHRISTIANE DAYMAR. "Popular lore and imagery in the drawings of Urs Graf (c.1485-1529)." Ph.D. dissertation, Stanford University, 1977. 412 pp.
Iconographic study of satirical drawings of Northern artist.

---Hans Baldung Grien---

29-45 HULTS, LINDA C. "Hans Baldung Grien's Weather Witches in Frankfurt." Pantheon 40, no. 2 (April-June 1982): 124+, illus. (some col.).
Sexual aspects of witches are explored in a detailed study of Grien's painting.

---Michelangelo---

29-46 BESDINE, MATTHEW. "Michelangelo: the homosexual element in the life and work of a genius." Medical Aspects of Human Sexuality 4, no. 5 (May 1970): 127-40, illus.
Suggests that their are observable homosexual elements in the art of Michelangelo.

---Parmigianino---

29-47* THOMAS, JOSEPH A. "Eroticism in the art of Parmigianino and its implications for the Mannerist style" [tentative title]. M.A. thesis, Southern Methodist University, 1987.

---Raimondi---

29-48* DUNAND, LOUIS. Les compositions de Jules Romain "Les amours des Dieux" graves par M-A Raimondi. Lausanne: J. Lemarchand, 1977. (First edition may have been Lyons: Albums du Crocodile, 1964.)

29-49* MURR, CHRISTOPHER GOTTLIEB DE. Notices sur les estampes gravees par Marc-Antoine Raimondi d'Apres les dessins de Jules Romain et Accompagnees de Sonnets de l'Aretin. Translated and annotated by Gustave Brunet. Brussels: A. Mertens, 1865. 66 pp. (Reprint of article that appeared in Journal zur Kunstgeschichte und Zur Allgemeinen Litteratur 4 [1785].)

---Rembrandt---

29-50* EMDE-BOAS, CONRAD VAN. "Erotic yes- but was Rembrandt pornographic?." British Journal of Sexual Medicine 2, no. 4 (August 1975): 23-28.
Discussion of Rembrandt's erotic prints.

29-51 OSTERMANN, GEORGES. Les erotiques de Rembrandt: gravures et dessins. Paris: Rene Baudouin, 1978. 13 pp. (text), illus.
Catalog of Rembrandt's erotic prints and drawings.

---Riccio---

29-52 JESTAZ, BERTRAND. "Un groupe de bronze erotique de Riccio." Monuments et Memoires, Fondation Eugene Piot 65 (1983): 25-54, illus., figs.
Sixteenth-century bronze erotic group of satyrs and nymphs that was donated in the nineteenth century to the Musee Cluny is described. Iconography of the erotic satyr motif and similar love-making postures in prints, paintings, and sculpture are discussed.

---Peter Paul Rubens---

29-53* CARROLL, MARGARET D. "The erotics of Absolutism: Rubens and the mystification of sexual violence." Paper delivered at the College Art Association Meeting (Dallas, Texas), 11 February 1988.

29-54 MITTIG, HANS-ERNST. "Erotik bei Rubens." In Der Garten der Luste, edited by Renate Berger and Daniela Hammer-Tugendhat, 48-88, illus. (some col.), bib. Cologne: Dumont, 1985
Exploration of the erotic aspects of Rubens's paintings, particularly the image of the female nude.

---Titian---

29-55 BOCCACCI, PAOLO. "Disvelamento e Dominio nel Mito di Europa." In Giorgione e la Cultura Venetra tra '400 e '500: Mito, Allegoria, Analisi, Iconologica. Rome: De Luca, 1981, 178-85, illus.
Analyzes Titian's Rape of Europa in the light of representations of the depiction of the loves of Zeus in Western art.

29-56 GINZBURG, CARLO. "Tiziano, Ovidio e i Codici della Figurazione Erotica nel Cinquecento." Paragone 29, no. 339 (May 1978): 3-24, illus.
Explores some aspects of sexual imagery in Renaissance art.

29-57 HOPE, CHARLES. "Problems of interpretation in Titian's erotic paintings." In Tiziano e Venezia: Convegno Internazionale di Studi, Venezia 1976. Venice: Neri Pozza, 1980, 111-24, illus.
Argues for simple interpretations of Titian's works with sexual element. Suggests two categories of works, one with a veneer of classical alibi, others for Venetian patrons who wanted unabashedly erotic works.

29-58 OST, HANS. "Tizians Sogenanntes 'Venus de Urbino' und andere Buhlerinnen." In Festscrift fur Eduard Trier, edited by Justus Mueller Hofstede and Werner Spies, 129-49, illus. Berlin: Mann, 1981.
Study of eroticism in Titian's portraiture.

Chapter 30
Eighteenth Century

Background

The eighteenth century was an especially rich period in the history of erotic art. Much of the aristocratic classes at the zenith of their power and wealth seem to have decided that they did not need to follow the morality promulgated by Christianity and to indulge their sensate pleasures. During this period, for instance, the hell-rake clubs of England (and their equivalents on the Continent) provided to their exclusive membership pleasure houses where almost any want could be satisfied (see Loudon's The hell-rakes), Czaress Catherine the Great pursued her pleasures to such an extent that she became a sexual legend in her own time, and the Marquis de Sade brought to the surface some of the darkest recesses of the human psyche (see the books by Bloch). Those people who followed this hedonistic life-style were known as libertines, a word that at the time could be used as a term of praise or vile condemnation. It should not be surprising that these libertines were patrons for erotic arts, reveling in the sensuality of the Rococo style, enthusiastically applauding risque theater productions, forming a viable market for publishers of erotic literature, and commissioning explicitly sexual works of art. While this indulgence may have been satisfying to those who were in a position to enjoy it, the moral double standards it promulgated served to fuel the growing discontent by the masses with the established order ultimately bringing about the end of the world of aristocratic privileges.

Perhaps because the eighteenth century was such a remarkable period in European history, it has received a great deal of attention by scholars and popular writers. The legend that there was almost total sexual abandon among the upper classes has been a significant stimulus of that interest. Among surveys of the sexuality of that century once again can be noted the pioneering scholarship of Eduard Fuchs who published Illustrierte Sittengeschichte vom Mittalter bis zur Gegenwart, vol. 2, Die galante Zeit in 1910 (followed by a supplement in 1911). Other useful surveys include Bouce's Sexuality in eighteenth-century Britain, Brussendorff and Henningsen's History of eroticism, vol. 3, From the time of Marquis de Sade, Hagstrum's Sex and sensibility: ideal and erotic love from Milton to Mozart, and, most recently, Rousseau and Porter's Sexual underworlds of the Enlightenment.

Eighteenth Century

Art

A great deal of erotic art was produced in the eighteenth century. It can even be argued that eroticism was an inherent feature of the predominant style of that era, the Rococo. Typical of that style is the use of playful, sensual colors, lushly ornate decoration, and an emphasis on subject matter relating to pleasure—lovers cavorting in gardens, nude or nearly nude females lying in bed playing with small dogs, etc. While the best-known artists of that style (Watteau, Fragonard, Boucher) produced few works that depict sexual activity, there was no shortage of explicit works available in a variety of forms, including mural decoration, collections of prints, book illustrations, and decorated personal objects like watches, snuff boxes, and cases. Almost without exception this erotic art depicted the aristocratic hedonists themselves engaging in illicit liaisons, group sex, or fantasy pleasures. Unlike the works from earlier periods, much of eighteenth-century erotic art has survived, allowing for detailed study and availability as photographic illustration.

Many of the entries listed in the "Surveys" and "Western (General)" chapters of this bibliography include sections on the eighteenth century. Especially useful are several surveys that focus on this period, including an early (1913) art historical study by Doucet entitled Peintures et graveurs libertins du XVIIIe siecle that provides a thorough overview of erotic themes; an article by Roberts places the eroticism in the arts in the social and cultural context of the era, and a catalog-like visual survey can be found in Die Liebeslaube: erotische Zeichnungen des Rokoko. A number of survey studies focus exclusively on erotic prints, including items by Brunn and Jacobsen, Camus, Demoriance, and others. Erotic minor arts are the subject of Henig, Munby, and Kelsail's report on sexually explicit ceramic tiles, Kimmig's volume on erotic miniatures, and Carrera's book on watches (cited in the "Surveys" chapter).

Individual Artists

The eroticism which pervaded much of the art of the eighteenth century directly related to the aristocratic social atmosphere and patronage. That some of the most well-known and influential artists of the era produced works with an undeniably erotic element (and in some cases explicit sexual imagery) was a culmination of a trend starting in the Renaissance. This includes not only Rococo painters like Boucher, Fragonard, and Watteau, but also such figures as the English satirists Hogarth, Gillray, and Rowlandson, the Neo-Classicist Swedish court artist Sergel, and the visionary romantic Fuseli. The patronage provided by the libertine aristocrats was sufficiently abundant that it created a category of artist previously unknown in Western culture since the fall of Rome, one who specialized in erotic art. These specialists were typically printmakers who illustrated erotic literature, rather than painters or sculptors. Among the most popular of these erotic artists were Borel, Chauvet, and Denon.

Background

30-1 BLOCH, IWAN. <u>Marquis</u> de <u>Sade: his life</u> and <u>works</u>. Translated
 by James Bruce. 1931. Reprint. N.p.: Brittany Press, 1948.
 269 pp., bib..
 Survey of the sex customs at the time of the Marquis de Sade.

30-2 _____. <u>Marquis de Sade's Anthropologie Sexualis of 600 Perver-</u>
 <u>sions: 120 Days of Sodom: or the School for Libertinage: and the</u>
 <u>sex life of the French age of debauchery from private archives of</u>
 <u>the French government.</u> Translated by Raymond Sabatier. New
 York: Falstaff, 1934. 320 pp., bib., illus.
 Study of French society and its relation to de Sade's work.

30-3 BOUCE, PAUL GABRIEL. <u>Sexuality</u> in <u>eighteenth-century Britain.</u>
 Manchester: Manchester University Press; Totowa, N.J.: Barnes
 and Noble, 1982. 262 pp., index.
 Anthology of papers on aspects of eighteenth-century sex cus-
 toms and practices in England.

30-4 BRUSENDORFF, OVE, and HENNINGSEN, POUL. <u>A history of erot-</u>
 <u>icism.</u> Vol. 3, <u>From the time of Marquis de Sade.</u> New York: Lyle
 Stuart, 1966. 80 pp., illus.
 Themes in erotic art and literature in the eighteenth century
 explored.

30-5 FUCHS, EDUARD. <u>Illustrierte Sittengeschichte vom Mittelalter</u>
 <u>bis zur Gegenwart.</u> Vol. 2, <u>Die galante Zeit.</u> Munich: Albert Lan-
 gen, 1910. 484 pp., illus. (some col.).
 Profusely illustrated study of sex practices and customs.

30-6 _____. _____. <u>Erganzsband.</u> Munich: Albert Langen, 1911.
 328 pp., illus.
 Supplement to above entry.

30-7 GIP, BERNARD. <u>The passions</u> and <u>lechery of Catherine the</u>
 <u>Great.</u> London: Skilton, 1971. 74 pp., map, illus. (Also pub-
 lished as <u>Katharina die Grosse und das Lustschloss Gatschina</u>
 [Olten: Fackel, 1971].)
 Discussion of Catherine's palace of pleasure allegedly filled
 with erotic furniture and murals.

30-8 HAGSTRUM, JEAN H. <u>Sex and sensibility: ideal and erotic love</u>
 <u>from Milton to Mozart.</u> Chicago: University of Chicago Press,
 1980. 350 pp., index, illus.
 Scholarly study of eighteenth century concepts of love, sen-
 suosity, and eroticism, especially as expressed in the arts.

30-9 KNIGHT, RICHARD PAYNE. <u>An account of the remains of the wor-</u>
 <u>ship of Priapus, lately existing at Isernia, in the Kingdom of</u>
 <u>Naples, in two letters, one from Sir William Hamilton, K.B. . . . to</u>
 <u>Sir Joseph Banks . . . and the other from a person residing at</u>

Isernia: to which is added a discussion on the worship of Priapus, and its connexion with the mystic theology of the Ancients. London, 1786.
Remarks on the continuity in European history of the worship of Priapus and fertility worship in general.

30-10 LOUDAN, JACK. The hellrakes. London: Books for You, 1967. 192 pp., por., illus.
Study of the risque life of eighteenth century England, with special attention to the 'hell-rake' clubs.

30-11* ROUSSEAU, G.S., and PORTER, ROY. Sexual underworlds of the enlightenment. Chapel Hill: University of North Carolina Press, 1987.

30-12 TOTH, KARL. Woman and Rococo in France, seen through the life and works of a contemporary, Charles-Pinot Duclos. Translated by Roger Abingdon. Philadelphia: Lippincott, 1931. 399 pp., bib., index, illus.
Social study of Rococo France, with emphasis on the aristocracy and their life-style.

30-13 VRIES, LEONARDO DE, and FRYER, PETER. Venus unmasked, or an inquiry into the nature and origin of the passion of love: interspersed with curious and entertaining accounts of several modern amours. New York: Stein and Day, 1967. 228 pp., bib., illus.
Eighteenth-century views on love and sex as expressed through stories, letters, etc. with some reproductions of prints.

Art

30-14* L'Aretin Francais. Paris: Editions Borderie, 1979.

30-15 BOUILLON, JEAN-PAUL; EHRHARD, ANTOINETTE; and MELOT, MICHEL. Aimer en France 1780-1800: cent pieces tirees du cabinet des estampes de la Bibliotheque Nationale. N.p.: Bibliotheque Municipale et Inter-Universitaire, 1977. 80 pp., bib., illus.
Catalog to an exhibition focusing on love in art (explicitly erotic images are listed but not illustrated).

30-16* BRUNN, L. VON, and JACOBSEN, G., eds. Ars Erotica: die erotische Buchillustration im Frankreich des 18 Jh. 3 vols. Dortmund: Harenberg, 1983. 399 pp., illus.

30-17* CAMUS, MICHEL. Cent figures licencieuses a la gloire des dames Romaines. Paris: Éditions Borderie, 1980.
Sampling of French erotic illustrations, including L'Academie des dames by Alyosia Sigea (1680), Monuments du culte secret de dames romains (1787), and Monumens de la vie prive des XII Cesars (1785) by Hughes d'Harcarville.

30-18 DEMORIANE, HELENE. "Les pervertis." Connaissance des Arts
 255 (1973): 120-27, illus.
 Illustrations to erotic literature penned by Binet.

30-19 DOUCET, JEROME. Peintres et graveurs libertins du XVIIIe
 siecle. Paris: Albert Mericant, 1913. 64 pp., illus.
 Study of eighteenth-century risque and erotic prints based on
 broad themes expressed in the art.

30-20 Es Lebe die Liebe: erotische Miniaturen aus galanter Zeit. Die
 Bibliophilen Taschenbucher, no. 305. Foreword by Roland Kim-
 mig. Dortmund: Harenberg, 1982. 81 pp., illus. (col.).
 Reproduces French seventeenth- and eighteenth-century erotic
 miniature prints.

30-21 French engravers of the 18th century. Introduction by Archibald
 Younger. London: Simpkin, Marshall, Hamilton, Kent, n.d. 34
 pp. (text), illus.
 Collection of Rococo engravings based on famous earlier paint-
 ings, few of which are explicitly sexual in character.

30-22 Galante Kupferstiche aus dem Frankreich des 18 Jahrhunderts.
 1911. Reprint. Munich, ca. 1980. 25 pp. (text), illus.
 Introductory essay and catalog of erotic prints.

30-23 HENIG, M.; MUNBY, K.; and KELSAIL, F. "Some tiles from the Old
 Chesire Cheese, London." Post-Medieval Archaeology 10 (1976):
 156-59, illus.
 Description of several erotic tiles from eighteenth century
 found during excavation of ceramics factory.

30-24* Die Liebeslaube: erotische Zeichnungen des Rokoko. Exquisit
 Kunst, no. 237. Munich: Wilhelm Heyne, 1981.

30-25 MOUNTFIELD, DAVID. Illustrated Marquis de Sade: Justine and
 Juliette: all the prints. Foreword by Robert Short. New York:
 Crescent Books, 1984. 111 pp., illus. (col.).
 Presented as reproductions of original eighteenth-century
 prints, but actually are poorly copied modern pastel and watercolor
 paintings of originals with no acknowledgment to the artist.

30-26 REUTERSVARD, OSCAR. The Neo-Classic Temple of Virility and
 the buildings with a phallic ground-plan. N.p., 1971. 32 pp.,
 illus.
 Attempts to show importance of "primitive virility" to art and
 architecture of neo-classicism. Illustrated with works of Sergel, Eh-
 rensvard, Piranesi, Ledoux.

30-27 ROBERTS, WARREN. "Hedonism in eighteenth century French lit-
 erature and painting." Symposium 30 (Spring 1976): 42-60.
 Sociocultural context of French erotic art and literature out-
 lined.

30-28* ROSENBLUM, ROBERT. "Caritas Romana after 1760: some Roman-
tic lactations." In Woman as sex object: studies in erotic art,
1730-1970, edited by Thomas B. Hess and Linda Nochlin, 42-63,
bib., illus. New York: Newsweek, 1972.
Study of a popular theme in European art, generally known as
Roman charity, in which an old imprisoned man is shown suckling at a
young woman's breast.

30-29 SEAVER, RICHARD. Sixty erotic engravings from Juliette. New
York: Grove, 1969. Unpaged, bib., illus.
Reproduces the illustrations from the 1797 edition of de Sade's
Juliette.

30-30 STEWART, PHILIP. "Representations of love in the French 18th
C." Studies in Iconography 4 (1978): 125-48, illus.
Study of the theme of love (including physical love) in engraved
prints.

30-31* WAGNER, PETER. Eros revived: the erotica of the Enlightenment
in England and America. London: Secker & Warburg, 1987. 384
pp., illus., bib.

30-32* _____. Lust und Liebe: erotische Kupferstiche der Rokoko-zeit.
N.p.: Delphi, 1986. 235 pp., ill. (some col.), bib.

Individual Artists

---Antoine Borel---

30-33* Borel, Antoine, 1743-1810. Cent vignettes erotiques gravees par
elluin pour illustrer sept Romans libertins du dix-huitieme siecle.
Images Obliques, no. 2. Lyons: Editions Borderie, 1978. 139
pp., illus.

30-34* Cent cinq vignettes erotiques. Introduction by Alain Clerval.
Paris: Images Obliques, 1980.
Reproductions of Borel's eighteenth-century erotic engravings.

---Boucher---

30-35* OWENS, I. "The Boucher dream: how an artist armed a King's
mistress for the battle of the boudoir." Art and Antiques, April
1986: 76-80+.

---Adolphe Chauvet---

30-36* Casanova: cent deux figures galantes. Paris: Images Obliques,
1980.
Illustrations by Chauvet reproduced.

30-37* CHAUVET, JULES ADOLPHE. Casanova in Bildern. Hamburg:
 Heyne ex Libris, 1973. 219 pp., illus., bib.

---Denon---

30-38* DENON, DOMINIQUE VIVANT. Priapees et sujets galants. Paris:
 A. Barraud, 1872.
 Portfolio of prints by Denon.

---Henry Fuseli---

30-39* ALLENTUCK, MARCIA. "Henry Fuseli's Nightmare: eroticism or
 pornography?" Manuscript (New York), 1972, 7 pp.

30-40 BERTELLI, CARLO. "I disegni che non sono stati esposti al Poldi
 Pezzoli: l'incubo erotico di Fuseli." Bolaffiarte 8, no. 75 (Decem-
 ber 1977): 9-11, illus.
 Study of erotic drawings of Fuseli.

30-41* Fuseli. Introduction by Gert Schiff. London: Tate Gallery, 1975.
 Includes comments on the eroticism in Fuseli's work.

30-42 POWELL, NICOLAS. Fuseli's The Night-Mare. London: Allen
 Lane, 1972. 120 pp., index, illus.
 Study of meaning of painting and possible sources for the image
 of sleep and nightmare in "The Night-Mare."

30-43 RUSSO, KATHLEEN. "Henry Fuseli and erotic art of the
 eighteenth century." In Eros in the mind's eye, edited by Donald
 Palumbo, 39-57, illus. New York: Greenwood, 1986.
 Study of Fuseli's erotic art in the light of trends in the sexual
 imagery of the eighteenth century.

30-44 WILSON, SIMON. "Henry Fuseli's women." Antique Collector 46,
 no. 3 (March 1975): 50-51, illus.
 Fuseli addressed the subject of female sexuality in his work.

---James Gillray---

30-45 GILLRAY, JAMES. Works of James Gillray: 582 plates and a sup-
 plement containing the 45 so-called "suppressed plates." 1851.
 Reprint. New York: Blom, 1968. Unpaged, illus.
 Catalog of the works of Gillray, including his erotic images.

---Pierre Francois Hugues Hancarville---

30-46 HANCARVILLE, PIERRE FRANCOIS HUGUES. Bilder aus dem Pri-
 vatleben der Roemischen Caesaren. [German edition] 1906. Re-
 print. Die Bibliophilen Taschenbuecher, no. 15. Dortmund: Har-
 enberg, 1979. 196 pp., illus.

Short chapters on erotic stories about the Roman emperors are illustrated with erotic prints probably by Hancarville in the form of small oval gem shapes.

30-47* _____ . Die Denkmaler des Geheimkults der Roemischen Caesaren. Capri: Sabellus, 1784. [German edition] 1906. Reprint. Die Bibliophilen Taschenbuecher, no. 23. Dortmund: Harenberg, 1979. 96 pp., illus.

30-48* _____ . Monumens de la vie privee des douze Cesars: d'apres une suite de Pierres gravees sous leur regne. Capri: Sabellus, 1782.

30-49* _____ . Monumens du culte secret des dames Romaines: pour servir de suite aux monumens de la vie privees des XII Cesars. Capri: Chez Sabellus, 1784. 98 pp., illus. (Later editions include Rome, 1787; Rome: l'Imprimerie du Vatican, 1790; reproduction edition n.p., 1920.)

30-50* _____ . Veneres et Priapi. Paris and London, 1785.

30-51* _____ . Veneres uti observantur in gemmis Antiquis: Veneres et Priapi. Lugd: Batavorum, 1771.

---William Hogarth---

30-52 GRANGE, KATHLEEN M. "An Eighteenth-century view of infantile sexuality in an engraving by William Hogarth (1697-1764)." Journal of Nervous and Mental Disease 137, no. 5 (November 1963): 417-19, illus.
Brief evaluation of a work by Hogarth that shows a small child urinating.

---Jean-Jacques Lequeu---

30-53 MARTY-L'HERME, JEAN-JACQUES. "Les cas de Jean-Jacques Lequeu." Macula 5-6 (December 1979): 138-49, illus.
Discussion of the drawings of Lequeu (1757-1825) and their relationship to eighteenth century erotic art.

---Murillo---

30-54 BROWN, J. "Murillo, Pintor de temas Eroticos: Una Faceta Inadvertida de su Obre." Goya 169-171 (July-December 1982): 35-43, illus. (some col.).
Study of the sexual symbolism and concealed meaning in Murillo's work.

---Thomas Rowlandson---

30-55 The amorous illustrations of Thomas Rowlandson. Introduction by Gert Schiff. N.p.: Cythera Press, 1969. Unpaged, illus. (col.).

Collection of Rowlandson's erotic work, with scholarly commentary.

30-56* Das erotische Werk des Thomas Rowlandson (Funfzig Erotische Grotesken). Vienna, n.d.

30-57* HILL, N. "The erotic art of Thomas Rowlandson." Penthouse 9, no. 1 (1975): 18-22, illus. (col.).

30-58 MEIER, KURT VON. The forbidden erotica of Thomas Rowlandson. Los Angeles: Hogarth Guild, 1970. 187 pp., illus. (col.).
Collection of Rowlandson's prints with catalog-like commentary preceded by several short essays on the artist and his work.

30-59 ROWLANDSON, THOMAS. Pretty little games for young ladies and gentlemen: with pictures of good old English sports and pastimes. Critical essay by James C. Hotton; "Rowlandson's Bawdry" by L. Revens. New York: Land's End, 1969. Unpaged, illus.
Facsimile edition of a Rowlandson set of prints with poems.

30-60* UNVERFEHRT, GERD, ed. Thomas Rowlandson: Allerlei Liebe: erotische Graphik. Die Bibliophilen Taschenbuecher, no. 190. Dortmund: Harenberg, 1980. 123 pp., illus.

---Tobias Sergel---

30-61* BJURSTROM, PER. Drawings of Johan Tobias Sergel. Chicago: University of Chicago Press, 1979.
Catalog of Sergel's drawings includes his little-known erotic works.

---Watteau---

30-62 POSNER, DONALD. "Swinging women of Watteau and Fragonard." Art Bulletin 64 (March 1982): 75-88, bib., illus.
Explores suggestive motifs in eighteenth-century Rococo art.

30-63 _____. Watteau: a lady at her toilet. London: Allen Lane, 1973. 112 pp., index, illus.
Study of this work by Watteau and related themes in eighteenth century art.

Chapter 31
Nineteenth Century

Background

The common image of nineteenth-century Europe as having been dominated by the restrictive morality of Queen Victoria is only partially accurate. While it is true that a moralistic middle class ethos was a dominant aspect of life (note the lengthy bibliographies of banned material compiled by Henry Spencer Ashbee), it was also a period that saw unprecedented growth in the publishing of erotic literature, increasing eroticism in mainstream art styles, and spread of a deviant sexual underground. This gulf between publicly proclaimed moral standards and privately practiced sexual activities has been the subject of many publications.

Surveys of nineteenth-century sexuality first appear at the end of that era with Fuchs's Illustrierte Sittengeschichte vom Mittelalter bis zur Gegenwart, vol. 3, Das burgeriche Zeitalter (1912), followed twenty-five years later by the less scholarly Erotikens historie: fra Graekenlands oldtid til vore dage, vol. 3 by Brusendorff. After World War II the development of Victorian studies in academia and a fascination with Victorianism among the public inspired numerous studies, including Fryer's compilation of passages from all sorts of nineteenth-century publications addressing aspects of sexuality entitled The man of pleasure's companion, Pearl's The girl with the swansdown seat, Pearsall's well researched The Worm in the bud: The world of Victorian sexuality, and Trudgill's Madonnas and Magdalens: the origins and development of Victorian sexual attitudes. An important influence on sexual attitudes of the nineteenth century was the image of the female in the popular imagination, the woman pure and the woman evil, a topic covered by Dijkstra, Kingsbury, Saltpeter, Steele, and others.

There were many people who chose, for various reasons, not to be followers of the nineteenth-century establishment pattern, especially in regards to sexual beliefs and behavior. These individuals could be religious extremists, radical utopians, pioneering feminists, political activists, prostitutes, publishers, or artists. Steven Marcus's well-documented The other Victorians: a study of sexuality and pornography in mid-nineteenth century England creates a vivid picture of the sexual underground of that era, as does Wendell Johnson's Living in sin: the Victorian sexual revolution and Hal Sears's The sex radicals: free love in high Victorian America.

Nineteenth Century

A combination of repressed sexuality among the middle class and the experimentation by the sexual underground seems to have inspired the dramatic increase in erotica, literary and visual, during the nineteenth century. Surely, more sexual novels and short stories were written at that time than any era in history, as explained by Bernhardt Hurwood in The golden age of erotica.

Art

A great deal of erotic art was produced in the nineteenth century, a result of the continuing breakdown of religious control over art content and patronage. The first half of the 1800s saw the emergence of several different categories of erotic artists (a trend that has continued up to the present day). From the previous century there continued to be specialist illustrators of erotic literature. Some artists appear to have specialized in art for an underground market for erotica, producing portfolios of prints, small-scale sculptures or decorated utilitarian objects, or commissioned paintings. Certain "mainstream" artists, such as Ingres or Renoir, sought to incorporate erotic elements into their work, even though the major portion of their output is not concerned with sexuality. And there were styles, like Symbolism, which emphasized eroticism as a major characteristic. By the middle of the century demands by artists for freedom of expression, even if that meant sexual subject matter, was a trend whose time had come, paving the way for the modern era.

There has not yet been an in-depth erotic art survey focusing on the nineteenth century, although many of the entries in the "Surveys" chapter and the "Western (General)" chapter include significant sections on that historical period, and the two books by Brusendorff and Henningsen listed below do offer some insights into the eroticism in the arts. Much of what has been written on nineteenth century erotic art focuses on a specific, narrow topic, examples being Amaya on the symbolists, Brinton's contemporary comments on American art, Heilmann on Paris Salons, Layne on fantasy illustrations, Maas and Pearsall on nudes, Nochlin on the image of the female, and van Liere on the bather as a theme.

Individual Artists

Until the nineteenth century few artists produced erotic art and few are known by name. This situation changes dramatically in the nineteenth century as more and more artists openly incorporated eroticism into their work. Many are minor artists little known beyond the examples of their work, but others are among the most famous names of the era. The entries on individual artists (arranged alphabetically by the artist's last name) listed below have been compiled because they focus on the erotic aspects of the work of those artists.

Background

31-1 ASHBEE, HENRY SPENCER (Pisanus Fraxi). Bibliography of prohibited books. Vol. 2, Centuria Librorum Absconditorium: bio-biblio-iconographical and critical notes on curious, uncommon and erotic books. London: Privately printed, 1879. 593 pp., index, illus.
List of books (and some art works) banned/censored in the nineteenth century.

31-2 _____. Forbidden books of the Victorians. Abridged and edited with introduction and notes by Peter Fryer. London: Odyssey Press, 1970. 239 pp., index.
Index of nineteenth-century erotic literature.

31-3 BRUSENDORFF, OVE. Erotikens historie: fra Graekenlands oldtid til vore dage. Vol. 3. Edited by Christian Rimestad. Copenhagen: Universal, 1938. 475 pp., index, bib., illus.
Sex customs and practices in Europe in the 1800s and early 1900s surveyed.

31-4 DIJKSTRA, BRAM. Idols of perversity: fantasies of feminine evil in fin-de-siecle culture. New York: Oxford University Press, 1986. 453 pp., bib., index, illus.
Study of the concept of the "evil woman" as expressed in the arts and popular culture in the late nineteenth century.

31-5 FRYER, PETER. The man of pleasure's companion: a nineteenth century anthology of amorous entertainment. London: Barker, 1968. 208 pp., illus., bib.
Brief passages from various nineteenth-century publications relating to sexual matters.

31-6 FUCHS, EDUARD. Illustrierte Sittengeschichte vom Mittelalter bis zur Gegenwart. Vol. 3, Das burgerische Zeitalter. Munich: Albert Langen, 1912. 496 pp., illus. (some col.).
Sex customs and practices in the nineteenth century surveyed.

31-7 _____. _____. Erganzsband. Munich: Albert Langen, 1912.
Further supplement to above volume.

31-8 GAY, PETER. "Victorian sexuality." American Scholar 49 (Summer 1980): 372-78.
Survey of Victorian sexual attitudes.

31-9 HURWOOD, BERNHARDT J. The golden age of erotica. Los Angeles: Sherbourne, 1965. 285 pp., bib., index. (Also published under title Erotica [New York: Paperback Library, 1968].)
Primarily considers erotic literature of the latter part of the eighteenth and most of the nineteenth centuries, but includes discussion of visual art.

31-10 JOHNSON, WENDELL STACY. Living in sin: the Victorian sexual revolution. Chicago: Nelson-Hall, 1979. 213 pp., bib., index.
 Discussion of the sexual underground in the Victorian age.

31-11 KINGSBURY, MARTHA. "The femme fatale and her sisters." In Woman as sex object: studies in erotic art, 1730-1970, edited by Thomas B. Hess and Linda Nochlin, 182-205, illus. New York: Newsweek, 1972.
 Study of view of women in late Victorian art and advertising.

31-12 MARCUS, STEVEN. The other Victorians: a study of sexuality and pornography in mid-nineteenth century England. New York: Basic Books, 1966. 292 pp., index.
 Survey of erotic literature in the nineteenth century.

31-13* MITTIG, H.E. "Zur Funktion erotischer Motive im Denkmal des 19 Jahrhunderts." Kritische Berichte 9, nos. 1-2 (1981): 1-2+, illus.

31-14* PEARL, CYRIL. The girl with the swansdown seat. New York: Signet, 1958. 277 pp., illus.
 Survey of Victorian sex habits.

31-15 PEARSALL, RONALD. The worm in the bud: the world of Victorian sexuality. Harmondsworth: Penguin, 1971. 560 pp., bib., index.
 Victorian sex habits surveyed, considering both the socially "acceptable" practices and some of the underground sexual life-styles.

31-16* SEARS, HAL D. The sex radicals: free love in high Victorian America. Kansas University Press, 1977. Illus.

31-17 STEELE, VALERIE. Fashion and eroticism: ideals of feminine beauty from the Victorian era to the Jazz Age. New York: Oxford University Press, 1985. 327 pp., app., bib., index, illus.
 Scholarly study of the topic of women's fashions and the concept of "appeal," especially sexual appeal.

31-18 TRUDGILL, ERIC. Madonnas and Magdalens: the origins and development of Victorian sexual attitudes. New York: Holmes and Meier, 1976. 336 pp., bib., index, illus.
 Considers the factors which lead to Victorian sexual attitudes.

Art

31-19 AMAYA, M. "Flesh and filigree: symbolists and decadents." Art News 68 (December 1969): 24-27+, illus.
 Discussion of the "decadent" themes used by the Symbolists.

31-20* BRINTON. "Obscenity in American art." American Antiquarian, January 1886.

31-21 BRUSENDORFF, OVE, and HENNINGSEN, POUL. Erotikens histor-
 ie. Vol. 2, Fra Marquis de Sade til Victoria. Copenhagen: Than-
 ing and Appels, n.d. 256 pp., illus. (some col.).
 Survey of European erotic art from the late eighteenth to the
 nineteenth century.

31-22 _____. A history of eroticism: Victorianism. New York: Lyle
 Stuart, 1966. 87 pp., illus.
 Discussion of some themes in nineteenth-century erotic art.

31-23* CELEBONOVIC, A. Some call it kitsch: masterpieces of bourg-
 eouis realism. London: Thames and Hudson, 1974. 200 pp.,
 index, bib., illus. (some col.).
 Includes mention of the eroticism in this late nineteenth-century
 style.

31-24 "Eros Malandrino [Galleria Bargobello, Parma]." Casabella 45
 (May 1981): 3, illus.
 Short review of an exhibition of "provincial" European erotic
 art of the period 1850-1930.

31-25* HEILMAN, W. Pariser Salons des 19 Jahrhunderts erotische Skiz-
 zen und Szenen zeitgenossicher Kunstler. Munich: Heyne, 1981.
 142 pp., illus.

31-26 LAYNE, GWENDOLYN. "Mum's the word: sexuality in Victorian
 fantasy illustration (and beyond)." In Eros in the Mind's Eye,
 edited by Donald Palumbo, 59-74, illus. New York: Greenwood,
 1986.
 Explores the eroticism in the works of artist's like Beardsley
 who specialized in book illustration.

31-27* LE PICHON, YANN. L'Erotisme des chers maitres. Foreword by
 Salvador Dali. Paris: Denoel, 1986. 192 pp., ill., bib.
 Survey of erotic works by painters of the Academic style,
 predominantly French artists.

31-28 MAAS, JEREMY. "Victorian nudes." Saturday Book 31 (1971):
 183-99, illus. (some col.).
 Study of the female nude in painting during the nineteenth cen-
 tury.

31-29 NOCHLIN, LINDA. "Eroticism and female imagery in nineteenth
 century art." In Woman as sex object: studies in erotic art,
 1730-1970, edited by Thomas B. Hess and Linda Nochlin, 8-15,
 illus. New York: Newsweek, 1972.
 Image of the female in nineteenth-century art reviewed, concen-
 trating on the erotic elements.

31-30 PEARSALL, RONALD. Tell me, pretty maiden: the Victorian and
 Edwardian nude. Exeter, England: Webb and Bower, 1981. 176
 pp., index, illus.

Study of several painters and illustrators of the second half of the nineteenth century who emphasized female nudes in their work.

31-31 Pleasure bound: diverse tales from the Edwardian underground. Drawings by Viset and Felicien Rops. New York: Grove, 1969. 355 pp., illus.
Reprint of nineteenth-century erotica, well illustrated by several well-known erotic artists of that period.

31-32 VAN LIERE, ELDON N. "Solutions and dissolutions: the bather in nineteenth-century French painting." Arts Magazine 54, no. 9 (May 1980): 104-14, illus.
Survey of a popular theme in late nineteenth-century art.

31-33 Weiner Blut: ein Bilder Zyklus mit Liedern. Bibliotheca Erotica et Curiosa. Introduction by Mark Quirin. Munich: Rogner and Bernhard, 1970. Unpaged, illus. (col.).
Collection of erotic watercolors and sketches accompany poetry.

Individual Artists

---Anonymous---

31-34* Dorf G'schicht'n im gmalnen Bildln mit Gstazl'n von an Fidaln We- ana. Nuremburg: DMK, n.d. 60 pp., illus. (col.).
Twenty full-page color prints after the original watercolors of an anonymous Viennese artist (working about 1854) with text commentary.

---Aubrey Beardsley---

31-35* ARISTOPHANES. Lysistrata. Translated by Jack Brussell. New York: St. Martin's Press, 1973.
Reprint of classic Beardsley's illustrations of Greek play.

31-36 BAZAROV, KONSTANTIN. "Aroma of sin." Art and Artists 14 (May 1979): 34-39, illus.
Study of the nature of Beardsley's art, particularly the sensuality which pervades many of his illustrations..

31-37* BEARDSLEY, AUBREY V. The uncollected work of Aubrey Beardsley. London: John Lane, 1925.

31-38 _____. Venus and Tannhauser: an erotic tale. 1907. Reprint. London: Bracken Books, 1985.

31-39 BROPHY, BRIGID. Black and white: a portrait of Aubrey Beardsley. London: Jonathon Cape, 1968. 95 pp., illus., bib.
Essay on the nature of Beardsley's life, method of working, and art. Includes discussion of the sexuality in his work.

31-40 HARRIS, BRUCE S., ed. The collected drawings of Aubrey
 Beardsley. Appreciation by Arthur Simmons. New York: Bounty
 Books, 1967. 212 pp., illus.
 Includes most of his erotic works.

31-41* HEYD, MILLY. "The case of Aubrey Beardsley: censorship in the
 Victorian period." Paper delivered at College Art Association
 Meeting (Dallas, Texas), 11 February 1988.

31-42* MEULENKAMP, W.G.J.M. "Aubrey Beardsley, John Lane en Leon-
 ard Smithers: een Tekenaar en zijn Uitgevers" [a draughtsman and
 his publishers]. Antiek (Amsterdam) 17, no. 3 (October 1982):
 139-51. (Summary in English.)
 In a study of the relationship between these three men, the
 erotic content of Beardsley's work is considered.

31-43 READE, BRIAN. Aubrey Beardsley. Introduction by John Roth-
 enstein. New York: Studio Book, 1967. 372 pp., index, illus.
 (some col.).
 Most of his erotic works illustrated.

31-44* Suppressed drawings of Aubrey Beardsley.

31-45 WEINTRAUB, STANLEY. Aubrey Beardsley: imp of the perverse.
 University Park: Pennsylvania State University Press, 1976. 292
 pp., index, illus.
 Includes illustrations of most of his works.

31-46* WILSON, SIMON. "A Beardsley mystery solved." Paper deliv-
 ered at Erotic Arts Section of 1977 Conference of the Association
 of Art Historians, 1977.
 Account of the censorship of original Beardsley drawing.

---Arnold Bochlin---

31-47 TAKAHASHI, I. [Arnold Bochlin: the twin themes of Eros and
 death]. Mizue 825 (December 1973): 13-55.
 Discussion of the erotic themes in Bochlin's work.

---Canova---

31-48* PRAZ, MARIO. "Canova: ice and Eros." In Academic art, edited
 by T.B. Hess and J. Ashberry. New York: Collier-MacMillan,
 1971.

---Cheval---

31-49 LYLE, JOHN. "Pantheon of an obscure hero." Art and Artists 6,
 no. 9 (December 1971): 38-39, por.
 Postal worker who constructed enormous monument against
 death, among the objects he created are symbols of fertility and sen-
 sual pleasures.

Nineteenth Century

---Gustave Courbet---

31-50 NEEDHAM, BEATRICE. "Courbet's Baigneuses and the rhetorical
 feminine image." In Woman as sex object: studies in erotic art,
 1730-1970, edited by Thomas B. Hess and Linda Nochlin, 80-89,
 illus. New York: Newsweek, 1972.
 Sensual and erotic elements in Courbet's work is explored, in
 the context of a the traditional image of female nude bathers,

---Jacques Louis David---

31-51 JOHNSON, DOROTHY. "Desire demythologized: David's L'Amour
 quittant Psyche." Art History 9 (December 1986): 45-70, ill.
 Depiction of mythic couple lounging in a bed by David is ana-
 lyzed and historical sources of the image explored.

---Eduard Degas---

31-52 ARMSTRONG, CAROL M. "Edgar Degas and the representation of
 the female body." In The female body in Western culture, edited
 by Susan Rubin Suleiman, 223-42, illus., bib. Cambridge, Mass.:
 Harvard University Press, 1986.
 Analysis of Degas' portrayal of the female figure.

31-53 GEIST, S. "Degas' interieur in an unaccustomed perspective."
 Art News 75 (October 1976): 80-82, illus.
 Author suggests the presence of sexual symbolism in Degas's
 work.

31-54 LIPTON, EUNICE. "Degas' bathers: the case for realism." Arts
 Magazine 54, no. 9 (May 1980): 94-97, illus.
 Study of Degas's versions of the theme of bathers.

31-55 LOUYS, PIERRE. Dialogues of the courtesans. Translated by
 Guy Daniels. N.p.: Cercle des Éditions Privees, 1973. 157 pp.,
 illus.
 Illustrations by Degas accompany translation of erotic play
 based on Roman original.

31-56 NORA, FRANCOISE. "Degas et les maisons closes." L'Oeil 219
 (October 1973): 26-31, illus. (some col.).
 Degas's studies of prostitutes explored.

---Eugene Delacroix---

31-57* DOY, GEN. "Active and passive sexual roles in Delacroix's Sar-
 danapalus." Paper delivered at Erotic Arts Section of 1977 Con-
 ference of the Association of Art Historians, 1977.
 Attempt to explain the meaning of the figures and objects in
 this famous painting.

31-58* POINTON. "Politics, power and the erotic and Delacroix's Liber-
ty." Ideas and Production 5 (1984 ?).

---Thomas Eakins---

31-59 WHELAN, RICHARD. "Thomas Eakins: the enigma of the nude."
Christopher Street 3, no. 9 (April 1979): 15-18, illus.
Nature of the male nude in Eakins's work explored.

---Peter Fendi---

31-60 DANHAUSER, JOSEF. Peter Fendi: 40 erotic aquarelles, with a
portrait of the artist. Introduction by Karl Merker. Los Ange-
les: Hogarth Press, 1970. Unpaged, illus. (col.).
Brief discussion and many illustrations of the erotic art of
Fendi.

---Jean-Leon Gerome---

31-61 BOIME, A. "Gerome and the bourgeois artist's burden." Arts 57
(January 1983): 64-73, illus.
Includes discussion of the eroticism in the work of Gerome.

---Ingres---

31-62 CONNOLLY, JOHN L. "Ingres and the erotic intellect." In Woman
as sex object: studies in erotic art, 1730-1970, edited by Thomas
B. Hess and Linda Nochlin, 16-31, illus. New York: Newsweek,
1972.
Study of the erotic aspects of Ingres's work.

31-63* DUNAND, LOUIS. "A propos des dessins dits secrets legues par J-
D Ingres au Musee de Montauban." Bulletin des Amis du Musee
Ingres 23 (July 1968).
Study of Ingres's drawings of Renaissance and Mannerist
prints.

31-64 HUYGHE, R. "Ingres--the fierce twilight." Realites 254 (Janu-
ary 1972): 50-57, illus. (some col.).
Discusses the eroticism in the late works of Ingres.

31-65 TERNOIS, DANIEL. "L'eros Ingreque." Revue de Art 64 (1984):
35-56, illus, bib.
Images of love and sexuality in Ingres' work is discussed.

---Charles Kingsley---

31-66 CHITTY, SUSAN. The beast and the monk: a life of Charles Kings-
ley. London: Hodder and Stoughton, 1974. 317 pp., bib., index,
illus.
Includes erotic drawings and writings of this clergyman.

Nineteenth Century

---Max Klinger---

31-67* Max Kislinger: erotische Holzschnitte und Aquarelle. Exquisit
Kunst, no. 213. Munich: Wilhelm Heyne, ca. 1980.

31-68* PFEIFFER, H.G. "Max Klingers (1857-1920) Graphikzyklen, Sub-
jektivat und Kompensation im kunstischen Symbolismus als Para-
llelentwicklung zu den Anfangen der Psychoanalyse." Giessener
Beitrage zur Kunstgeschichte 5 (1980): 1-205, illus.
Thesis on Klinger includes analysis of the sexual motifs in his
works.

---Martin van Maele---

31-69 SOKOLOW, MEL L. The satyrical drawings of Martin van Maele.
New York: Cythera, 1970. 50 pp., bib., illus.
Erotic illustrations by a popular book illustrator.

---Eduard Manet---

31-70 FARWELL, BEATRICE. "Manet's Bathers." Arts Magazine 59, no.
5 (January 1985): 78-80, illus., bib.
Discussion of the eroticism in Manet's paintings, emphasizing
that the women depicted express the Romantic concept of sexual
women--in harems, as prostitutes, etc.

---Henry Monnier---

31-71* GRAPPE, GEORGES PIERRE FRANCOIS. Meisterwerke der erot-
ischen Kunst Frankreichs. Vol. 1, Henry Monnier. Leipzig,
1909.

---Gustave Moreau---

31-72 MEYERS, J. "Huysman and Gustave Moreau." Apollo 99 (January
1974): 39-44, por., bib., fig., illus. (some col.).
Study of symbolism in Moreau's Salome.

---Alphonse Mucha---

31-73 MUCHA, JIRI. The master of Art Noveau Alphonse Mucha.
Translated by Geraldine Thomsen; introduction by Enid da Silva.
N.p.: Artia, 1966. 300 pp., index, illus. (some col.).
Chronological study of Mucha, includes examples of his semi-
draped and naked female figures.

---Auguste Renoir---

31-74 FOUCHET, MAX POL. Les nus de Renoir. Paris: Vilo, 1974. 176
pp., illus. (some col.).
Survey of the image of the female nude in Renoir's works.

31-75 WHITE, BARBARA EHRLICH. "Renoir's sensuous women." In
 Woman as sex object: studies in erotic art, 1730-1970, edited by
 Thomas B. Hess and Linda Nochlin, 166-81, illus. New York:
 Newsweek, 1972.
 Discussion of the role of the semi-draped and nude female in
 Renoir's paintings.

---Felicien Rops---

31-76 ARWAS, VICTOR. Felicien Rops. New York: St. Martin's Press,
 1972. 7 pp. (text), bib., illus.
 Catalog of art by Rops, including his erotic work.

31-77 BRIEN, ALAN. "Get your hair cut, Rops." New Statesman 82 (6
 August 1971): 177-78.
 Report on exhibition of Rops's erotic etchings in London.

31-78 BRISON, CHARLES. Pornocrates, an introduction to the life and
 work of Felicien Rops 1833-1898. London: Charles Skilton, 1969.
 50 pp. (text), illus.
 Collection of works by Rops, concentrating on his erotic
 pieces.

31-79 DENVIR, BERNARD. "The lust for lust." Art and Artists 11, no.
 11 (March 1977): 20-26, illus.
 Study of the erotic elements in Rops's work.

31-80 HASSAUER, FREDERICKE, and ROOS, PETER. Felicien Rops: der
 weibliche Korper, der mannliche Blick. Zurich: Haffmans, 1984.
 166 pp., bib., illus.
 Focuses on images of women in Rops's artwork, including the
 explicitly sexual pieces.

31-81* HOEKSTRA, R. "L'Ingame fely." Tableau (Netherlands) 7, no. 5
 (April-May 1985): 25-29, illus.
 Study of Rops's artistic career, emphasizing his libertine life-
 style and the erotic subject matter of his art.

31-82 HUYSMANS, JORIS-KARL. "L'Oeuvre erotique de F. Rops." La
 Plume 172 June 15 1896: 388-401, illus. (Reprinted by Geneva:
 Slatkine Reprints, 1968).
 Overview of Rops's erotic works.

31-83 MAC ORLAN, PIERRE, and HUYSMANS, JORIS-KARL. L'oeuvre
 grave de Felicien Rops. Paris: Henry Veyrier, 1975. 286 pp.,
 illus.
 Complete catalog of Rops's work.

31-84* MARIS, LEO VAN. Felicien Ropes: over kunst, melancholie en per-
 versiteit. Amsterdam: Arbeiderspers, 1982. 214 pp., illus.,
 bib., index. Summary in English.

31-85* MEERT, J. Felicien Ropes: l'oeuvre grave erotique. Antwerp:
 Loempia, 1986. 98 p., ill., bib.
 Collection of 141 erotic prints by Rops.

31-86 MELVILLE, ROBERT. "Towards an art of the shiver." Archi-
 tectural Review 150, no. 897 (November 1971): 305-7, illus.
 Review of a major exhibition of Rops's work.

31-87 REVENS, LEE. The graphic work of Felicien Rops. Includes "In-
 strumentum Diaboli" by Joris-Karl Huysmans. New York: Land's
 End, 1968. 286 pp., illus.
 Collection of Rops's prints and commentary on his life and art.

31-88* ROPS, FELICIEN VICTOR JOSEPH. Das erotische Werk des Feli-
 cien Rops. Privately Printed, 1905. 3 pp. (text), illus.

31-89 [Rops issue.] La Plume 172 (15 June 1896): 387-514, illus.
 Entire issue given over to criticisms, studies, paeans, etc. to
 Rops and his works.

31-90 UNNO, HIROSHI. "[The etchings of Felicien Rops]." Mizue 875
 (February 1978): 60-71, illus. With English summary.
 Study of Rops's prints, including mention of the erotic works.

---Toulouse-Lautrec---

31-91 LOFTUS, JOHN. "Sex in the art of Toulouse-Lautrec." Medical
 Aspects of Human Sexuality 6, no. 4 (April 1972): 64-83, por.,
 illus.
 Descriptive study of Latrec's paintings of prostitutes.

---Mihaly Zichy---

31-92* Michael von Zichy: Liebe: das erotische Oeuvre des Hofmalers von
 Zar Alexander II. Exquisit Kunst, no. 231. Munich: Wilhelm
 Heyne, 1981.

31-93 ZICHY, MIHALY. The erotic drawings of Mihaly Zichy: forty
 drawings. Limited edition. 1911. Reprint. New York: Grove,
 1969. Unpaged, illus.
 Collection of erotic prints by Zichy, a court painter for the
 Russian csar.

Section 7
The Modern World

Section V

The Medical World

Chapter 32
Modern World
(Background)

The twentieth century has been a period of considerable change in Western sexuality. The changes in attitude and behavior toward sexuality in the last one hundred years is a complex subject about which a great deal has been published by scholars, journalists, and popular writers. It has been necessary for the purposes of this bibliography to limit the background material in this chapter to those works that include discussions of issues closely related to the expression of eroticism in visual media and the arts. Erotic art has flourished in the twentieth century largely because of this atmosphere of change; thus, a brief look at literature describing modern developments in sexuality as they impact the arts is useful.

A sense of just how much Western attitudes to sexuality have changed can be gained by looking at sources like Teller's This was sex and Rusbridger's A concise history of the sex manual, compilations of sex advice from books in the period from 1875 to 1986. The development of effective birth control methods, increased prosperity and leisure time, rejection of tradition, emphasis on new concepts of mental health, increased knowledge and appreciation of the diversity of the human community, and many other factors have lead to an era of unprecedented change. Part of this trend is an interest by social scientists and commentators to investigate what is sometimes called in the popular press "the sexual scene." Such studies have been made since the turn of the century, but were concentrated in the 1960s and 1970s when the so-called "sexual revolution" was taking place, a time of rapid change and radical experimentation. Many of the books and articles listed in the "Sex Customs" chapter of this bibliography include significant discussions of the late nineteenth and twentieth century; however, in this chapter works specific to this century are covered.

During the last two decades innumerable magazine articles have been written on the subject of sexual change; they have not been compiled in this bibliography. However, certain books have been included because they have at least short discussions of modern erotic art or sexuality in popular visual media. Pasle-Green and Haynes's Hello, I love you is an anthology of some of the more interesting articles and interviews relating to the "sexual revolution" of the late sixties and early seventies. A partial list of works that claim to be reportorial (rather than critical) includes books by Tristam Coffin, Helen Colton, Sara Harris, Morton Hunt, Lester Kirkendall, Michael Leigh, Philip Nobile, Vance Packard, Jacque Sole, and Gay Talese. A radical feminist view of modern sexuality can be found in a special "Sex

issue" of Heresies, a magazine dedicated to discussing issues of modern art and society as they relate to women. Works critically hostile to the changes in modern sexuality are Holbrook's The pseudo revolution and Heath's The illusory freedom.

An aspect of the "sexual revolution" included the growth of an industry dedicated to supplying people, via sex shops, mail order sources, and even home merchandising parties (for a description of the latter see John Masters' article "Dingdong! Eros calling"), with sexual paraphernalia (a history of some of those devices can be found in Mano's Playboy article "Tom Swift is alive and well and making dildoes") and explicit publications, an industry investigated by Csicsery in The sex industry, See in Blue money, and Schipper in an article in Mother Jones entitled "Filthy lucre: a tour of America's most profitable frontier." For a few years this industry held trade fairs in Denmark that have been described by Lauret in The Danish sex fairs.

This century has seen serious political and social debate over certain issues relating to sex, including issues involving art and the visual media. The highly volatile topic of pornography is covered in an earlier section of this bibliography. Related to pornography is the controversy over the nature and degree of sexuality to be found in popular culture (television, movies, magazines, newspapers, etc.) and especially advertising. That visual images of sex attract attention and help sell products is incontrovertible, what is questioned is its appropriateness in commonly available media and whether it constitutes unfair manipulation of people's feelings and behavior. Studies and commentaries on sex and eroticism in advertising and the popular media have been published by Blanchard, Blokker, Bugler, Durgnat, Goffman, Key, Lo Duca, Lucie-Smith, Millum, Schlesinger, Webb, White, and others. Communist countries are fond of criticizing the degree of "porno" in the West's pop culture (for an example see Rainov's article "Massovaya Kul'tura" in Tvorchestvo), while studies of the nature of sex beliefs and practices in modern Communist countries can be found in Stafford's Sexual behavior in the Communist world and Stern's Sex in the USSR.

32-1 BLANCHARD, GERARD. "Et l'or de leurs corps." Opus International 13-14 (November 1969): 74-81, illus.
 Erotic body images in advertising discussed.

32-2* BLEUEL, HANS PETER. Sex and society in Nazi Germany. Edited, with preface, by Heinrich Fraenkel. Translated by J. Maxwell Brownjohn. Philadelphia: Lippincott, 1973. 272 pp., gloss., index, illus.

32-3 BLOKKER, JAN ANDRIES. De Erotiek van het dagelijks leven. Zaandijk: J. Heijnis, 1959. 72 pp., bib., figs., illus.
 Eroticism in popular modern culture explored.

32-4 BUGLER, JEREMY. "The sex sell." New Society 13, no. 346 (15 May 1969): 247-49, illus.
 Exploration of the concept that advertising is directed at how women see themselves sexually.

32-5 COFFIN, TRISTAM. The sex kick: eroticism in modern America. New York: Macmillan, 1966. 256 pp., bib., index.
 Survey of contemporary sexual mores.

32-6 COLTON, HELEN. Sex after the sexual revolution. New York: Association Press, 1972. 254 pp.
 Survey of sexual trends in modern American society.

32-7 CSICSERY, GEORGE PAUL. The sex industry. New York: New American Library, 1973.
 Collection of articles on the "sexual revolution," including several chapters on eroticism in cinema.

32-8 DURGNAT, RAYMOND. "From mechanical brides to rubber women." Art & Artists 5, no. 2 (August 1970): 10-13.
 Essay attempting to define and outline mass media eroticism, suggesting that capitalism's interest in sex is really anti-erotic.

32-9 HARRIS, SARA. The Puritan jungle: America's sexual underground. New York: Putnam, 1969. 256 pp., intro.
 Some examples of sexual deviance in modern America.

32-10 HEATH, GRAHAM. The illusory freedom: the intellectual origins and social consequences of the sexual revolution. London: Heinemann Medical Books, 1978. 131 pp., bib., index.
 English critique of the so-called "sexual revolution."

32-11 HEINDRICH, WALTER (pseudonym). Guia del Erotismo en el Mundo. Barcelona: Producciones Editoriales, 1976. 248 pp., illus.
 Sociological survey of sex practices in Europe.

32-12 HERESIES. [Sex issue.] Heresies 3, no. 4 (1981): 1-95, illus.
 Articles from a feminist perspective on issues of modern sexuality, many dealing with the arts.

32-13* HODDESON, BOB. The porn people: a first-person documentary report. Watertown, Mass.: American Publishing Corp., 1974. 124 pp., illus.
 Insiders look at people who work in America's sex industry.

32-14 HOLBROOK, DAVID. The pseudo-revolution: a critical study of extremist "liberation" in sex. London: Tom Stacey, 1972. 202 pp., bib.
 Criticism of the modern sex "revolution."

32-15 _____. Sex and dehumanization in art, thought and life in our times. London: Pitman, 1972. 228 pp., bib.
 Critical essay on the role of sexuality in modern society. Actually says little about art.

243

32-16 HUNT, MORTON M. Sexual behavior in the 1970's. New York:
 Dell, 1975. 395 pp., bib., index.
 Survey of contemporary sexual mores.

32-17 KEY, WILSON BRYAN. Media sexploitation. Englewood Cliffs,
 N.J.: Prentice-Hall, 1976. 234 pp., bib., index.
 How advertising people use the knowledge of human behavior,
 especially sexual behavior, to manipulate the public.

32-18 _____ . Subliminal seduction: ad media's manipulation of a not so
 innocent America. New York: New American Library, 1974. 205
 pp., bib., index, illus.

32-19* KIRKENDALL, LESTER A., and WHITEHURST, ROBERT N., eds.
 The new sexual revolution. Preface by Paul Kurtz. New York:
 D.W. Brown, 1971. 236 pp., bib.

32-20 LAURET, JEAN-CLAUDE. The Danish sex fairs (Copenhagen-Odense
 1969/70). Foreword by Fernando Henriques. London: Jasmine
 Press, 1970. 179 pp., illus.
 Study of sex fairs as indicators of change in European sex
 attitudes.

32-21* LEIGH, MICHAEL. The velvet underground. New York: MacFad-
 den, 1968. 192 pp.
 Study of the growth of "kinky" sex over the last 100 years.

32-22* LO DUCA, GIUSEPPE (J.-M.). The technique of eroticism. Lon-
 don: Rodney Books, 1966.
 Use of eroticism in advertising and entertainment explored.

32-23* LUCIE-SMITH, EDWARD. "Erotic ads: how far can you go?." De-
 sign & Art, 30 April 1982.

32-24 MANO, D. KEITH. "Tom Swift is alive and well and making dil-
 does." Playboy, 1979, 133-34+, illus. (col.).
 Story of the modern vibrator and the sex device industry.

32-25 MASTERS, JOHN. "Dingdong! Eros calling." MacLeans 94 (2 Feb-
 ruary 1981): 30, illus.
 Growth of sex aid buying parties discussed.

32-26* MERZER, MERIDEE. "Eros in advertising." Penthouse 8 (Octo-
 ber 1976).

32-27 NOBILE, PHILIP, ed. The new eroticism: theories, vogues and
 canons. New York: Random, 1970. 238 pp., intro.
 Collection of essays on aspects of contemporary sex mores.

32-28 PACKARD, VANCE. The sexual wilderness: the contemporary up-
 heaval in male-female relationships. New York: D. McKay, 1968.
 553 pp., app., index.
 Sexual mores of the 1950s and early 1960s appraised.

Sexual mores of the 1950s and early 1960s appraised.

32-29* PASLE-GREEN, JEANNE, and HAYNES, JIM. Hello, I love you.
 Paris: Almonde, 1975.
 Collection of articles on the sexual revolution of the 1960s.

32-30* PLAYBOY. The sensuous society. Chicago: Playboy Press, 1973.
 Anthology of articles.

32-31* POLAND, JEFFERSON, and SLOAN, SAM, eds. Sex marchers. Los
 Angeles: Elysium, 1968. 150 pp., bib.
 Anthology of articles on the sexual freedom movement of the
 1960s.

32-32 RAINOV, B. "Massovaya Kul'tura ['Mass Culture']." Tvorchestvo
 (U.S.S.R.), pt. 3 (1976): 18-20, illus.
 Marxist view of pornography in the popular culture of the West.

32-33* RUSBRIDGER, ALAN. A concise history of the sex manual. New
 York: Faber & Faber, 1988. 204 pp., illus.
 Excerpts from sex manuals published between 1880s and 1980s.

32-34 SCHIPPER, HENRY. "Filthy lucre: a tour of America's most pro-
 fitable frontier." Mother Jones 5, no. 111 (April 1980): 30-33+,
 illus. (some col.).
 Survey of the porn industry.

32-35 SCHLESINGER, PHILIP. "Underground sex." New Statesman 82
 (29 October 1971): 585-86, figs.
 Discussion of the eroticism in the ads and posters in London's
 subway transportation system.

32-36 SEE, CAROLYN. Blue money: pornography and pornographers--an
 intimate look at the two-billion-dollar fantasy industry. New
 York: David McKay, 1974. 234 pp., intro.
 Interviews with participants in the pornography industry.

32-37* SELTH, JEFFERSON. Alternate lifestyles: a guide to research col-
 lections on international communities, nudism, & sexual freedom.
 Bibliographies and Indexes on Sociology series. Greenwood
 Press, 1985. 133 pp., bib., index.

32-38 SOLE, JACQUES. L'amour en Occident a l'epoque moderne. L'Aven-
 ture humaine. Paris: A. Michel, 1976. 311 pp., bib.
 Description of modern sex life.

32-39 STAFFORD, PETER. Sexual behavior in the Communist world: an
 eyewitness report of life, love and the human condition behind the
 Iron Curtain. New York: Julian, 1967. 287 pp., bib., illus.
 Survey of sex life in Communist countries.

32-40 STERN, MIKHAIL (with August Stern). Sex in the USSR. Edited and translated by Mark Howson and Cary Ryan. New York: Times Books, 1980. 221 pp., illus.
 Description of sex life in the U.S.S.R. with a section on pornography.

32-41 TALESE, GAY. Thy neighbor's wife. Garden City, N.J.: Doubleday, 1980. 568 pp., index.
 Journalistic exploration of modern sexual mores.

32-42 TELLER, SANDY. This was sex. New York: Lyle Stuart, 1978. 214 pp., illus., index.
 Survey of sex advice popular in the period from 1875 to approximately 1935.

32-43* WEBB, PETER. "Sex in ads–so far and no further." Adweekly, 12 March 1971.
 Interview with Webb about sex in advertising.

32-44 WHITE, DAVID. "Light whose fire?" New Society 45, no. 827 (10 August 1978): 297, illus.
 Sex motifs in English advertising discussed.

Chapter 33
Art Surveys

The last hundred years has been one of the richest periods of erotic art. Artists in virtually every media, utilizing the full range of modern styles, have produced erotic art. The reasons for this include the general liberalization of sex beliefs and practices in the West, the increased freedom of artists to pursue almost any interest, and a ready market for both implicitly and explicitly sexual imagery. Concomitant with the artistic output has been the publication of articles and books on erotic art. The peak period for both erotic art and publications about erotic art is the decade from 1965 to 1975. Even a cursory look will suggest that the vast majority of items listed throughout this bibliography come from that ten-year period.

There have been a number of surveys that attempt to provide an overall understanding of modern erotic art (note that many of the general erotic art surveys discussed previously in this bibliography include coverage of modern art). A pioneering effort was Edan Wright's "Modern sculpture" and C.J. Bulliet's "Modern painting" published in Sex in the arts: a symposium (1932); both of these articles concentrate almost exclusively on nudes (which today might not even be considered erotic art). Peter Gorsen's 1963 essay on sexuality in modern art published in the Bilderlexikon der Erotik, vol. 1 discussed more explicitly sexual imagery. About the same time Ove Brusendorff and Poul Henningsen published several volumes on modern erotic art in their series A history of eroticism (vol. 5, The XXth century and vol. 6 The our time [sic]), books that suffer from questionable scholarship, quirky text, and very poor black and white illustrations. More thorough studies emerged in the middle 1960s with Arthur Rabenalt's Mimus Eroticus: Beitraege zur Sittengeschichte der erotischen Szenik im zwanzigsten Jahrhundert, 2 vols. (1965-1967) and Guiseppe Lo Duca's Die Erotik im 20 Jahrhundert (1967). The most thorough effort to date has been Volker Kahmen's Erotic art today (1972; published in English as Eroticism in contemporary art), which incorporated much of what was happening in the early 1970s. E. Bradley Smith's 20th century masters of erotic art provides a wide variety of sumptuously reproduced images, but the book's text is too uneven in its coveage and quality to serve as a definitive survey. Several of D.M. Klinger's auction catalogs provide a remarkable range of imagery from the most amateurish drawings to works by acknowledged masters.

33-1* ADRIAN, DENNIS. "Illusive/allusive; sexuality in contemporary art." New Art Examiner 6, no. 10 (Summer 1979): 6, illus.
Explicitly sexual images in contemporary art discussed.

33-2* ALDISS, BRIAN. "Planet of the rapes." Penthouse 9, no. 3 (1974): 24-28, illus.
On erotic sci-fi illustration.

33-3 "Art in heat." New Art Examiner 14 (November 1986): 52-53.
Review of an exhibition on erotic art held at the Halstead Gallery in Chicago.

33-4 BALL, M. "Theme on shaky ground: Abraxas Gallery, Newport Beach, CA." Artweek 12 (31 January 1981): 12, illus.
Review of show of drawings dealing with theme of love.

33-5 BALLATORE, SANDY. "Erotica." Art Week 6, no. 6 (8 February 1975): 7.
Review of inaugural exhibition of Point Gallery, Santa Monica, entitled "Erotica."

33-6* BARRETT, CYRIL. [Exhibition catalogue.] Robert Fraser Gallery, September-October 1966.
Catalog including some modern erotic works that were subsequently confiscated by the police.

33-7 BAYL, FRIEDRICH. "L'art obscene et la provocation hedoniste." Opus International 13-14 (November 1969): 16-21, illus.
Discussion of some of the more aggressive images in modern erotic art.

33-8* BEARCHELL, C., et al. "Art/Alter Eros." Body Politic 105 (July 1984): 37.

33-9* BONE, OMAR K. [Sex in Art]. Players 3 (September 1976): 76.

33-10 BRADBURY, RAY. The art of Playboy. New York: A. van der Marck Editions, 1985. 184 pp., illus. (col.), index.
Selections of the original art used to illustrate articles in Playboy, including some with sexual themes.

33-11 BRUSENDORFF, OVE, and HENNINGSEN, POUL. Erotikens Historie. Vol. 3, Det 20. Arhundrede. Copenhagen: Thaning and Appels, n.d. 255 pp., index, illus. (some col.).
Survey of twentieth century erotic art.

33-12 _____ . A history of eroticism. Vol. 5, The XXth century. New York: Lyle Stuart, 1966. 86 pp., illus.
Discussion of some modern themes in erotic art.

33-13 . A history of eroticism. Vol. 6, The our time. New York: Lyle Stuart, 1963. 66 pp., illus.
Miscellaneous thoughts on contemporary erotic elements in art.

33-14 BULLIET, C.J. "Modern painting." In Sex in the arts: a symposium, edited by John Francis McDermott and Kendall B. Taft, 233-52. New York: Harper 1932.
Discussion of modern paintings of nudes in light of Western erotic art.

33-15* CARTER, M. "The strip laid bare: unevenly." Art & Text 10 (Winter 1983): 48-60, illus., bib.
Discussion of the role of clothing in erotic photos and paintings from a feminist viewpoint.

33-16* CASATI, PIER ANDREA. "Standard Erotici 1985." D'Ars 26, no. 109 (October 1985): 33+.

33-17 CHALUPECKY, J. "U.S.A.: retour du puritanisme." Chroniques de l'Art Vivant 55 (February-March 1975): 37.
Brief observation on the puritanical atmosphere influencing American art in the 1970s.

33-18 CHESI, GERT. Erotik zwischen Kunst und Pornographie. Storchenhaus: Galerie Eremitage, 1969. 111 pp., bib., illus.
Catalog of modern erotic drawings and prints.

33-19 COHEN, R.H. "Love is blind." Artforum 20 (October 1981): 82-83, illus.
Brief review of exhibition at Castelli Graphics (New York) of twentieth images of love.

33-20* COLOMO, GAVINO. L'arte del nudo. Enciclopedia d'arte contemporanea, no. 1. Florence: Edizione della Nuova Europa, 1974. Index, illus.

33-21 COMINI, ALESSANDRO. "Vampires, virgins and voyeurs in Imperial Vienna." In Woman as sex object: studies in erotic art, 1930-1970, edited by Thomas B. Hess and Linda Nochlin, 207-21. New York: Newsweek, 1972.
Erotic aspects of the vampire legend and its depiction in the arts is explored.

33-22* CRISPOLTI, ENRICO. Erotismo nell'arte astratta e altre schede per una iconologia dell'arte astratta. Trapani: Celebes, 1977. 361 pp., bib., index, illus.
Study of abstract erotic art.

33-23 . "Pour une phenomenologie de L'erotisme dans l'art abstrait." Opus International 13-14 (November 1969): 40-46, illus.
Survey of erotic abstract art.

33-24 DANTO, ARTHUR. "Charles Demuth." Nation 246 (23 January 1988): 101-4.
 Essay inspired by a show of Demuth's work explores some underlying eroticism in early modern art.

33-25 DAVIS, DOUGLAS. "The new eroticism." Evergreen Review 12, no. 58 (September 1968): 48-55+, illus.
 Analysis of the emerging erotic element in the arts.

33-26 DITLEA, STEVE. "The X-rated hologram." Penthouse 7, no. 5 (January 1976): 38-39, illus.
 Report on x-rated holographic imagery by women artists.

33-27 DOMINGO, JAVIER. "El Erotismo en la Prensa Marilena del Siglo XIX." Villa de Madrid 22 (October 1984): 27-40, illus.
 Risque images of women in ads from magazines of the late nineteenth and early twentieth centuries published in Madrid are described and analyzed.

33-28 DUNCAN, C. "The esthetics of power in modern erotic art." Heresies 1 (January 1977): 46-53, illus.
 Feminist essay asserting that much of modern erotic art is about men subjugating women.

33-29 _____. "Virility and domination in early 20th century vanguard painting." Artforum 12 (December 1973): 30-39, bib., illus. (some col.).
 Contends that early twentieth century painters concentrated on female nudes to assert dominance through dehumanizing and aggressive depiction of the female form.

33-30 DUNHAM, JUDITH L. "Museum of Erotic Art." Art Week 4, no. 13 (31 March 1973): 3.
 Review of recently opened International Museum of Erotic Art in San Francisco.

33-31* DURAND, MONIQUE. "Le sexe fait--il peur?" La Vie en Rose 39 (October 1986): 52-53.
 Exhibition review of a show entitled "Corps et Jouissances: Regards de Femmes" at Rimouski in 1986.

33-32* The encyclopedia of erotic artists. Renaissance, Calif.: Director's Guild Publishers, [announced for publication in 1988].
 Directory of contemporary artists who produce erotic art.

33-33* EDGINTON, J. "Sex for art's sake." Guardian (?) (20 December 1972): 10.
 Review of a show put on by the Welsh Arts Council.

33-34 "En Torno al Erotismo: El Coleccionista, Madrid." Goya, no. 142 (January 1978): 231-32, illus.
 Notice for an exhibition of erotic art.

33-35* ENGLISCH, PAUL. "Erotische Graphik der Gegenwart." Zeit-schrift fur Sexualwissenschaft 14 (1927-28): 339-43.

33-36 "Eros in Polyester; show at Sidney Janis Gallery called Erotic Art 66." Newsweek 68 (10 October 1966): 102-3, illus.
 Review of Sidney Janis Gallery erotic art exhibition.

33-37 The Erotic Art Gallery [February-March 1974]. New York: Erotic Art Gallery, 1974. 39 pp., illus.
 Catalog of exhibition of erotic art.

33-38 "Erotica: coming exhibition at the Sidney Janis Gallery." Arts 40, no. 9 (September-October 1966): 12-13.
 Announcement of erotic art exhibition.

33-39* Erotics. Toronto: Coach House Press, 1976. 128 pp., illus.
 Collection of erotic poetry, prose, and artwork from Canada.

33-40* FABER-CASTELL, CHRISTIAN VON. "Zum Thema 'Erotik'—Aus-stellung in Bern." Weltkunst 56, no. 7 (1 April 1986): 1005.

33-41 FABO, ANDY. Desire: Gallery 101 [14 February-10 March]. Otta-wa: Artist's Centre, 1984. 41 pp., illus.
 Exhibition catalog of modern Canadian drawings relating to love and sex.

33-42 FINCH, CHRISTOPHER. "Synthetic pubism." Art and Artists 1 (8 November 1966): 8-9.
 Discussion of the contemporary interest in erotic art by the public and artists.

33-43 FLECK, ROBERT. "Wandlungen des eros-Wien um 1900." Kunst und Kirche 2 (1987): 108-13, illus. (col.).
 Explores the eroticism in the work of Klimt, Kokoschka, Schiele, and others.

33-44* FLOWER, CEDRIC. Erotica: aspects of the erotic in Australian art. Sun-Academy Series. South Melbourne, Victoria: Sun Books, 1977. 80 pp., illus. (some col.).
 Modern Australian erotic art surveyed.

33-45 FRITSCH, GEROLF. "Korper-Texte-Maschine." Das Kunstwerk 34, no. 5 (1981): 52-58, bib., illus.
 Study of the human/machine hybrid image, including its erotic aspects.

33-46* FROHNER, ADOLF. Korperrituale. Vienna, 1975. 251 pp.

33-47* GALERIE MARGOT OSTHEIMER. Erotik [3 April-29 May]. Frank-furt: Galerie Margot Ostheimer 1970. 110 pp., illus.

33-48 _____ . Erotische und phantastiche Kunst [6 November-18 December]. Frankfurt: Galerie Margot Ostheimer, 1970. 142 pp., bib., illus.
Exhibition catalog.

33-49 GALERIE ROTHE. Eros und Sexus in der Kunst des 20 Jahrhunderts. Heidelberg: Galerie Rothe, 1976. 75 pp., illus.
Exhibition catalog of modern erotic art.

33-50 GASSIOT-TALABOT, GERALD. "La distanciation erotique." Opus International 13-14 (November 1969): 49-55, illus.
Images of machines and mechanized forms in modern art and their eroticism are considered.

33-51* GILLES, JEAN. "Sexual imagery in Chicago art." New Art Examiner 5, no. 3 (December 1977): 4-5, illus.

33-52* GORSEN, PETER. Das Bild Pygmalions: Kunst-Soziologische Essays. Hamburg: Rowohlt, 1969. 218 pp., bib., illus.
Includes chapters on aspects of modern erotic art.

33-53 _____ . "Erotic art." Kunst 10, no. 37 (1970): 1613-43, illus.
Overview of contemporary developments in European erotic art.

33-54* _____ . "Sexualitat im Spiegel der modernen bildenden Kunst." In Bilderlexikon der Erotik. Vol. 1. Hamburg: Armand Mergen 1963.

33-55* GOTO, YUKIO. Cross: Japanesque '70. N.p.: Sugimoto, 19??. 38 pp., illus.

33-56 HARRISON, HARRY. Great balls of fire!: an illustrated history of sex in science fiction. New York: Grosset and Dunlop, 1977. 118 pp., illus. (some col.).
Sex as a theme in science fiction literature and its illustration is surveyed.

33-57 HART, JEAN. "Erotic art by 3 West Coast artists." Art Week 5, no. 16 (20 April 1974): 13, illus.
Review of exhibition of works by John Altoon, Alden Mason, and Ralph Corners at the Polly Friedlander Gallery in Seattle.

33-58 "L'image erotique" [special issue]. Opus International 13-14 (November 1969): 15-101, illus.
Issue focuses on erotic art with a number of articles on modern art.

33-59 JANIS, SIDNEY. Erotic Art 66. New York: Sidney Janis, 1966. Unpaged, illus.
Exhibition catalog of erotic art show.

33-60 JOHNSON, TERRY. "Store window erotica: an Edmonton gallery
 defies the porn police." Alberta Report 14, no. 38 (7 September
 1987): 50, por.
 Report on a public display of erotic art at the Guerilla Galler-
 ies in Edmonton, which to the surprise of the curator created no con-
 troversy.

33-61 JOUFFROY, ALAIN. "Le collage erotique est-il petit bourgeois ou
 populaire." Opus International 13-14 (November 1969): 56-57,
 illus.
 Study of modern erotic collages.

33-62 KAHMEN, VOLKER. Erotic art today. Translated by Peter New-
 mark. Greenwich, Conn.: N.Y.G.S., 1972. 282 pp., bib., illus.
 (some col.). (Also published as Eroticism in contemporary art
 [London: Studio Vista 1972].)
 Survey of major trends in modern erotic art.

33-63* KLINGER, D[OMINIK] M. Erotic art in Europe. Vol. 2, From Art
 Nouveau until Art Deco. Neustadt/Aisch: DMK, ca. 1986.
 Selections of illustrations from the Klinger auction catalogs.

33-64 . Erotic art In Europe 1500-1935. Vol. 2a, 1880-1935.
 Nuremburg: DMK, 1983. 172 pp., illus. (some col.), bib.
 Collection of 374 black and white and 26 color reproductions of
 European erotic art.

33-65 . Erotic art in Europe 1880-1935. Vol. 14. Foreword by
 Christian Faber-Castell. Nuremburg: DMK, 1987. 88 pp. + 15
 col. illus., bib., illus.
 Introductory essay on erotic art followed by auction catalog of
 works by mostly little-known or amateur artists.

33-66 . Erotic art in Europe 1935-1980. Vol. 15. Nuremburg:
 DMK, 1987. 96 pp. + 24 col. illus., bib., illus.
 Auction catalog of works by many artists, almost all of whom
 are little known.

33-67 . Erotische Kunst in Europa. Vol. 10, 1880-1935, mit Kunst-
 lerlexikon C-F. Nuremburg: DMK, 1985. 112 pp., illus. (some
 col.).
 Part of a continuing erotic artist's lexikon (C-F) precedes 325
 black and white and 20 color illustrations representing the work of
 some 25 European artists.

33-68 . Erotische Kunst in Europa. Vol. 11, 1935-1980, mit Kunst-
 lerlexikon G-Ko. Nuremburg: DMK, 1985. 103 pp., illus. (some
 col.).
 Part of a continuing erotic artist's lexikon (G-Ko) precedes 292
 black and white and 24 color illustrations of modern European erotic
 art.

33-69 _____. Zeitgenoessische Meister der Erotik: the classical modernism and contemporary masters. Vol. 4. Nuremburg: DMK, 1984. 112 pp., illus. (some col.).
Erotic art by 17 modern artists, including Dali, Fini, and Picasso, as well as lesser known artists. Short biographies included.

33-70 KRONHAUSEN, PHYLLIS, and KRONHAUSEN, EBERHARD. "Modern erotic art." Art and Artists 5, no. 2 (August 1970): 14-17, illus. (some col.).
Outline of some trends in contemporary erotic art.

33-71 KUHN, KURT-HERMANN. "Weder Schlussellochperspektive noch Exhibitionismus." Bildende Kunst 24, no. 5 (1976): 227-30, illus.
Depictions of couples fondling each other are discussed.

33-72 KUNIKO, and NERET, GILLES. "L'eros Japonais." Opus International 13-14 (November 1969): 82-85, illus.
Survey of contemporary Japanese erotic art.

33-73 LAMBERT, JEAN-CLARENCE. "L'image erotique." Opus International 13-14 (November 1969): 14-15, illus.
Editorial commentary on this erotic art special issue.

33-74 LAYNE, GWENDOLYN. "Subliminal seduction in fantasy illustration." In Eros in the mind's eye, edited by Donald Palumbo, 95-110, illus. New York: Greenwood, 1986.
Study of subtle sexual imagery in popular illustration.

33-75 LESNIAKOWSKA, M. "Spetany Eros" [Eros in bonds]. Sztuka (Poland) 6, no. 6 (1979): 9-16+, illus. Summary in English.
Review of an exhibition entitled "Eroticism" organized in Warsaw by the Dom Artysty Plastyka during October 1978. Fifty Polish artist's work included.

33-76 LEVINE, NANCY BRUNING. Hardcore crafts. New York: Ballantine Books, 1976. Unpaged, illus. (some col.).
Photographic album of contemporary erotic crafts.

33-77 LEWANDOWSKI, HERBERT. Das sexual Problem in der modernen Literature und Kunst: Versuch einer Analyse und Psychopathologie des kunstlerischen Schaffens und der Kulturentwicklung seit 1800. Dresden: Paul Aretz, 1929. 361 pp., illus. (some col.), index.
Study of sexuality in late nineteenth- and early twentieth-century art and literature (mostly female nudes).

33-78 LIPPARD, LUCY R. "Eros presumptive." Hudson Review 20 (Spring 1967): 91-99, illus.
Discussion of contemporary abstract art.

33-79 _____. "New York letter." Art International 9, no. 3 (April 1965): 54-57, illus.

Recent exhibitions of erotic art stimulate this essay on official responses to such shows and the role of eroticism in contemporary art.

33-80 LO DUCA, GUISEPPE, ed. Die Erotik im 20. Jahrhundert. Die Welt des Eros. Basel: Kurt Desch, 1967. 399 pp., index, illus. Thorough survey of modern erotic art.

33-81* LUCIE-SMITH, EDWARD. "Gay seventies?" Art and Artists 14, no. 8 (issue 165) (December 1979): 4-11, illus. Study of gay erotic imagery in the late 1970s and early 1980s.

33-82 McDERMOTT, JOHN FRANCIS, and TAFT, KENDALL B., eds. Sex in the arts: a symposium. Introduction by Floyd Bell. New York: Harper 1932. 328 pp., intro. Collection of papers on the topic of sex in modern arts.

33-83 MACDONALD, ROBERT. "Erotic art for the Bicentennial." Art Week 7, no. 4 (3 July 1976): 4. Review of show entitled "Bicentennial Erotic Show" at Hot Flash of America, San Francisco.

33-84 McLEAN, WILLIAM. Contribution a l'etude de l'iconographie populaire de l'erotisme, recherches sur les nandes dessinees et photo-histoires de langue Francaise dites 'Pour Adultes' et sur les graffiti de Paris et de ses allentours. Collection l'erotisme populaire, no. 1. Paris: G.P. Maisonneuve et Larose, 1970. 200 pp., bib., index, illus. Sexual images, themes, and symbols in popular culture explored.

33-85 MARUSSI, G. "8 Serate Sotto il Segno dell'Eros" [Eight evenings under the sign of Eros]. Le Arti 24, nos. 11-12 (November-December 1974): 36-44, illus. Review of "Eros as Language" exhibition at the Eros Gallery, Milan.

33-86 MELVILLE, R. "Erogenous Zone, SW1." New Statesman 75 (19 April 1968): 522. Review of exhibition of erotic art by contemporary artists at the Institute of Contemporary Art in London.

33-87 MERZER, MERIDEE. "Erotic edibles: how food can be lewd." Penthouse 7, no. 6 (February 1976): 36-37, illus. Artists who use food as erotic images in their art are featured.

33-88 _____. "Genital art." Penthouse 7, no. 2 (October 1975): 44-46, illus. Explicit images of human genitalia in the art of Doug Johns, Judy Chicago, and Hannah Wilke briefly discussed.

33-89 _____. "A new kind of sexism." Penthouse 8, no. 2 (October 1976): 44-45, illus.

Problems of suppression against erotic art exhibitors like the Museum of Erotic art, Erotics Gallery, etc., discussed.

33-90* MILLER, ELISE. "Erotic art: good, clean fun in the penthouse." San Diego Magazine 32 (March 1980): 86-92.

33-91 "The most recent realism and its pornographic potential." Art-Rite 2 (Summer 1973): 8-10, illus.
Examples of eroticism in the style known as super-realism.

33-92 MOUFARREGE, NICHOLAS A. "Erotic impulse." Arts 57 (November 1982): 5, illus.
Review of erotic art exhibition ("Erotic Impulse") at Roger Litz Gallery.

33-93 _____. "Lavender: on homosexuality and art." Arts 57 (October 1982): 78-87, illus. (some col.).
The work of contemporary gay artists is explored.

33-94 NADANER, D. "Histories within the gaze." Artweek 17 (11 January 1986): 3, illus.
Exhibition review of show at Eraka Meyerovich Gallery in San Francisco.

33-95 NOEL, BERNARD. L'Enfer, dit-on—: dessins secrets, 1919-1939: du grand verre de Marcel Duchamp a la poupee de Hans Bellmer. Paris: Herscher, 1983. 207 pp., illus. (some col.), index.
Erotic images in the drawings of early twentieth-century are surveyed.

33-96* Les noveaux dessinateurs. La Bibliotheque Volante, no. 3. Paris: J.-J. Pauvert, 1971. 32 pp., illus.

33-97 "Obscenites" [special issue]. Art Presse 59 (May 1982).
Series of articles on topics relating to sexuality; includes one on Schiele's work.

33-98 O'DOHERTY, BRIAN. "Urogenital plumbing." Art and Artists 1, no. 8 (November 1966): 14-19, illus. (some col.).
Review of Sidney Janis Gallery "Erotic Art 66" exhibition.

33-99 OHFF, HEINZ. "Erotic in German art." Art and Artists 5, no. 2 (August 1970): 45-47, illus.
Major developments in modern German erotic art reviewed.

33-100 d'ORVILLE, CHRISTIAN. Eros versus Sexus. Munich: Galerie Richard P. Hartman, 1967. Unpaged, illus.
Erotic and sensual drawings by German and northern European artists featured in catalog.

33-101 PEPPIATT, MICHAEL. "Balthus, Klossowski, Bellmet: three approaches to the flesh." Art International 17, no. 8 (October 1973): 23-28, illus.
Three modern artists who have explored different ideas of the erotic and the sensual in their work.

33-102 PERREAULT, J. "I'm asking- does it exist? Whom is it for?" Artforum 19, no. 3 (November 1980): 74-75.
Interview with an art critic who is focusing his attention on contemporary gay art issues.

33-103* PETERBILT, CHUCK. Men in erotic art. New York: Rob Gallery, 1979. 57 pp., illus. (some col.).
Catalog of show of erotic works by Dutch, American, English, and Scandanavian artists.

33-104* PEZOLD, FRIEDERIKE. Pfirsich 15/75/76. Lenbachhaus: Stadtische Galerie, 1975.
Exhibition catalog.

33-105* "Pornographische Kunst." Artis 22, no. 7 (1970): 16-19, illus.

33-106 RABENALT, ARTHUR MARIA. Mimus Eroticus: Beitrage zur Sittengeschichte der erotischen Szenik im zwanzigsten Jahrhundert. 2 vols. Hamburg: Kulturforschung, 1965-1967. Index, illus.
Thorough study of eroticism in the modern arts.

33-107 "Raid in Providence: Private Parts, Exhibit." Art News 78 (January 1979): 10+.
Report on tough new antipornography law in Rhode Island and its effect on an art exhibition.

33-108* RICH, C. "Reflections on eroticism." Sinister 15 (Fall 1980): 59.

33-109 RICHARDSON, JOHN ADKINS. "Dirty pictures and campus comity." Journal of Aesthetic Education 4, no. 3 (July 1970): 85-96.
Discussion of erotic art on college campuses.

33-110 ROBERTS, TIM. "Safe sex in popular prints." New Society (9 May 1986): 9-11, illus.
Critical commentary on the contemporary market for poplular prints and posters, pointing out that titillating eroticism plays a significant role.

33-111 ROMBOLD, GUNTER. "Eros und Tod bei Edvard Munch und Max Beckmann." Kunst und Kirche 2 (1987): 103-8, illus. (some col.).
The themes of love and death in the works of two major early twentieth-century artists discussed.

33-112 ROSE, BARBARA. "Filthy pictures: some chapters in the history of taste." Artforum 3, no. 8 (May 1965): 21-25, illus.
Survey of the nude in modern art.

33-113 _____. "Protest in art." Partisan Review 40, no. 2 (1973): 207-18.
 Comparison of Dada and the American avant-garde. Considers modern nihilism, which proclaims the futility of political action. Also discusses nihilistic eroticism, especially emphasizing masochism, self-mutilation, and selfdestruction.

33-114* "Les ruses d'Eros" [special theme issue]. Revue d'Esthetique, n.s. 11 (1986): 1-186, illus.
 Series of articles relating to modern art, performance, cinema, etc.

33-115 RUSSELL, JOHN. "London pornocrats." Art in America 53, no. 5 (October-November 1965): 125+, illus.
 Offers an explanation for the modern relaxed attitude toward erotic art.

33-116* SALMON, ANDRE. L'Erotisme dans L'art contemporain. Paris: Librarie des Arts Decoratifs, 1932.

33-117 SCHIFF, GERT. Images of horror and fantasy. New York: Abrams, 1978. 158 pp., bib., index, illus. (some col.).
 Includes a chapter on 'Sex/Sadism' in modern art.

33-118 SELZ, JEAN. "L'erotisme dans la peinture contemporaine." Galerie des Arts 6 (April 1963): 10-13, illus. (some col.).
 Survey of contemporary developments in erotic art in Europe.

33-119* SEPPALA, MARKETTA. "Ironia, Erotiikka, Leikkimielisyys Ja Ilo-Kouban Taide." Taide 28, no. 3 (1987): 45+.
 Review of exhibition of Cuban art.

33-120* "Sexuality in art and the media." Lecture series sponsored by the School of the Art Institute of Chicago, 1984.

33-121 SMITH, E. BRADLEY. "Contemporary masters: an erotic portfolio." Commentary by Henry Miller. Playboy, December 1980, 207-15, illus. (col.).
 Illustrations of modern erotic art.

33-122 _____. 20th century masters of erotic art. New York: Crown 1980. 222 pp., bib., index, illus. (col.).
 Lavish visual survey of modern erotic art.

33-123 SMITH, HOWARD, and HARLIB, LESLIE. "Ladies buntiful." Village Voice 22 (7 November 1977): 30, illus.
 Confectionary store features erotically shaped foods.

33-124 SOMMER, ED. "Erotische Kunst/erotische Wahrnehmung." Das Kunstwerk 34, no. 5 (1981): 3-51, illus. (some col.).
 Survey of trends in modern erotic art, especially in Germany.

33-125* TOSCHES, NICK, and KIRK, MALCOLM. "Erotic notions." Penthouse 16 (October 1984): 140-45.

33-126 ULITZSCH, ERNST. "Die Erotik in der Expressionistischen Kunst." Zeitschrift fur Sexualwissenschaft 5 (March 1919): 361-62, illus.
　　　Survey of sexual imagery in expressionist art of early twentieth century.

33-127 VENTURA, MICHAEL. "Notes on three erections." High Performance 8, no. 2 (1985): 46-49, figs.
　　　Essay on the nature of phallic symbolism in modern & ancient art.

33-128 WALDBERG, PATRICK. Eros modern style. Bibliotheque internationale d'erotologie, no. 14. Paris: J-J Pauvert, 1964. 236 pp., illus. (Later published as Eros in la belle epoque [New York: Grove Press, 1969].)
　　　Survey of art nouveau and turn of the century sexual behavior and erotic art.

33-129 WRIGHT, BARBARA. "Erotic paintings and drawings." Arts Review 29, no. 5 (4 March 1977): 142, illus.
　　　Brief review of a show at the Kaleidoscope Gallery in London of 150 pieces by various artists.

33-130 WRIGHT, EDAN. "Modern sculpture." In Sex in the arts: a symposium, edited by John Francis McDermott and Kendall B. Taft, 253-77. New York: Harper, 1932.
　　　Study of the erotic element in modern erotic sculpture.

33-131 WURDEMANN, H. "Stroll on La Cienega." Art in America 53 (October-November 1965): 115-8+.
　　　Survey of artists and galleries in Los Angeles specializing in erotic art.

Chapter 34
Surrealism

Surrealism is one of several twentieth-century art styles that make considerable use of sexual imagery. The influence of the writings of Freud and the emphasis on dreams and the subconscious among surrealist artists led to works filled with sexual allusions and symbols. Few surrealists explicitly depicted sexual activity, but the sexual themes of their work is undeniable. Robert Benayoun's Erotique du Surrealisme explores the sexual aspects of surrealism, while Xaviere Gauthier's Surrealisme et sexualite takes a critical (from a feminist viewpoint) look at the subject (as does Whitney Chadwick's article in Artforum: "Eros or Thanatos--the Surrealist cult of love reexamined"). Certain Surrealists were especially interested in depicting images of a sexual nature in their work, including Hans Bellmer, Salvador Dali, Paul Delvaux, Max Ernst, Pierre Klossowski, Rene Magritte, and (the more recent) Jean-Marie Poumeyrol.

34-1 AYALA, WALMIR. "Erotic Surrealism." Translated by Estavao Kranz. Art and Artists 5, no. 2 (August 1970): 48-51, illus.
 Survey of Brazilian surrealist artists who deal with erotic imagery.

34-2 BENAYOUN, ROBERT. Erotique du Surrealisme. Bibliotheque internationale d'erotologie, no. 15. Paris: J.-J. Pauvert, 1965. 244 pp., bib., illus.
 Survey of surrealist erotic art.

34-3 BERGER, RENATE. "Pars Pro Toto; Zum Verhaltnis von Kunstlerischer Freiheit und Sexueller Integritat." In Der Garten der Luste, edited by Renate Berger and Daniela Hammer-Tugendhat, 150-99, illus. (some col.), bib. Cologne: Dumont, 1985.
 Essay on concepts of the body, eroticism, and violence in Surrealist art.

34-4 BOATTO, ALBERTO. "Sull'erotismo: Sade, Bataille, Breton." In
 Studi sul Surrealismo, edited by Filiberto Menna, 97-103. Roma:
 Officina, 1977.
 Discusses the images of sexuality in the works of three Sur-
 realists.

34-5 CAWS, MARY ANN. "Ladies Shot and Painted: Female Embodiment
 in Surrealist Art." In The Female Body in Western Culture, edited
 by Susan Rubin Suleiman, 262-87, illus., bib. Cambridge, Mass.:
 Harvard University Press, 1986.
 Female body as depicted in Surrealist art is analyzed.

34-6 CHADWICK, WHITNEY. "Eros or Thanatos-the Surrealist cult of
 love reexamined." Artforum 14 (November 1975): 46-56, illus.
 Study of how Surrealist artists used the female form to ex-
 press their Freudian based concepts of male/female conflict.

34-7 DI GENOVA, GIORGIO. Il Fantastico Erotico. Collana terzo oc-
 chio, no. 7. Bologna: Bora, 1982. 56 pp., illus. (some col.),
 bib., index.
 Twentieth-century Western erotic art is discussed, concentrat-
 ing on Surrealism.

34-8* DRAXLER, HELMUT. "Der entruckte Tod." Kunst und Kirche 2
 (1987): 114-19, illus. (some col.).
 Examination of Surrealist views of the themes of eroticism and
 death.

34-9 GAUTHIER, XAVIERE. Surrealisme et sexualite. Preface by J.-
 B. Pontalis. Paris: Gallimard, 1971. 375 pp., bib., illus.
 Critical study of some major features of Surrealist erotic art,
 especially the depiction of women.

34-10 JOUFFROY, ALAIN. "Erotisme et liberte intellecturelle depuis le
 Surrealisme." Opus International 13-14 (November 1969): 22-25,
 illus.
 Discussion of the nature of Surrealist erotic imagery.

34-11 KOSLOW, FRANCINE. "Sex in Surrealist Art." In Eros in the
 Mind's Eye, edited by Donald Palumbo, 75-83, illus. New York:
 Greenwood, 1986.
 Brief essay on some aspects of Surrealist erotic art.

34-12* PIERRE, J. "La Seconde Guerre Mondiale et Le Deuxieme Souffle
 de Surrealisme." In Paris-Paris: creations en France, 1937-1957,
 compiled by A. Lionel-Marie, M.-C. Llopes, and M. Thomas, 136-
 47, illus. bib.
 Exhibition catalog with essays on Surrealism which includes
 one on its erotic aspects.

See also (among others) in "Individual Artists" chapter

---Hans Bellmer---

---Salvador Dali---

---Max Ernst---

---Magritte---

---Jean-Marie Poumeyrol---

Chapter 35
Graphics

Little has been written on the use of eroticism in graphic design in modern times. The use of sex in advertising has been hotly debated in modern times (and some sources were noted earlier in this chapter), but the sexual image in posters, fashion illustration, etc., have been overlooked. Two sources do focus on posters of the early twentieth century: Rickard's book Banned posters and Springer's manuscript on "Women in French Fin-de-Siecle posters," while a few recent articles discuss the erotic element in graphics work.

35-1 "Jacques Richez, Bruxelles; erotic imagery." Novum Gebrauchs-grafik 49 (May 1978): 47-51, illus. (some col.).
 Photos and theater posters by a graphic designer who likes to use the human form in his work.

35-2 RICKARDS, MAURICE. Banned posters. London: Evelyn Adams and McKay, 1969. 72 pp., illus. (some col.).
 Examples of posters that have been affected by censorship, mostly the work of English artists.

35-3* SPRINGER, ANNA-MARIE. "Women in French Fin-de-siecle posters." Manuscript at University of Indiana, Bloomington, 1969. 59 pp.

35-4 STEVENS, CAROL. "Gutter graphics." Print 30, no. 1 (January-February 1976): 72-73, illus.
 Study of massage parlor and leisure spa advertisements.

Chapter 36
Bookplates

A unique tradition in the history of erotic art is the erotic bookplate. These were small prints commissioned by collectors who specialized in acquiring erotic literature and illustrations to identify in a unique way their collections. This tradition seems to have been most common in central and eastern Europe in the early decades of this century. The bookplates usually included the words "Ex Libris Eroticis" and provided a sexually suggestive or explicit image, often in a humorous vein. Some artists gained a considerable reknown in this field: Franz von Bayros produced a large number (see Prescott's The book-plate work of the Marquis von Bayros), as did several Czech and Hungarian artists (see, for example, books by Rasmussen and Blaesbjerg). A number of books providing illustrations of erotic bookplates have been published, the most accessible of which is the Kronhausen's Erotic bookplates.

36-1* ARNEL, THOMAS. Exlibris--belledaigte: en samling stukne og koldnalsraderede bogejermaerker med erotiske motiver 1964.

36-2* BAYROS, FRANZ VON. Ex Bibliotheca erotica. Leipzig, 1926.

36-3 BRAUNGART, RICHARD. Der Akt im modernen Exlibris. Munich: Franz Hangstaengl, 1922. 48 pp., index, illus.
Survey of nudes in bookplates.

36-4 _____. Neue deutsche Akt-Exlibris. Munich: Hangstaengl, 1924. 162 pp., index, illus.
Collection of bookplates depicting nudes.

36-5 FOGEDGAARD, HELMER. Erotica: ex libris af Christian Blaesbjerg. Frederikshavn: Exlibresten, 1972. 58 pp., illus. (col.).
Reproductions of bookplates by Blaesbjerg done in the 1960s.

36-6 _____. "De Erotiske Exlibris." Nordisk Exlibris Tidsskrift (Denmark) 29, no. 1 (1977): 88, 93-95, illus., bib.
Brief descriptions and illustrations of a few erotic bookplates by Valentin le Campion, Arpad Nagy, Wim Zwiess, and Josef Weiser.

Bookplates

36-7* _____. Erotiske exlibris I og II 1964 og 1966.

36-8 KLINGER, D[OMINIK] M. Erotic exlibris. Vol. 13. Nuremburg:
 DMK, 1983. 80 pp., bib., illus.
 Collection of 241 illustrations of bookplates with a sexual
 theme.

36-9 KRONHAUSEN, PHYLLIS, and KRONHAUSEN, EBERHARD. Erotic
 bookplates. New York: Bell, 1970. 213 pp., illus.
 Large collection of bookplates from European collections.

36-10* MICHAL, RATISLAV. Kleine Grafik. Frederikshavn: Exlibrist-
 en, 1977. 16 pp., illus. (some col.).
 Czecholslovakian erotic bookplates. Includes an English in-
 troduction.

36-11 PRESCOTT, WINWARD. The book-plate work of the Marquis von
 Bayros. Boston: Privately printed, 1913. 20 pp., illus.
 Collection of bookplates by von Bayros.

36-12 RASMUSSEN, KRISTEN. Ex Erotica: det erotiske motiv i ex lib-
 ris-kunsten. 2 vols. Prefaces by Mark Severin and Francesco
 Carbonara. Copenhagen: Arete, 1952-1954. Illus, bib.
 Collection of erotic bookplates.

36-13 REUMERT, EMMERICK. Kvinden i exlibris kunsten. Copenhag-
 en: Arete, 1954. 68 pp., index, illus.
 Study of images of women in bookplates.

36-14* Seksten ex erotici, originale exlibris udfort af forende Europae-
 iske kunstnere. Denmark: Arete, 1954. Ill.

Chapter 37
Women's Art Movement

With the possible exeption of the sexual pottery of pre-Incan Peru, most of the erotic art produced has been made by male artists. Thus, the florescence of erotic art by and for women in the late 1960s and through most of the 1970s in America and Europe is a unique development. That women artists have produced art with sexual themes is not unique to this century; what is significant is the quantity, quality, and diversity of imagery to be found in recent decades.

The feminist movement in America inspired many young female artists to assert their gender identity in their lives and work (a process described in numerous autobiographies and diaries, the best known being Judy Chicago's Through the flower). This development became an art trend that has been called the Woman's Art Movement (WAM). WAM is not a term to describe a single style or narrow range of images, but rather a collective determination by women artists to redefine their role in the art world.

Among the aspects of the WAM was the increasing expression of sexuality in the work of many artists. That women even had an interest in sexual imagery had long been questioned, but some feminists denied that assumption, a topic discussed in articles by Germaine Greer ("What turns women on"), Maryse Holder ("Another cuntree--at last a mainstream female art movement"), John Godwin ("Do women enjoy erotica?"), and others. Some feminists even asserted that women's erotic art was a necessary development in their liberation.

Traditionally, women artists were expected to avoid sexual imagery, although there were precursors to the WAM erotic art. Georgia O'Keefe constantly denied, but critics insisted, that some of her paintings had a decidedly sexual element. Leonor Fini, a Surrealist, turned increasingly to sexual themes, until by the 1950s she became the leading European artist commissioned to illustrate special editions of such erotic literature classics as The story of O. With the work of these women and others as inspiration, the WAM artists sought to explore what had been "forbidden territory." The sexual themes depicted by WAM artists ranged widely, from works that condemned what the artist considered to be male-oriented sexual practices and beliefs to the depiction of males in traditionally female imagery (the reclining nude, etc.) to explicitly sexual subjects intended to appeal to women's sexuality. By the latter half of the 1970s some elements of the feminist movement became increasingly concerned about the issue of pornography and pressured artists to abandon openly sexual themes, a

topic still controversial among women artists (see articles by Feinstein, Myers, and others). However, some women artists have continued to produce erotic works, such as the illustrator Olivia de Berardinis, who creates sexually whimsical greeting cards and magazine illustrations.

Certain artists became well known for their erotic art (see the "Individual Artists" chapter of this Section). Betty Dodson became an early spokesperson for women artists' right to deal with sexual imagery. Her own work included portraits of female gentalia and realist drawings of lovers in passion. Even more controversial was Lynda Benglis, whose full-page ad in the November 1974 issue of Artforum, showing a photograph of the artist nude, oiled, and using an enormous dildo, created considerable controversy. Hannah Wilke emphasized the female body and vaginal images. Judy Chicago conceived and supervised the massive collaborative effort that became known as the "Dinner Party," an assemblage that included vaginal-form plates honoring famous women in history. Other active artists include Dorothy Iannone, Pat Oleszko, Penny Slinger, Lillian Broca, Rhett Brown, Irina Ionesco, Tamar Laks, Rachel Menchior, Rita Yokoi, Badanna Zack, and others.

Much of what has been written about women's erotic art was published in the mid-1970s. Articles (and catalogs) on exhibitions of WAM erotic art and articles commenting on its development proliferated in this period. Especially interesting are articles by Lawrence Alloway, Judy Chicago, Jamaica Kincaid, Lucy Lippard, Cindy Nemser, Barbara Rose, and Dorothy Seiberling. In 1978 Lisa Tickner wrote an excellent, thorough survey of the WAM erotic art in her article in Art History entitled "The body politic: female sexuality and women artists since 1970." Since then the art press has been less interested in the topic, but reviews of shows appear occasionally. The debate over pornography in the mid-1980s has dominated almost all discussions of erotic art, and it is in that context that most commentary on women's erotic art is found (see the "Pornography" chapter of this bibliography).

37-1* ALLIATA, V. "Il Seso Visito dalle Donne." Bolaffiarte 5, no. 38 (March 1974): 68-71.

37-2 ALLOWAY, LAWRENCE. "Women's art in the 70's." Art in America 64, no. 3 (May-Jun 1976): 64-72, bib., illus.
 Includes a discussion of women artists' depictions of sexuality.

37-3* BALLATORE, SANDY. Erotic visions, art by women [8 January-28 February 1978]. Los Angeles: George Saud Gallery, 1978. 32 pp., illus.
 Catalog of exhibition of erotic works by women artists working in a wide range of media.

37-4* BRAND, PEGGY ZEGLIN. "Is feminist imagery erotic?" Paper delivered at the American Society for Aesthetics 44th Annual Meeting, Boston, 22-25 October 1986.

37-5 BREITLING, GISELA. "Uber die Abwesenheit der Manner in der erotischen Kunst der Frauen." In Korper-Liebe-Sprache, edited by Anna Tune, 23-32, illus. bib. Berlin: Elefanten, 1982.
 Essay on how female artists depict men in their erotic art.

37-6* CHICAGO, JUDY, and SCHAPIRO, MIRIAM. "Female imagery." Womanspace Journal 1, no. 3 (Summer 1973).

37-7* CRAWFORD, L. "Women in the erotic arts." Viva, January 1974, 74-83, illus.

37-8* FEINSTEIN, SHARON. "Our bodies, ourselves." Gay News (London) 245 (July 1982).

37-9 FISHER, JEAN. "Carnival knowledge, 'The Second Coming,' Franklin Furnace; Club 90, 'Deep Inside Porn Stars,' Franklin Furnace." Artforum 22, no. 9 (May 1984): 86.
 Group of women writers and artists who oppose anti-pornography activist's sexual abnegation explore erotic alternatives.

37-10* GAINES, J. "Women and representation." Jump Cut 29 (February 1984): 25.

37-11* GODWIN, JOHN. "Do women enjoy erotica." Forum 3, no. 12 (September 1974): 50-54.

37-12 GOLDEN, EUNICE. "The male nude in women's art; dialectics of a feminist iconography." Heresies 3, no. 4 (1981): 40-42, illus.
 Artist discusses the development of female erotica.

37-13 GREER, GERMAINE. "What turns women on?" Esquire 80 (July 1973): 88-91+, illus. (some col.).
 Erotic visual images of interest to women considered.

37-14 HOLDER, MARYSE. "Another cuntree—at last a mainstream female art movement." Off Our Backs 3, no. 10 (September 1973): 11-17, illus.
 Contemporary erotic art by women is featured.

37-15 KINCAID, JAMAICA. "Erotica." MS 3, no. 7 (January 1975): 30-33, illus. (col).
 Modern erotic art by and for women is explored.

37-16* KYRA. "Male nudes still draw hostility." New Directions for Women 9, no. 6 (November 1980): 7.

37-17* "Lesbian art and artists" [theme issue]. Heresies 3 (1977).

37-18 LIPPARD, LUCY R. "Pains and pleasures of rebirth: women's body art." Art in America 64 (May-June 1976): 73-78, por., illus.
 Women artists of the 1970s are using their own bodies as an art medium.

37-19* LORDE, A. "Defining our own/erotic as power." Big Mama 7, no. 8
 (September 1979): 11.

37-20* MEDIA WATCH. "Enough with one-sided erotica!!" Feminist Con-
 nection 5, no. 1 (September 1984): 23.

37-21* MYERS, KATHY. "Towards a feminist erotica." Camerawork 24
 (March 1982).

37-22 NEMSER, CINDY. Art talk: conversations with 12 women artists.
 New York: Charles Scribner's, 1975. 367 pp., bib., illus.
 Interviews with women artists some of who do erotic work.

37-23 _____."Four artists of sensuality." Arts Magazine 49 (March
 1975): 73-79, bib., por., illus. (Also published in Feminist Art
 Journal, Spring 1975.)
 Analysis of the work of four women artists who deal in erotic
 imagery.

37-24* _____. "Towards a feminist sensibility: contemporary trends in
 women's art." Feminist Art Journal 5 (Summer 1976): 19-23, illus.
 Includes discussion of art incorporating sexual imagery.

37-25* PARKER, ROSZIKA. "Censored." Spare Rib 54 (January 1977).

37-26* PITZEN, MARIANNE. Erotik. Bonn: Frauen Museum, 1986. 164
 pp., illus. (col.).

37-27* PUSHKIN, RUTH. "Sexual imagery in art--male and female."
 Womanspace Journal 1, no. 1 (Summer 1973).

37-28 ROSE, BARBARA. "Vaginal iconology." New York Magazine, 11
 February 1974, 59.
 Analysis of contemporary women's erotic art.

37-29 SEIBERLING, DOROTHY. "The female view of erotica." New
 York Magazine, 11 February 1974, 54-59, por., illus. (col.).
 Overview of erotic art by women in New York and around the
 country.

37-30 TICKNER, LISA. "The body politic: female sexuality and women
 artists Since 1970." Art History 1, no. 2 (June 1978): 236-51,
 notes, illus.
 Thorough survey of recent developments in erotic and sexual
 themes explored by women artists.

37-31 TUER, DOT. "Alter Eros [A Space, Gallery 940, and Gallery 76
 Toronto 28 February to 14 April]." Vanguard 13, nos. 5-6 (Sum-
 mer 1984): 47, illus.
 Feminist critic writes about an exhibit of works on the subject
 of eros by women artists. Discusses women artists defining a new
 erotic imagery.

37-32* TUNE, ANNA, ed. Korper-Liebe-Sprache, uber weibliche Kunst, erotik Darzustellen. Berlin: Elefanten Press, 1982. 224 pp., illus., por.

Catalog of works by many female German artists, includes discussion of the depiction of love, sex, etc. in women's art.

Also see (among others) in "Individual Artists" chapter

---Lynda Benglis---

---Lillian Broca---

---Rhett Brown---

---Judy Chicago---

---Olivia De Berardinis---

---Betty Dodson---

---Leonor Fini---

---Dorothy Iannone---

---Irina Ionesco---

---Tamar Laks---

---Rachel Menchior---

---Pat Oleszko---

___Penny Slinger---

---Hannah Wilke---

---Rita Yokoi---

---Badanna Zack---

Chapter 38
Postcards

Not long after the appearance of the first postcard in the latter part of the nineteenth century, postcards with sexual depictions were produced. From the beginning erotic postcards have fallen into four categories--the suggestive card utilizing sexual allusion and double entendres, humorous illustrations (closely related to erotic comics), photographs of nude females, and sexually explicit photographs. Typically, early examples of erotic postcards are in good condition because they were not actually sent through the postal system as postcards but placed in envelopes. The heyday of the erotic postcard was the pre-World War I period. While most erotic postcards were "underground" items, illustrated types became standard souvenir fare at seaside resorts in Europe, England, and America in the twentieth century. The erotic postcard has recently been supplanted by the erotic greeting card, which seem to have reached their height of popularity in the early 1980's.

The erotic postcard has been the subject of a number of books and articles. All tend to have the same format, providing a synopsis history of the genre and a collection of reproductions. Reliable text and good illustrations can be found in Griffon's The golden years and Ouellette and Jones's Erotic postcards. Collections of early postcards are found in Ferran, Hammond, and Montel. A humorous look at British illustrated postcards is Alan Wyke's Saucy seaside postcards.

38-1* "The erotic postcard." Idea 98 (18 January 1970): 92-97, illus.

38-2* FERRAN, PIERRE. L'Amour a la carte. Paris: Pierre Horay, 1980.

38-3 "French post cards." Eros 1, no. 3 (Autumn 1962): 72-79, illus.
 Reproductions of photo cards of female nudes.

38-4 GRIFFON, JULES. The golden years: masterpieces of the erotic
 postcard. Preface by Stratton Lindenmeyer. Panorama, Calif.:
 Helios Press, 1978. 128 pp., figs., illus.
 Illustrated history of the erotic postcard, from ca. 1880-1950.

38-5 HAMMOND, PAUL. French undressing: naughty postcards from 1900 to 1920. New York: Pyramid Books, 1975. 136 pp., bib., illus. (some col.).
　　　　Erotic postcards of the early twentieth century.

38-6* HOWELL, GEORGINA. The Penguin book of naughty postcards. New York: Penguin, 1977. 64 pp., illus. (col.).

38-7* "John Craig: erotic postcard illustration." Playboy, July 1974, 117-19, illus.

38-8* KYROU, ADONIS. An honest man. Translated by Alan Hull Walton. London: Rodney Books, 1964.
　　　　Illustrations of turn-of-the-century erotic postcards.

38-9 LEBECK, ROBERT. The kiss. London: St. Martin's Press, 1981. Unpaged, illus.
　　　　Early postcard images of kissing.

38-10 　　　. Playgirls of yesterday. New York: St. Martin's Press, 1981. Unpaged, illus.
　　　　Album of postcards of posing naked women.

38-11* MONTEL, ALFRED DE. Cartes postales pornographiques de la Belle Epoque. Paris: Le Club du Livre Secret, 1982.
　　　　Sexually explicit photos of ca. 1900.

38-12* NORGAARD, ERIK. Drommen om Kaerligh edens Glaeder. Copenhagen: Lademann, 1972. (Translated into French as Quand les hommes revaient a l'amour [Paris: E. Losfeld, 1971].)

38-13 　　　. With love to you: a history of the erotic postcard. New York: Clarkson N. Potter, 1969. 119 pp., illus. (some col.).
　　　　Thematic look at early postcards.

38-14* Nude 1900: a look at French postcards. Dobbs Ferry, N.Y.: Morgan and Morgan, 1978. Unpaged, illus.
　　　　Turn of the century female nudes on postcards.

38-15 Nude 1925: a look at French postcards. Dobbs Ferry, N.Y.: Morgan and Morgan, 1978. Unpaged, illus.
　　　　Scantily clad women on French postcards of the post-World War I era.

38-16 OUELLETTE, WILLIAM, and JONES, BARBARA. Erotic postcards. New York: Excalibur, 1977. 127 pp., illus. (some col.).
　　　　Selection of Victorian- and Edwardian-era "naughty" postcards featured.

38-17 . Fantasy postcards. Introduction by Barbara Jones. Garden City, N.Y.: Doubleday, n.d. 87 pp., notes, illus. (some col.).

 Includes fantasy/humorous themes with an erotic flavor.

38-18 WYKES, ALAN. Saucy seaside postcards: an illustrated disquisition. London: Jupiter, 1977. 131 pp., illus. (some col.).

Chapter 39
Pin-ups

The scantily clothed or fully nude female figure has had a long tradition in Western fine art, especially in post-Renaissance painting. While such works of art were accessible to only a small elite, the development of photography and mass-production printing technologies in the nineteenth century lead to what was to become a popular culture phenomenon--the pin-up (and the closely related cover-girl). Definitions of what constitutes a pin-up vary, but generally they are held to be mass-produced, inexpensive images (either photographs or illustrations) of a provocatively posed woman, either clothed or naked, often in proximity to or using a sexually suggestive object, but explicitly sexual activity is not appropriate.

The earliest pin-ups appeared at the turn-of-the-century and soon became common as calendar decorations, advertisements, and magazine illustrations. The heyday of the pin-up was the 1940s when they were virtually standard issue possessions of millions of G.I.s (one Betty Grable photo was the most widely reproduced pin-up ever), and after the war they became a staple feature of a number of periodicals, Esquire in particular. In the late 1940s and early 1950s there were pin-up illustrators who specialized in the genre and who had an avid following, fame, and fortune. With the increasingly easy availability of sexually explicit materials and in the face of condemnation from feminist critics, the classic pin-up has almost disappeared, surviving primarily in the form of the "centerfold" layouts of such magazines as Playboy, Penthouse, etc. Conversely, in the 1970s emerged a female audience for male pin-ups (which had previously been almost exclusively for the homosexual audience), spawning such publications as Viva and Playgirl.

Given that pin-ups were such a ubiquitous element of male culture in America and Western Europe in the first half of the twentieth century, it is not surprising that a considerable literature on the topic exists. The close relationship between pin-ups and photography means that many of the surveys in the "Photography" chapter of this bibliography discuss pin-ups. Pin-up surveys with useful well-illustrated text have been written by Gabor, Hess, Stein, Sternberg and Chapelot, and Wortley. Equally interesting but more narrow in scope are Bokelberg's look at one early form of pin-ups--the vending machine card, Bowles's article on centerfolds, Colmer's book on "calendar girls," Crawley on commercial starlet pin-ups, Gabor on "girlie magazines," Lacy and Morgan on the fascination with

women's legs, Logan and Nield on female figures painted on fighter aircraft, Smilby on early cover girls, and articles on male pin-ups by Carter and Greer.

39-1 BAZIN, ANDRE. "Entomology of the pin-up girl." In What is cinema? Berkeley: University of California Press, 1967, 158-62.
 Short history of the development of the pin-up.

39-2 BERNARD OF HOLLYWOOD. Pin-ups: a step beyond: a portfolio of breathtaking beauties. Hollywood: Bernard of California Publications, 1950. 63 pp., illus.
 Pin-ups by a master of the genre.

39-3* BOKELBERG, WERNER. Vending machine cards: pin-up-girls von gestern. Afterword by Michael Naumann. Dortmund: Harenberg, 1980. 171 pp., illus. (col.).

39-4 BOWLES, JERRY. "A history of the centerfold; the fold-out girl." Gallery 7, no. 1 (January 1979): 64-68, illus. (col.).
 Development of the centerfold in men's magazines featured.

39-5 CARTER, ANGELA. "A well hung hang-up." In Arts in society, edited by Paul Barker, 73-78. Glasgow: Fontana/Collins, 1977.
 Analysis of the modern male pin-up magazines for women.

39-6* CHELLAS, ALLEN, ed. Cheesecake: an American phenomenon. N.p.: Hillman, 1953.

39-7 COLMER, MICHAEL. Calendar girls, a lavishly illustrated, colourful history spanning six decades. London: Sphere Books, 1976. 144 pp., illus. (some col.).
 History of commercial calendar pin-up pictures.

39-8* CRAWLEY, T., and CARAEFF, E. Screen dreams: the Hollywood pinup.

39-9 GABOR, MARK. The illustrated history of girlie magazines: from National Police Gazette to the present. New York: Harmony Books, 1979. 181 pp., index, illus. (some col.).
 History of the themes and images of "girlie" magazines.

39-10 _____. The pin-up: a modest history. New York: Universe Books, 1973. 222 pp., index, bib., illus. (some col.).
 A well-illustrated history of the pin-up.

39-11 GREER, GERMAINE. "What do we want from male pin-ups?" Nova, October 1973, 51-55, illus.
 Discussion of the nature of eroticism in reference to pin-ups, nudity, body features, etc.

39-12 HESS, THOMAS B. "Pinup and icon." In Woman as sex object: studies in erotic art, 1730-1970, edited by Thomas B. Hess and Linda Nochlin, 222-37, illus. New York: Newsweek, 1972.
Pin-up image in modern popular culture is explored.

39-13 HICKS, ROGER. Techniques of pin-up photography. Secaucus, NJ: Chartwell, 1982. 128 pp., illus. (col.).
How-to book on creating pin-up images.

39-14* HOWE, ERIC. How to draw pin-ups. London: Studio Books, 1963.
Art instruction book.

39-15 LACY, MADISON S., and MORGAN, DON. Leg art: celebrating a century of love and devotion to the photographic wonders of the prettiest girls with the prettiest legs in the most glamorous profession of 'em all, show business. Foreword by James Cagney. Secaucus, N.J.: Citadel, 1981. 288 pp., illus. (some col.), intro., index.

39-16 LOGAN, IAN, and NIELD, HENRY. Classy chassy. New York: A&W Visual Library, 1977. Unpaged, illus. (some col.).
Picture book of pin-ups painted on American warplanes in World War II and Korea.

39-17 MANDER, RAYMOND, and MITCHERSON, JOE. "Pin-ups of the past." Saturday Book 34 (1974): 80-95, illus.
Description of Victorian pin-ups.

39-18* "La naissance d'une pin-up." Photo 62 (1972).

39-19* NIVEN, DAVID. The complete Pirelli calendar book. London: Pan, 1975.

39-20 "Portrait of the artist as a young pinup." Playboy, 198?, 208-9, illus. (col.).
Nude self-portraits in satire of traditional pin-ups.

39-21 SMILBY, FRANCIS. Stolen sweets: the cover girls of yesteryear: their elegance, charm, and sex appeal. Foreword by Michelle Urry. Chicago: Playboy, 1981. 138 pp., illus. (some col.).
Cover girl images from the 1880s to the 1930s.

39-22 STEIN, RALPH. The pin-up; from 1852 to today. Chicago: Playboy Press, 1974. Reprint. New York: Crescent, 1984. 255 pp., illus. (some col.).
History of the pin-up with each chapter focusing on a particular period of pin-up development.

39-23 STERNBERG, JACQUES, and CHAPELOT, PIERRE. Pin up. London: Academy Editions, 1974. 96 pp., illus.
Picture book of pin ups.

39-24 "30 memorable years; three decades of the best, the brightest, the most beautiful women to grace these pages." Playboy, January 1984, 96-109, illus. (some col.).
 Nude centerfolds and photo features from 30 year history of Playboy.

39-25 WAGNER, GEOFFREY. "Part three; pin-ups: the 'proper' art." In Parade of pleasure: a study of popular iconography in the U.S.A., edited by Geoffrey Wagner, 115-53. London: Derek Verschoyle, 1954.
 Essay on the pin-up.

39-26 WAKERMAN, ELYCE. Air powered: the art of the air brush. New York: Random House, 1979. 222 pp., bib, illus. (some col.).
 Some of the most famous pin-up artists used the air brush in their work, many of which are illustrated.

39-27 WORTLEY, RICHARD. Pin-ups progress: an illustrated history of the immodest art. London: Panther, 1971. 175 pp., illus. (some col.).
 History of the pin-up.

Chapter 40
Comics

Sexual graffiti and caricatures have existed since ancient times, a topic explored in Edouard Fuchs early twentieth-century book L'Element erotique dans la caricature and elsewhere. However, the modern comics (which include single panel illustrations, comic strips, and comic books) began at the turn of the century. Almost from the beginning, sexual humor and imagery were an element in comics. The sexual humor in newspaper and magazine cartoons has been circumspect but significant, as evidenced by Jaques Saddul's study of eroticism in French and American comic strips of the 1930s and 1940s in L'Enfer des bulles, Arthur Berger's article on American comics of the 1960s, and Moliterni and Amadieu's article on ravishing and ravished women in comics. The so-called "men's magazines" such as Playboy and Penthouse specialize in soft-core sexual comics. Sexually explicit material has existed since the turn of the century and can be seen in one of D.M. Klinger's auction catalogs (Die Fruehzeit der erotischen Comics 1900-1935, vol. 8).

During this century there have been several periods in which special genres of erotic comics have emerged. During the Great Depression of the 1930s there appeared in the United States a type of surreptitiously produced, crudely manufactured publication that became known by many names--bluebooks, Tijuana bibles, eight-pagers, two-by-fours, etc. Each followed a remarkably consistent format, printed on crude pulp paper, two inches by four inches in dimension, consisting of a simple cover with a title utilizing suggestive words, sexual puns, and double entendres enclosing eight pages of illustrations, each with a single comic-style frame. The content of the bluebooks was also constant, an opening frame introducing the main characters and what might euphemistically be called "the story-line," six frames of sexual activity, and a closing frame in which the "story" is completed. Commonly, the main character is a famous person of stage, screen, politics, etc. (even well-known cartoon characters) who is depicted engaging in activities not in keeping with his or her public image. Social scientists who have studied the bluebooks tell us that they are a phenomenon of the crisis of the Depression, a view supported by the fact that by the early 1940s the availability of the books had greatly dwindled. Scholarly studies of the bluebooks include works published by Klotman, Palmer, and Olson. There are many books that reproduce bluebook illustrations, but only a few attempt to analyze or explain them. The books of reproductions by Holt, Gilmore, Atkinson, and Reynolds provide at least some

introductory (clearly nonscholarly) remarks on the history and social role of the bluebooks. In recent years many bluebooks have been reprinted in their original format.

In the late 1960s a new type of comic emerged as an alternative to the established comic strip and comic book industry. What became known as "underground comics" were an expression of the counterculture then flourishing among America's youth. The underground comics reflected the political, social, drug use, and sexual attitudes of the counterculture and sometimes did it through radical experiments in illustrative techniques. Most of the comics focused on topics ignored by establishment cartoonists. Sex was a favorite subject of the underground cartoonists, often depicting sexual practices strongly condemned in Western society (bestiality, incest, etc.). The whole underground comics phenomenon has been well documented in Mark Estren's A history of underground comics, which includes a long chapter on the subject of sex. Estren's book can serve as a reference resource because he includes information on as many publishers and titles as he was able to locate. Zack's article "Smut for love, art, society" focuses on the history and development of these sexual comics. One cartoonist who proved especially prolific and popular was Robert Crumb, about whose work Alessandrini published a book in 1974. The underground comics genre spread to Europe where it flourished in Germany and Sweden (presumably included in Rymarkiewicz's Swedish sex comics). Some of the most popular issues of the underground comic books have been reissued, and a few of the titles are still occasionally appearing in new numbers.

An outgrowth of the underground comics has been the production of hardcore comic books for the burgeoning "pornography industry" from the 1960s on. Prominent illustrators in this category are the Americans James McQuade and Rod M'Gurk and the French artist Hubert.

A special category of explicitly sexual comics are the illustrated sadomasochistic comics that focus on stories about bondage, mythical sex wars, and the use of sadistic sexual devices. Certain illustrators have specialized in this genre, a field dominated since the 1950s by John Willie and Bob Bishop. The European illustrator Guido Crefix produces softcore sadomasochistic comics (featured in an article by Wolinski) and in recent years has produced comic book style versions of such sex classics as Emmanuelle and The story of O. The Japanese have a subgenre of comic books which focus on sex and violence (typically scenes of rape) which have been discussed by Angela Carter in her article "Once More into the Mangle" and the French have their cartoon illustrated versions of famous literature, operas, etc., surveyed by Bourgeois.

40-1 Adult komix no. 1. N.p., n.d. Unpaged, illus.
 Reproductions of 'Tijuana Bibles' from the 1930's.

40-2* ALESSANDRINI, MARJORIE. Robert Crumb. Paris: Albin Michel, 1974. 120 pp., bib., illus.
 Biography of best known underground cartoonist.

40-3 ATKINSON, TERENCE. More little "dirty" comics. Reseda, Calif.: Socio Library, 1971. 215 pp., bib., illus. (some col.).

Reproductions of "Tijuana Bibles" from the 30s and 40s with commentary on their history and sociology.

40-4 BERGER, ARTHUR. "Eroticomics or 'what are you doing with that submachine gun, Barbarella?'" Social Policy 1, no. 3 (September-October 1970): 42-44, illus.
Study of eroticism in American comics.

40-5* BISHOP, BOB. Bishop. 3 Vols. Los Angeles: House of Milan, ca. 1970s. Illus. (some col.).
Series of bondage and domination (sadomasochistic) stories about a character called Fanni Hall.

40-6* _____. [Collection of illustrations.] Hustler, November 1977.
Full-color illustrations of bondage and domination scenes.

40-7* Bizarre comix.

40-8 BOURGEOIS. Erotisme et pornographie dans la bande dessinee. Glenat, 1978. 160 pp., ill. (some col.), index, bib.
Hundreds of text illustrations provide a visual sampling of erotic cartoons, emphasizing the names of artists like Forest, Crumb, and Crepax.

40-9 BRYAN, DWAIN, ed. Carnal comics. N.p., n.d. Unpaged, illus.
Reproductions of "Tijuana Bibles" of the 1930s and 1940s.

40-10 CARTER, ANGELA. "Once more into the mangle." New Society 448 (29 April 1971): 726-27, illus.
Article on Japanese sex and violence comic books.

40-11* CRUMB, ROBERT. Carload o'comics.
Collection of Crumb's work, including much of his sexually oriented material.

40-12* DAVID, WILTON. The Zelda Gooch erotic art coloring book. New York: Zelda Gooch Studio, 1974.

40-13 ESTREN, MARK JAMES. A history of underground comics. San Francisco: Straight Arrow Books, 1974. 320 pp., illus. (some col.).
Survey includes several chapters that discuss the sexual aspects of underground comics.

40-14* Fantastic treasure of porno funnies. 320 pp.

40-15 GILBEY, JAY. Dirty little sex cartoons. Los Angeles: Argyle Books, 1972. 192 pp., bib., illus.
Collection of "Tijuana Bibles" from the 1930s and 1940s.

40-16* GILMORE, DONALD H. Sex in comics: a history of the eight pagers. 4 vols. San Diego: Greenleaf Classics, 1971.

40-17 HOLT, R.G. Little "dirty" comics. Reseda, Calif.: Socio Library, 1971. 215 pp., bib., illus. (some col.).
 Reproductions of "Tijuana Bibles" from the 1930s and 1940s.

40-18 HORN, MAURICE. Sex in the comics. New York: Chelsea House, 1985. 215 pp., bib., index, illus. (some col.).
 Survey of implicit and explicit sexuality in the history of comics.

40-19* JENNINGS, MICHAEL. A treasury of dirty little comics--the kind men like. New York: Valiant, 1972. 66 pp., illus. (col.).
 Reproduction of "Tijuana Bibles" from the 1930s and 1940s.

40-20 KANESAKS, KENJI. [Cartoons by Takashi Ishii.] Mizue 864 (March 1977): 98-99, illus. (In Japanese; summary in English.)
 Japanese cartoonist's main theme is rape.

40-21 KLINGER, D[OMINIK] M. Die Fruehzeit der erotischen Comics 1900-1935. Vol. 8. Nuremburg: DMK, 1985. 135 pp., illus.
 Brief introductory text and 878 reproductions of erotic comics.

40-22 KLOTMAN, PHYLLIS R. "Racial stereotypes in hard core pornography." Journal of Popular Culture 5, no. 1 (Summer 1971): 221-35, illus.
 Study of role of blacks in "Tijuana Bibles" from the 1930s and 1940s.

40-23 LEYLAND, WINSTON, ed. Meatmen: an anthology of gay male comics. San Francisco: G.S. Press, 1986. 191 pp., illus.
 Collection of gay comics, most with explicit sexual themes by many of the best-known cartoonists.

40-24* _____. More meatmen; an anthology of gay comics. Vol. 2. San Francisco, ca. 1987. Ca. 200 pp., illus.
 Includes work by 23 cartoonists.

40-25 MOLITERNI, CLAUDE, and AMADIEU, G. "Bandes dessinees: la revanche de la femme." Opus International 13-14 (November 1969): 58-65, illus.
 Study of ravished and ravishing women in comics.

40-26* OLSON, JAMES. Sex, humor and the comics: an illustrated study. A Pendulum Psychomed Study.

40-27 PALMER, C. EDDIE. "Filthy funnies, blue comics, and raunchy records: dirty jokes and obscene language as public entertainment." In Sexual deviancy in social context, edited by Clifton D. Bryant, 82-98, bib. New York: New Viewpoints, 1977.
 Study includes description of contemporary porno-comics.

40-28 . "Pornographic comics: a content analysis." Journal of Sex Research 15, no. 4 (November 1979): 285-98, ref.
Psychological study of the contents of "Tijuana Bibles."

40-29* PARKINSON, ROBERT E. "Carnal comics." Sexscope Magazine 1, nos. 3 & 4.

40-30* PEYNET, RAYMOND. Les amoureux de Peynet. Paris?: Les Editions les Jarres d'Or, ca. 1963. 96 pp., por., illus.

40-31 Playboy's Buck Brown. Chicago: Playboy, 1981. 128 pp., illus. (some col.).
Popular Playboy cartoonist whose work focuses on sexual themes.

40-32 RAYMOND, OTIS. An illustrated history of sex comic classics. 2 vols. New York: Comic Classics, 1972. Index, illus.
Reproductions of "Tijuana Bibles" from the 1930s and 1940s.

40-33 REYNOLDS, JOHN J. Famous sex comics. Foreword by C. Leslie Lucas. Reseda, Calif.: Socio Library, 1971. 216 pp., bib., illus. (some col.).
Reproductions of "Tijuana Bibles" from the 1930's and 1940's.

40-34* RYMARKIEWICZ, WENCEL. Swedish sex comics. 2 vols. N.p.: Monogram, 1972. Illus.

40-35 SADOUL, JAQUES. L'Enfers des bulles. Paris: Pauvert, 1968. 254 pp., illus. (some col.).
Sex in commercially produced comics in the 1930s.

40-36* SIDEN, H. "The amazing art of the kinky comic." Mayfair 9, no. 1 (1974): 40-41+, illus.

40-37* TETSU. Dessins des que des Q. N.p., ca. 1960.
Portfolio of cartoons by Tetsu.

40-38* . Histoire pas tres naturells. N.p., ca. 1960.
Portfolio of cartoons.

40-39* The Tijuana Bible revival. Vol. 1. Blue Balls, Pa.: Penetrating, 1977. 96 pp., illus. (col.).
Reproduction of "Tijuana Bibles" from the 1930s and 1940s.

40-40* The Tijuana Bible revival. Vol. 2. Hooker, Calif.: Paramounds Products, 1977. 96 pp., illus. (col.).
Reproduction of "Tijuana Bibles" from the 1930s and 1940s.

40-41* VON TRUBBLE. The many faces of Philbert Foxhunt. Chatsworth, Calif.: Red Lion, 1972. 14 pp.

40-42 WOLINSKI. "Guido Crefax." L'Oeil 230 (September 1974): 54-59, illus.
 Short article on a French cartoonist who specializes in soft-core sado-masochistic images.

40-43 ZACK, D. "Smut for love, art, society." Art and Artists 4, no. 9 (December 1969): 12-17, illus.
 History and development of contemporary underground comics.

Chapter 41
Kitsch

Kitsch is a term that describes objects that are not simply poorly rendered or shoddily produced, but that exemplify "bad taste", while aspiring to be considered art. Vacation souvenirs and billboard advertising supply many examples of kitsch. Eroto-kitsch or porno-kitsch are terms that have been used to describe a special category of kitsch that encompasses objects with a sexual component. While some writers have suggested that all "pornography" is kitsch, eroto-kitsch is commonly associated with ashtrays decorated with nudes or breast shaped coffee mugs, for example. While no book exclusively deals with sexually oriented kitsch, almost all kitsch surveys include a chapter or section on the subject. Sternberg's Kitsch gives the most attention to erotic kitsch, with useful discussions also included in Brown's Star-spangled kitsch and Dorfles's Kitsch.

41-1 BROWN, CURTIS F. Star-spangled kitsch: an astounding and tastelessly illustrated exploration of the bawdy, gaudy, shoddy mass-art culture in this grand land of ours. New York: Universe Books, 1975. 202 pp., bib., illus. (some col.).
 Includes a small section on eroto-kitsch.

41-2 DORFLES, GILLO. Kitsch: the world of bad taste. New York: Universe, 1969. 311 pp., bib., index, illus. (some col.).
 Study of kitsch includes comments on porno-kitsch.

41-3 RICHTER, GERT. Kitsch-Lexikon von A bis Z. Berlin: Bertelsmann Lexicon, 1972. 240 pp., bib., index, illus. (some col.).
 Includes entries on erotic motifs in kitsch.

41-4* STERNBERG, JACQUES. Les chefs d'oeuvre du kitsch. Paris: Editions Planete, 1971. 412 pp., illus.
 Includes discussion of eroto- and porno-kitsch.

41-5 _____. Kitsch. London: Academy Editions, 1972. Unpaged, illus.
 Picture study of kitsch imagery, with some emphasis on the sexual/erotic.

Chapter 42
Interior Decoration

Architecture is not usually associated with erotic art, but there are a few entries in this bibliography that indicate that there have been architects and builders who toyed with erotic notions in their work. The idea of designing interior spaces to foster a sensual or erotic atmosphere is nothing new. Chinese literature, for example, reveals a strong concern for making love in a place carefully arranged to delight the senses. Throughout history it appears that wealthier houses of prostitution have been lavishly decorated and outfitted with special furniture built for enhancing pleasure. Only in the twentieth century do we find descriptive how-to literature on this subject, the most complete being Sivon Reznikoff's book Sensuous spaces: designing your erotic interiors, and erotic interior design products featured, as in Smith and Harlib's article on wallpaper with sexual imagery.

42-1 FRASER, PAUL, and RIDER, CARYN. "Come up and swim in my room sometime—a visit to America's sweetheart hotels." Gallery, February 1980, 37-39+, illus. (col.).
 Honeymoon hotels in Pennsylvania featured.

42-2 GAILLARD, MARC. "Une architecture organique Ricardo Porro." Opus International 13-14 (November 1969): 34-38, illus.
 Examples of the work of a modern architect who uses organic forms that are sometimes erotic.

42-3 POST, HENRY. "Orgy art: decorating for sex." Penthouse 7 (July 1976): 46-47, illus.
 How to outfit a house for an orgy.

42-4 REZNIKOFF, SIVON C. Sensuous spaces: designing your erotic interiors. New York: Whitney Library of Design, 1983. 203 pp., bib., index, illus. (some col.).
 Sensual/erotic design ideas discussed and illustrated.

42-5 SMITH, HOWARD, and HARLIB, LESLIE. "X-rated hang-up." Village Voice 22, no. 49 (5 December 1977): 16, illus.
 Erotic wallpaper featured.

Chapter 43
Individual Artists

The twentieth century has been one of the most prolific in the history of erotic art. In the last one hundred years artists have maintained that the restrictions which society and religion had placed on earlier artistic activity are no longer tenable, freeing them to explore almost any idea or emotion they wished. As a result many artists have at some time in their careers experimented with the concept of sexuality in their work. As the names listed in this chapter indicate, erotic art has been produced by some of the most famous artists of the modern era. The motivations for producing erotic art vary greatly--artists may have a personal interest in expressing something about sexuality, as in Picasso's erotica; others assert that the creation of erotic art in itself is a political statement, as with the work of a number of feminist artists; many artists are responding to commissions from book publishers, private collectors, and others; certain modern styles emphasize sexuality as a characteristic element, as with Surrealist paintings. Whatever the reasons, modern artists who hold that production of erotic works is an artistic right still face the problems in displaying and selling such works. Publication of erotic art in articles and books is a frequently utilized means of publicizing the existence of such erotic art to a wide audience.

The artists listed in this chapter have been included because at least one publication on the erotic aspects of their art exist. Only items that are mainly concerned with the erotic art of an artist have been compiled. A book on the life of Picasso, for instance, that may tangentially mention his erotica is not listed, but an article on his erotic prints is. The user is advised that research into the erotic art of a particular artist should be expanded beyond this bibliography to include more general publications on that individual.

---Anonymous---

43-1* Kugelrunda [Round as a ball]. Nuremburg: DMK, 198?.
 Reproduction of 32 full-color prints after watercolors by an anonymous technical illustrator from about 1920.

Individual Artists

---Aslan---

43-2* ASLAN. Pin-up.

---Elvira Bach---

43-3 VON BELOW, STEPHANIE. "Elvira und die Schlange." Kunst und
 Kirche 2 (1987): 133-35, illus. (col.).
 Features the work of Elvira Bach, a German artist who com-
 bines images of women with snakes.

---Otto Bachmann---

43-4* BACHMANN, OTTO. Vom Steinbock zum Schutzen: Tierkreiszei-
 chen erotisch Geschen (verse von Wilhelm Krohn). Hamburg:
 Gala, ca. 1973. 27 pp., illus.

---Clayton Bailey---

43-5 LAWREN, BILL. "Robot sexism." Omni 6, no. 6 (March 1984): 92,
 illus.
 Brief description of controversy surrounding Clayton Bailey's
 robot sculpture of a coffee-serving maid/waitress.

---Balthus---

43-6 BENNETT, I. "Balthus come Giorgione: erotico, lirico e misteri-
 oso." Bolaffiarte 11, no. 99 (June 1980): 20-24, illus. (col.).
 Study of Balthus's work, including a discussion of the erotic
 element.

43-7 CLAIR, J. "Eros et Cronos: le rite et le myth dans l'oeuvre de
 Balthus." Revue de Art 63 (1984): 83-92, illus., bib.
 Analysis of mythic and artistic sources for Balthus's paintings.

43-8 FLOOD, R. "Sugar and spice and . . .: Balthus a retrospective."
 Artforum 22, no. 10 (June 1984): 84-85, illus., bib.
 Review of Balthus show at MOMA. Author focuses on eroticism
 in Balthus's work.

43-9 GIBSON, M. "Balthus." Artnews 83, no. 4 (April 1984): 96-101,
 illus.
 Discussion of Balthus' early life and his erotic depictions of
 girls, with consideration of possible sources for his imagery.

43-10* HASSENKAMP, S. "Diskrete Szenen aus dunklen Trauemen." Art:
 Das Kunstmagazin 2 (February 1983): 58-65, illus.
 Survey of the career of Balthus, including his fascination with
 the eroticism of young girl's.

43-11 HYMAN, TIMOTHY. "Balthus: a puppet master." Artscribe, no.
 23 (June 1980): 30-40, illus.

Study of the work of Balthus, including the erotic element of his paintings.

43-12 KINGSLEY, APRIL. "The sacred and erotic vision of Balthus." Horizon 22, no. 12 (December 1979): 26-35, illus. (col.).
Study of Balthus's nudes.

43-13* LEYMARIE, JEAN. Balthus/Cantini [Musee Cantini, July-September 1973]. Preface by Albert Camus. Marseilles: Musee Cantini, 1973. 152 pp., bib., illus.
Exhibition catalog of show on Balthus with discussion of the eroticism in his work, especially in scenes of children.

43-14* SCHJELDAHL, P. "Pretty babies." Art & Antiques, March 1984, 92-99, illus.
Critical assessment of Balthus's work, including discussion of the nature of his depiction of young girls.

—Franz von Bayros—

43-15 BAYROS, FRANZ. Choisy le Conin: Bilder aus dem Boudoir der Madame C.C. Vienna: Privately printed, 1912. N.p., illus.
Collection of erotic prints.

43-16* _____. Erotische Graphik. ca. 1975. 208 pp., illus.

43-17 BRETTSCHNEIDER, RUDOLF. Franz von Bayros: Bibliographie seiner Werke und beschriebendes Verzeichnis seiner Exlibris. Leipzig: A. Wiegel, 1926. 83 pp., illus.
Catalog of Bayros's illustrations.

43-18 BRUNN, LUDWIG VON. The amorous drawings of the Marquis von Bayros. Preface by Wilhelm Busch; biography by Johann Pilz. New York: Cythera Press, 1968. 238 pp., illus.
Reproductions of the sexual works by Bayros, accompanied by essays on the artist and his work.

43-19* Marquis Franz von Bayros: im Garten der Aphrodite: erotische Zeichnungen und Illustrationen. Exquisit Kunst, no. 225. Munich: Wilhelm Heyne, 1980.

43-20* RATI-OPPIZONI, CONTE L.U. "Francesco di Bayros." Journal Maestri della Stampa Erotica (Turin), 1912, 9, illus.

43-21* _____. "Francesco di Bayros." Archivio dell' Associazione Italiana fra Amatori di Ex-Libris 1, no. 1 (March 1912): 8.

43-22* WEBB, PETER. Franz von Bayros and die Grenouilliere. London: Amorini, 1976.
Reproductions of prints from the early part of this century. Text relates Bayros to such nineteenth-century artists as Rops and Beardsley.

Individual Artists

---Hans Bellmer---

43-23* ALEXANDRIAN, SARANE. Hans Bellmer. Paris: Editions Filipac-
 chi, 1971. 87 pp., bib., illus. (some col.).

43-24 AWAZU, NORIO. [Hans Bellmer's prints and sketches: the line of
 Eros]. Mizue 838 (January 1975): 46-51, illus. In Japanese; sum-
 mary in English.
 Survey of Bellmer's erotic works.

43-25 BAILLY, JEAN CHRISTOPHE. "Le reve et le desir: au regard de la
 poupee." XXe Siecle, n.s. 42 (June 1974): 101-7, illus. (some col.).
 Study of Bellmer's doll sculptures in terms of Surrealist tradi-
 tion of depicting the nude female form.

43-26 BELLMER, HANS. The drawings of Hans Bellmer. Preface by
 Constantin Jelenski; translated by Helen Lane. New York: Grove,
 1967. 109 pp., bib., illus. (Originally published as Les dessins
 des Hans Bellmer by Editions Denoel, 1966.)
 Reproductions of many drawings by Bellmer.

43-27 _____. Die Puppe. Berlin: Gerhardt, 1962. 190 pp., illus.
 (some col.).
 Three long essays provide commentary on Bellmer's use of the
 body, especially female figure, in his art.

43-28 BROC-LAPEYRE, MONIQUE. "Hans Bellmer ou l'artisan criminal."
 Revue d'Esthetique 1-2 (1978): 241-76.
 Analysis of Bellmer's writings and art, focusing on his theme of
 the amoral victim who accepts everything.

43-29 CONIL-LACOSTE, MICHEL. "L'erotisme tetratologique de Bell-
 mer." Le Monde 8379 (22 December 1971): 13, figs.
 Review of an exhibition of the works of Bellmer at the Centre
 National d'Art Contemporain.

43-30 FLEUR, FRANCIS. "Hans Bellmer." L'Oeil, December 1971, 10-
 13, illus.
 Study of Bellmer's drawings of "doll" figures.

43-31 GRALL, ALEX, ed. Hans Bellmer. Introduction by Constantin
 Jelenski. London: Academy Editions, 1972. 109 pp., illus. (some
 col.).
 Catalog of Bellmer's drawings.

43-32* "Hans Bellmer" [special issue]. Obliques, 1975, 1-284, bib.

43-33 JOUFFROY, ALAIN. Hans Bellmer. Chicago: William and Noma
 Copley Foundation, n.d. 26 pp., por., bib., illus. (some col.).
 Brief catalog of Bellmer's drawings.

43-34 LYLE, JOHN. "Hans Bellmer: the machine gun in a state of grace."
Art and Artists 5, no. 2 (August 1970): 22-25, illus.
Article attempts to explain the philosophical background to
Bellmer's art.

43-35* Oeuvre grave. Introduction by Andre Pieyre de Mandiargues.
Paris: Denoel, 1969.
Complete collection of Bellmer's graphic art.

43-36 PIERRE, J. "J'ecoute la Cousine Ursula." l'Oeil 204 (December
1971): 14-17+, illus.
Study of Bellmer's female images.

43-37* PORCHERON-FERSHING, M-D. "Un dessin erotique de Hans Bell-
mer et l'erotisme du dessin." Revue d'Esthetique 1-2 (1980): 83-
85.

43-38* SHORT, ROBERT. "Eros and surrealism: Bellmer's Doll." Paper
delivered at the Erotic Arts Section of the 1977 Conference of the
Association of Art Historians, 1977.
Bellmer's doll as an example of the Surrealist ideas of eroticism
and the "crisis of the object."

43-39 SOUTHERN, TERRY. "The show that never was." Art and Art-
ists 1, no. 8 (November 1966): 10-12, illus.
Reproduction of part of the catalog for an exhibition of Bellmer
prints that was cancelled due to fear of official suppression.

43-40* WEBB, PETER, and SHORT, S. Hans Bellmer. London: Quartet,
1985. 300 pp., bib., illus.
Artistic biography of Surrealist artist, including assessment of
his erotic imagery.

---Lynda Benglis---

43-41 ALLOWAY, LAWRENCE et al. [Letters protesting and defending
Lynda Benglis's advertisement in the November 1974, Artforum].
Artforum 13 (December 1974): 9; (March 1975): 8-9.
Color photo of a naked Lynda Benglis using an enormous dildo
(an ad for her exhibition at the Paula Cooper Gallery) instigates a
lively controversy over the meaning of the image and artist's rights.

43-42 PINCUS-WITTEN, ROBERT. "Lynda Benglis-the frozen gesture."
Artforum 13, no. 3 (November 1974): 54-59, illus.
Detailed study of contemporary artist who often uses sexual
images in her work.

---Raymond Bertrand---

43-43* "Bertrand et les rigeurs de la passion." Zoom (Paris) 1 (January
1970): 90-96.

Individual Artists

43-44 BERTRAND, RAYMOND. The drawings of Raymond Bertrand. In-
 troduction by Emmanuelle Arsan. New York: Grove, 1974. 126
 pp., illus. (some col.). (First edition published as Dessins ero-
 tiques de Bertrand, edited by Eric Losfield [Paris: Le Terrain
 Vague, 1969].)
 Drawings and paintings of a fantasy, surrealistic depictions of
 women engaged in erotic play.

43-45* _____. Dessins erotiques de Bertrand II. London: Proffer,
 1971.

43-46 "The erotic drawings of Bertrand." Evergreen Review 14, no. 76
 (March 1970): 39-45, illus.
 Excerpts from The Drawings of Raymond Bertrand.

---Larry Blizard---

43-47 LUBELL, ELLEN. "Larry Blizard: Razor Gallery, New York."
 Arts 51, no. 7 (March 1977): 41, illus.
 Report on exhibition of the work of Blizard, including anthro-
 pomorphic bananas.

---Ron Boise---

43-48 BOISE, RON, and WATTS, ALAN. "Sculpture: the Kama Sutra
 theme." Evergreen Review 9, no. 36 (June 1965): 64-65 (text),
 illus.
 Erotic sculptures made from scrapped auto parts illustrated,
 accompanied with a short text about problems of censorship of the
 arts.

---Laszlo Boris---

43-49* BORIS, LASZLO. Der Kuss: 10 handkolorierte Original - Litho-
 graphien von L. Boris. Munich: D. & R. Bischoff, ca. 1921.

---Antoine Bourdelle---

43-50 DUFET, MICHEL. Bourdelle et l'erotisme Grec: 100 epigrammes
 Grecques/aquarelles d'Antoine Bourdelle. Translated by Paul-
 Louis. Paris: Editions du Temps, 1976. 135 pp., ref., illus.
 (some col.).
 Watercolors by Bourdelle to illustrate short passages from
 Greek literature, some relating to the loves of the gods, etc.

---Louise Bourgeois---

43-51* EROTIC ART GALLERY. The Erotic Art Gallery: [exhibit of
 works by] Louis Bourgeois [and others] (Feb. 8-March 30, 1974).
 New York: Erotic Art Gallery, 1974. 39 pp., illus.
 Exhibition catalog of the sculptures of Bourgeois and others.

43-52 LIPPARD, LUCY R. "Louise Bourgeois: from the inside out." Art-
 forum 13, no. 7 (March 1975): 26-33, bib., illus.
 Study of sculptor whose work includes erotic imagery, parti-
 cularly in works done in the 1950s.

43-53 ROBINS, CORINNE. "Louis Bourgeois: primordial environments."
 Arts Magazine 50, no. 10 (June 1976): 81-83, por., illus.
 Includes discussion of erotic aspects of her work.

43-54 RUBIN, WILLIAM S. "Some reflections prompted by the recent
 work of Louis Bourgeois." Art International 13, no. 4 (20 April
 1969): 17-20, illus.
 Critical review of works by Bourgeois.

---John Boyce---

43-55 NIN, ANAIS. Aphrodisiac: erotic drawings. Illustrated by John
 Boyce. New York: Crown Pub., ca. 1976. 159 pp., illus.
 Elegant line drawings illustrate erotic passages from the works
 of Anais Nin.

---Lillian Broca---

43-56 LORGE, MARK. "Works of love at Jackson Street." Signature
 (Seattle) 1, no. 6 (15 November 1984): 3, illus.
 Review of show of erotic ceramic plates by Canadian artist.
 Art is reminiscent of visually rich, turn-of-century Viennese painting
 (especially like that of Klimt and Mucha).

---Jurgen Brodwolf---

43-57 MEYER, WERNER. "Jurgen Brodwolf: Tod und Madchen." Kunst
 und Kirche 2 (1987): 127-28, illus. (some col.).
 German artist who frequently plays with the traditional theme
 of "Death and Maiden."

---Bob Delford Brown---

43-58 EISENHAUER, L.L. "Portrait: Bob Delfora Brown." Art and Art-
 ists 8, no. 4 (July 1973): 34-37, illus. (some col.).
 Biography of pop artist who has used "pornographic" images as
 a feature in some of his art.

---Rhett Brown---

43-59 [BROWN, RHETT DELFORD]. [Advertisement for Great Building
 Crack-Up]. Artforum 12 (7) Mar 1974: 92, illus.
 Color photo of a humorous erotic tapestry by this artist.

Individual Artists

---Gunter Brus---

43-60 BRUS, GUNTER. Drawings 1969-1971. Cologne: Konig, ca. 1971.
 83 pp., illus.
 Reproduction of a group of strange, scatological and sado-
 masochistic drawings, including some gruesome images of impalement,
 death, dismemberment, etc.

---Scott Burton---

43-61 PINCUS-WITTEN, ROBERT. "Scott Burton: conceptual perform-
 ance as sculpture." Arts Magazine 51, no. 1 (September 1976):
 112-17, illus. (some col.).
 Study of an artist who does performance art and whose work
 includes sexual elements.

---Michael Butho---

43-62* KOCHS, MARITA. "Licht, Liebe, Leben." Sexualmedizin 9, no. 9
 (September 1980): 393, illus.

---Joao Camara Filho---

43-63 MORAIS, FREDERICO. Dez Casos de Amor e Uma Pintura de Cama-
 ra: Teorla e Corpo do Pintor Secreto. Rio de Janeiro, ca. 1983.
 137 pp., illus. (some col.).
 Surrealist imagery with distinctive sexuality.

---Vittorio Caricchioni---

43-64 CAVICCHIONI, VITTORIO. Vittorio Cavicchioni ovvero la seman-
 tica della semiologia erotica. Rome: EM, 1973. 130 pp., illus.
 (some col.).
 Drawings and photo montages used to create images of sexual
 anatomy.

---Judy Chicago---

43-65 BLAIR, GWENDA. "The womanly art of Judy Chicago." Mademoi-
 selle 88 (January 1982): 99-101+, por., illus. (some col.).
 Description of Chicago's Dinner Party.

43-66* CHICAGO, JUDY. Through the flower. New York: Doubleday,
 1975.
 Artist's autobiography.

43-67 _____. The dinner party: a symbol of our heritage. New York:
 Doubleday, 1979. 256 pp., index, illus. (some col.).
 Artist's explanation of an assemblage work of art celebrating
 women's accomplishments in history.

---Francesco Clemente---

43-68 BOURDON, DAVID. "Eye to I." Vogue 175 (April 1985): 89, illus.
Brief discussion of the art of Clemente, especially the erotic
element in the works of this Italian Neo-Expressionist painter.

43-69* GARDNER, PAUL. "Gargoyles, goddesses and faces in the
crowd." Artnews 84, no. 3 (March 1985): 52-59, illus. (col.), por.
Includes analysis of the erotic aspects of Clemente's art.

---William Copley---

43-70 COPLEY, WILLIAM. "William Copley (Brooks Jackson Iolas, New
York)." Art News 80 (November 1981): 189, illus.
Review of show of Copley's satirical paintings that are largely
about sex.

---Corneille--

43-71 MARCHESSEAU, DANIEL. "Corneille." Cimaise 28, no. 151
(April-June 1981): 7-18, illus.

---John Craig---

43-72 CRAIG, JOHN. "Wish you were here." Playboy 21, no. 7 (July
1974): 117-20, illus. (col.).
Series of collages superimposing female anatomy onto and with-
in architectural settings and landscapes.

---Mauro Cristofano---

43-73 FERRARA, M.N. "Mauro Cristofano." Le Arti 24, nos. 7-8 (July-
August 1974): 251.
Study of artist includes some of his erotic prints.

---Salvador Dali---

43-74* DALI, SALVADOR. Eroticism in clothing. Beachwood, Ohio: Dali
Museum, 1975. 15 pp.

43-75* _____. Les metamorphoses erotiques: choix de dessins executes
de 1940 a 1968. Lausanne: Edita, 1969. 60 pp., illus.

43-76* _____. "Salvador Dali on eroticism." Penthouse 2, no. 8 (June-
July 1967).

43-77* PEREZ, N.N. "Dali, Horst, and the Dream of Venus." Israel Mus-
eum Journal 3 (Spring 1984): 52-57, illus., bib.
Analysis of photo of costume by Dali, a female figure draped in
sea creatures.

Individual Artists

---Olivia De Bernardinis---

43-78* "De Bernardinis, Olivia." Penthouse 15 (November 1983): 124+,
 illus.

---Paul Delvaux---

43-79 BOCK, PAUL-ALOISE DE. Paul Delvaux. Brussels: Laconti, 1967.
 318 pp., por., bib., illus. (col.).
 Study of the life and work of Delvaux.

43-80 COHEN, RONNY. "Paul Delvaux's imagination." Artforum 23, no.
 5 (February 1985): 55-59, illus.
 Survey of Delvaux's work, especially his nudes and skeletons.

43-81 DELVAUX, PAUL. Delvaux. Geneva: Galerie Kruger, ca. 1966.
 24 pp., bib., illus. (some col.).
 Catalog of some of the works by Delvaux.

43-82* NISHIZAWA, S. [Delvaux's territory]. Mizue 840 (March 1975):
 5-43. In Japanese; summary in English.
 Discusses the eroticism in Delvaux's works.

43-83 O'HARA, J. PHILIP. Paul Delvaux. Chicago: J. Philip O'Hara,
 1973. 79 pp., bib., illus. (some col.).
 Study of Delvaux's ideas as expressed in his paintings.

43-84 PEIGNOT, JEROME. "L'Erotisme occulte de Delvaux." Opus In-
 ternational 19-20 (October 1970): 36-38, illus.
 Short article on Delvaux's erotic work.

---Charles Demuth---

43-85 CHAMPA, KERMIT. "Charlie was like that." Artforum 12, no. 6
 (March 1974): 54-59, por., illus. (some col.).
 Sexual symbolism in paintings by Demuth based on a mixture of
 sources.

43-86* HASKELL, BARBARA. Charles Demuth. New York: Whitney Mus-
 eum, 1987.
 Catalog from a retrospective exhibition of Demuth's work, in-
 cluding the erotic paintings.

43-87 KOSKOVICH, GERARD. "A gay American modernist: homosexu-
 ality in the life and art of Charles Demuth." Advocate, 25 June
 1985, 50-52, illus. (some col.).
 In-depth discussion of the role of homosexuality in Demuth's
 life and its expression in his work.

43-88 SCHWARTZ, SANFORD. "Auctions: glimpsing the 'hidden' De-
 muth." Art in America 64 (September-October 1976): 102-3, illus.

302

Among little known drawings and paintings put on exhibition in 1976 are several with strong male homosexual flavor.

43-89 WEINBERG, Jonathan. "Some unknown thing: the illustrations of Charles Demuth." Arts Magazine 61 (December 1986): 14-21, illus. (some col.).
Exploration of the importance of homosexuality in many of the works of Demuth.

43-90 _____. "Demuth and difference." Art in America 76, no. 4 (April 1988): 188-95+, ill. (col.).
Retrospective exhibition of Demuth's paintings raises questions about the homosexual aspects of his work.

43-91 WHELAN, RICHARD. "Charles Demuth: the resonance of ambiguity." Christopher Street 3, no. 6 (January 1979): 16-18, illus.
The disguised homosexuality in Demuth's work is featured.

---Otto Dix---

43-92 KARCHER, EVA. Eros und Tod im Werk von Otto Dix: Studien zur Geschichte des Korpers in den zwanziger Jahren. Munster: Lit, 1984. 146 pp. (text), index, figs., illus., bib.
Study of the themes of sex, violence, and death in Dix's work, especially his female nudes.

---Betty Dodson---

43-93 DODSON, BETTY. Liberating masturbation: a meditation on self love. New York: Betty Dodson, 1976. 60 pp., figs., por.
Book on women's sexuality by artist, including her drawings of women's genitalia.

43-94* _____. "Betty Dodson: erotic illustrations." Viva, February 1974, 42-45+, illus.

43-95 PHILLIPS, MARY. "The fine art of lovemaking; an interview with Betty Dodson." Evergreen Review 15, no. 87 (February 1971): 37-43+, illus.
Thoughts and philosophy of a woman artist whose work is explicity sexual.

---Dolesch---

43-96 EROS PRODUCTIONS. [Advertisement for print series entitled "Eros Affirmed"]. Art in America 75, no. 3 (March 1987): 155, illus. (col.).

Individual Artists

---Jean Dubuffet---

43-97 GAGNON, FRANCOIS. "An erotic tinge in the art of Jean Dubuffet."
 Translated by Yvonne Kirbyson. Vie des Arts 57 (Winter 1969-
 70): 76-77, illus. (some col.). (English translation of French art-
 icle on pp. 23-27).
 Erotic elements in Dubuffet's work is discussed.

---Marcel Duchamp---

43-98 CALAS, N. "Duchamp's last work." Arts Magazine 48, no. 1
 (September-October 1973): 46-47, illus.
 Analysis of erotic sculptural environment that was the last
 work by Duchamp.

43-99 CRARY, J. "Marcel Duchamp's The passage from virgin to bride."
 Arts Magazine 51, no. 5 (January 1977): 96-99, bib., illus.
 Verbal and symbolic meaning of Duchamp's famous sculpture.

43-100* MAUR, K. VON. "Marcel Duchamp 'Fenetrier' Überlegungen zu ein-
 er Neuerwerbung der Staatsgalerie." Jahrbuch der Staatliche
 Kunstsammlungen Baden-Wurttenburg 18 (1981): 99-104, illus.
 Discussion of the symbolic and erotic aspects of the Bagarre
 d'Austerlitz of 1921.

43-101 MURAY, P. "Le religion sexuelle de Marcel Duchamp." Art Press
 84 (September 1984): 4-7, illus.
 Discussion of the erotic elements in Duchamp's work and his
 statement that he had a profound belief in eroticism.

---Max Ernst---

43-102 LIPPARD, LUCY R. "World of Dadamax Ernst." Art News 74, no.
 4 (April 1975): 27-30, illus. (some col.).
 Themes in Ernst's work explored, including his sexual con-
 cepts.

43-103 METKEN, G. "Paramythen: Max Ernst Haus in Saint-Martin d'Ar-
 deche." Pantheon 32, no. 3 (July-September 1974): 289-96, bib.
 Ernst made sculptures of couples for his home in 1938-1941.

---Erro---

43-104* ERRO. Erro-tics. Geneva: Claude Givaudan, 1969. 66 pp.,
 illus.

---Agustin Fernandez---

43-105 ANDERSON, D., and BOWLER, G. "Agustin Fernandez." Arts Mag-
 azine 54, no. 10 (June 1980): 24, illus.
 Study of the work of Fernandez which includes an interest in
 erotic imagery.

---Tommasi Ferroni---

43-106 TATRANSKY, VALENTINE. "Portraiture and excellence, or, Ferroni's new paintings." Art International 24, nos. 1-2 (September-October 1980): 117-23, illus. (col.).
Allegorical paintings of erotic scenes.

---Jean Filhos---

43-107 PIEYRE DE MANDIARGUES, ANDRE. "La tres chere trait nue." Opus International 13-14 (November 1969): 90-91, illus.
Artist produces metal sculptures of intertwined people.

---Leonor Fini---

43-108 CLEMENT, VIRGINIA. "Leonor, un souterrain nomme desir." Aesculape 35, no. 3 (March 1954): 63-69, illus.
Study of the sensual and erotic work of Fini.

43-109* DIDIEU, JEAN-CLAUDE. Fetes secretes: dessins. Paris: Editions du Regard, 1978. 128 pp., illus.

43-110 FELS, FLORENT. "L'ange du bizarre, Leonor Fini." Aesculape 35, no. 3 (March 1954): 52-62, illus.
Study of Fini's Surrealist art.

43-111 GAGGI, SILVIO. "Leonor Fini: a mythology of the feminine." Art International 23 (September 1979): 34-39+, illus. (some col.).
Study of Fini's work as feminist expression.

43-112 JELENSKI, CONSTANTIN. Leonor Fini. London: Olympia, 1968. 171 pp., por., bib., illus. (some col.).
Chronological study of the development of Fini's work.

43-113 KRAMBERG, KARL HEINZ. Schone Liebe der Hexen: erotische Zeichnungen. Munich: Kurt Desch, 1971. 82 pp., illus.
Eighty-three erotic drawings by Fini.

43-114* MESSADIE, GERALD. Leonor Fini. Milan: E.P.I., 1951. Unpaged.

---Eric Fischl---

43-115 STEVENS, MARK. "Sex and success." New Republic 3718 (21 April 1986): 25-27, illus. (col.).
Inspired by exhibition at the Whitney Museum, discusses the sexual allusions and interest in the middle-class world seen in Fischl's paintings.

Individual Artists

---Frohner---

43-116* GORSEN, PETER. Korperrituale: Monografie und Werkkatalog.
 Vienna and Munich: Jugend and Volk, 1975. 251 pp., bib., illus.
 (some col.).

---Ernst Fuchs---

43-117* KOCHS, MARITA. "Ernst Fuchs." Sexualmedizin 9, no. 12 (Dec-
 ember 1980): 523, illus.

---Gerard Gachet---

43-118 "Gerard Gachet." Penthouse 15, no. 11 (July 1984): 113-21, illus.
 (col.).
 Reproductions of works of this French fantasy/surrealist art-
 ist.

---Frank Gallo---

43-119 WITT, LINDA. "To the horror of his corn belt neighbors, Frank
 Gallo is the king of plastic casters." People 6, no. 10 (6 Septem-
 ber 1976): 44-46, illus.
 Brief article featuring Gallo and his plastic female nudes.

---Frans Gast---

43-120* VERWIEL, J. "Frans Gast, Beeldhouwer." Scheppend Ambacht
 28, no. 5 (October 1977): 113-15, illus. Summary in English.
 Description of some sculptures by Frans Gast, including his
 erotic abstract Elle: The Eternal Woman.

---George---

43-121 "Sculpture a la rorschach." Avant Garde, March 1969, 42-45,
 illus.
 Erotic/sensual plastic abstract sculptures featured.

---H.R. Giger---

43-122 GIGER, H.R. Necronomicon. London: Big O, 1977. 85 pp.,
 bib., illus. (some col.).
 Background, interests, and art of fantasy artist, whose work
 sometimes includes strangely erotic imagery.

43-123 "H.R. Giger's alien encounters." Penthouse, May 1980, 142-53,
 illus. (col.).
 Reproduction of some of Giger's work utilizing phallic and vul-
 vic imagery.

---Eric Gill---

43-124* GILL, ERIC. The engraved works of Eric Gill. London: H.M.
Stationery Office, 1977. 82 pp., illus.
The graphic works of an artist who did pieces showing nudes
and couples engaged in sexual activity.

43-125 _____. Twenty-five nudes. New York: Devin-Adair, 1950. Un-
paged, illus.
Examples of Gill's nudes.

43-126 SPEAIGHT, ROBERT. Life of Eric Gill. New York: P.J. Kene-
dy, 1966. 323 pp., bib., index, illus.
Early twentieth-century artist famous for art deco graphics,
includes his nudes and erotic work.

43-127 YORKE, MALCOLM. Eric Gill, man of flesh and spirit. London:
Constable, 1981. 304 pp., bib., index, por., illus.
Survey of the life and work of Eric Gill with one chapter focus-
ing on his erotic art.

---Francine Goldblatt---

43-128 RESTANY, PIERRE. "Francine Scialon Goldblatt: women between
themselves." Cimaise 32, nos. 178-79 (November-December 1985):
65-71, ill. (some col.).
Appreciation of Goldblatt's paintings of women in ecstasy.

43-129 XURIGUERA, GERARD. "An iconography of voluptuousness."
Cimaise 32, nos. 178-79 (November-December 1985): 72-76, ill.
(some col.), por.

---Gerald Gooch---

43-130 ZACK, DAVID. "Kama Sutra to life." Art and Artists 5, no. 2
(August 1970): 26-27, illus.
Art teacher who uses lovemaking couples in his drawing classes
featured.

---Arshile Gorky---

43-131 MCCONATHY, D. "Gorky's Garden: the erotics of paint." Arts-
canada 38 (July-August 1981): xvi-3, illus.
Erotic meaning in Gorky's abstract work discussed.

---Gunter Grass---

43-132 IIYOSHI, MITSUO. [From kitchen to bedroom: Gunter Grass's
copper prints]. Mizue 849 (December 1975): 44-56, por., illus.
(In Japanese; summary in English.)
Grass's prints use everyday objects to depict genital organs.

Individual Artists

---George Grosz---

43-133* GROSZ, GEORGE. Ecce Homo. Introduction by Henry Miller.
New York: Grove, 1966. (First edition, Berlin: Malik, 1923.)
Satirical drawings of prostitutes and party goers.

---Renato Guttuso---

43-134 GUTTUSO, RENATO. Renato Guttuso: i disegni dell'amore. In-
troduction by Antonio del Guerico. Milan: Domus, 1974. 157 pp.,
por., illus. (some col.), bib.
Collection of drawings of nudes and explicit scenes of erotic
play by Italian artist.

---Thomas Haefner---

43-135 FRIEDRICH, GERHARDPOUL. "Painter of dreams." Art and Art-
ists 5, no. 2 (August 1970): 18-21, illus. (some col.).
Dreamlike paintings of Thomas Haefner with erotic imagery fea-
tured.

---Ernst Hansen---

43-136 HANSEN, ERNST. Erotika: et halvt hundrede tegninger i pen og
bly. Introduction by Poul Sorensen. Copenhagen: Nytteboger,
1948. Unpaged, illus.
Line drawings of couples.

---Shiro Hayami---

43-137 YOSHIDA, Y. [Shiro Hayami's sculpture]. Mizue 870 (September
1977): 78-81, illus. (In Japanese; summary in English.)
Artist makes baked clay tile erotic sculptures.

---Barbara Heinisch---

43-138 KERBER, BERNHARD. "Barbara Heinisch: rote Liebe." Kunst
und Kirche 2 (1987): 129-31, illus. (some col.).
German artist who paints abstract works incorporating vulvic
forms featured.

---d'Henencourt---

43-139 [D'HENENCOURT.] "Portfolio of drawings." Evergreen Review
15, no. 86 (January 1971): 39-43, illus.
Drawings with erotic themes by a late nineteenth- or early
twentieth-century artist in France.

---Mariano Hernandez---

43-140 CHALUMEAU, J-L. "Les venus barbares de Mariano Hernandez."
Opus International 93 (Spring 1984): 30-31, illus.

Author contends that Hernandez has been painting versions of the same nude for almost a decade. Some of his works are sexually explicit.

---Antonius Hockelmann---

43-141 KAHLCKE, W., and GOHR, S. Antonius Hockelmann (20 June-17 Aug 1980). Cologne: Kunsthalle, 1980. 96 pp., bib., illus.
Sculptor and draughtsman whose mature work expresses aggressive sexuality.

---John Holmes---

43-142* HOLMES, JOHN. "The seven deadly sins." Men Only 38, no. 11 (November 1973): 92-95, illus.
Erotic images by a regular illustrator to the British magazine Men Only.

---Dorothy Iannone---

43-143* "Le cul dans les plumes: entretien avec Dorothy Iannone." ARTitudes International 30-32 (January-May 1976): 14-15, illus.
Artist who makes fantasy seats decorated with feathers.

43-144* [IANNONE, DOROTHY]. Follow me. Berlin: Berliner Kunstlerprogramm/DAAD, 1978. (In English and German.)

---Icart---

43-145* SCHNESSEL, S.M. Icart. New York: Clarkson N. Potter, 1976. 178 pp., illus.

---Ikeda---

43-146 RUSH, D. "Masuo Ikeda's eroticism." Artweek 7, no. 8 (February 21 1976): 6, illus.
Female form is displayed erotically by Japanese printmaker.

43-147 TANIGAWA, SHUNTARO. [Venus plan: Masuo Ikeda's "Venus"]. Mizue 849 (December 1975): 32-41, illus. (col.). (In Japanese; summary in English.)
Features the erotic images of lounging female figures by Japanese artist Ikeda.

---Jasper Johns---

43-148 FEINSTEIN, RONI. "New thoughts for Jasper Johns' sculpture." Arts Magazine 54, no. 8 (April 1980): 139-45, illus.
Includes discussion of eroticism in Johns's work.

Individual Artists

—Allen Jones—

43-149 ADAMS, H. "Marksman extraordinary: Allen Jones." Art and Artists 13 (March 1979): 4-11, illus.
 Review of Jones's career.

43-150 JONES, ALLEN. Allen Jones, retrospective of paintings, 1957-1978. Liverpool: Walker Art Gallery, 1979. Unpaged, bib., illus. (some col.).
 Thorough catalog, with many of Johns's sexual works.

43-151 _____. Allen Jones' figures. Milan and Berlin: Edizioni O/Galerie Mikro, 1969. 87 pp., illus. (some col.).
 Study of the paintings, drawings, and sculptures of Jones.

43-152 _____. Allen Jones' projects. London: Matthew Miller Dunbar, 1971.
 Drawings, plans, and photos from a number of projects (most never completed). All are strongly sexual in nature.

43-153 LEMAIRE, G.-G. "Les fixions, sexographiques d'Allen Jones." Opus International 73 (Summer 1979): 30-32, illus.
 Suggests that Jones's works derive from bondage imagery.

43-154 LIVINGSTONE, MARCO. Allen Jones: sheer magic. Introduction by Alan Bownes. London: Thames and Hudson, 1979. 144 pp., bib., index, illus. (mostly col.).
 Study of Jones's work, especially the sexual imagery.

43-155 _____. "Il Sesso con gli Stivali." Bolaffiarte 8, no. 73 (October-November 1977): 40-45, illus. (some col.).
 Survey of Jones's erotic work.

43-156 MULVEY, LAURA. "You don't know what is happening do you, Mr. Jones?" Spare Rib, no. 8 (February 1973): 13-16+, illus.
 Feminist analysis of Jones's work and fetishistic images.

—John Kacere—

43-157* "The end of art." Oui, May 1974, 78-81, illus.

—Michael Kanarek—

43-158* "Michael Kanarek: erotic illustrations." Viva, July 1974, 65+, illus.

—Kandinsky—

43-159* WASHTON LONG, R.C. "Kandinsky's vision of utopia as a Garden of Love." Art Journal 43, no. 1 (1983): 50-60, illus.

---Tilo Keil---

43-160 GORSEN, PETER. "Les montages de Tilo Keil." Opus Internation-
al 13-14 (November 1969): 98-99, illus.
Erotic montages discussed.

43-161* KOCHS, MARITA. "Eingefangene Korpersprache." Sexualmed-
izin 9, no. 8 (August 1980): 346, illus.

---Kitaj---

43-162* KITAJ, RONALD B. R.B. Kitaj, Pictures/Bilder. Catalog, no. 358.
Introduction by Robert Creeley. London and Zurich: Marlbor-
ough Fine Art, 1977. 44 pp., illus. (some col.).
Exhibition catalog includes some of his erotic works.

---Gustav Klimt---

43-163* COMINI, ALESSANDRA. Gustav Klimt, Eros und Ethos. Salzburg,
1975.

43-164 _____. "Titles can be troublesome: misinterpretations in male art
criticism." Art Criticism 1, no. 2 (1979): 50-54.
Author chides what she feels are deliberate misreadings of
Klimt's works that seek to deny the explicit sexual meanings of his art.

43-165 FLIEDL, GOTTFRIED. "'Das Weib Macht keine Kunst, aber den
Kunstler' zur Klimt--Rezeption." In Der Garten der Luste, edited
by Renate Berger and Daniela Hammer-Tugendhat, 89-149, illus.
(some col.), bib. Cologne: Dumont, 1985.
Study of the sensuality, eroticism, and role of women in Klimt's
art.

43-166 GIBSON, MICHAEL. "L'art de Klimt: eros et ornement." L'Oeil
368 (March 1986): 36-41, illus. (some col.), bib.

43-167 HOFMANN, W. "Einsame Zwiegspraeche." Art (Germany) 5 (1980):
70-80, illus.
Erotic drawings by Klimt, 1907-1917.

43-168 HOFSTATTER, HANS. Gustav Klimt erotic drawings. Translated
by Jean Steinberg. New York: Abrams, 1980. 87 pp., illus.
(some col.).
Full-size reproductions of Klimt's most erotic drawings from
part of an Austrian private collection.

43-169 NOVOTNY, FRITZ, and DOBAI, JOHANNES. Gustav Klimt. New
York: Praeger, 1970. 424 pp., bib., index, illus. (some col.),
por.
Survey of the artist's life and work includes discussion of his
erotic imagery.

Individual Artists

43-170* WERNER, ALFRED. Gustav Klimt: 100 drawings. New York: Dover Publications, 1972. 45 pp., illus.

---Klossowski---

43-171 CAGNETTA, FRANCO. "De Luxuria Spirituali." Translated by Henry Martin. Art and Artists 5, no. 2 (August 1970): 52-53, illus.
Description of Klossowski's art that largely consists of scenes of the rape of mature women.

43-172 FELLENBERG, W. VON. "Das zeichnerische Werk eines Schriftstellers." Weltkunst 51, no. 14 (15 July 1981): 2080-81, illus.
Review of exhibition of Klossowski's drawings, with remarks on the sexual content of the works.

43-173* JOUFFROY, ALAIN. "Klossowski, axelos et l'amour." Opus International 13-14 (November 1969).

---Robert Knight---

43-174 WOLFRAM, E. "Erogenous knights." Art and Artists 6, no. 9 (December 1971): 30-33, illus.
Knight's assemblage sculptures of groping hands featured.

---Howard Kottler---

43-175 FAILING, PATRICIA. "Howard Kottler: conceptualist and purveyor of psychosexual allusions." American Craft 47, no. 6 (December 1987-January 1988): 22-29, illus. (col.).
Analysis of the meanings of certain forms and images which repeatedly appear in Kottler's ceramic sculptures.

---Alfred Kubins---

43-176 MULLER-THALHEIM, WOLFGANG K. Erotik und Damonie im Werk Alfred Kubins: eine psychopathologische Studie. Munich: Nymphen-Burger, 1970. 110 pp., illus.
Early twentieth century artist and his sadomasochistic erotic art are featured.

---Georges Kuthan---

43-177 KUTHAN, GEORGES. Aphrodite's cup. Edmonton: Hurtig, 1976.
Canadian artist illustrates book with two color prints based on Greek erotic pottery paintings.

---Felix Labisse---

43-178 DESNOS, ROBERT. Felix Labisse. Les peintres d'imagination. Paris: Sequana, 1945. 31 pp. (text), illus.
Collection of works by Surrealist artist who frequently incorporates sexual imagery in his paintings.

312

43-179 WALDBERG, PATRICK. Felix Labisse. Translated by Simon Watson Taylor. Brussels: Andre de Rache, 1970. 325 pp., illus. (some col.), bib., index.
　　　　Thorough and scholarly overview of the artist's life and his work. Artist frequently utilizes female nudes and sexual symbols.

---Lachaise---

43-180 BAKER, E.C. "Late Lachaise, uncensored at last." Art News 63, no. 1 (March 1964): 44-45+, illus.
　　　　Artist's late work, the most sexual in nature, is now being made accessible to the public.

43-181 GOLDSTEIN, C. "The erotic baroque of Lachaise." Art International 18, no. 8 (1974): 48-49+, illus.

---Tamar Laks---

43-182 "Tamar Laks: The Sixth Estate Gallery, New York." Arts Magazine 50 (January 1976): 29.
　　　　Painter who specializes in the human form featured.

---D.H. Lawrence---

43-183 CREHAN, HUBERT. "Lady Chatterley's painter: the banned pictures of D.H. Lawrence." Art News 55 (February 1957): 38-41+, illus.
　　　　Study of Lawrence's paintings of nudes and couples.

43-184 LEVY, MERVYN, ed. The paintings of D.H. Lawrence. With essays by Harry T. Moore, Jack Lindsay, and Herbert Read. New York: Viking, 1964. 104 pp., illus. (col.).
　　　　Nudes and sex play in later Lawrence paintings from the 1920s and 1930s are examined.

43-185* MILLETT, ROBERT W. The vultures and the Phoenix: a study of the Mandrake Press edition of the paintings of D.H. Lawrence. Philadelphia: Art Alliance Press, 1982. Index, bib.

43-186 TUTEUR, MARIANNE. "Lawrence, D.H. forbidden art." Connoisseur 215, no. 875 (January 1985): 16, illus. (col.).
　　　　Brief article on the history of Lawrence's "obscene" paintings and the only time they were exhibited in 1929.

---Martial Leiter---

43-187* LEITER, MARTIAL. Wanted [Dessins 1401]. Yverdon: Editions des Egraz, 1973. 53 pp., illus.

Individual Artists

—Hans Henrik Lerfeldt—

43-188 THORSEN, JENS JORGEN. Hans Henrik Lerfeldt. Copenhagen,
 1981. 72 pp., illus. (Summary in English.).
 Surrealist illustrator who combines sex and sadomasochistic
 images in his work.

—Darcilio de Paula Lima—

43-189 EVANS, R. BERESFORD. "Erotic metaphysician." Art and Art-
 ists 6, no. 7 (November 1971): 38-39, illus.
 Exhibition review for Brazilian artist Lima, some of whose work
 is erotic.

—Richard Lindner—

43-190 ASHTON, DORE. Richard Lindner. New York: Abrams, ca. 1968.
 217 pp., bib., illus. (some col.).
 "Cold" eroticism of Lindner's semi-naked and nude figures dis-
 cussed.

43-191 DIENST, ROLF-GUNTER. "Richard Lindner." Translated by Mich-
 ael Werner. Art and Artists 5, no. 2 (August 1970): 54-57, por.,
 illus. (some col.).
 Lindner often uses machine-like female figures in his work.

43-192 _____. Lindner. Translated by Christopher Cortis. New York:
 Harry N. Abrams, n.d. 21 pp. (text), bib., illus. (some col.).
 Study of Lindner includes his paintings of figures.

43-193 GORSEN, PETER. "Der Sexualfetisch als Ikone der Versagung; zu
 dem Arbeiten Richard Lindners." In Richard Lindner. Zurich:
 Kunsthaus, 1974, 28-39.
 Essay postulates that Lindner's erotic symbolism reflects sub-
 limation and repression of sexuality in capitalist society.

43-194 KRAMER, HILTON. "Lindner's ladies." Playboy (March 1973):
 96-101, illus. (col.).
 Selection of Lindner's female nude paintings.

—Norman Lindsay—

43-195 LINDSAY, NORMAN. Siren and Satyr: the personal philosophy of
 Norman Lindsay. Introduction by A.D. Hope. Melbourne: Sun
 Books, 1976. 80 pp., illus.
 Artist takes themes from Greek myths, especially those con-
 cerning sexual activity.

43-196 PRUNSTER, URSULA. "Norman Lindsay and the Australian Renaissance." In Australian art and architecture: essays presented to Bernard Smith, edited by A. Bradley and T. Smith, 161-76, illus.
Study of the work of Lindsay including his erotic illustrations.

---Rene Magritte---

43-197 ESSERS, V. "Rene Magritte: Das Vergnuegen und Der bedrohte Moerder." Pantheon 36, no. 4 (1978): 339-49, illus. (Summary in English.)
Sadism and eroticism from paintings of 1927 with sexual murder theme popular with Surrealists.

---Aristide Maillol---

43-198 CHARBONNEAUX, JEAN. Maillol. Paris: Les Editions Braun, 1947. 12 pp. (text), illus.
Catalog of his female nudes.

43-199 HOPHOUSE, J. "Reverence and eroticism." Art News 75, no. 3 (March 1976): 36-38, por., illus.
Review of an exhibition of Maillol's work emphasizing the artist's love of the naked female form.

43-200 MAILLOL, ARISTIDE. Maillol erotic woodcuts: 135 illustrations. New York: Dover, 1980. 43 pp., illus.
Reproductions of illustrations Maillol produced for several books of classical literature.

43-201 REWALD, JOHN. Maillol. London: Hyperion Press, 1939. 167 pp., bib., figs., illus. (col.).
Study of the diverse art media Maillol worked in, almost all of which were utilized to depict the female nude.

---Malevich---

43-202 BETZ, MARGARET. "Malevich's nymphs: erotica or emblem?" Soviet Union 5, no. 2 (1978): 204-24, illus.
Study of the meaning of a small painting of nymphs; author denies there is any eroticism in it.

---Hilda Maron---

43-203* CIRCULO ONCE. "Plastic eroticism of Hilda Maron." Connexion 3 (Winter 1982): 26.

---Reginald Marsh---

43-204 COHEN, MARILYN. Reginald Marsh's New York: paintings, drawings, prints and photographs. New York: Whitney Museum of American Art, 1983. 115 pp., illus. (some col.), bib.

Individual Artists

Catalog survey of Marsh's work, includes discussion of the eroticism in his art.

---Andre Masson---

43-205 BURR, JAMES. "Labyrinthine sexuality." Apollo 126, no. 307 (September 1987): 220, illus.
 Short note on Masson's Surrealist eroticism.

43-206* POLING, CLARK. "Sexuality, death, and the loss of self: the collaborative work of Andre Masson and Georges Bataille." Paper delivered at the College Art Association Meeting (Dallas, Texas), 13 February 1988.

---Henri Matisse---

43-207 HOBHOUSE, JANET. "Odalisques; what did these sensuous images really mean to Matisse?." Connoisseur, January 1987, 60+, illus. (col.), por.
 Considers the numerous odalisques painted by Matisse, including discussing their eroticism.

---Ferenc Maurits---

43-208 MAURITS, FERENC. Piros Frankenstein [Az Eloszot Irta Oto Bihalji-Merin Nemetbol Forditotta Brasnyo Istvan]. Ujvidek: "Forum," 1970. 106 pp., illus. (some col.).
 Drawings with a brutal, yet childlike nature, some of which are sexual in content.

---Rachel Menchior---

43-209* MENCHIOR, RACHEL. Dessins erotiques. Paris: Losfield, 1971. Ill. (some col.).
 Art book of erotic drawings by French Surrealist.

---Henry Miller---

43-210 JOUFFROY, ALAIN. "Henry Miller et Toledo." Opus International 13-14 (November 1969): 68-69, illus.
 Erotic paintings by Miller featured.

---Maurilio Minuzzi---

43-211* KOCHS, MARITA. "Maurilio Minuzzi: Augenzwinkern und Witz." Sexualmedizin 9, no. 10 (October 1980): 438, illus.

---Amadeo Modigliani---

43-212 HOBHOUSE, JANET. "The world, the flesh, and Modigliani." Connoisseur, July 1985, 42-49, illus. (some col.), por.

Consideration of Modigliani's nudes, including discussion of their eroticism.

---Henry Moore---

43-213 ARMSTRONG, DOROTHY. "Henry Moore: the sensuous imagination." Cambridge Journal 9, no. 2 (1980): 143-54, illus.
Study of the sensual aspects of Moore's work.

43-214 NEUMANN, ERICH. The archetypal world of Henry Moore. Translated by R.F.C. Hull. New York: Pantheon, 1959. 138 pp., bib., illus.
Includes an examination of the eroticism in Moore's work.

---Edvard Munch---

43-215 DOBAI, J. "Randbemerkungen zum Thema der Erotik bei Munch und einigen Zeitgenossen." In Edvard Munch: Probleme, Forschungen, Thesen, edited by H. Bock and G. Busch, 77-98, illus. Munich: Prestel, 1973.

43-216 MOEN, ARVE. Edvard Munch. Oslo: Norsk Kunstreproduksjon, 1957. Illus. (col.), bib.
Study of eroticism and nudity in works by Munch.

43-217* VALKONEN, A. "Erotika ja Kuolema" [Eroticism and death]. Taide 16, no. 2 (1975): 28-35, illus.

---Mel Odom---

43-218 ODOM, MEL. Dreamer. Introduction by Edmund White. New York: Penguin, 1984. 96 pp., illus. (some col.).
Sensual, hedonistic images focusing on male faces and half figures.

---Arthur Okamura---

43-219* KOWIT, STEVE. Passionate journey: poems & drawings in the erotic mood. N.p.: City Miner Books, 1984. 88 pp., illus.

---Georgia O'Keefe---

43-220 SPALDING, LAURA H. "Sexual symbolism, feminity, and feminism in the painting of Georgia O'Keefe." M.A. thesis, Northern Illinois University, DeKalb, ca. 1985.

---Claes Oldenburg---

43-221 CLARIDGE, ELIZABETH. "Aspects of the erotic--1: Warhol, Oldenburg." London Magazine 15, no. 1 (February-March 1976): 94-101, illus.
Includes examples of Oldenburg's erotic drawings.

43-222 OLDENBURG, CLAES. <u>Claes Oldenburg, an exhibition of recent erotic fantasy drawings</u> [4 November-6 December 1975]. Introduction by Richard Morphet. London: Mayor Gallery, 1975. 27 pp., illus.

43-223 "Oldenburg's erotic fantasy drawings: Mayor Gallery." <u>Art International</u> 19, no. 10 (December 1975): 25.
Criticism of an exhibition held in London.

43-224 PETERSBURG PRESS. "Claes Oldenburg." <u>Arts Magazine</u> 50, no. 3 (November 1975): 13-14, illus.
Review of an exhibition of erotic drawings held in London.

---Pat Oleszko---

43-225 MCNIFF, VERONICA. "Cold turkey and other larger-than-life city birds." <u>Nova</u>, April 1974, 70-73, illus. (col.).

---Paul Parce---

43-226 "Felt sculpture." <u>Oui</u>, August 1974, 97-109, illus.
Erotic soft sculpture by Paul Parce is featured.

---Pascin---

43-227 WERNER, A. "Lawrence and Pascin." <u>Kenyon Review</u> 23 (Spring 1961): 217-28, illus.
Appreciation of the paintings of Pascin, especially works showing lounging young females.

---Terry Pastor---

43-228 PASTOR, TERRY. "The joy of pain." <u>Penthouse</u> 8, no. 2 (October 1976): 79-83, illus. (col.).
Images of sadomasochism and pain in paintings by German artist.

---G.L. Pauly---

43-229 PAULY, G.L. <u>The weird sexual fantasies of G.L. Pauly: reproductions from original watercolor paintings</u>. Los Angeles: Diverse Industries, 1978. Unpaged, illus. (col.).
Reproductions of folk art style work of California artist.

---Raymond Peynet---

43-230* PEYNET, RAYMOND. <u>Les amoureux de Peynet</u>. Paris, 1963. 96 pp.

---Pablo Picasso---

43-231* BLOCK, G. Picasso. Vol. 4, Catalogue of the printed graphic work 1970-1972. Supps. 1-2. Berne: Kornfeld and Klipstein, 1979. 254 pp., illus.
 Catalog of work from one of Picasso's productive periods of erotic art.

43-232 CROMMELYNCK, ALDO, and CROMMELYNCK, PIERO. Picasso: 347 gravures: 13/3/68-5/10/68. London: I.C.A., 1968. Unpaged, illus.
 Catalog of exhibition of Picasso prints, some of which are erotic.

43-233 "Erotica at 87." Time 93 (31 January 1969): 66, illus.
 Review of exhibition of late Picasso engravings with erotic themes.

43-234 GAGNEBIN, MURIELLE. "Erotique de Picasso." Espirit (France) 1 (1982): 71-76, illus.
 Survey of Picasso's erotic works since the 1930s.

43-235 GALASSI, S.G. "Picasso's The Lovers of 1919." Arts 56 (February 1982): 76-82, illus.
 Iconography and background of synthetic cubist painting.

43-236 HAENLEIN, CARL-ALBRECHT. Pablo Picasso: letzte graphische Blatter 1970-1972 [4-27 May 1979]. Hanover: Kestner, 1979. 133 pp., bib., illus.
 Picasso works from a period in which he concentrated on erotic themes.

43-237* HOLLOWAY, MEMORY. "Eroticism, myth and the bullfight: Picasso's Femme Torero I and Corrida." Art Bulletin of Victoria 22 (1982): 42-51, illus.

43-238 KENNEDY, ROBERT WOODS. "Picasso; a 20th century masque." New Republic 143, no. 3 (18 July 1960): 10-14, illus.
 Theme of the relationship between the sexes in Picasso's work is explored.

43-239 PALAU I FABRE, JOSEP. Picasso: the early years 1881-1907. New York: Rizzoli, 1981. 559 pp., bib., illus. (some col.).
 Includes many of his early erotic works.

43-240 PICASSO, PABLO. "Picasso's erotic gravures" [special theme issue]. Avant Garde 8 (September 1969): unpaged, illus.
 Picasso's erotic prints organized by subject matter.

43-241 _____. 347 graphische Blaetter. New York: Random House, ca. 1969. 25 pp. (text), illus.

Reproductions of Picasso's engravings of 1968, including numerous erotic works.

43-242　PIERRE, JOSE. "Raphael le bienheureux ou le peintre recompense." Opus International 13-14 (November 1969): 70-73, illus.
　　　Collection of Picasso prints from 1968, including many erotic ones.

43-243　POENTE, NELLO; SAGARRA, JOAN DE; and SALVI, SERGIO. Picasso e dintorni: "I Quattro Gatti," il "Modernismo" catalano, Picasso Erotico, (1901-1902). Florence: Palazzo Medici Riccardi, 1979. 95 pp., bib., illus. (some col.).
　　　Exhibition catalog with a selection of Picasso's early erotica.

43-244　ROSENBLUM, ROBERT. "Picasso and the anatomy of eroticism." In Studies in Erotic Art, by Theodore Bowie et al, 339-94, illus. New York: Basic Books, 1970.
　　　Study of Picasso's erotic art and its relationship to works of the Surrealists.

43-245　———. "Picasso's Woman with a Book." Arts Magazine 51 (January 1977): 103+, bib., illus.
　　　Study of one work by Picasso leads to discussion of his treatment of women in his art.

43-246　SCARPETTA, GUY. "Picasso porno." Art Press 122 (February 1988): 26-27, illus.
　　　Brief commentary on five examples of Picasso's erotic prints from the late 1960s and early 1970s.

43-247　SCHEIDEGGER, ALFRED. "Erotik in der bildenden Kunst-Pablo Picasso." In Der Befreite Eros, edited by Anton Grabner-Halder and Kurt Luthi, 165-75. Mainz: Mathias Grunewald, 1972.
　　　Study of Picasso's erotic art.

43-248　SCHIFF, GERT. "Picasso's Suite 347, or paintings as an act of love." In Woman as sex object: studies in erotic art, 1730-1970, edited by Thomas B. Hess and Linda Nochlin, 238-53, illus. New York: Newsweek, 1972.
　　　Study of one set of Picasso erotic prints.

43-249　SCHWEBEL, HORST. "Eros und Kreuzigung bei Picasso." Kunst und Kirche 2 1987: 120-23, illus. (some col.).
　　　Consideration of the crucifixion image in several Picasso paintings and drawings; notes the eroticism expressed in those works.

43-250*　SELVAGGI, GIUSEPPE, ed. Erospicasso. Le Venti Incisioni Proibite. Rome: Bonavita, 1972. 31 pp., illus.

43-251　SMITH, L.E. "Iconographic issues in Picasso's Woman in the Garden." Arts 56 (January 1982): 142-47.
　　　Iconography of a 1930s metal sculpture.

43-252* SUBIRANA, ROSA MARIA, and BONET, BLAI. Picasso Erotic [27 February-18 March 1979]. Barcelona: Museo Picasso, 1979. 44 pp., bib., index, illus.
 Catalog of erotic drawings, prints, and collages.

43-253* TOMKINS, CALVIN. "Late Picasso." New Yorker 60 (16 April 1984): 128+.
 Review of exhibition at the Guggenheim that includes some erotic prints.

---Georges Pichard---

43-254* BOURGEOIS, M. Oeuvre erotique de G. Pichard. Grenoble: Glenat, 1981. 160 pp., illus.
 Works by French artist of sexually explicit erotic illustration.

---Suzan Pitt---

43-255* WASSERMAN, H. "Animated erotica of Suzan Pitt." Alternative Media 13, no. 2 (Spring 1982): 36.

---Jean-Marie Poumeyrol---

43-256 BORDE, RAYMOND. Dessins erotiques de Jean-Marie Poumeyrol. Edited by Eric Losfeld. Paris: Le Terrain Vague, 1972. 80 pp., illus. (col.).
 Essay followed by a portfolio of the surreal, sensual, ornate, and erotic scenes by Poumeyrol, mostly of seminaked young women in sexual situations.

43-257 POUMEYROL, JEAN-MARIE. "Poumeyrol; a surrealistic portfolio." Penthouse, June 1980, 76-85, illus. (some col.).
 Works by Poumeyrol reproduced.

---Fernando Puma---

43-258 PUMA, FERNANDO. Love, this horizontal world. N.p., 1948. Unpaged, illus.
 Collection of cartoon-like drawings.

---Carol Rama---

43-259 BRIZIO, G.S. "Carol Rama." D'Ars 22, no. 97 (December 1981): 144-47, illus., bib.
 Rama, born in 1918, has included erotic elements in her art throughout her career.

---Mel Ramos---

43-260 CLARIDGE, ELIZABETH. The girls of Mel Ramos. Chicago: Playboy Press, 1975. 158 pp., bib., index, illus. (some col.).
 Pop art featuring female figures by Ramos examined.

Individual Artists

43-261* _____. "Mel Ramos: sex appeal and the product." London Maga-
zine, June-July 1975, 83-86, illus.

43-262 TRUEWOMAN, HONEY. "Realism in drag." Arts 48, no. 5 (Febru-
ary 1974): 44-45, illus. (some col.).
Focuses on those Ramos paintings in which he mimics famous
historical works of art but uses pinup-type nudes.

---Ernst Reischenbock---

43-263* MUELLER-THALHEIM, W.K. "Sexus und Religion : der Maler Ernst
Reischenbock." Confinia Psychiatrica 15, no. 1 (1972): 91-98,
illus.

---Rodin---

43-264 BORDEAUX, J.L. "Some reflexions on Rodin's The Kiss." Gazette
des Beaux Arts, 6th ser., 86 (October 1985): 123-28, bib., illus.
Study of the meaning of the statue and possible historical
sources.

43-265* GARIFF, DAVID M. "The amorous sculpture of August Rodin: a
study in sensuality." M.A. thesis, Arizona State U, 1980.

43-266 NADELMAN, CYNTHIA. "Auguste Rodin's late, erotic drawings."
Drawing 9, no. 5 (January-February 1988): 97-100, illus.
Discussion of the erotic female nude drawings produced toward
the end of Rodin's life.

43-267* SOLLERS, PHILIPPE, and KIRILI, ALAIN. Rodin: dessins ero-
tiques. Paris: Gallimard, 1987. 109 pp., illus. (col.).
Catalog of erotic drawings.

43-268 SUTTON, DENYS. Triumphant Satyr: the world of Auguste Rodin.
London: Country Life, 1966. 149 pp., index, illus. (some col.).
Study of artist includes the erotic elements in his work.

---Jose Rodrigues---

43-269 SENA, JORGE DE. Transformacoes e metamorfoses do sexo.
N.p.: So Oiro do Dia, ca. 1980. Unpaged, illus.
Portfolio, with introductory text, of black and white "silhou-
ette" images of an erotic nature.

---Rotella---

43-270* TRINI, TOMMASO. Rotella. Milan: Prearo, 1974. 206 pp., bib.,
illus.
Survey of artist's work includes his erotic pieces.

---David Salle---

43-271 FERNANDES, JOYCE. "Exposing a phallocentric discourse: images of women in the art of David Salle." New Art Examiner 14 (November 1986): 32-34.
 Feminist criticism of Salle's depiction of women.

43-272 HEARTNEY, ELEANOR. "David Salle: impersonal effects." Art in America 76, no. 6 (June 1988): 120-29+, illus. (col.).
 Includes discussion of the sexual aspects of Salle's work.

43-273* MILLET, C. "David Salle: la peinture que le regard." Art Press 89 (February 1985): 18-21, illus.
 Assessment of Salle's style and its sources. Discusses the sexual imagery in his work.

43-274 STORR, ROBERT. "Salle's gender machine." Art in America 76, no. 6 (June 1988): 24-25, illus.
 Critical evaluation of the work of David Salle, especially his use of female images largely culled from pop culture sources.

---Gareth Sanson---

43-275 STURGEON, G. "Gareth Sanson: a re-ordered reality." Art and Australia 15, no. 2 (December 1977): 187-95, illus. (some col.).
 Australian artist frequently works with hermaphroditic figures and sexual themes.

---Antonio Saura---

43-276 LAMBERT, JEAN-CLARENCE. "La chambre argent." Opus International 13-14 (November 1969): 26-33, illus.
 Examples of erotic photos and paintings by Saura.

---Egon Schiele---

43-277* "Egon Schiele: journal de prison." Art Press 3 (1984): 21, illus.
 Extracts from Schiele's journal written in April and May 1912 during the first month after he was imprisoned for immorality, seduction, and execution of pornographic drawings.

43-278 HOBHOUSE, JANET. "Nudes; the vision of Egon Schiele and Pierre Bonnard." Connoisseur, June 1984, 100-109, por., illus. (some col.).
 In-depth study of the meaning of nudes and eroticism in the work of Schiele and Bonnard.

43-279 SABARSKY, SERGE. "Egon Schiele." Mizue 870 (September 1977): 5-28, illus. (col.).
 Collection of paintings by Schiele including some of his erotic ones.

43-280 SABARSKY, SERGE, and SMECCHIA, MUNI DE. Egon Schiele: ero-
tische Zeichnungen. Cologne: Du Mont, 1982. 90 pp., illus.
Short introductory essay followed by a collection of color re-
productions of Schiele's female nudes.

43-281 TOKUDA, YOSHIHITO. [Egon Schiele: in search of sex identity.]
Mizue 870 (September 1977): 29-44, por., illus. (In Japanese.)
Article focuses on Schiele's interest in human sexuality as ex-
pressed in his art.

---Ronald Searle---

43-282 SEARLE, RONALD. Secret sketchbook: the back streets of Ham-
burg. London: Weidenfeld and Nicholson, 1970. 80 pp., illus.
Reproduction of sketchbook filled with female nudes; some
drawings show women in sex embraces with other women.

---George Segal---

43-283 RUBINFIEN, LEO. "On George Segal's reliefs." Artforum 15, no.
9 (May 1977): 45-46, illus.
Mention made of the erotic aspects of Segal's work.

---Penny Slinger---

43-284* DUFF, EVAN. "Penny Slinger, Angela Flowers Gallery." Guardian,
11 July 1973, 8, illus.

43-285* "The erotic art of Penelope Slinger." Alpha, 1973, 16-19, illus.

43-286* FULLER, P. "Penelope Slinger: opening, Angela Flowers Gallery."
Connoisseur, September 1973, 72, illus.

43-287* MULVEY, LAURA. "Laura Mulvey looks into Penelope Slinger."
Spare Rib 17 (1973): 37-38, illus.

43-288 WILLIAMS, SHELDON. "Penny Slinger's life." Art & Artists 8,
no. 8 (November 1973): 44-47, illus.
Analysis of trends in the artist's work.

---John Sloan---

43-289 BAKER, JOHN. "Erotic spectacle in the art of John Sloan: a study
of the iconography, sources and influences of a subject matter
pattern." M.A. thesis, Indiana University, Bloomington, 1972.
256 pp., bib., illus.
Study of some themes in Sloan's paintings.

---Hajime Sorayama---

43-290 SORAYAMA, HAJIME. Pin-up. Cologne: Taschen Comics, 1985.
Unpaged, illus. (col.). (Originally in Japanese, published by Gra-
phic-Sha Publications.)
Collection of airbrush superrealistic images of women.

---Dan Sterup-Hansen---

43-291 WIVEL, OLE. Mand Kvinde. Drawings by Dan Sterup-Hansen.
Verlose: Grafoden, 1980. Unpaged, illus.
Erotic drawings of a couple at sex play accompany collection of
poems.

---Jon Stevens---

43-292* "Le robots erotiques de Jon Stevens." Zoom 17 (March-April
1973): 58-67, illus.

---Jean-Pierre Stholl---

43-293 STHOLL, JEAN-PIERRE. Dessins erotique. Paris: Losfield,
1971. 112 pp., illus.
Erotic drawings by a modern surrealist artist.

---James Strombotne---

43-294 DUNHAM, JUDITH L. "James Strombotne's erotica." Art Week 5,
no. 30 (14 September 1974): 5, illus.
Review of exhibition of drawings at the Museum of Erotic Art.

---Franz von Stuck---

43-295 VOSS, HEINRICH. Franz von Stuck, 1863-1928. Werkkatalog der
Gemalde mit einer Einfuhring in seinen Symbolismus. Mat. zur
Kunst des 19 Jhr., vol. 1. Munich: Prestel, 1973. 323 pp., illus.
(some col.), intro.
Focuses on the erotic symbolism in von Stuck's work.

---Tabuchi---

43-296 MOULIN, RAOUL-JEAN. "Les images sexuees de Tabuchi." Opus
International 13-14 (November 1969): 86-88, illus.
Japanese artist Tabuchi featured.

---Pavel Tchelitchew---

43-297* HAMPTON, THANE. "The Divine Comedy of Pavel Tchelitchew."
Gay, 11 October 1971, 8-9+.

Individual Artists

---Andre Theroux---

43-298* THEROUX, ANDRE. Eros: d'Andre Theroux. Text revised by
Francoise Saint-Michel and Bill Bantey. Montreal: Musee des
Beaux-Arts, ca. 1976.
 Exhibition catalog.

---Tom of Finland---

43-299* The best of Tom of Finland. Appreciation by Orsen. Los Angeles:
A.M.G. Studios, ca. 1970.
 Survey of the work of the most famous illustrator of male homo-
sexual erotica.

43-300* REED, DAVID. "Repression and exaggeration: the art of Tom of
Finland." Christopher Street 4, no. 8 (April 1980): 16-21.

---Jacque-Adrien Tremble---

43-301 GAGNON, CLAUDE-LYSE. "Jacque-Adrien Tremble: un erotisme
discreet." Vie des Art 74 (Spring 1974): 66-67+, illus. (With
English translation).
 Abstract paintings with nude figures and lovers described and
discussed.

---Clovis Trouille---

43-302 CAMPAGNE, JEAN-MARC. Clovis Trouille. Paris: Pauvert, 1969.
142 pp., illus. (some col.).
 Surrealist painter who includes some sexual imagery in his
work is featured.

43-303* KUSAN, F. "Religion, Sex och Dod." Palatten (Sweden) 1 (1978):
6-9.
 Survey of Trouille's work.

---Tomi Ungerer---

43-304 UNGERER, TOMI. Fornicon. Introduction by John Hollander.
New York: Grove, 1969. Unpaged, illus.
 Picture book of Ungerer's fantasy sex machines.

43-305 _____. The party. New York: Paragraphic Books, 1966. Un-
paged, illus.
 Satiric cartoons of a party where erotic activity sometimes
takes place.

43-306 _____. "Tomi Ungerer's girls." Evergreen Review 11, no. 47
(June 1967): 55-60, illus.
 Ungerer's drawings of seminude women.

43-307* _____. Totempole: erotische Zeichnungen, 1968-1975. Zurich: Diogenes, 1976. 110 pp., illus.
Collection of Ungerer's erotic drawings from the years 1968 to 1975.

43-308 _____. The underground sketchbook of Tomi Ungerer. Preface by Jonathon Miller. New York: Viking, 1964. Unpaged, illus.
Typical examples of Ungerer's fantasy cartoons, some of which are sexual in nature.

---Sergio Vacchi---

43-309* VACCHI, SERGIO. Le piscine lustrali de Sergio Vacchi. Essay by Alfonso Gatto. Bologna: Bora, [1974]. 141 pp., bib., illus. (some col.). (Essay also in English.)

---Nicolaus Vadasz---

43-310* ANONYMOUS. Tableaux vivants: 15 erotic tales. Drawings by Nicolaus Vadasz. London: Council of the Erotika Biblion Society, 1870. 116 p., pref., illus. Reprint. New York: Grove, 1969.

---Boris Vallejo---

43-311* VALLEJO, DORIS. Enchantment. Illustrations by Boris Vallejo. New York: Ballantine, 1984. 107 pp., illus. (some col.).

43-312 _____. Mirage. Illustrations by Boris Vallejo. New York: Ballantine Books, 1982. 90 pp., illus. (some col.).
Eroto-fantasy images, very strongly sexual without being explicit.

---Alberto Vargas---

43-313* VARGAS. Varga: the Esquire years: a catalogue raisonne. Foreword by Kurt Vonnegut. New York: Alfred van der Marck Editions, 1987. 176 p., ill. (col.).

43-314 VARGAS, ALBERTO, and AUSTIN, REID. Vargas. New York: Harmony Books, 1978. 128 p., intro., ill. (some col.).
Study of the life and artistic development of famous pin-up artist.

---Marcel Vertes---

43-315* VERTES, MARCEL. The erotic perceptions of Marcel Vertes. Introduction by M. Gloser. Los Angeles: Art Editions, 1972.
Erotic engravings by early twentieth-century artist.

Individual Artists

---Vigeland---

43-316 ARNAUD, J.-R. "Eros and Thanatos." Cimaise 28, no. 151 (April-
 June 1981): 19-26, illus.
 Norwegian sculptor's work in Frogner Park, Oslo are featured,
 some with a decidedly erotic quality.

---Hugh Weiss---

43-317 PRADEL, J.-L. "Hugh Weiss." Opus International 59 (May 1976):
 56-57, illus.
 Fantasy painter who sometimes creates erotic imagery.

---Tom Wesselmann---

43-318 GARDNER, PAUL. "Tom Wesselmann: 'I like to think that my work
 is about all kinds of pleasure'." Art News 81, no. 1 (January
 1982): 67-72, illus. (some col.).
 Interview with artist includes consideration of the erotic ele-
 ment in his art.

43-319 SWENSON, G.R. "Wesselmann: the honest nude." Art and Artists
 1, no. 5 (May 1966): 55-57, illus. (some col.).
 Study of Wesselmann's use of nudes in his work.

43-320* WESSELMANN, TOM (pseudonym Slim Stealingworth). Tom Wessel-
 mann. New York: Abbeville Press, 1980. 321 pp., illus. (some
 col.), index, bib.
 Overview of Wesselmann's work, including his Pop sexual
 images.

43-321 _____. Tom Wesselmann: graphics 1964-77: a retrospective of
 work in edition form. Introduction by Trevor Fairbrother. Bos-
 ton: ICA, 1978. 20 pp., illus. (some col.).
 Catalog of Wesselmann's most blatantly sexual images.

---Joyce Wieland---

43-322* CREAN, SUSAN. "Forbidden fruit: the erotic nationalism of Joyce
 Wieland." ThisMagazine 21, no. 4 (August-September 1987): 12-
 20, ill.

---Hannah Wilke---

43-323 SAVITT, M. "Hannah Wilke: the pleasure principle: Ronald Feld-
 man Fine Arts Gallery, New York." Arts 50, no. 1 (September
 1975): 56-57, illus.
 Wilke concentrates on vaginal images in her art, often with a
 sense of humor. Reviews a show of her work.

---Claire Wilks---

43-324* WILKS, CLAIRE WEISSMAN. Tremors. Introduction by William
Ronald. Toronto: Exile Editions, 1983. 31 pp., illus.

--Paul Wunderlich---

43-325 GIESE, HANS. "Das obszone Bild (Beispiel Paul Wunderlich)."
Beitrage zur Sexualforschung 38 (1967): 1-10. (Summary in Eng-
lish.)
Psychiatric look at the "obscene" in art, using Wunderlich as an
example.

43-326 JOUFFROY, ALAIN. "L'Arriere-pensee de Wunderlich." XXe Sie-
cle, n.s. 39, no. 48 (June 1977): 16-21, illus. (some col.).
Fantasy images by Wunderlich reproduced.

43-327 "Paul Wunderlich's painted women." Avant Garde, March 1969,
24-31, por., illus. (some col.).
Photos of the artist and his models along with his erotic art.

43-328 PIERRE, JOSE. "Paul Wunderlich et Erotisme Contemplatif."
Opus International 13-14 (November 1969): 92-95, illus.
Examples of the erotic art of Wunderlich.

43-329 RADDATZ, FRITZ J. Homo Sum: 34 Zeichnungen von Paul Wunder-
lich. Munich: R. Piper, 1978. 22 pp. (text), illus. (some col.).
Catalog of prints of lesbians and homosexuals.

43-330* WUNDERLICH, PAUL. Werkverzeichnis der Gemalde 1957-1978.
Introduction by Jens Christian Jensen. Offenbach am Main: Edi-
tion Volker Huber, 1979.

43-331 WUNDERLICH, PAUL, and SZEKESSY, KARIN. Correspondenzen.
Stuttgart: Raddatz, 1977. 128 pp., illus. (some col.).
Catalog of Wunderlich paintings and the photos from which
they were derived.

43-332* _____. Transpositions. Introduction by Fritz J. Raddatz. Lon-
don: Academy, 1980.

---Rita Yokoi---

43-333 BALLATORE, SANDY. "Sex objects as art." Art Week 5, no. 29 (7
September 1974): 7, illus.
Review of show of Yokoi's mixed media constructions at the
David Stuart Galleries in Los Angeles.

---Katsu Yoshida---

43-334* YOSHIDA, KATSU. High coup. Tokyo: Kodansha; U.S. distribu-
tion by Harper & Row, 1985. 319 pp., ill. (some col.).

Individual Artists

---Inoue Yosuke---

43-335* YOSUKE, INOUE. Inoue Yosuke Gashu. 1971. 64 pp., illus.
 Modern Japanese erotic artist.

43-336* [YOSUKE, INOUE.] Inoue Yosuke no Sekai. 1974. 127 pp., illus.

---Sasaki Yutaka---

43-337* AIKO, K. "Sasaki Yutaka's rhetoric." Graphic Design (Japan),
 no. 72 (December 1978): 55-62, illus.
 Examples of paintings and drawings by this Japanese artist.

---Badanna Zack---

43-338 FLEISHER, P. "Conversations with Badanna Zack: a female view
 of sexuality." Art Magazine 7, no. 24 (December 1975): 24-25.
 Interview with artist who works with erotic imagery.

---Zaragoza---

43-339* KLINTOWITZ, JACOB. Zaragoza. Sao Paulo, Brazil, 1980. 199
 pp., illus. (some col.).

Chapter 44
Photography

Early photographers were strongly influenced by trends, both stylistic and thematic, in mid-nineteenth century painting, including the use of the nude female as a subject. That emphasis on the nude figure posed in an "arty" setting, together with the adoption of the postcard as a postal format and a growing market for inexpensive erotic images in the latter half of the nineteenth century ensured that the nude would become a staple of the standard reportoire of photography to the present day. It is, indeed, difficult to find a photography publication or exhibition that does not include nudes. While nude human figures need not be considered in sexual terms, the fascination with nudes suggests that eroticism plays a significant role in the history of photography.

It appears that by the 1870s explicit sexuality was being photographed, quickly provoking public campaigns against the "menace of pornography." Previously, "erotica" produced in traditional artistic media had been available only to a small audience of wealthy collectors, but with photography explicitly sexual images could be widely distributed. This parallel existence of "legitimate (or artistic)" photography of nudes (and other erotic subjects) and the photographic recording of explicit sexual acts has created problems for photographers for many decades, as the latter is often used by the forces of censorship to restrict or discourage the expression of eroticism in the former.

The preponderance of "pornography" is in the form of photographs, a situation that created considerable difficulties in defining the scope of the entries in this chapter of the bibliography. For the most part, the items listed below are either works about erotic photography or collections of works by named photographers. Only publications that were unambiguously presented (in the title, text, advertising, etc.) as discussing or reproducing erotic photography have been included. No effort was made to include the innumerable periodical format publications that have ever displayed nudes or more explicitly sexual images, whether women's glamor magazines, male-oriented periodicals (like <u>Playboy</u> and <u>Penthouse</u>), or "adult materials" publications. Because of the need to define meaningful limits, this chapter has been the most difficult to compile and, consequently, the most selective in the entire bibliography.

Photography

History

The history of erotic photography is almost as old as photography itself (see "The first authochrome nudes" and Jay's "The erotic dawn of photography"). There seem to have always been photographers who sought to explore the theme of eroticism in their work. That there may even be some kind of inherent relationship between the nature of photography and eroticism is an aesthetic/philosophic proposition that has been discussed and debated by many people, especially well-expressed in publications by Claridge, Gallop, Gever, and Phillips.

Surveys of erotic photography typically have the word nude(s) in their titles rather than use terms like erotic, sex, etc., yet most do address the topic of eroticism. It appears that there is a fear that any book emphasizing eroticism too forthrightly might be labelled "pornographic", potentially hurting sales to the large audience of people who appreciate "legitimate" photography. An early survey study of nudes and eroticism in photography is Erich Wulffen's multivolume Die erotik in der photographie published in 1931. Since the mid 1960s well-illustrated surveys have been published by Barns, Goldsmith, Lacey, Lewinski, and Sullivan.

Oddly enough, there seems to be a kind of nostalgic fascination with explicit sexual photographs from the first 100 years of photography (approximately 1840 to the end of World War II). Surveys of the erotic photographs from that period typically consist of short essays offering some level of analysis (some more scholarly than others) followed by extensive catalogs of reproductions, as in the auction catalogs of D.M. Klinger, Aratow's 100 years of erotica, presentations of the Bartosch and the Merkin collections, and entries by Bonhomme, Mendes, Nelson, Ovenden, Stockay, and Walters. Patrice Boussel's Erotisme et galanterie au 19e siecle is more analytical than most, since it is organized by the various visual themes expressed by those early photographs. Other than in commentaries on "pornography," almost no serious analytical study has focused on more contemporary sexually explicit photography, with one possible exception being Coleman's discussion of the increasing explicitness seen in exhibited photography of the mid-1970s.

How-to Guides

So many photographers are interested in dealing with nudes in their work, if not outright eroticism, that many how-to guides have been written. In some cases these books are thinly disguised excuses to display numerous erotic photographs, but many are written by respected professionals who discuss the technical and psychological aspects of this photographic specialty. Only Barry's The art of erotic photography really emphasizes the expression of eroticism and sexuality.

Anthologies

Modern erotic photography is typically presented in the form of exhibition catalog format anthologies. Such anthologies offer little text, but include selections of images by named photographers. These may range in quality, the best offering distinctly diverse approaches to the erotic by highly skilled professional photographers. A recently established glossy

periodical, Collector's photography, uses this anthology format to provide a continuing outlet for high quality reproductions of the most contemporary photographers of the female nude (and also has articles on historical material).

Individual Photographers

While it may be true that virtually every photographer has done a nude study at some point in their career, only a small portion of them have sought to emphasize eroticism. The individual photographers listed in this chapter were included because the publications compiled presented their work as being erotic (or were considered such by reviewers and critics). Many of the names are well known as specialists in other areas of photography, such as portrait or glamor photography. There are a few photographers who concentrate on erotic photography, but the limited market for such images precludes making a full-time career of it.

Historical Surveys

44-1 Antique porn: a loving look at the way they were." Hustler 7, no. 1 (May 1981): 51-53, illus.
 Late nineteenth- and early twentieth-century erotic photos shown.

44-2* Ansichten vom Korper: Das Aktfoto 1939-1987. 208 pp., illus.

44-3 ARATOW, PAUL. 100 years of erotica: a photographic portfolio of mainstream American subculture from 1845-1945. San Francisco: Straight Arrow Books, 1973. Unpaged, illus.
 Examples of erotic photographs from the first century of photographic history.

44-4 BARNS, LAWRENCE, ed. The male nude in photography. Introduction by Marcuse Pfeifer. Waitsfield, Vt.: Vermont Crossroads Press, 1980. 96 pp., illus. (Expanded version of The male nude, a survey in photography, exhibition catalog for the Marcuse Pfeifer Gallery in New York, 1978.)
 Study of the male nude in the history of photography.

44-5 BARTOSCH, GUNTER. Der Akt von Damals: der Erotik in der fruhen Photographie: aus der privaten Sammlung Ernst und Gunter Bartosch. Munich: Herbig, 1976. 195 pp., illus.
 Collection of early photographs of nude females in the Bartosch collection.

44-6 BONHOMME, JACQUES. L'Art erotique (voluptes sensuelles). Reprint. Paris: L'Or du Temps, 1970. 96 pp., illus.
 Catalog of erotic photographs from the turn of the century.

44-7 BOUSSEL, PATRICE. Erotisme et galanterie au 19e siecle. Paris: Berger-Levrault, 1979. 101 pp., illus.

Introductory text on the history of eroticism in nineteenth-century photography, followed by illustrations organized by theme.

44-8 CARLYLE-GORDGE, PETER. "An erotic error that titillates." MacLeans 93, no. 26 (30 June 1980): 19-20, illus.
 Story of a court case involving a photograph depicting cunnilingus exhibited by Richard Nigro of Ottowa.

44-9* CELATI, GIANNI, and GAJANI, CARLO. Il chiodo in testa. Pollenza: La Nuova Foglio, ca. 1975. 167 pp., illus.

44-10 CLARIDGE, ELIZABETH. "Aspects of the erotic." London Magazine 16 (April-May 1976): 101-104, illus.
 Erotic potential of the nature of photography is discussed in a review of a London exhibition of Helmut Newton's work.

44-11 COLEMAN, A.D. "Erotica: the arrival of the explicit." Camera 35 24, no. 9 (September 1979): 20-35, illus. (some col.).
 Description of the current trend toward explicit sexuality in late 1970s photography.

44-12 COLLINS, K. "Photography and politics in Rome: the Edict of 1861 and the scandalous montages of 1861-62." History of Photography 9 (October-December 1985): 295-304, illus.
 In 1860s an office was set up to register and effectively censor photographs, largely because of politically critical montages showing images of penis' and Francis II, King of Naples.

44-13 CZARNECKI, JOSEPH. "The erotic eye." Art Week 6, no. 4 (25 January 1975): 12-13, illus.
 Review of show entitled "Erotica" at the Lamkin Camerawork Gallery.

44-14* DICKERSON, J.A. "Boudoir portraiture." Petersens Photography Magazine 14 (March 1986): 18-21, illus.
 Report on the popularity in the 1980s of provocative portraits commissioned not by trained models or entertainment business professionals, but by ordinary people; includes technical how-to information.

44-15* DOWD, M. "Hot shots; why nice girls take off their clothes." Mademoiselle 93 (September 1987): 205-206+, ill.
 On the popularity of boudoir photography.

44-16 "The first autochrome nudes." Camera 35 24, no. 9 (September 1979): 63-65, illus. (col.).
 Four examples are illustrated of the work of Georges Belagny & Paul Bergon.

44-17 GALLOP, JANE. "The pleasure of the phototext." Afterimage 12, 9 (April 1985): 16-18.
 Essay based on the ideas of Roland Barthes concerning the nature of sexuality and photography.

44-18 GEVER, MARTHA. "Neurotic erotic: debating art and pornography." Afterimage 10, nos. 1-2 (Summer 1982): 5.
 Description of a conference on photography and pornography in New York City sponsored by the International Center for Photography.

44-19 GOLDSMITH, ARTHUR. The nude in photography. Chicago: Playboy Press, 1975. 253 pp., illus. (some col.).
 Historical survey and visual diversity of the nude in photography featured in lavishly illustrated book.

44-20* HEDGECOE, JOHN. Nude photography. New York: Simon & Schuster, 1984. 224 pp., illus. (some col.).

44-21* JAY, BILL. "The erotic dawn of photography." Image 1, no. 4 (1972): 40-46, illus.

44-22 KLINGER, D[OMINIK] M. The early period of erotic photography and postcards. Vol. 5. Nuremburg: DMK, 1984. 111 pp., illus., bib.
 Short essays on the history of the erotic postcard and early photographic technology precede 603 reproductions.

44-23 _____. The early period of erotic photography 1900-1950. Vol. 17. Nuremburg: DMK, 1987. 119 pp., illus.
 Auction catalog of 623 images.

44-24* _____. Die erotische Fotografie in den 50er Jahren: aus der Sammlung eines Olmagnaten. Nuremburg: DMK, scheduled for publication in 1987. Illus.

44-25* _____. Die Fruhzeit der erotischen Fotografie 1880-1935: aus der Sammlung S. Baltimore, USA, sowie aus einer Wiener Sammlung. Nuremburg: DMK, scheduled for publication in 1987. Illus.

44-26 _____. Die Fruhzeit der erotischen Fotografie 1900-1950. Vol. 6. Nuremburg: DMK, 1985. 93 pp., illus.
 Short essay on erotic photography followed by 530 reproductions.

44-27 LACEY, PETER. The history of the nude in photography. New York: Corgi, 1964. 215 pp., illus.
 Historical survey; organized by and places emphasis on the work of certain renowned photographers.

44-28* LEWINSKI, JORGE. The naked and the nude: a history of the nude in photographs 1839-1987. New York: Harmony, 1987. 224 pp., illus. (some col.).

44-29* MARZONI, GIAN FRANCO. Per te Amor Mio: Fotografie. Milan: G. Marzoni and V. Savoldi, 1976. 112 pp., illus.

44-30 MENDES, PETER. "Victorian erotic photography." Creative
 Camera 118 (April 1974): 122-29, illus.
 Study of early erotic photography.

44-31 MERKIN, RICHARD and MCCALL, BRUCE. Velvet Eden: The
 Richard Merkin collection of erotic photography. New York:
 Methuen, 1979, 144 pp., illus. (Representative selections from
 this book were published in Gallery 8, no. 8 [August 1980]: 39-43.)
 Private collection of erotic photographs reproduced.

44-32* NAZARIEFF, SERGE. The stereoscopic nude 1850-1930. Preface
 by Jacques Cellard. Berlin: Taco, 1987. 160 pp., pref., intro.,
 illus. (some col.).
 Stereoscopic photos of female nudes from 1850-1930 featured.

44-33* NELSON, EDWARD J. Yesterday's porno: a pictorial history of
 early stag photographs. 2 vols. New York: Nostalgia Classics,
 1972. 160 pp., illus.
 History of early explicit erotic photographs.

44-34 NICHOLSON, CHUCK. "Erotic Fantasies?" Artweek 13, no. 44 (25
 December 1982): 11, illus.
 Critical review of exhibition of erotic photographs by many a
 number of American photographers at Cameravision in Los Angeles,
 entitled "The Erotic Photography: Contemporary Trends."

44-35* "The Nude and the window." Camera 50, no. 9 (September 1971):
 3-34, illus.

44-36 OVENDEN, GRAHAM, and MENDES, PETER. Victorian erotic pho-
 tography. New York: St. Martin's Press, 1973. 111 pp., illus.
 (some col.).
 Victorian photographs of the female nude discussed and repro-
 duced.

44-37 PHILLIPS, DONNA-LEE, ed. Eros and photography: an explora-
 tion of sexual imagery and photographic practice. San Francisco:
 Camerawork/NFS Press, 1977. 119 pp., bib., illus.
 Collection of essays and contemporary photographs on the
 theme of the erotic in photography.

44-38 La pornographie des annees folles. Paris: Editions L.S.P., 1981.
 Reproductions of turn-of-the-century erotic photos.

44-39 RUSSELL, A.M. "Censuring the censor: a new porno report bodes
 ill for legitimate photography." American Photographer 17 (July
 1986): 19.

44-40 _____. "Sexual devolution: naughty pictures never die, they just
 fade away." American Photographer 19 (September 1987): 16,
 illus., por.

Report on the history of an annual (since 1987) show of erotic photography at Neikrug Photographia in New York.

44-41* Smut from the past. New York: Milky Way, 1974.

44-42* SOBIESZEK, ROBERT. "Addressing the erotic: reflections on the nude photograph." In Nude Photographs 1850-1980, edited by Constance Sullivan. New York: Harper & Row, 1981.

44-43* SOLOMON-GODEAU, ABIGAIL. "Reconsidering photography: notes for a project of historical salvage." Journal: A Contemporary Art Magazine 5, no. 47 (Spring 1987): 53-54.

44-44* STOCKAY, G.G. America's erotic past, 1868-1940 [an annotated collection of erotic photographs in America from the Civil War to today]. San Diego: Greenleaf Classics, 1973. Unpaged, illus.

44-45* SULLIVAN, CONSTANCE, ed. Nude: photographs 1850-1980. New York: Harper & Row, 1981. 203 pp., illus. (some col.).

44-46* TAMBLYN, C. "Images of manipulation." Artweek 17 (1 February 1986): 13, illus.
Review of an exhibition of photos with sexual images at the San Francisco Camerawork gallery.

44-47 THOMAS, S. "Gender and social-class coding in popular photographic erotica." Communication Quarterly 34 (Spring 1986): 103-104, bib.
Research project studying the photos in nine erotica magazines, determining how the presentation of figures vary in terms of social class, gender, and sexual preferences of the readers of those periodicals.

44-48 WALTERS, THOMAS. Nudes of the 20's and 30's. New York: St. Martin's, 1976. 88 pp., illus.
Brief introduction and many photos of nudes from that period.

44-49* WAUGH, T. "Photography passion/power." Body Politic 1, no. 1 (March 1984): 29.

44-50* WULFEN, ERICH, et al. Die Erotik in der Photographie. Die geschichtliche Entwicklung der Aktphotographie und des erotischen Lichtbildes und seine Beziehunger zur Psychopathia Sexualis. Vienna: Kulturforschung, 1931. 252 pp., illus.
Collection of photos of nudes.

44-51* _____. _____. Erganzungsband. Vienna: Kulturforschung, 1931. 128 pp., illus. (some col.).
Supplement to above.

Photography

How-to Guides

44-52 BANKS, IAIN. Classic glamour photography. London: Hamlyn;
Crescent, 1983. 175 pp., illus. (some col.), index.
Professional how-to book with historical perspective.

44-53 BARRY, PETER. The Art of Erotic Photography. New York: Cres-
cent, 1983. 63 pp., illus. (col.).
How-to book emphasizing techniques and issues in erotic photo-
graphy.

44-54* _____. Art of nude photography. New York: Crescent, 198?.

44-55 _____. Techniques of pin-up photography. Text by Roger
Hicks. New Malden: Colour Library International, 1982. 128
pp., illus. (col.).
How-to book on a specialized area of photography, especially
popular in the 1940s and 1950s.

44-56 BIANCANI, LAURENT. Nude photography: the French way. New
York: American Photographic Book Publishing Co., 1980. 160
pp., illus., index.
How-to book on photographing the nude emphasizing techni-
ques popular in Europe.

44-57* BRAVO, M.A., et al. Nude: theory.

44-58 GOWLAND, PETER. The secrets of photographing women. New
York: Crown, 1981. 211 pp., index, illus. (some col.).
How-to book includes section on erotic photography.

44-59* HICKS, ROGER. Practical glamour photography. Illus. (some
col.).

44-60 MATANLE, IVOR. Techniques of photographing the nude. Se-
caucus, N.J.: Chartwell, 1982. 128 pp., illus. (col.).

44-61* WILD, VICTOR. How to make and sell erotic photographs: sec-
rets of the masters. Photos by Michael Kovachevich. Carpin-
teria, Calif.: Wildfire, 1981. 126 pp., illus.

Anthologies

44-62* BAILEY, DAVID. The naked eye: great photographs of the nude.
192 pp., illus.
One hundred and fifty photos surveying the nude in the his-
tory of photography, primarily works by modern masters.

44-63* BENN, TRACY. "Perfect body, perfect production." Camerawork
25 (November 1982).
Photos by Mapplethorpe and Tress.

44-64 BERG, ANDRE. Creature. I libri segreti di photo. Preface by
 Walerian Borowczyk; introduction by Piero Raffaeli. Milan: A & G
 Marco, 1983. Unpaged, illus. (col.).
 Collection of photos of beautiful transexuals.

44-65* CELANT, G. "Les divinites infernales de la photographie chez
 Mapplethorpe et Witkin." Art Press 89 (February 1985): 4-8,
 bib., illus.
 Study of the eroticism in the work of two well-known contem-
 porary photographers.

44-66 CLYNE, JIM, ed. Exquisite creatures. Introduction by Donald
 Barthelme. New York: William Morrow, 1985. Unpaged, illus.
 Collection of nude studies by four photographers: Gilles Lar-
 rain, Robert Mapplethorpe, Deborah Turbeville, Roy Volkmann.

44-67 Collector's photography 1, no. 1 (1986-).
 Magazine dedicated to depicting the work of photographers
 worldwide who specialize in the nude female. Each issue focuses on
 several photographers, providing background information on the pho-
 tographers and their techniques (also includes articles on nineteenth-
 and early twentieth-century photographers). Beginning with issue
 #14 (1988) editorial policy changed the magazine's contents to include
 all areas of art photography.

44-68 Contemporary American erotic photography. Vol. 1. Prestige
 Collection. New York: Melrose, 1984. Unpaged, illus. (some
 col.).
 Samples of the work of about fifteen contemporary photogra-
 phers.

44-69 DEMARIS STUDIO. Erotic photography: an exhibition. Trenton,
 N.J.: Demaris Studio Press, 1981. 102 pp., illus.
 Catalog of exhibition of contemporary erotic art.

44-70* Le dessous de l'erotisme. France: Le Club du Livre Secret.
 Photos of women in lingerie by European photographers.

44-71* Erotik I: der modernen Fotographie. Vol. 1. 216 pp., illus.
 (some col.).
 Works by thrity-five photographers.

44-72* Erotik II. 185 pp., illus.
 Collection of works by thirty-three European photographers.

44-73* Erotische Photographie in Amerika Heute. 128 pp., illus. (some
 col.).
 Eighty photos by fourteen photographers shown.

44-74 "The eye of the beholder: sex appeal through the eyes of eleven
 different photographers." Sunday Times Magazine (2 May 1971):
 50-55, illus.
 Eleven photographers offer their images of sex appeal.

44-75* Girls '86. 230 pp., illus. (some col.).
 Photos by over 150 Japanese photographers.

44-76 Girls in Focus. New York: Crescent Books, 1979. Unpaged, illus.
 (col.).
 Color photos of nude women.

44-77* Die grossen Sexualgeheimnisse in Wort una Bild. 162 pp., illus.

44-78* HALL, L. Lust [21 May-23 June 1983]. Stockholm: Camera Ob-
 scura, 1983. 44 pp., illus.
 Exhibition catalog of erotic photos by thirty-three Swedish
 artists.

44-79* HEUENSTEIN, BETTINA VON, and VERROU, JAN LUE. Softgirls.
 Germany: Zero, ca. 1969. Illus.
 Explicitly sexual photographs.

44-80 HOWELL, JOHN. "The explicity image, Ex Voto Gallery." Art-
 forum 24 (April 1986): 114-15.
 Report on an exhibition of fifty-five erotic photographs from
 the 1880s to the 1960s.

44-81 "Huit photographies autour d'une modele de 18 ans." Photo 45
 (June 1971): 36-43+, illus.

44-82 JENKINS, CHRISTIE. A woman looks at men's buns. New York:
 Perigee, 1980. Unpaged, illus.
 Collection of photos of men's buttocks.

44-83* JONES, TERRY, ed. Private viewing: contemporary erotic photo-
 graphy. London: New Leaf; Sphere, 1983. 215 pp., illus. (col.).

44-84* KANE, ART, et al. Masterpieces of erotic photography.
 Work of twelve famous photographers of the erotic displayed.

44-85* KENNY, LORRAINE. "Rated X." Afterimage 15, no. 5 (December
 1987): 15.
 Exhibition review.

44-86 KLINGER, D[OMINIK] M. Contemporary masters of erotic photo-
 graphy, pt. 1. Vol. 16. Nuremburg: DMK, 1987. 99 pp., illus.
 Auction catalog of works by contemporary European photo-
 graphers.

44-87* Das Klistier. 144 pp., illus.

44-88 LACEY, PETER. Nude photography: the art and technique of nine
 modern masters. New York: Amphoto, 1985. 160 pp., illus. (some
 col.).
 Modern interpretations of the female nude in photography.

44-89 LAURENT, JACQUES. <u>Le nu</u> <u>Francaise</u>. Paris: Editions Jannick, 1982. 79 pp., illus., <u>por.</u>
 Anthology of female nudes by modern French photographers with brief biographies.

44-90* <u>Liebe</u> <u>zu</u> <u>Kaufen</u>. 135 pp., illus.
 Ten European photographers show images of prostitution.

44-91* <u>Love</u> <u>scenes:</u> <u>great</u> <u>moments</u> <u>of</u> <u>passion</u> <u>and</u> <u>tenderness</u>. Chicago: Playboy, 1976. 112 pp., illus.

44-92* <u>Lust</u> <u>mit</u> <u>Genuss</u>. 144 pp., illus.

44-93* "Madchen: vier Meister der erotischen Fotografie." <u>Foto</u> <u>und</u> <u>Film</u> <u>Prisma</u>, September 1970): 386-96, illus.

44-94 MINKKINEN, ARNO RAFAEL, ed. <u>New</u> <u>American</u> <u>nudes:</u> <u>recent</u> <u>trends</u> <u>and</u> <u>attitudes</u>. Rev. ed. Dobbs Ferry, N.Y.: Morgan and Morgan, 1984. 109 pp., illus. (some col.).
 Collection of contemporary photographs of the nude.

44-95 <u>More</u> <u>rear</u> <u>views</u>. New York: Delilah Books, 1984. Unpaged, illus. <u>(some</u> <u>col.)</u>.
 Photograph album of women's buttocks.

44-96 NAUMANN, MICHAEL, et al. <u>Vier</u> <u>Meister</u> <u>der</u> <u>erotischen</u> <u>Foto-</u> <u>grafie:</u> <u>Sam</u> <u>Haskins,</u> <u>David</u> <u>Hamilton,</u> <u>Francis</u> <u>Giacobetti and</u> <u>Kishin</u> <u>Shinoyama</u>. Edited by Christian Diener. Munich: Wilhelm Heyne, 1970. Unpaged, illus. (some col.). (Published in English as <u>Four</u> <u>Masters</u> <u>of</u> <u>Erotic</u> <u>Photography</u>, 1970.)
 Collection of erotic photos from an exhibition staged in Munich and London showing the work of four of the acknowledged masters of erotic photography.

44-97* <u>Nudes</u>. Los Angeles: Melrose, 1985. 85 pp., illus.
 Eleven female photographers present their works depicting the female nude.

44-98 <u>Nudes</u> <u>of</u> <u>yesteryear</u>. New York: Eros Books, 1966. 92 pp., illus.
 Nude photos from the turn of the century.

44-99 O'HARA, SHARON. <u>Noelle</u> <u>and</u> <u>the</u> <u>Twelve</u> <u>Nights</u> <u>of</u> <u>Christmas</u>. Photos by Francois Robert, Robert Keeling, and Natacha Robert. Chicago: Playboy Press, 1976. 112 pp., illus. (some col.).
 Collection of erotic photo stories.

44-100 OMMER, UWE, et al. <u>Cover</u> <u>girls</u>. Los Angeles: Collector's Editions, 1984. Unpaged, illus. (col.).
 Photos of the female nude by professional photographers.

44-101 PELLERIN, MICHAEL. Masterpieces of erotic photography.
New York: Greenwich House, 1977. Unpaged, illus. (some col.).
Examples of the work of twelve of the most influential erotic
photographers.

44-102 PLAYBOY. Ecstasy: book one: women's sexual fantasies. Chi-
cago: Playboy, 1976. 112 pp., illus. (some col.).
Album of erotic photo stories.

44-103 _____. Ecstasy: book two: men's sexual fantasies. Chicago:
Playboy, 1976. 111 pp., illus. (some col.).

44-104* _____. Ecstasy: exploring the erotic imagination. Chicago: Play-
boy, 1977. 216 pp., illus.

44-105 _____. Eve Today [the sensuous image of woman]. Chicago: Play-
boy, 1974. Unpaged, illus. (some col.).
Collection of photos of women by many photographers.

44-106* _____. The girls of Playboy. Chicago: Playboy Press. Illus.
At least three volumes of female nudes.

44-107 _____. Love scenes: great moments of passion and tenderness.
Chicago: Playboy, 1976. 112 pp., illus.

44-108* _____. Playboy's leading ladies. Chicago: Playboy Press.
Illus.

44-109* PLAYGIRL. Cheeks. New York: Cornerstone, 1982. 80 pp.,
illus. (col.).

44-110 _____. Playgirl Presents Fantasies. Santa Monica: Playgirl,
1979. 128 pp., illus. (col.).

44-111* Private Photos.
One hundred and fifty erotic pictures by thirty-five famous
photographers.

44-112* Private viewing. 220 pp., illus. (col.).
Work of thirty-five photographers.

44-113* ROSEN, MICHAEL A. Sexual magic: the S-M photographs. After-
word by Mark Chester. San Francisco: Shaynew Press, 1986.
72 pp., illus.

44-114* Samt und Seide. 128 pp., illus. (some col.).
Images of females in lingerie and leathers.

44-115 Sensuality: captured by the great photographers of the world.
Introduction by Anne Cumming. New York: Delilah, 1983. 106
pp., illus. (col.).
Collection of photos of beautiful women.

44-116* <u>Sexual fantasies</u>. 96 pp., illus. (some col.).
 Photo album of lovemaking couples.

44-117* STEINBERG, DAVID, ed. <u>Erotic by nature</u>. Berkeley: Shakti Press, ca. 1987.
 Collection of erotic stories are accompanied by photos by a number of photographers.

44-118 TOSCHES, NICK. <u>Rear View</u>. With Karen Moline and Jeannie Sakol. New York: <u>Delilah</u>, 1981. 97 pp., illus. (col.).
 Photo album of female buttocks with commentary.

44-119* WELLS, LIZ, and COOPER, EMMANUEL. "'The erotic and exotic in photography' subtitles 'Private View,' a large scale RPS show in Bath." <u>Creative Camera</u> 2 (1988): 33+.
 Exhibition review.

44-120 WHITTET, G.S. "London: four masters of erotic photography, Photographers Gallery." <u>Art and Artists</u>, 6 August 1971, 53, illus.
 Review of exhibition of the works of Hamilton, Giacobetti, Haskins, and Shinoyama.

Individual Photographers

---Dominik Alterio---

44-121* ALTERIO, DOMINIK. <u>Aphrodite</u>. 104 pp., illus. (some col.).

44-122* _____. <u>Childwoman</u>. 96 pp., illus. (some col.).

44-123* _____. <u>Country girls</u>. 96 pp., illus. (col.).

44-124* _____. <u>Maidens, still-lifes, and landscapes</u>.

---Roswell Angier---

44-125 ANGIER, ROSWELL. "<u>. . . A kind of life</u>": conversations in the Combat Zone. Danbury, N.H.: Addison House, 1976. 130 pp., illus., intro.
 Photo study of people in Boston's "Combat Zone," especially those who work in the sexual marketplace.

---Yokagi Arao---

44-126* ARAO, YAKOGI. <u>Seaside freeway</u>.

---R. Baker---

44-127* <u>Lovers behind closed doors</u>. Illus. (col.).

Photography

---Peter Barry---

44-128* BARRY, PETER. Couples in love.

44-129* _____. Erotic lingerie.

44-130* _____. Girl friends.

44-131* _____. Touch of lace.

44-132 _____. Touch of leather. Guildford, England: Arlington House,
1984. Unpaged, illus. (col.).
Soft-core photos of women in leather outfits.

44-133* _____. Touch of silk. New York: Crescent, 1983.

44-134* _____. Women in love.

---Andre Belorgy---

44-135* BELORGY, ANDRE. Striptease.

---Jacques Bergaud---

44-136* BERGAUD, JACQUES. Close-up. Illus. (col.).

---Ruth Bernhard---

44-137* The eternal body. 144 pp., illus.

---Gary Bernstein---

44-138 TAUPIN, BERN. Burning cold. Photos by Gary Bernstein. New
York: Harmony, n.d. Unpaged, illus. (col.).
Collection of photos of a woman posing in provocative situ-
ations.

---Rebecca Blake---

44-139 BLAKE, REBECCA. Forbidden dreams. New York: Quartet
Books, 1984. Unpaged, illus. (col.), index.
Fashion photography with an erotic touch.

---Patricia Booth---

44-140 BOOTH, PATRICIA. Self portrait. New York: Quartet, 1983.
115 pp., illus. (some col.).
Collection of erotic self-portraits.

---Heribert Brehm---

44-141 BREHM, HERIBERT. "The eye of the beholder." Penthouse 13,
 no. 1 (September 1981): 64-69, illus. (col.).
 Collection of surreal images of women.

---Alan Brien---

44-142* BRIEN, ALAN. Dome of fortune. 95 pp., illus. (some col.).
 Photographic study of the female breast.

---Paul Brown---

44-143 BROWN, PAUL THURSTON. Venus in ultraviolet light. Cardiff:
 Second Aeon, ca. 1973. Unpaged, illus.
 Photos juxtaposing female nudes and semi-nudes with images of
 outer space, the moon, etc.

---Patrice Casanova---

44-144* GUETARY, HELENE, and CASANOVA, PATRICE. Skin deep. Pre-
 face by Federico Fellini. New York: Melrose, 1984. 90 pp., illus.
 (some col.).

---Bob Carlos Clarke---

44-145 CLARKE, BOB CARLOS. Dark summer. New York: Quartet
 Books, 1985. 126 pp., illus. (some col.).
 Glamor photos with some unusual props and costumes.

44-146 _____. Obsession. Foreword by Patrick Lichfield; introduction
 by Phillipe Garner. New York: Quartet Books, 1981. 146 pp.,
 illus. (col.).

---Lucien Clergue---

44-147 CLERGUE, LUCIEN. Nude work shop. New York: Viking, 1982.
 108 pp., illus.
 Collection of nude photos and commentary about the photogra-
 pher's approach to this subject.

---James Collins---

44-148 PINCUS-WITTEN, R. "James Collins: the erotic and the didactic."
 Arts Magazine 50, no. 5 (January 1976): 77-81, illus. (some col.).
 Conceptual photographer utilizes erotic themes in portraits.

---Charles Collum---

44-149 COLLUM, CHARLES R. Dallas nude: a photographic essay. New
 York: American Photographic Book, 1977. 96 pp., illus.
 Photographic nude studies.

44-150 _____. New York nude: a photographic essay. New York: Am-
photo, 1981. 128 pp., illus.
 Nude portraits of New Yorkers.

---Bernard Corvaisier---

44-151* CORVAISIER, BERNARD. Pulsions. 56 pp.

---Pierre Cuisinier---

44-152 CUISINIER, PIERRE. Orgy: an erotic experience. Surrey: Ar-
lington House, 1985. Unpaged, illus. (col.).
 Soft core photos of loving couples.

44-153* _____. Private lines. 1985?

44-154 _____. Women loving women. New York: Arlington House, 1985.
Unpaged, illus. (col.).
 Collection of photos of female couples fondling each other.

---Peter DiCampos---

44-155* DICAMPOS, PETER. Lesbos. Drawings by the Marquis Franz von
 Bayros. Amsterdam: Uitgeverij Central, 1970. Unpaged, illus.
 (In English, Dutch, French, and German.)

---Patrice Dohollo---

44-156* DOHOLLO, PATRICE. Calines. 80 pp., illus. (col.).

---Terence Donovan---

44-157* DONOVAN, TERENCE. Glances. 132 pp.

---Frantisek Drtikol---

44-158* Frantisek Drtikol: photographe art deco. 200 pp., illus. (some
col.).
 1920s photographer of the nude featured.

---Jeff Dunas---

44-159 DUNAS, JEFF. Captured women. Los Angeles: Melrose, 1981.
112 pp., illus. (some col.).
 Collection of photos of female nudes.

44-160* _____. Mademoiselle, Mademoiselle. Los Angeles: Melrose,
1982. 102 pp., illus. (col.).

44-161 _____. Voyeur. Los Angeles: Melrose, 1983. 91 pp., illus.
(some col.).
 Female nudes in various poses and locations.

---Allen Dutton---

44-162* DUTTON, ALLEN A. The great stone tit: a photographic study. Tempe: Richard Dixon, 1974. Illus.
Seriocomic images of female breasts.

---Robert Farber---

44-163 FARBER, ROBERT. Farber nudes. New York: Amphoto, 1983. 144 pp., illus. (some col.).
Photos of nudes, both male and female.

44-164 _____. Images of woman. Garden City, N.Y.: Amphoto, 1976; 1979. 112 pp., illus. (some col.).
Photos of the female nude.

---Richard Fegley---

44-165 FEGLEY, RICHARD. Dreams. New York: Playboy Press, 1982. Unpaged, illus. (some col.). (Excerpted in Playboy during 1982.)
Collection of photos of female nudes.

---Didier Gaillard---

44-166 GAILLARD, DIDIER. Femmes fatales: photographies. Los Angeles: Melrose, 1984. 94 pp., illus. (some col.).
Photos of semi-nude and nude female figures.

---Charles Gatewood---

44-167 GATEWOOD, CHARLES, and BURROUGHS, WILLIAM S. Sidetripping. Secaucus, N.J.: Strawberry Hill, 1975. 79 pp., illus. (some col.).
Photos of people in bizarre sexual situations.

---Gehenne---

44-168* GEHENNE. Indiscretions. Pink Star Editions, 1984. 80 pp.

---Cara Giovannina---

44-169 CELATI, GIANNI, and GAJANI, CARLO. Il Chiodo in Testa. Pollenza: La Nuova Foglio, 1974. 167 pp., illus.
Collection of surreal and mildly sadomasochistic photos.

---Wilhelm von Gloeden---

44-170 GLOEDEN, WILHELM VON. The boys of Taormina: the photographic work of Wilhelm von Gloeden. Vol. 1. N.p., n.d. Unpaged, illus.
Famous collection of photos of naked Sicilian youths.

Photography

44-171 _____. Photographs of the classic male nude: Baron Wilhelm von Gloeden. Preface by Jean-Claude Lemagny. New York: Graphic Press, 1975. 105 pp., illus.
 Short essay on von Gloeden and a collection of his photos of nude youths and boys.

44-172 LESLIE, CHARLES. Wilhelm von Gloeden, photographer: a brief introduction to his life and work. New York: J.F.L. Photographic Publishers; Soho Photographic Publishers, 1977. 143 pp., illus.
 Study of the life and work of the famous photographer of naked Sicilian youths.

44-173* PUIG, HERMAN. Von Gloeden et le XIX siecle: Eugene Durieu, Charles Simart, Guglielmo Marconi, Vincenzo Galdi, Guglielmo Pluschow, Baron Willhelm von Gloeden. Paris: Puig, 1980. 43 pp., illus.
 Nineteenth-century photos of the nude male.

---Ed Goldstein---

44-174 GOLDSTEIN, ED. Love scenes. Text by Zack Richardson. New York: Bell, 1984. 191 pp., illus. (some col.).
 Photo illustrated erotic short stories.

---Jean-Paul Goude---

44-175* GOUDE, JEAN-PAUL. Jungle fever. New York: Xavier Moreau, 1981. 144 pp., illus. (some col.).

---Joyce Greller---

44-176* GRELLER, JOYCE. Tool box scandal. New York: Cestrum Nocturum, 1971. 32 pp., illus.
 Collection of nineteenth- and early twentieth-century hard core photos reproduced with humorous commentary. Arranged by subject.

---David Hamilton---

44-177* HAMILTON, DAVID. The best of David Hamilton. Text by Denise Couttes. New York: Morrow, 197?. 144 pp., illus. (some col.).
 Collection of images from his Dreams of a Young Girl, Sisters, and La Danse.

44-178 _____. David Hamilton's private collection. New York: Morrow Quill Paperbacks, 1980. 125 pp., illus. (col.).

44-179* _____. Dreams of a young girl. Text by Alain Robbe-Grillet. New York: Morrow, 1977. 144 pp., illus. (some col.).
 Photographs of adolescent girls in provocative poses.

44-180 _____. Hamilton's movie, Bilitis (a photographic scrapbook from the movie). New York: Cameragraphic, 1977. 111 pp., por., illus.
Photo essay on the making of a movie with many photos of seminaked and naked female figures.

44-181* _____. Homage to painting: photography. Emeryville, Calif.: Publishers Group West, 1984. Illus. (some col.).

44-182 _____. Sisters. Text by Alain Robbe-Grillet. New York: Morrow, 1973. 142 pp., illus. (some col.).
Photos of young sensuous women.

44-183 _____. Tender cousins. New York: Quill, 1982. 109 pp., illus. (some col.).
Photos of young women in provocative poses.

---Sam Haskins---

44-184 HASKINS, SAM. Five girls. New York: Crown, 1962. 143 pp., illus.
Five women in nude and seminude poses.

44-185 _____. Cowboy Kate and other stories. Introduction by Desmond Skirrow. New York: Crown, 1965. Unpaged, illus.
Photo stories of a sensual nature.

44-186 _____. November girl. New York: Madison Square Press, 1967. Unpaged, illus.
Photo study of the female.

---John Hedgecoe---

44-187* HEDGECOE, JOHN. Nude photography. Ill. (some col.).

---Arnie Hendin---

44-188 HENDIN, ARNIE, and MOSKOF, MARTIN S. Nude landscapes. Foreword by Clara Hoover. New Hyde Park: University Press, 1968. 118 pp., illus.
Photos of the female form which emphasize landscape forms.

---George Hester---

44-189* HESTER, GEORGE M. The classic nude. New York: American Photographic Book, 1973.
Nude studies of the male and female.

44-190 _____. Man/Woman. 2 vols. Garden City, N.Y.: Amphoto, 1975. Unpaged, illus. (some col.).
One book of female nudes, one of male nudes.

Photography

---Eikoh Hosoe---

44-191 HOSOE, EIKOH. Barakei: ordeal by roses. Preface by Yukio Mi-
 shima; afterword by Mark Holborn. New York: Aperture, 1985.
 Photographic appreciation of the philosophy and life of Yukio
 Mishima, including images dealing with sexuality.

44-192 LUNDSTROM, JAN-ERIK. "Eros and Thanatos." Afterimage 14, no.
 7 (February 1987): 10-11, illus.
 Japanese photographer Hosoe explores concepts of sex and
 death in his works. Article reviews three different issues of Barakei.

---Irina Ionesco---

44-193* IONESCO, IRINA. Femmes sans tain: poemes. Poems by Renee
 Vivien. Geneva: Bernard Letu, 1975. 47 pp., illus.
 Collection of sensual/erotic photos.

44-194* _____. Irina Ionesco, cent onze photographies erotique. Pre-
 face by Pierre Bourgeade. Paris: Images Obliques, 1980.

44-195* _____. Lilacees langoureuses aux parfums d'Arabie. Preface by
 Andre Pieyre de Mandiargues. Paris: Chene, 1974. 2 pp. (text),
 illus.

44-196 _____. Passions. Paris: Pink Star; Nyons: Le Club du Livre
 Secret, 1984. 79 pp., illus. (col.).
 Sensual and erotic photos of female semi-nudes and nudes.

44-197 _____. Temple aux miroirs. Paris: Editions Seghers, 1977. Un-
 paged, illus.

---William Jolitz---

44-198* JOLITZ, WILLIAM R. Deborah's dreams: a Victorian fantasy. Chi-
 cago: Playboy Press, 1976. 110 pp., illus. (some col.).

---Jean-Francois Jonvelle---

44-199* JONVELLE, JEAN-FRANCOIS. Mistress. Los Angeles: Melrose,
 1983. 102 pp., illus.

---Tana Kaleya---

44-200* KALEYA, TANA. Woman. Ill. (col.).

---John Kane---

44-201* KANE, JOHN. Paper dolls. 136 pp.

350

---Pierre Keller---

44-202 BORRINI, C. "Lieux hantes par Pierre Keller." Art Press 84 (September 1984): 16-17, illus.
Interview with Keller in which photographer defends his work against those who see it as voyeurism and pornography.

---John Kelly---

44-203* KELLY, JOHN. Heat.

44-204* _____. Heat II.

44-205* _____. Heat III.

---Stacy Kimball---

44-206* KIMBALL, STACY. Up front, the book!: a deliciously erotic photographic collection. Sausalito, Calif.: Landmark, 1983. 95 pp., illus. (some col.).

---M. Richard Kirstel---

44-207 KIRSTEL, M. RICHARD. Pas de deux. Introduction by Nat Hentoff. New York: Grove, 1969. Unpaged, illus. (Selections published in Evergreen Review 13, no. 70 (September 1969): 33-39.)
Photographs of sexual activities of heterosexual and homosexual couples.

---Les Krims---

44-208 KRIMS, LES. Fictcryptokrimsographs: a book-work by Les Krims. Introduction by Hollis Frampton. Buffalo, N.Y.: Humpy Press, 1975. 8 pp. (text), illus. (col.).
Collection of color photos in a style best described as funk-eroto-sadomasochism.

---Eric Kroll---

44-209 KROLL, ERIC. Sex objects: an American photodocumentary. Danbury, N.H.: Addison House, 1977. Unpaged, illus.
Photographs of prostitutes.

---Cheyco Leidmann---

44-210 "Cheyco Leidmann: a surrealist's American odyssey." Oui 9, no. 9 (September 1980): 101-10, illus. (col.).
Collection of color photos by German photographer working in the U.S.

Photography

---William Levy---

44-211* LEVY, WILLIAM. The Virgin sperm dancer. The Hague: Bert
Bakker, 1972.

---Patrick Magaud---

44-212* MAGAUD, PATRICK. Exhibition in Paris. ca. 1984.

---Robert Mapplethorpe---

44-213* BONDI, I. "The Yin and Yang of Robert Mapplethorpe." Print
Letter (Switzerland) 19 (January-February 1979): 9-11, illus.
Interview includes discussion of the sexuality in his work.

44-214 BOURDON, D. "Robert Mapplethorpe." Arts Magazine 51, no. 8
(April 1977): 7, illus.
Short discussion of the work of Mapplethorpe, including his
sexual themes.

---Susan Marchant-Haycox---

44-215 MARCHANT-HAYCOX, SUSAN. Secret pleasures. New York: Gal-
lery Books, 1984. Unpaged, illus. (col.).
Photographs of women provocatively posed in lingerie.

---Pierre Molinier---

44-216* BOURGEADE, PIERRE. "Molinier homme et femme." Artitudes 33-
38 (June 1976-March 1977).

44-217* GORSEN, PETER. Pierre Molinier lui-meme: Essay uber den sur-
realistischen Hermaphroditen. Munich: Rogner & Bernhard.

44-218* HAMON, YVES. "Lettre oeuverte aux amis posthumes de Pierre
Molinier." Artitudes 33-38 (June 1976-March 1977).

44-219* MOLINIER, PIERRE. "Maniere de concevoir l'oeuvre d'art." Arti-
tudes 33-38 (June 1976-March 1977).

44-220* _____. Pierre Molinier, cent photographies erotiques. Intro-
duction by Pierre Bourgeade. Paris: Images Obliques, 1980.

---Rich Montage---

44-221* MONTAGE, RICH. [Erotic photos.] After Dark 12 (February
1979): 64-67.

---Michel Moreau---

44-222* MOREAU, MICHEL. Exhibitions. Paris: Pink Star.

44-223* _____ . Indiscretions.

---Muybridge---

44-224 ANDERSON, THOM. "Eadweard Muybridge." Film Culture 41 (Summer 1966): 22-24, illus.
 Muybridge's use of the zoopraziscope to photograph nude women discussed.

---Byron Newman---

44-225 NEWMAN, BYRON. English rose. Preface by Duncan Fallowell.
Los Angeles: Collector's Edition, 1985. Unpaged, illus. (col.).

---Helmut Newton---

44-226* NEWTON, HELMUT. Big nudes. Introduction by Karl Lagerfeld.
New York: Xavier Moreau, 1982. 67 pp., illus., bib.

44-227* _____ . Helmut Newton: sleepless nights. Introduction by H.
Behr. New York: Congreve, 1978. 152 pp., illus.

44-228 _____ . Helmut Newton: special collection: 24 photo lithos. New
York: Congreve, 1979. Unpaged, illus.
 Collection of typically Newton photographs of women with a
strong sado-masochistic flavor.

44-229 _____ . White women. New York: Stonehill, 1976. 98 pp., illus.
(some col.).

44-230 "Newton's physiques." Playboy 23 (September 1976): 83-89, illus.
 Collection of typical Newton works.

---Paul Outerbridge---

44-231 HOWE, GRAHAM. "Outerbridge from Cubism to fetishism." Artforum 15, no. 10 (Summer 1977): 51-55, illus. (some col.).
 Study of the photographer whose work in the 1920s and 1930s
turned to erotic themes.

---Bryan Patten---

44-232 PATTEN, BRYAN. "Nudes in the abstract: four photographs." Saturday Book 17 (1957): 248-51, illus.
 Four stark black and white photos of women's breasts.

---Wladyslaw Pawelec---

44-233 PAWELEC, WLADYSLAW. Friends of Zofia. Los Angeles: Melrose,
1985. Unpaged, illus.
 Erotic nudes from Eastern European countries.

Photography

44-234* _____. Privat (1 through 4). Ill (some col.).
 Works by Polish photographer.

44-235* _____. Privat 5 "Silvia."

—Mark Power—

44-236* "Mark Power: erotic portraits." Creative Camera 71 (May 1970):
 150-51, illus.

—Ron Raffaelli—

44-237 RAFFAELLI, RON. Desire: a collection of erotic photography.
 N.p.: Diverse Industries, 1976. Unpaged, illus. (some col.).
 Collection of erotic photographs.

44-238 _____. Rapture: 13 erotic fantasies photographed by Rafaelli.
 Appreciation by Steve Hull. New York: Grove, 1975. Unpaged,
 illus.
 Collection of erotic photo stories.

—Suze Randall—

44-239* RANDALL, SUZE. Suze. London: Talmy Franklin, 1977. 174 pp.,
 illus.

—Frank Rheinboldt—

44-240 RHEINBOLDT, FRANK. Tight angles. N.p.: Haney Pub. Co., dis-
 tributed by Collector's Editions, Ltd., 1986. 95 pp., illus. (col.).
 Collection of close-up photos of nude and scantily clad female
 models.

—Joe Rice—

44-241* RICE, JOE. Heart dance. Poetry by JoCindee Allen. Acme,
 Mich.: Workshop Publications, ca. 1987. 64p., illus.

—Piero Rimaldi—

44-242 WILSON, COLIN. L'amour: the ways of love. Photos by Piero
 Rimaldi. New York: Crown, 1970. Ill. (col.).
 Photographic celebration of sexual love, showing a young sen-
 suous nude couple.

—Jean Rougeron—

44-243* ROUGERON, JEAN. Fantasms II: the world of Jean Rougeron.

44-244* _____. Phantasmes. 112 pp., illus. (col.).

---William Rowe---

44-245 ROWE, WILLYUM. Fiestaware. Rochester, N.Y.: Visual Studies
 Workshop, 197?. Unpaged, illus.
 Humorous illustrations created with collages of photos of wo-
 men and mechanical devices.

---Jan Saudek--

44-246* SAUDEK, JAN. The world of Jan Saudek.
 Eastern European photographer.

---Schenk--

44-247 EDGE, CUTHBERT. "Mr. Schenk and his draperies." Saturday
 Book 22 (1962): 204-19, illus.
 Study of the master of the Victorian draped nude photograph.

---Diane Schmidt---

44-248 SCHMIDT, DIANNE. Chicago exhibition. Los Angeles: Melrose,
 1985. 104 pp., illus.
 Seminude and nude female figures at various sites in the Chi-
 cago area.

---Martin Schrieber---

44-249 SCHREIBER, MARTIN H. Bodyscapes. Introduction by Carter
 Ratcliff. New York: Abbeville Press, 1980. 92 pp., illus., por.
 Collection of photos of female nudes.

---Reinhard Seufert---

44-250* SEUFERT, REINHARD. The porno-photographics. Los Angeles:
 Argyle Books, 1968. 116 pp., illus.
 A collection of erotic photos and illustrations.

---Kishin Shinoyama---

44-251* SHINOYAMA, KISHIN. Nude. Tokyo: Camera Mainichi, 1970. 65
 pp., bib., illus.
 Nude photographs by a master of erotic photography.

---Jeanloup Sieff---

44-252 SIEFF, JEANLOUP. Torses nus. Paris: Centre Jour, 1986. 103
 pp., illus.
 Collection of photos of female nudes with commentary by the
 photographer for each image.

Photography

---J. Frederick Smith---

44-253 CALLAHAN, SEAN. Photographing sensuality, J. Frederick
 Smith. Masters of contemporary photography. New York: Crow-
 ell; Los Angeles: Alskog, 1975. 96 pp., illus. (some col.).
 How-to advice and selections of the work of J. Frederick Smith.

44-254* SMITH, J. FREDERICK. The art of loving women: the poetry of
 Sappho. 160 pp., illus. (col.).
 Photo study of two women making love.

44-255* _____. Sappho by the sea: an illustrated guide to the Hamptons.
 Text by Mary Arigan McCarthy. New York: Belvedere, 1976.
 Photo study of two women making love in the Hamptons, New
 York.

---Karl Stoecker---

44-256* "Art punches Amanda out of shape." Oui, September 1974: 52-55,
 illus.
 Photos by Stoecker based on the sculptures of Allen Jones.

---Jean Straker---

44-257* STRAKER, JEAN. Nudes of Jean Straker. London: Charles Skil-
 ton, 1958.

---Streuber Schulke---

44-258 STREUBER SCHULKE, FLIP, and STREUBER SCHULKE, DEBRA.
 "Human sensuality." Camera 35 24, no. 9 (September 1979): 36-
 41+, illus. (some col.).
 Brief description by the photographers of their interest and
 techniques of photography the nude.

---John Swannell---

44-259 SWANNELL, JOHN. Fine lines. London: Quartet, 1982. 127 pp.,
 illus.
 Photos of female nudes.

---Jack Thornton---

44-260 THORNTON, JACK. Pipe dreams. Preface by Peter Mayle. New
 York: Morrow, 1979. 125 pp., illus. (col.).
 Surreal photos of female nudes.

---David Thorpe---

44-261 THORPE, DAVID. Rude food. Text by Pierre Le Poste. New
 York: Ballatine, 1978. Unpaged, illus. (col.).
 Photo essay on food and sex.

---Arthur Tress---

44-262* TRESS, ARTHUR. Facing up. New York: St. Martin's Press, 1980. 79 pp., illus.

---Karen Tweedy-Holmes---

44-263 TWEEDY-HOLMES, KAREN. "A curious occupation: or why does a nice girl like you take pictures of naked men." Feminist Art Journal 2, no. 3 (Fall 1973): 12-13+, illus.
Survey of the work of a woman photographer who specializes in male nudes.

---Unknown Photographer---

44-264* A Fior de Pelle: Afrodisiaci in seta emerlefti. Visualbooks; Grandi Libri di Erotica.

44-265* Exhibitions. Visualbooks; Grandi Libri di Erotica.

44-266 Solo flights: the pleasures of masturbation. London: Arlington House, 1986. Unpaged, illus. (col.).
Photos of women masturbating and fondling themselves.

44-267* Two women.

---Christian Vogt---

44-268* VOGT, CHRISTIAN. In camera: eighty two images by fifty two women. Geneva: Rotovision, 1982. 96 pp., illus.
Swiss photographer of the nude female photographs fifty-two women in poses chosen by the sitter to express their sensuosity.

---Roy Volkmann---

44-269* VOLKMANN, ROY. Two women in love—a photographic novel. New York: Strawberry Hill, 1976. 153 pp., illus. (some col.).

---John Walsh---

44-270* BAKER, ROGER. Lovers behind closed doors. Photos by John Walsh.

44-271* _____. Sex fantasies. Photos by John Walsh.

---Edward Weston---

44-272 WILSON, CHARIS. Edward Weston nudes. New York: Aperture, 1977. 116 pp., illus.
Nude photos by a master photographer.

Photography

—Baron Wolman—

44-273 WOLMAN, BARON. _Profiles_. Mill Valley, Calif.: Squarebooks, 1974.
Forty-three black and white photos of close-up profiles of women's breasts.

Chapter 45
Cinema

Almost from its inception, the erotic potential of cinema was recognized by filmmakers and audiences alike. One of the first movies publicly displayed showed a man and a woman kissing, but even that innocent action drew a storm of protest over questions of morality. The naturalistic depiction of sexual activity that appears to characterize post-Renaissance Western erotic art could, with the development of cinema, reach full fruition.

The commercial film industry from the beginning has sought to straddle the gap between audience desire for sexuality on the screen and the strictures placed by legal and moral authorities. The history of Hollywood (paralleled elsewhere) clearly demonstrates the creative efforts by producers and directors to contend with these contending forces, in some periods dealing with sex only circumspectly and in others quite openly (if not fully explicitly).

Explicitly sexual films probably were first produced in the late 1890s, a film genre that came to be known by a variety of terms including "blue movies," "porno flics," "one reelers," "adult movies," "stag films," "X-rated films," etc. These explicit films had only a limited, largely underground, distribution until the mid-1960s when changes in the legal atmosphere allowed them to be shown at public movie houses. Availability spread phenomenally when video tape playing machines became common household entertainment appliances in the 1980s.

Thus, there have been two separate sources of erotic films, the relatively restrained, if steamy, output of the commercial film establishment and the explicitly sexual product of what was, until the early 1970s, an underground industry. Only in the mid-1970s did the gap between these two sources narrow to gossamer thinness. Also to be acknowledged is a third source of erotic films, the work of independent filmmakers who are part of neither the commercial establishment nor the "adult" film industry.

Films are an immensely popular entertainment medium, and the public's interest in them is fed by a constant flow of publications--nostalgic photo books, biographies of stars, criticism columns, scholarly studies, etc. In addition there are numerous periodicals dedicated to the cinema, including ones just for "adult" films. Considering this situation, the entries listed in this chapter are only a very selective portion of all publications that might relate to sex in cinema. Those compiled here were chosen because they are primarily studies and commentaries on various aspects of

eroticism in films, with preference given to the more scholarly sources. Purposefully excluded are such categories as reviews of specific films, plot outlines, "adult" film specialty magazines (like Adam's World and the like), etc. There are several excellent published bibliographies on the history of cinema, several of which were helpful in compiling this chapter, especially MacCann's New film index and Limbacher's directory two-volume Sexuality in world cinema.

Surveys of the role of sex in films are a perenially popular type of cinema book. They range from being simply compilations of titillating stills to in-depth academic studies and are generally either chronologically or thematically organized (a few do both). Most only deal tangentially with the explicitly sexual films, focusing primarily on the treatment of love and sex in mainstream Hollywood, European, and Japanese films. The prototype for the many surveys was a series of articles Raymond Durgnat wrote for Films and filming in 1961 (although as early as 1932 S. Burt was discussing the topic), which he reworked into Eros in the cinema in 1966. Other surveys published since the early 1960s are by Arlen, Atkins, Brusendorff and Henningsen, Fagan, Film Journal, Hanson, Knight and Alpert, Lenne, Lo Duca, Milner, Pascall, Seeselen and Weil, Tyler, Walker, Williams, and Wortley. Of these the most thorough are Fagan's chronological overview, Knight and Alpert's richly illustrated book and long-running article series in Playboy, and the entries by Lenne, Pascall, Tyler, and Wortley. The more explicitly sexual films are best covered in Di Lauro and Rabkin's historical survey Dirty movies: an illustrated history of the stag film 1915-1970, while more contemporary development's in "adult" films and videos are covered by Blake, Harris, and Rotsler. More narrow in scope are surveys of specific aspects of erotic cinema, such as De Coulteray on sadism, Franklyn and Richie on Japanese films, Genin on Swedish films, Hogan on horror films, Hopfinder on Polish films, Madden on the 1940s, Malone on male and Mellen on female sexuality, and Martin and Tyler on homosexuality.

Other than the surveys mentioned above, most of the entries listed below are articles and popular books concerned with aspects of the "adult" film industry of the last twenty years. These include essays on the nature of eroticism in cinema and the debate over pornography (see Alpert, Becker, Blackburn, Blouin, Callenbach, Canby, Durgnat, Fabrizio, Geduld, Grazia, Harrington, Hofsess, Jones, Kortz, Rhode, Robinson, Schifes, Shapiro, Slade, and Williamson; sex film appreciation advice (see Bolduc, Carroll, Corliss, Gill, Jaehne, Judson, Lil, MacDonald, and Slade); interviews with and exposes of the directors, producers, performers, distributors, etc., involved in the "adult" movie industry (see Bond and Hill, Corliss, Csicsery, Ebert, Hamill, Lazare, Leach, Rotsler, Schickel, Solinas, and Troyano); how-to guides for filmmakers (Hilliard and Ziplow); and directories of films and videos (Agostini, Limbacher, Rimmer, Rowberry, Smith, and Moore and Reagle).

45-1* AGOSTINI, FABIO DE. "Filmerotikon; anthology of forbidden cinema." Adelina 14, no. 5 (June 1980-): illus. (col.).
 Serialized articles on mostly European R-, hard R-, and X-rated movies.

45-2 Almanach erotisme au cinema. Paris: Rene Julliard, 1964. 207
 pp., illus.
 Erotic themes in contemporary European films outlined.

45-3 ALPERT, HOLLIS. "Whither the erotic film." Sexual Behavior 2,
 no. 6 (June 1972): 45-47.
 Critique on sex films of the 1970s.

45-4* ARLEN, RICHARD. Sex and pornography in the movies. N.p.:
 Valiant, 1971. 192 pp., illus.

45-5 ATKINS, THOMAS R., ed. Sexuality in the movies. Bloomington:
 Indiana University Press, 1975. Reprint. New York: Da Capo
 Press, 1984. 244 pp., illus.
 Anthology of essays on sex in cinema, providing a broad range
 of social studies and analysis of the genre.

45-6 BAKER, PETER. "France makes them so xy." Films and Filming 3,
 no. 4 (January 1957): 11, illus.
 French filmakers concentrate on sex fantasies to enliven their
 films.

45-7* BAZIN, ANDRE. What is cinema? 2 vols. Berkeley: University
 of California Press, 1971.
 Two volumes of early essays including 'Entomology of the Pin-
 Up Girl' (1946) and 'Eroticism in the Cinema' (1957).

45-8* BEAUFRANT, ERIC DE. Le petit livre rouge de: l'erotisme au cin-
 ema. Soisy-sur-Seine: Editions du Senart, 1973. Unpaged, illus.
 Stills from a selection of movies from the 1960s and early 1970s.

45-9* _____. La revolution sexuelle au cinema. Soisy-sur-Seine: Edi-
 tions du Senart, 1974. 192 pp., illus.

45-10 _____. "Sex in the cinema: moral values and the aesthetic of
 film." Film Journal 2, no. 1 (September 1972): 24-27, illus.
 Essay critical of much of what is written about morals and
 aesthetics.

45-11 BENAYOUN, ROBERT. "Le sofa rouge." Positif: Revue de Cinema
 61-63 (June-August 1964): 36-51, illus.
 Psychosexual problems as portrayed in modern film.

45-12* "Best of 1st NY Erotic Film Festival." Dragonseed 1, no. 7 (13
 October 1972): 11.

45-13* BLACKBURN, B. "They don't make good clean dirty movies like
 they used to." Maclean's Magazine 83 (February 1970): 76+.

45-14* BLAKE, ROGER. The porn movies. Cleveland: Century, 1970.

45-15* BLOUIN, C.R. "Reflexions sur l'erotisme dans le cinema." Cinema Quebec 48 (1977): 36-37.

45-16 BOLDUC, ALBERT. "Confession d'un erotoscopitomane." Positif: Revue de Cinema 61-63 (June-August 1964): 169-70.
Essay of appreciation of sex in cinema.

45-17* BOND, RENE and HILL, WINSTON. Girls who do stag movies, intimate interviews. Los Angeles: Melrose Square, 1973. 220 pp., illus.

45-18 _____. "Interview with a pornographic film star." In Sexual deviance and sexual deviants, edited by Erich Goode and Richard R. Troiden, 68-72. New York: William Morrow, 1974.
Views of the X-rated film industry by a performer.

45-19 BORDE, RAYMOND. "No man's land." Positif: Revue de Cinema 61-63 (June-August 1964): 52-56, illus.
Study of lesbianism in modern film.

45-20* BOUYXOU, JEAN-PIERRE. "Le cinema et la presse (VII): les revues du cinema erotique." La Revue du Cinema 348 (March 1980): 87-96.

45-21 BRUSENDORFF, OVE, and HENNINGSEN, POUL. Erotica for the millions: love in the movies. Los Angeles: Book Mart, 1960. 147 pp., illus.
Essays and many stills concerning sexuality in commercial films in Europe and the United States.

45-22 BURT, STRUTHERS. "The motion pictures." In Sex in the arts: a symposium, edited by John Francis McDermott and Kendall B. Taft, 130-45. New York: Harper, 1932.
Study in eroticism in films of the 1920s and early 1930s.

45-23* "Les cahiers du sinema." Lui, May 1974, 84-87, illus.

45-24 CALLENBACH, ERNEST. "End of the foreplay flick?" Film Quarterly 22, no. 4 (Summer 1969): 1-2.
Essay bemoaning the willingness of modern films to show sex.

45-25* CANBY, VINCENT. "'Dirty movies' are a bore." New York Times, 7 June 1970.

45-26 Cannes: le festival erotique (de la rue d'Antibes). Evry: Editions du Senart, 1975. 191 pp., illus.
Stills and brief descriptions of films shown at special exhibition of European erotic films.

45-27* CARROLL, J. "Porn symposium: a reminiscence: my first." Take One 4 (May-June 1973): 28, illus.

45-28 CHUTE, DAVID. "Tumescent market for one-armed videophiles."
Film Comment 17, no. 5 (September-October 1981): 66+.
Review of current developments in X-rated film industry.

45-29* CINEMA D'AUJOURDHUI. "L'erotisme en question" [special issue].
Cinema d'Aujourdhui, Winter 1975-76, bib.
Collection of articles on eroticism in modern movies.

45-30 COLIN, MOLLY. "Women tuning into porn." Mother Jones, January
1985: 13, illus.
Report on women renting X-rated films; includes a list of the
most frequently requested videos.

45-31* "Confessions of a reluctant hard-core movie-maker." Los Angeles,
April 1977, 115+.

45-32 COOPER, KAREN. "The New York Erotic Film Festival." Filmmak-
er's News 6, no. 1 (November 1972): 14+.
Article on the problems and pleasures of running this festival.

45-33 CORLISS, RICHARD. "Confessions of an ex-pornologist." Vill-
age Voice 16, no. 22 (3 June 1971): 62+.
Appreciation and analysis of sex films.

45-34 _____. "Cinema sex, from The Kiss to Deep Throat." Film Com-
ment 9, no. 1 (January-February 1973): 4-5, illus.
Brief history of porno films and analysis of the basic features
of the genre.

45-35 _____. "Radley Metzger: aristocrat of the erotic." Film Com-
ment 9, no. 1 (January-February 1973): 18-29, illus., filmog.
Interview with producer of softcore sexploitation films of the
1950s and 1960s.

45-36 CSICSERY, GEORGE PAUL. "The sex film people." In The Sex
Industry, edited by Csicsery, 165-81. New York: New American
Library, 1973.
Chronicle of the early years of the commercial X-rated film
industry.

45-37 _____. "Sex in cinema." In The Sex Industry, edited by Csi-
csery, 194-207. New York: New American Library, 1973.
Brief history of sex in 1960s films.

45-38 DAVY, JEAN-FRANCOIS. "Le film pornographique n'est pas un
genre." Art Press 22 (January-February 1976): 11.
Analysis of X-rated movies.

45-39 DE COULTERAY, GEORGES. Le sadisme au cinema. Paris: Le
Terrain Vague, 1964. 175 pp. (text), illus.
Study of images of sadism in cinema.

45-40 DEBROOK, AXEL. "Le sadisme au cinema." Positif: Revue de Cinema 61-63 (June-August 1964): 171.
Sadism as depicted in 1960s cinema.

45-41* The deep throat papers. Introduction by Pete Hamill. New York: Manor Books, 1973. Ill.

45-42* DELANEY, M. "Pornocinema, sexplicity, erotic pix: the editors at Variety view with alarm. . . ." Saturday Night 84 (August 1969): 41-42.

45-43 DILAURO, AL, and RABKIN, GERALD. Dirty movies: an illustrated history of the stag film 1915-1970. Introduction Essay by Kenneth Tynan. New York: Chelsea House, 1976. 160 pp., bib., filmog.
History of early stag films.

45-44 DURGNAT, RAYMOND. Eros in the cinema. London: Calder and Boyars, 1966. 207 pp., bib.
Topical look at sex in modern cinema.

45-45 _____. "Eroticism in cinema; part one: definitions and points of departure; the dark gods." Films and Filming 8, no. 1 (October 1961): 14-46+, illus.
Essay on the nature of the erotic in cinema.

45-46 _____. "Eroticism in cinema; part two: the deviationists; saturnalia in cans." Films and Filming 8, no. 2 (November 1961): 33-34+, illus.
Sexual perversions as themes in cinema.

45-47 _____. "Eroticism in cinema; part three: the mass media and their public; Cupid v. the Legions." Films and Filming 8, no. 3 (December 1981): 16-18+, illus.
History of the conflict between filmmakers, the public, and censors.

45-48 _____. "Eroticism in vinema; part four: the subconscious; from pleasure castle to libido motel." Films and Filming 8, no. 4 (January 1962): 13-15+, illus.
Overviews obsession and terror themes in films that also have erotic meaning.

45-49 _____. "Eroticism in cinema; part five: the sacred and the profane." Films and Filming 8, no. 5 (February 1962): 16-18+, illus.
Religious and erotic themes in cinema considered.

45-50 _____. "Eroticism in cinema; part six: mind and matter, analysis of French and Italian styles; some mad love and the sweet life." Films and Filming 8, no. 6 (March 1962): 16-18+, illus.
Eroticism in European films discussed.

45-51 _____. "Eroticism in cinema; part seven: symbolism; another word for it." Films and Filming 8, no. 7 (April 1962): 13-15+, illus.
Erotic symbolism in the cinema surveyed.

45-52 _____. "Erotism in cinema; midnight sun." Films and Filming 8, no. 8 (May 1962): 21-23+, illus.
Some thoughts on the nature of eroticism in cinema.

45-53 _____. "An evening with Meyer and Masoch; aspects of Vixen and Venus in Furs." Film Comment 9, no. 1 (January-February 1973): 52-61, illus.
Critical review of some Russ Meyer softcore films.

45-54* _____. Sexus, Eros Kino: das Film als Sittengeschichte. Bremen: Schunemann, 1965. 206 pp., illus., filmog., bib., index.

45-55 _____. "Skin games." Film Comment 17 (November-December 1981): 28-32, illus.
Survey of sadomasochism in European mainstream commercial movies.

45-56 EBERT, ROGER. "Russ Meyer: king of the nudies." Film Comment 9, no. 1 (January-February 1973): 34-45, illus., filmog.
Career and films of Russ Meyer analyzed, with emphasis on Beyond the Valley of the Doll's.

45-57* EDERA, BRUNO. "Eros, image par image." La Revue du Cinema 354 (October 1980): 85-96.
On erotic animated films.

45-58* "The erotic cinema." Sight and Sound 22 (October-December 1952): 67-74+.

45-59* The erotic screen: a probing study of sex in the adult cinema. Los Angeles: Private Collectors, 1969. 237 pp., illus. (some col.).
Study of the common themes in X-rated films.

45-60 EVENSMO, SIGURD. Den nakne Sannheten: Sex i Filmene. Oslo: Glydendal Norsk, 1971. 203 pp., index, illus.
History of sex in the cinema.

45-61 FABRIZIO, MIKE. "The name of the game in eroticism." Sexual Freedom 11 (1972?): 12+.
Essay on the nature of eroticism in cinema.

45-62* FAGAN, JIM. Sex at the cinema. London: Scripts, 1967. 129 pp., illus.
Sex in films from the beginning of the cinema to the early 1960s.

45-63 FARBER, STEPHEN. "Censorship in California." Film Comment 9, no. 1 (January-February 1973): 32-33.
Problems with censors in California discussed.

45-64 . "Sex in contemporary movies: the new puritanism." Sexual Behavior 1, no. 9 (December 1971): 16-23, illus.
 Study of sex in Hollywood commercial films of the 70's.

45-65* FILM JOURNAL. Movies and sexuality. New York: Film Journal, 1972.
 Sex in commercial and porno films.

45-66 FISHER, JACK. "Three paintings of sex: the films of Ken Russell." Film Journal 2, no. 1 (September 1972): 33-43, illus.

45-67 . "Too bad, Lois Lane: the end of sex in 2001." Film Journal 2, no. 1 (September 1972): 65, illus.
 Discussion of the lack of sex in Kubrick's 2001.

45-68 FRANKLYN, A. FREDERIC. "Sexual freedom in Japanese cinema." Transition 7, no. 3 (December-January 1968): 55-62, illus.
 History of the role of sex in Japanese cinema.

45-69 FRENCH, MICHAEL R. "Sex in the current cinema." Kansas Quarterly 4 (Spring 1972): 39-46.
 Essay on sex in commercial Hollywood films.

45-70 GEDULD, HARRY M. "The sexual image: a note on eroticism in the movies." Film Journal 2, no. 1 (September 1972): 28-29, illus.
 Consideration of eroticism as an element of environment and technique as well as film content.

45-71 GENIN, CLAUDE. "Le cinema Suedois est-il erotique?" Positif: Revue de Cinema 61-63 (June-August 1964): 132-35.
 Review of contemporary Swedish cinema and its eroticism.

45-72 GILL, BRENDAN. "Blue notes." Film Comment 9, no. 1 (January-February 1973): 6-11, illus.
 Critic's analysis of X-rated films and their audiences.

45-73 GLAESSNER, VERINA. "Censorship in London." Film Comment 9, no. 1 (January-February 1973): 30-31.
 Problems encountered in showing sex films in London.

45-74 GRAZIA, EDWARD DE, and NEWMAN, ROGER K. Banned films: movies, censors & the First Amendment. New York: Bowker, 1982.
 455 pp., app., bib., index, illus.

45-75 HAHN, F. "Kinos in der Kaiser Strasse." Filmkritik 17, no. 3 (March 1973): 12-131, illus.
 Report on a 'sexploitation' film shown in Frankfurt.

45-76 HANSON, GILLIAN. Original skin: nudity and sex in cinema and theatre. London: Tom Stacey, 1970. 192 pp.
 Study of sex in modern commercial cinema.

45-77 HARRINGTON, CURTIS. "The erotic cinema." Sight and Sound 22, no. 2 (October-December 1952): 67-74+, illus.
Study of the nature of eroticism in commercial films.

45-78* HARRIS, LARRY. The stag film report. Socio Library, 1971.

45-79 HILLIARD, RICHARD. "How to make a skin flick on a 1-to-1 ratio: the secret files of Detective X." Film Journal 2, no. 1 (September 1972): 60-61, illus.
How to make the least costly X-rated film possible.

45-80 HOFFMANN, FRANK A. Analytical survey of Anglo-American traditional erotica. Bowling Green, Ohio: Bowling Green University Popular Press, 1973. 309 pp., bib.
Study of erotic folklore includes discussion of stag films (with a brief filmography).

45-81 _____. "Prolegomena to a study of traditional elements in the erotic film." Journal of American Folklore 78, no. 308 (April-June 1965): 143-48.
Study of the nature of stag films.

45-82 HOFSESS, JOHN. "The mind's eye." Take One 2, no. 2 (November-December 1968): 28-29.
Essay on the philosophical implications of sex acts shown in modern cinema.

45-83 HOGAN, DAVID J. Dark romance: sexuality in the horror film. N.p.: McFarland, 1986. 352 pp., illus., bib., filmog., index.
Survey of the element of sex in the history of horror films.

45-84 HOOD, STUART. "Hard and soft." New Statesman 99 (6 June 1980): 868.
Report on a recent seminar on film pornography.

45-85* HOPFINGER, M. "Eros Spetany." Kino 8, no. 8 (August 1972): 16-20, illus.
Eroticism in modern Polish films.

45-86 JAEHNE, KAREN. "Confessions of a feminist porn programmer." Film Quarterly 37, no. 1 (Fall 1983): 9-16.
Thoughts of a woman on the soft and hardcore sex films which she selects as part of her job.

45-87 JONES, G. WILLIAM. "Eroticism and the art of film." Library Journal 96, no. 20 (15 November 1971): 3809-10, illus.
Commentary on the nature of eroticism in films.

45-88 JUDSON, HORACE FREELAND. "Skindeep: how to watch a pornographic movie." Harper's Magazine 250, no. 1497 (February 1975): 42-49, illus.
Essay on the appreciation of X-rated movies.

45-89* KLINGER, D[OMINIK] M. Die Fruhzeit des erotischen Films von
 1900-1935. Nuremburg: DMK, scheduled for publication in 1987.
 Illus.

45-90 KNIGHT, ARTHUR, and ALPERT, HOLLIS. "The history of sex in
 cinema: the stag film." Playboy 14 (November 1967): 154-58+,
 illus.
 Study of the history and nature of the stag film.

45-91 _____. "The history of sex in cinema." Playboy, April 1965-
 November 1967, April, July 1968, January 1969, illus.
 Series of articles surveying the role and history of sex in all
 genre of the cinema.

45-92* _____. Playboy's sex in cinema. 7 vols. Chicago: Playboy.
 Illus.
 Thorough history of the role of sex in films.

45-93 _____. "Sex in cinema." Playboy, November issues, 1969-82.
 Survey of sex in the previous year's crop of movies.

45-94 KORTZ, DIRK. "Eroticism vs porn by an ex-practitioner." Take
 One 4, no. 5 (May-June 1973): 28-29.
 Brief discussion of the nature of the erotic, the pornographic,
 and film making.

45-95 KYROU, ADONIS. Amour-erotisme au cinema. Paris: Le Terrain
 Vague, 1957. 569 pp., index, illus.
 Love scenes and beautiful actresses up to the mid-1950s.

45-96 _____. "D'un certain cinema clandestin." Positif: Revue de Cin-
 ema 61-63 (June-August 1964): 205-208.
 Description of underground sex films.

45-97 _____. "L'erotisme cinematographique en 1964." Positif: Revue
 de Cinema 61-63 (June-August 1964): 9-16, illus.
 Review of the sex in films for 1964.

45-98 LAZARE, LEWIS. "Russ Meyer analyzes his own films, 'No los-
 ers'." Variety 296, no. 8 (26 September 1979): 22.
 Softcore filmmaker describes his career and his work.

45-99 LEACH, MICHAEL. I know it when I see it: pornography, vio-
 lence, & public sensitivity. Philadelphia: Westminster Press, 1975.
 153 pp.
 Discussion of sex and violence in films.

45-100 LEDUC, J. "The best of the New York Erotic Film Festival." Cin-
 ema Quebec 3, no. 1 (September 1973): 48-49.
 Description of the films shown at 1973 festival.

45-101 LEGRAND, GERARD. "Femme x film=fetiche." Positif: Revue de
Cinema 61-63 (June-August 1964): 17-35, illus.

45-102 LENNE, GERARD. Sex on the screen: eroticism in film. Trans-
lation of Le sese a l'ecran (1978) by D. Jacobs. New York: St.
Martin's Press, 1985. 245 pp., index, illus.
Thematic and chronological history of sexual imagery in the
cinema.

45-103 LEVERRIER, LAURENT. "Enquete sur l'erotisme au cinema." Pos-
itif: Revue de Cinema 61-63 (June-August 1964): 73-128, illus.
Prominent individuals in the cinema scene in Europe are sur-
veyed as to their opinions on eroticism in films.

45-104* LEVY, WILLIAM, ed. Wet dreams: films and adventures. Amster-
dam: Joy, 1973.
Account of erotic film festivals held in Amsterdam in 1970 and
1971.

45-105 LIL, MOBILE. "P.O.V. broad." Take One 4, no. 5 (May-June 1973):
28, figs., illus.
Essay which relates a woman's reactions to X-rated films.

45-106 LIMBACHER, JAMES L. Sexuality in world cinema. 2 vols. Me-
tuchen, N.J.: Scarecrow, 1983. 1511 pp., gloss., filmog., bib.
Massive listing of thousands of films organized into subject
categories, with glossary of terms and excellent bibliography.

45-107 LO DUCA, GIUSEPPE. L'erotisme au cinema. His de Erotica, no.
3. 2 vols. Paris: J.-J. Pauvert, 1958-60. 254 pp., figs., illus.
Sexual themes in the history of the cinema.

45-108 MACCANN, RICHARD DYER, and PERRY, EDWARD. The new film
index: a bibliography of magazine articles in English 1930-1970.
New York: Dutton, 1975. 522 pp., index.
Thorough bibliography of film topics.

45-109 McCORMACK, E. "Hip smut baron's pornographic film fest." Roll-
ing Stone, January 4 1973, 16+.
Discussion of second New York Erotic Film Festival.

45-110 MACDONALD, SCOTT. "Confessions of a feminist porn watcher."
Film Quarterly 36, no. 3 (Spring 1983): 10-16.
Discussion by a male feminist on aspects of X-rated films.

45-111 MACY, CHRISTOPHER, ed. The arts in a permissive society. In-
troduction by D.J. Stewart. London: Pembertom Books, 1971.
103 pp.
Essays on various controversies in the arts, especially film.

45-112 MADDEN, DAVID. "Marble goddesses and mortal flesh: notes for an erotic memoir of the forties." Film Journal 2, no. 1 (September 1972): 2-19, illus.
 Essay on sex on the screen and at the movies of the 1940s.

45-113 MALONE, MICHAEL. Heroes of eros: male sexuality in the movies. New York: Dutton, 1979. 181 pp., illus.

45-114 MARTIN, JIM. "Out of the closets and into the Bijous." Take One 4, no. 5 (May-June 1973): 30.
 Brief history and analysis of gay X-rated films.

45-115 MELLEN, JOAN. "Female sexuality in films." Sexual Behavior 2, no. 11 (November 1972): 4-11.
 Study of the sexuality of women in commercial films.

45-116 _____. Women and their sexuality in the new film. New York: Horizon, 1973. 255 pp., illus.
 Study of women's sex roles in modern films discussed.

45-117 MESNIL, MICHEL. "Le cinema porno: du reel au songe." Revue d'Esthetique 1-2 (1978): 286-304.
 Discussion of different types of porno films.

45-118 MILNER, MICHAEL. Sex on celluloid. New York: McFadden-Bartell, 1964. 224 pp., illus.
 Sex in mainstream commercial films surveyed.

45-119* MORTHLAND, J. "Porn films: an in-depth report." Take One 4 (March-April 1973): 11-17, illus.

45-120 PASCALL, JEREMY, and JEAVONS, CLYDE. A pictorial history of sex in the movies. London; New York: Hamlyn, 1975. 219 pp., index, por., illus. (some col.).
 Well-researched chronological and thematic survey of sexual themes in the cinema.

45-121 PAUL, WILLIAM. "New York's porn: holding our own." Village Voice 16, no. 20 (20 May 1971): 67+.
 Short history of porno films with analysis of the work of two directors.

45-122 PEEPLES, SAMUEL A. "Films on 8 ana 16." Films in Review 26, no. 1 (January 1975): 36-37.
 Short review of the types of X-rated films available for purchase.

45-123 PERRONE, J. "Ins and outs of video." Artforum 14 (June 1976): 54-55, illus.
 Essay on the nature of video medium with mention of its erotic potentials.

45-124* POLSKIN, HOWARD. "Love and money." Home Video (January 1982).

45-125 "Porn symposium." Take One 4, no. 5 (May-June 1973): 28-30, illus.
Several short articles on X-rated movies from various points of view.

45-126 POSITIF. [Special issue on eroticism in the cinema.] Positif: Revue de Cinema 61-63 (June-August 1964).

45-127 PURDY, STROTHER B. "The erotic in film." In Fundamentals of Human Sexuality, edited by Katchadourian and Lunde, 389-420, illus., bib. New York: Holt, Rinehart, Winston, 1975.
Themes of sex in film history discussed.

45-128 RHODE, ERIC. "Sensuality in the cinema." Sight and Sound 30, no. 2 (Spring 1961): 93-95, illus.
Essay on the failure of cinema to truly be erotic.

45-129 RICHIE, DONALD. "Sex and sexism in the eroduction." Film Commentary 9, no. 1 (January-February 1973): 12-17, illus.
Discussion of Japanese sex films.

45-130 RIMMER, ROBERT H. The adult x-rated videotape guide: over 500 reviews and ratings and a listing of 1,650 more videotapes. New York: Arlington House, 1983. Index.

45-131 ROBINSON, W.R. "The imagination of skin: some observations on movies as striptease." Film Journal 2, no. 1 (September 1972): 44-53, illus.
Philosophical musing over the sensuality of the film medium and how it relates to erotic imagery.

45-132* ROCHA, G. "Ten slodki sport seks." Kino 8, no. 12 (December 1973): 41-44, illus.
Essay on eroticism in films today.

45-133 _____. "Le doux sport du sexe." Ecran 17 (July-August 1973): 52-58, illus.
Evolution of eroticism in the cinema outlined.

45-134 ROLLIN, R.B. "Triple-X: erotic movies and their audiences." Journal of Popular Film and TV 10, no. 1 (Spring 1982): 2-21.

45-135 ROTSLER, WILLIAM. Contemporary erotic cinema. New York: Penthouse/Ballatine, 1973. 280 pp., filmog., illus.
Overview of modern erotic films with a rating system.

45-136* _____. Superstud: the hard life of male stag film stars. Melrose Square, 1975.

45-137 ROWBERRY, JOHN W. Gay video: a guide to erotica. San Francisco: G.S. Press, 1986. 156 pp., index.
Rated directory of sexually explicit gay films, plus information on other related materials.

45-138* RUSSO, Vito. The celluloid closet: homosexuality in the movies. New York: Harper & Row, 1987. 368 p., por., filmog., index. (First edition published in 1981.)

45-139* RYAN, T. "They're showing the wrong film." Lumiere 26 (August 1973): 20-21, illus.
Success of sex films in Australia is discussed.

45-140 SALBER, WILHELM. Film und Sexualitat: Untersuchungen zur Filmpsychologie. Bonn: H. Bouvier, 1970. 188 pp., index, bib.
Study of sex in commercial films.

45-141* SCHEUGL, HANS. Sexualitat und Neurose im Film—die Kinomythen von Griffith bis Warhol. Munich: Hanser, 1974. 443 pp., illus., filmog., bib., index.

45-142 SCHICKEL, RICHARD. "Porn and man at Yale." Harper's 241 (July 1970): 34-38.
Report on a Russ Meyer film festival staged at Yale.

45-143* SCHIFRES, ALAIN et al. "L'invasion erotique." Le Nouvel Observateur 1130 (4 June 1986): 38-44.

45-144 SCHWARTZ, TONY. "The TV pornography boom." New York Times, 13 September 1981, sec. 6, 44+, illus.
Excellent analysis of sexually oriented materials available for TV, on cassettes and cable.

45-145 SEESSLEN, GEORG and WEIL, CLAUDIUS. Asthetik des erotischen Kinos: eines Einfuhrung in die Mythologie, Geschichte und Theorie des erotischen Films. Grundlagen des popularen Films, no. 4. Munich: Rolof and Seesslen, 1978. 269 pp., index, filmog., bib., illus.
Historical survey of sex in European and American commercial films.

45-146 "Sexuality" [special issue]. Film Journal 2, no. 1 (September 1972): 1-65, illus.
Series of articles on sexuality in films.

45-147* SHAPIRO, SUSAN. "Sex on screen: explicit, yes; erotic, rarely." After Dark, July 1980.

45-148 SHIPMAN, DAVID. Caught in the act: sex and eroticism in the movies. London: Elm Tree Books, 1985. 160 pp., illus., index.
History of sex in commercial American and European films.

45-149* SJOMAN, VILGOT. "An egret in the porno swamp: notes on sex in the cinema." Cineaste, Fall 1977.

45-150 SLADE, JOSEPH W. "The porn market and porn formulas: the feature film of the seventies." Journal of Popular Film 6, no. 2 (1977): 168-86, illus.
Thorough discussion of the X-rated movie and its growth.

45-151 _____. "Pornographic theaters off Times Square." Transaction 9, nos. 1-2 (November-December 1971): 35-43+, illus.
Description of movie theaters specializing in X-rated films.

45-152 _____. "Recent trends in pornographic films." Society 12, no. 6 (September-October 1975): 77-84, illus.
Discussion of contemporary developments in X-rated films.

45-153 _____. "Violence in the hard-core pornographic film: a historical survey." Journal of Communication 34, no. 3 (Summer 1984): 148-63, illus., ref.
Detailed study of images of violence in X-rated films.

45-154 SMITH, KENT; MOORE, DARRELL W.; and REAGLE, MERL. Adult movies. New York: Beekman House, 1982.
Reviews of more than 200 X-rated films, includes a history of the genre.

45-155 SOLINAS, PIERNICO. Ultimate porno. New York: Eyecontact, 1981. 337 pp.
Memoirs of filming the movie Caligula.

45-156 TOROK, JEAN-PAUL. "Le desir sous les ruines." Positif: Revue de Cinema 61-63 (June-August 1964): 65-71.
Fantasy and sci-fi sex images in films discussed.

45-157 _____. "Teenagers, Lolitas, et filles en fleurs." Positif: Revue de Cinema 61-63 (June-August 1964): 172-204, illus.
Image of the young, sexy woman in modern film surveyed.

45-158 TOYANO, ELA. "Ken Jacobs' film-performance XCXHXEXRXRX-IXEXSX." Drama Review 25, no. 1 (March 1981): 95-100, illus.
Experimental film created by overlaying images onto a 1920s French porno film.

45-159* TUCHOLSKY, KURT. "Erotische filme." Ausgewaehlte Werke 2 (1965).

45-160* TURAN, KENNETH, and ZITO, STEPHEN. Sinema: American pornographic films and the people who make them. New York: Praeger, 1974. 244 pp., ill.

45-161 TUSHER, WILL. "See sex out of theatres into homes: cassettes save porn pushers?." Variety 301, no. 10 (7 January 1981): 7+.
Death of X-rated theaters predicted because of home video.

45-162 TYLER, PARKER. A pictorial history of sex in films. Secaucus, N.J.: Citadel Press, 1974. 256 pp., illus.
Thorough history of sex in films.

45-163 _____. Screening the sexes: homosexuality in the movies. New York: Holt Rinehart and Winston, 1972. 367 pp., gloss., index, illus.
Study of the depiction of homosexuality in movies.

45-164 _____. Underground film: a critical history. New York: Grove, 1969. 249 pp., filmog., illus.
History of underground films since early in this century.

45-165 ULITZSCH, ERNST. "Der erotik im film." Zeitschrift fur Sexual-wissenschaft 3 (March 1917): 431-38.
Early discussion of sexuality in the cinema.

45-166 VOGEL, AMOS. Film as a subversive art. London: Weidenfeld and Nicholson, 1974. 336 pp., illus., bib., index.
Includes chapters on sex in the cinema (pp. 212-34).

45-167 _____. "Missionary positions." Film Comment 18, no. 3 (May-June 1982): 73-75, illus.
Anti-censorship call for more open access to films of an erotic nature.

45-168 WALD, JERRY. "Sex in movies." Films in Review 7, no. 7 (August-Sept 1956): 309-13, illus.
Brief history of sex in Hollywood films.

45-169 WALKER, ALEXANDER. The celluloid sacrifice: aspects of sex in the movies. New York: Hawthorn, 1966. 241 pp., index, illus. (Later published as Sex in the movies).
Sexual themes in commercial films up to the early 1960s surveyed.

45-170 WEIGHTMAN, J. "Cobblers from France; Paris porn." Encounter 46 (January 1976): 34-35.
Film review of French X-rated films and discussion of government attempts to censor them with a special tax.

45-171* WILLIAMS, WALLACE. The art flics: sex on celluloid. Ram, 1969.

45-172 WILLIANSON, BRUCE. "Porno-chic." Playboy 20, no. 8 (August 1973): 132-41+, illus.
Discussion of major hardcore films and their performers.

45-173* WOLF, WILLIAM. "Sex in the movies." Cue, 24 August 1968.

45-174 WOOD, ROBIN. "Most erotic moment in the history of the cinema." Film Comment 10 (March 1974): 33.
 Critic's choice of the most erotic scene in film history.

45-175 WORTLEY, RICHARD. Erotic movies. New York: Crescent Books, 1975. 140 pp., index, illus. (some col.).
 History of sex in the cinema.

45-176 "You are cordially invited to attend an orgy." Cinema 2, no. 3 (October-November 1964): 23-29, illus.
 Semi-nudity in early films discussed.

45-177 ZIPLOW, STEVEN. The film maker's guide to pornography. New York: Drake, 1977. 160 pp., illus.
 A complete how-to guide to make marketable porno films.

Author Index

Author Index

WITKOWSKI, G., 9-31, 9-32, 9-33, 27-41,
 28-18
WITT, L., 43-119
WITTHOFT, J., 25-7
WIVEL, O., 43-291
WOLF, W., 45-173
WOLFRAM, E., 43-174
WOLINSKI, 40-42
WOLMAN, B., 44-273
WOOD, R., 1-129, 13-23, 45-174
WOODCOCK, G., 6-136
WOODROFFE, J., 20-9
WORTLEY, R., 1-130, 39-27, 45-175
WRIGHT, B., 33-129
WRIGHT, E., 33-130
WRIGHT, R., 1-16
WRIGHT, T., 3-24, 28-9
WU, W., 21-10
WU LIEN-TEH, 18-14
WULFEN, E., 44-50, 44-51
WULFFEN, E., 6-137
WUNDERLICH, P., 43-330, 43-331, 43-332
WURDEMANN, H., 33-131
WYKES, A., 38-18

X, J., see JACOBUS X
XURIEGUERA, G., 43-129

YAFFE, M., 5-106
YORKE, M., 43-127
YOSHIDA, K., 43-334
YOSHIDA, T., 21-120
YOSHIDA, Y., 43-137
YOSUKE, I., 43-335, 43-336
YOUNG, J., 24-18
YOUNG, W., 1-131

ZACK, D., 40-43, 43-130
ZANNAS, E., 20-171
ZERI, F., 29-35
ZERNER, H., 29-32
ZHENG, C., 21-30
ZICHY, M., 31-93
ZIPLOW, S., 45-177
ZITO, S., 45-160
ZOLLA, E., 7-39
ZWANG, G., 8-40